THE GLASGOW BOYS

The Glasgow Boys

THE GLASGOW SCHOOL OF PAINTING 1875–1895

ROGER BILLCLIFFE

JOHN MURRAY

published in association with

BRITOIL

The publisher acknowledges subsidy
from Britoil plc
towards the publication of this volume

© Roger Billcliffe 1985

First published 1985
by John Murray (Publishers) Ltd
50 Albemarle Street, London W1X 4BD

Reprinted (with corrections) 1986

Design by Peter Campbell

Printed in Great Britain
by Balding + Mansell Limited, Wisbech

British Library Cataloguing in Publication Data
Billcliffe, Roger
 The Glasgow boys: the Glasgow school of painting
 1875–1895.
 1. Glasgow school of painting
 I. Title
 759.2′911 ND481.G5

ISBN 0 7195 4118 2

CONTENTS

FOR BRONWEN

Unless otherwise stated all works are in oil, on canvas or panel as indicated. Watercolours, drawings and pastels are on paper unless otherwise stated. All measurements are in centimetres, height × width.

WATERSTONE'S

BOOKSELLERS

114 GEORGE STREET
EDINBURGH EH2 4LX
Telephone: 031-225 3436

236 UNION STREET
ABERDEEN AB1 1TN
Telephone 0224-571655

PREFACE

In the twenty-five years before the outbreak of War in 1914 Glasgow was associated, in centres of artistic achievement in both Europe and the United States, with the latest advances in the decorative arts, painting and architecture. Today we usually attribute Glasgow's international fame to the attention paid to the young Charles Rennie Mackintosh who took Germany and Austria almost by storm in a series of exhibition interiors which he designed between 1900 and 1910. In fact, the way had been prepared for Mackintosh a decade earlier by another group of young men who came to be known as the Glasgow School, or, less formally, as the Glasgow Boys.

From the mid-1880s their paintings had been shown at the Salon in Paris but in 1890 they were invited to exhibit as a group in Munich where they were acclaimed by the younger generation of painters. Throughout the following decade the Boys exhibited in the principal European cities and in the United States. The name of Glasgow became synonymous with a certain kind of modern painting and Mackintosh would have been welcomed as the latest product of a city from which such adventurous thinking had become accepted as normal. At home, however, the Boys found this new celebrity somewhat galling after their treatment by collectors and officialdom during the 1880s. In many ways their careers foreshadowed that which would befall Mackintosh, except that when Europe took them to its heart the Glasgow public hurriedly did likewise. Mackintosh continued to be decried at home while being regaled abroad.

By 1910 two monographs had appeared devoted to their painting and almost all of the Boys had established careers as successful painters whose work was in demand throughout Scotland and in London too. Like Mackintosh, however, after the First World War they entered a kind of limbo (with the exception of the most successful, such as Guthrie and Lavery) from which they were not to be rescued for over fifty years. While Mackintosh had his faithful band of supporters throughout the 1930s and 1940s, the Boys were ignored by all but a few practising painters in Scotland who admired their stance against convention and their fight to have their beliefs listened to (or looked at). Like many Victorian and Edwardian painters their work fell out of fashion, to be consigned to the museum basement and sold without reserve in the auction rooms. The Boys had not been rebels; they had wanted to exhibit at the Academies and Salons and in many ways they remained part of the academic tradition of the nineteenth century. The Impressionists, however, and other movements which were deemed to be more 'advanced', dominated the researches of art historians and the passions of collectors from the 1920s. The Boys were bundled together with

Bouguereau and Troyon, Waterhouse and Millais, Leighton and Hunt, against whom the avant-garde had supposedly rebelled. They were labelled as unadventurous and were ignored, their paintings considered trivial and shallow compared with the achievements of the School of Paris.

With the general revival of the arts of the nineteenth century during the 1960s came a specific interest in the Boys. Several scholars began to see the, by now traditional, account of the development of new ideas in modern painting to be somewhat distorted and a new interest was born in the work of groups such as the Pre-Raphaelites, French painters of the realist tradition and the Glasgow Boys. Much had been lost and even more forgotten about their achievements in Glasgow, both artistically and socially, but in 1968 the Scottish Arts Council organised a major exhibition of their work at Glasgow Art Gallery. In 1970 The Fine Art Society arranged a similar, but smaller, show in London, the scene of their great triumph in 1890 which had initiated the invitation to exhibit in Germany. Other exhibitions followed, usually devoted to individual painters, which took advantage not only of recent research into British painting of the period but also that into French painting which had offered an alternative to the route followed by the Impressionists and their heirs. Melville (Dundee Art Gallery), Henry and Hornel in Japan (Scottish Arts Council), Guthrie (The Fine Art Society), Hornel (The Fine Art Society), Paterson (Lillie Art Gallery), Lavery (The Fine Art Society) – all contributed some parts of the jigsaw, which was taken further by more general studies of the Boys' connections with Helensburgh (Helensburgh Art Society) and with their relationships with Mackintosh and the designers and painters of the Glasgow Style (The Fine Art Society). This book is an attempt to find more pieces of the puzzle, to place them in a more coherent pattern in order to see what is still missing. Earlier writers have included as many as two dozen painters in the School but I have generally excluded a number of peripheral figures such as D. Y. Cameron, Grosvenor Thomas and J. E. Christie in order to concentrate on the central group of artists gathered around Guthrie, Macgregor, Lavery and Melville.

I have to acknowledge the help of many people, particularly those who have trodden some of the same paths in earlier years. William Buchanan, when Director of Art at the Scottish Arts Council, acted as prime mover and co-ordinator of all the different researchers who contributed to *The Glasgow Boys* in 1968. He and his team uncovered many sources of material and brought it to public attention in a way which added greatly to our knowledge of the period and which also helped prevent the destruction of many primary sources – paintings, drawings, letters and diaries. In addition to his two-volume catalogue of that exhibition (my much-tattered copy being witness to its indispensability), Bill Buchanan has been open and generous in sharing other unpublished material and in discussing my theories about the development of the Boys' work. In a much more direct manner, however, I am especially grateful to Mrs Ailsa Tanner, a contributor to the 1968 exhibition and the organiser of others since, for her reading of my first drafts and the many suggestions which she has made. Mrs Tanner has an unrivalled knowledge of the Boys' relationship with the town and people of Helensburgh and I am indebted to her guidance on this and other

matters. Where we have not agreed on the interpretation of certain pieces of evidence, however, the responsibility for the opinions offered must rest with me. In addition I must sincerely thank a number of other people who will, I hope, accept this small token of gratitude for making my task that much more attainable: L. L. Ardern; Christie's, Scotland; Jack Dawson; Anne Donald and the staff of the Fine Art Dept, Glasgow Art Gallery; my colleagues at The Fine Art Society in Glasgow, Edinburgh and London; the staff of the Glasgow Room, Mitchell Library, Glasgow; the staff of the Glasgow School of Art Library; Ross Harper; Martin Hopkinson of the Hunterian Art Gallery, Glasgow; The Hornel Trust, Kirkcudbright; photographers Ina Graham, Marilynn Muirhead and John Gilmour of Ideal Format; Hilary Macartney; Kenneth McConkey; Sir Norman Macfarlane; Angus Maclean; the National Galleries of Scotland; Andrew McIntosh Patrick; Una Rota; Sotheby's; Anne Paterson Wallace and the Paterson Family Trust; the many private collectors who wish to remain anonymous and the curatorial staffs of the public galleries who have answered my questions and allowed me to illustrate their paintings.

This book would not have appeared at all were it not for the timely and considerable financial help towards its publication which came from Britoil plc, and also from Sir Norman Macfarlane. To them both I and my publishers, John Murray, owe a special debt of gratitude. At John Murray my editor, Duncan McAra, displayed great patience, tempered by an enthusiasm for the subject which helped sustain my own when deadlines approached and were passed without an end in sight. A much more immediate source of encouragement, however, has been my wife, Bronwen. Without her help and support, in countless forms, I should never have found my way to the end of this book.

Roger Billcliffe
Glasgow, February 1985

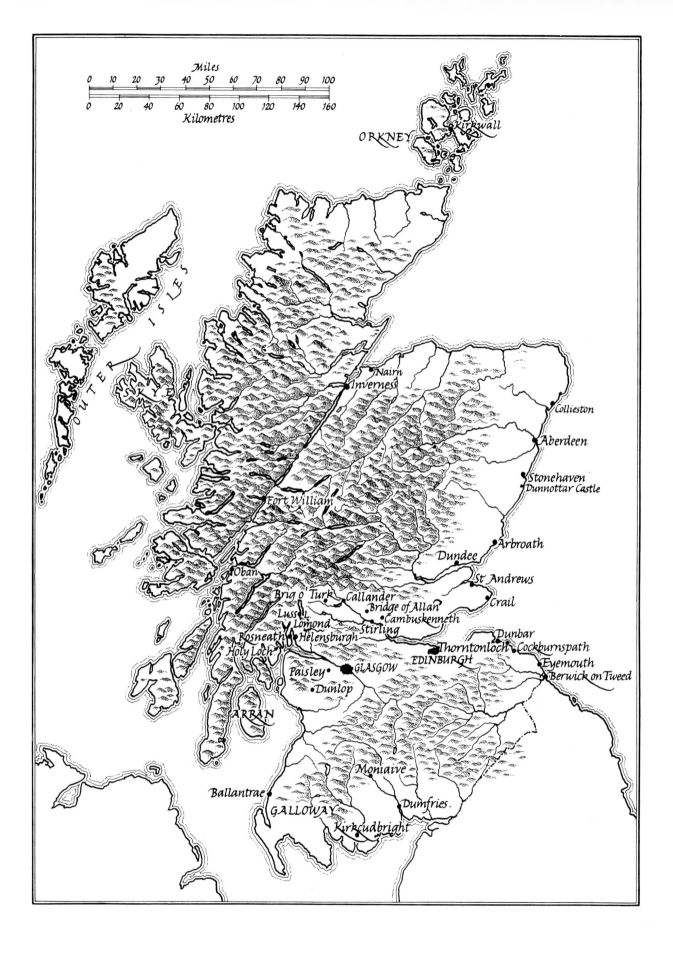

CHAPTER 1

The Second City

As the nineteenth century drew to a close, bringing with it the decline of Glasgow's influence in the affairs of the world, the work of a group of young men was celebrated in a book which made public acknowledgement of their achievements in the city, in London, continental Europe and North America. They were not engineers, shipbuilders or industrialists but painters and sculptors. Their fame outside the city led to their being clearly associated with their birthplace, or adopted home. At the same time, however, as this was openly acknowledged in David Martin's *The Glasgow School of Painting* these same young men were busy establishing their careers in other cities and few of them remained behind to enjoy the new celebrity which the book bestowed on them in a city which, ten years earlier, had not been so appreciative of their talents.

The introduction to that book was contributed by another young painter, Francis (Fra) Newbery, who, as Director of the Glasgow School of Art, occupied a position of some standing within the community. His support of this new 'Glasgow School' was seen to give them the kind of critical and social approval that Glasgow society needed before making open its own approbation of these young men. He set out to make sure that his audience knew where he stood:

And at this end of the nineteenth century, in the midst of one of the busiest, noisiest, smokiest cities, that with its like fellows make up the sum-total of the greatness of Britain's commercial position, there is a movement existing, and a compelling force behind it . . . which . . . may yet, perhaps, put Glasgow on the Clyde into the hands of the future historian of Art, on much the same grounds as those on which Bruges, Venice and Amsterdam find themselves in the book of the life of the world.[1]

With hindsight we can see how Newbery exaggerated his case but there is no doubt that he was writing with some of the evangelistic fervour that he had brought to the city on his appointment as Director of the School of Art in 1885. Newbery, perhaps better than anyone else in the city at that time, could see that the visual arts of the last decades of the century were going to play a greater part in the cultural development of Glasgow, and of Scotland, than anyone would have thought possible of this 'Second City' of the Empire. He had just arranged for the commission for the new building for the School of Art to be given to a young and unknown architect called Charles Rennie Mackintosh. Newbery was well aware of Mackintosh's promise and he saw that, combined with the interest in modern art that the painters of the so-called Glasgow School had generated, there was a hope that the Glasgow of the 1890s would indeed rank alongside the great city-states he cited in his eulogy.

The painters listed in Martin's book[2] would not, themselves, have claimed the unity of purpose that the sobriquet 'school' confers on them. Only a dozen or so of them formed any coherent group, with shared ideas and common aims. Perhaps the most common denominator was, in fact, their association with Glasgow, although many of the painters spent long periods away from it and one of the leading figures – Arthur Melville – was never resident there, being an Edinburgh man. Glasgow was, however, for most of them a home base in the 1880s. It was also where the peculiar conditions and conventions of artistic life in Scotland seemed most unfair and least acceptable. Glasgow was the largest and, without doubt, most prosperous city in Scotland but in the visual arts at least it played a distinct second fiddle to Edinburgh. When this meant that Glasgow artists had to send to London to be guaranteed a showing outside their native city it hardened their determination to overcome the bastions of tradition and privilege that held sway in Scottish art.

Whatever else Glasgow was renowned for in Victoria's reign it was not for its qualities as a nursery for the young creative artists of the day. The inventors of steam engines and of waterproof coats, the designers and builders of the great fleets with which Glasgow dominated the trade routes, the engineers who produced the powerful steam locomotives which were exported to all parts of the Empire – these were the sons of the city who achieved world renown, not its painters and poets, writers and architects. Yet the city and its clever businessmen who made it so prosperous did not spurn the arts. Its buildings erected in the great years of its expansion in the nineteenth century give it a dignity and a quality of life denied to many of its competitors. That same prosperity, however, which built Victorian commercial and residential Glasgow also produced more than its fair share of overcrowded housing, bad working conditions, and appalling poverty. Cholera swept through the city on more than one occasion in the nineteenth century, its passage encouraged by the insanitary conditions in which the majority of the population then lived. The problems were not ignored, however, and much was done, through Act of Parliament and the hard work of the city's civic leaders, to improve standards of housing, health care and, above all, to provide the city with an adequate and pure water supply to replace the dependence on polluted wells and streams, the sources of many of the epidemics which assailed the city.

Given this popular image of the workaday city it is not surprising that Edinburgh eclipsed Glasgow as the artistic as well as the administrative capital of Scotland. In the visual arts, the establishment of a Scottish Academy in Edinburgh concentrated public attention and attitudes to the east of the country. In such a small country as Scotland it surely should not have mattered that Edinburgh was the home of the supposedly supreme body in the fine arts. Unfortunately, petty jealousies, perhaps fired by the oft-assumed superiority of the capital's inhabitants, caused the Royal Scottish Academy and its members to close ranks, effectively making it impossible for any artist to join the body of Academicians and Associates without first setting up residence in Edinburgh. At times it seemed almost impossible for a Glasgow man to be hung on the Academy's walls, so tight and blinkered became the attitude to intruders from

the west. A contemporary commentator expressed these widely held views thus:

Wednesday's elections of ARSAs can hardly be said to have improved or strengthened the position of that body . . . Unless an artist occupies a Studio in George Street or Picardy Place [both fashionable streets in Edinburgh] he need not hope to find any favour in the eyes of the Royal Scottish Academy. Against Glasgow and Glasgow painters the animus is particularly strong . . . the authorities of the RSA have all along done their best to ignore or discourage Glasgow art. Glasgow is rapidly developing an important school of her own and she has claims as an art centre, and especially as an art-purchasing centre, with which Edinburgh can never hope to compete.[3]

Faced with these attitudes and the very effective obstacles placed in their path, many Glasgow painters directed their attention towards London. A considerable number of Scottish artists settled in London after 1850 – Pettie, Orchardson, McWhirter, Graham and Nicol among them – and achieved considerable success at the London exhibitions. Despite the apparent willingness of the Royal Academy to welcome refugees from its Scottish sister, a home base and shop-window was desperately needed for the west of Scotland artists. To fulfil this need a new exhibiting body was established in Glasgow in 1861. It was not, however, a simple association of artists, architects and sculptors. From the beginning full membership was open to both laymen and artists and the body was jointly administered by a Council on which both lay and artist members had equal say. Its President was a layman, as was its Treasurer, both offices being filled by leading patrons of the arts in the city. The Glasgow Institute of the Fine Arts was to play a considerable role in the development of the younger painters in the city in the 1870s and 1880s. Most of the laymen involved in the new venture were keen collectors of contemporary art. Glasgow had already seen a number of collectors whose interests were in the past, notably Archibald McLellan (1796–1854) whose pictures became the nucleus of the city's art collection. The availability of these famous paintings, including works from the Renaissance and Dutch pictures from the seventeenth century, no doubt played its part in the education of the younger men but it was towards the collectors of contemporary work that the young painters looked for encouragement.

Art collectors in Glasgow at the time were well served by a group of dealers based in the city who were able to supply them with not only the pictures of Scottish artists but also work from London and abroad. The best-known Glasgow dealer was probably Alexander Reid, who knew van Gogh in Paris and eventually merged his firm with Messrs Lefèvre in London to become Reid & Lefèvre. In the 1890s Reid was very helpful to the young painters of the Glasgow School but in the 1870s and 1880s other firms held the leading positions within the city. Craibe Angus was perhaps the most important of the dealers operating in Glasgow at this time, and in the 1880s he was to arrange several exhibitions of the work of these new young painters. His daughter married the son of Hendrik van Wisselingh, who was the principal dealer in the kind of Hague School pictures that became so popular with Glasgow collectors, and Angus was presumably the main agent assisting their entry into the city. He was almost certainly acting as an agent also for Daniel Cottier, an Aberdeen-born artist and designer turned dealer, who had earlier been apprenticed to a glass-stainer in

Glasgow and who became a close friend of Matthew Maris and other Dutch and French painters of the period. In the 1870s the works of the Maris brothers, Artz, and Mauve could be seen in Angus's gallery alongside paintings by Corot, Diaz, Rousseau and other Barbizon painters.[4] Many of these artists also sent work for sale to the annual Glasgow Institute exhibitions where they often found buyers among the Glasgow magnates who were busy building up their collections. It is interesting to note that while collectors in provincial England were buying English painting, particularly the Pre-Raphaelites, their Scottish contemporaries bought not only the local painters but continental pictures as well.[5] Taking one of these collections as an example, that of James Donald which was bequeathed to Glasgow Art Gallery in 1905, Glasgow taste of the period is represented by Jacob Maris, Corot, Millet, Daubigny, Mauve, Frère, Dupré, Pettie and Orchardson. Although this was not an insubstantial collection there were not at this date, however, any collectors who bought on the scale that William Burrell was to buy in later years in Glasgow.

Because of the involvement of many of these collectors with the Institute, and probably because of their keenness to have their purchases publicly approved or at least acknowledged, many of their acquisitions were included in the annual exhibitions. Very often the Council would invite work from artists who otherwise might not have sent to the Institute, thus improving the standard of the exhibition and also providing an added incentive to the public to visit and see works which otherwise could be found only in London. In this way painters such as Burne-Jones, Watts, Millais and Leighton were seen alongside such regular exhibitors as Whistler who, in the 1880s, needed no such prompting to give his work another platform. In 1880, for instance, the Institute received loans from, among others, collectors such as William Connal, James Donald, Leonard Gow and Sir Peter Coats. Artists whose work was lent that year included Diaz, Troyon, Rousseau, Fantin-Latour, Doré, Israels, Maris and Millet from abroad; Leighton, Alma-Tadema, Albert Moore, Pettie, Orchardson, Sam Bough and Noel Paton. 1880 was also the first year that the Institute exhibition was held in a new gallery of its own, designed by the young J. J. Burnet and built in the heart of Sauchiehall Street, one of the city's more fashionable thoroughfares. Previously it had been dependent on the Corporation to provide space for its exhibitions. Now, with its splendid new rooms, it could embark on a more regular series of exhibitions, supplementing the annual spring show with smaller displays of, for instance, 'black-and-white' and pastels.

The young artists of the new School could hope to count on a more sympathetic reception at the Institute than at the Royal Scottish Academy. Their work was not accepted without criticism, however, especially from more established painters within the city who held great power on the Selection and Hanging Committees. These older artists also held a tight control over another artistic body within the city, the Glasgow Art Club, established in 1867 and a powerful force in artistic circles. Unlike the Institute, where membership was open to all on payment of the subscription, the Art Club elected its members and thus carefully controlled those to whom it gave artistic 'respectability'. In this way the more radical of the younger painters were denied entry to a professional

association, so diminishing their public status and drawing them closer together in their discontent. Several of the younger men sought to overcome their exclusion by setting up in 1874 a cadet club, the St Mungo Society, where they could meet and discuss their own work and, no doubt, vilify the reputations of their 'elders and betters'; these were christened the 'Gluepots' by the younger men, a reference to their dependence on a brown, heavy medium – megilp. Their shallow and often anecdotal subject-matter also annoyed these young painters, but it was popular and painters such as Alexander Davidson and James A. Aitken made a good living from it. They, and painters such as James Docharty and David Murray, controlled the Art Club in the 1870s and early 1880s and ensured that their young critics were kept at bay.

And what of the School of Art, to which Newbery came in 1885 as a new broom? To some extent it was certainly in need of one for its classes were organised on old-fashioned lines and its teaching uninspired. For apprentices such as John Lavery (articled to a photographer for three years) or those chained to an office desk like James Paterson, it provided early morning classes with a model or casts but it had not the style or flair of other schools in London where several of the Glasgow School were to study in preference to their local academy.

If conditions were not encouraging for the younger generation, then, at least, they provided a focus for their dissatisfaction and grounds for rebellion. It was not, however, a carefully organised revolution complete with manifestos and martyrs that these young artists set out to achieve. Nor were they the coherent group that history made them, complete with the tag 'School'. In fact, any artist from Glasgow was cited as a member of the Glasgow 'School' by the local social magazines *Quiz* and *The Bailie* at the beginning of the 1880s. Recognition outside Glasgow of their work as having a certain unity came to the painters after an exhibition at the Grosvenor Gallery in London in 1890. It was at that time and by the London critics that the term 'School' was coined; to the painters themselves and their friends in Glasgow they 'were just the Boys'[6] and that is how they are still best known in their native city.

1
(Sir) James Guthrie
1859–1930

2
E. A. Walton
1860–1922

3
James Paterson
1854–1932

4
W. Y. Macgregor
1855–1923

5
Joseph Crawhall
1861–1913

6
George Henry
1858–1943

7
E. A. Hornel
1864–1933

8
(Sir) John Lavery
1856–1941

9
William Kennedy
1859–1918

10
Alexander Roche
1861–1921

11
Thomas Millie Dow
1848–1919

12
Robert Macaulay Stevenson
1854–1952

CHAPTER 2

New Friendships

In 1877 the members of the Glasgow Art Club rejected applications for membership from James Guthrie (pl.1), E. A. Walton (pl.2), James Paterson (pl.3) and W. Y. Macgregor (pl.4).[1] Guthrie and Walton were not yet twenty and so would have been seen as very junior, if not impudent, applicants, but for Macgregor and Paterson it was no doubt a deliberate rebuff. Both had studied at the Glasgow School of Art under Robert Greenlees RSW (1820–96) and had then entered the studios of local painters – Macgregor going to James Docharty ARSA (1829–78) and Paterson to A. D. Robertson (1807–86) who gave classes in watercolour. Macgregor then left Glasgow for the Slade in London where he worked under Alphonse Legros (1837–1911). Legros, trained in France and a friend of Degas, was a strong advocate of *peinture au premier coup* and also a fine draughtsman. His strong links with French painting, particularly those artists who were concerned with the depiction of peasant life in France, must have had some effect on Macgregor but the latter's work of this period shows no immediate change from the competent but unimaginative style of his Glasgow mentors.

Paterson, after persuading his parents to allow him to leave the offices where he had worked for four years as a clerk, made a more direct contact with French painting by enrolling in the studio of Jacquesson de la Chevreuse, a minor French artist who had once worked in Ingres' *atelier*. He stayed there for two winters, 1878 and 1879, and then left to study under Jean-Paul Laurens, spending three sessions in his studio from 1880 until 1882. In the October 1888 issue of *The Scottish Art Review* Paterson recalled his experiences in an article entitled 'The Art Student in Paris'. His account of life as a *bienvenu* throws much light on the camaraderie which existed among the English-speaking students in Paris, as there was, according to Paterson, very little social contact between the Frenchmen and the foreigners. His account of the novice's approach to the *atelier* is worth repeating:

To the aspirant fresh from some palatial school of art in England or Scotland the outlook is not inviting. Armed probably with a letter of introduction to the *massier*, the secretary and treasurer of the studio elected annually, he knocks timidly at the door, which he has found with difficulty. A yell of '*Entrez!*' invites him to proceed, and he finds himself in the centre of the room, keenly scrutinised by some, calmly ignored by most, who proceed with their work. Some facetious Frenchman, pretending to mistake the visitor for a model in search of work, will most likely shout out '*Déshabillez-vous*', but the *massier*, who by this time understands that he is wanted, politely inquires his business. Mustering his best French, the newcomer explains that he desires the honour of numbering himself among the pupils of the celebrated Mons Z. The *massier* looks grave. Very sorry, studio quite full, many refused already, but if he will go and see the patron, on Sunday morning before nine, perhaps something might be done later.

13
Alexander Mann
1853–1908

14
Arthur Melville
1855–1904

Acceptance by the *patron*, however, precedes acceptance by the other students who might not so readily welcome another to their ranks:

That the *dernier nouveau* has his duties soon becomes apparent. Loud cries of '*Charbon!*' incite him to replenish the stove with coke; and this is no sooner done than he is admonished, by numerous requests for *petits pains*, to procure the same from a neighbouring baker's shop. At the first rest, after premonitory hints, the universal cry of '*Ponch, ponch, dernier nouveau*' becomes more peremptory, and his former adviser recommends a prompt compliance with the demand. The inevitable café at the corner soon supplies the wonted beverage, for which the novice pays. He may be invited to sing a song, in some ateliers he may even be subjected to some annoyance, but as a rule the *bienvenu* is generally held as sufficient initiation . . . His main duties, in addition to those already alluded to, will be to procure hard soap occasionally for brush washing, and form one of a search party for a model, should the one engaged not turn up.

Of the tuition offered he has this to say:

Very earnest work is pursued in this dirty, comfortless room, and the latest arrival is soon deeply engrossed in search of *les valeurs*. From the antique he is in time promoted to the life; and he goes his way at last, having learned what he is capable of assimilating. That the bulk of studies done are hopelessly bad, and that the majority of men have mistaken their profession, himself perhaps among the number, will most likely come increasingly apparent to him. His undoubting zeal in the conviction that art is simply a matter of so many years' study will become a myth, but that a man gifted with real artistic capacity does not learn much in the routine of work in an atelier is an invention of those who are too lazy or too conceited to take advantage of it.

And of his fellow students:

To the student of human nature the nondescript gathering of nationalities and 'types' will be ever interesting. The *flaneur*, who looks in occasionally to see what is being done by others . . . ; the *blageur* who has always some tomfoolery in hand; the *jeune homme arrivé*, who had a third-class medal in last Salon, and gives himself airs accordingly – these are met in every atelier, while no less conspicuous will be the pet of the studio, whose studies it is openly hinted surpass the work of the *maître*, who has nearly attained the Grand Prix de Rome, and will most probably continue to produce accomplished technical studies which may become fashionable but can never become real art.

Paterson followed the usual practice of Scots artists who studied abroad of spending the winter in the *ateliers* and the summers at home or travelling on the continent. He was subsidised to the extent of £10 per month by his father, a partner in a Glasgow warehouse. Macgregor also managed to maintain a reasonable standard without having to rely on selling his pictures as his father had been a partner in one of the big Clyde shipyards. He had, however, to overcome his father's strong opposition to his choice of career and had to rely on his mother's somewhat doting support in persuading him to accept the situation; indeed, it was his mother who came to the financial aid of her son in his wish to become a painter.

Paterson and Macgregor had known each other at school, where the latter was called 'Gigi' or 'Puffy' by his few friends, and in 1877 (or possibly 1878, as Paterson's notes on this period are not totally reliable) they spent the summer together – the first of many – painting on the east coast of Scotland. His few months in Paris had instilled in Paterson a bold approach to his subject which

soon found its way into Macgregor's work. In the words of Sir James Caw[2] (who knew most of the Boys and who is probably a more reliable witness than Martin or Baldwin Brown, the author of the other monograph on the Glasgow School[3]), after his visit to St Andrews:

Macgregor began to reconsider his relationship to Nature, and, as a result, commenced to paint effects rather than facts. Then, about a year later, it came to him all at once . . . that for him the least primal quality in painting, as in Nature, was fullness and richness of tone. And getting big brushes he attempted to attain this forcibly and directly.

Caw's reference to 'effects' recalls an anecdote in a manuscript memoir of Macgregor written by Paterson[4]:

Somewhere about 1872 a fair-headed, plump and rosy-cheeked youth could be seen sitting day after day, in cloudless summer weather, morning and afternoon, on the same spot, above the pier at St Andrews, labouring at a small picture of St Regulus' tower. W. E. Lockhart, the newly elected Associate of the Royal Scottish Academy, who, from time to time, had marked the solitary earnest student, at last ventured to address him with the question 'Don't you find the effect changes as the sun goes round?' Without raising his eyes from the diminutive canvas, the curt rejoinder 'Docharty doesn't paint effects' discouraged further comment and the work went on.

Paterson and Macgregor remained friends until the latter's death and their submissions to the Glasgow Institute show that they worked together during the summers of 1878–81 at St Andrews, Nairn and Stonehaven.

Guthrie and Walton, the other rejected applicants to the Art Club in 1877, also turned to each other in their adversity and became life-long friends. Together with Joseph Crawhall (pl.5) and George Henry (pl.6) they formed the second of the three groups on which the Glasgow School was concentrated.

Born in 1859, Guthrie, a son of the manse, was destined for a legal career. His own sympathies lay elsewhere, however, and Caw[5] records how Guthrie's father relented after the intervention of James Drummond RSA (1816–77) and John Faed RSA (1820–1902) and allowed his son to leave Glasgow University, without taking his degree, to train as a painter. Any plans the young man had were soon upset by the sudden death of his father in September 1878 in London. Guthrie had been staying there with his parents who were on the point of emigrating to New Zealand where their two other sons and daughter had already settled. Mrs Guthrie decided to return to Glasgow and James came north with her. He did not, however, enrol in classes at the Glasgow School of Art nor did he attach himself to any painter in Glasgow. Having already been shunned by the Glasgow Art Club he was attracted to the St Mungo Society, where he made contact with E. A. Walton and where Crawhall was later to join them.

In 1879 Guthrie, Walton and Crawhall spent the summer together painting at Rosneath on the Clyde coast just beyond Helensburgh. In this they were following what had become a standard practice among Glasgow painters of leaving the city for several months in the summer to fill sketch-books and small canvases to work up in the winter into exhibition pictures for the Institute and the Academies. Later that year Guthrie left Glasgow with his mother to visit Paris, stopping in London on the way to call on John Pettie RA HRSA

(1839–93). Pettie was one of the most successful of the Scottish painters who had settled in London. Trained in Scott Lauder's Trustees' Academy in Edinburgh he had built a reputation on producing the kind of narrative and subject pictures which had caught the imagination of the bourgeois picture buyers at the Royal Academy. Guthrie was not without connections in Glasgow – his father's sister had married the Revd Andrew Gardiner whose three sons had founded a successful shipping company. Throughout the 1880s the Gardiner brothers – James, Frederick and William – were to support the young Glasgow painters (and some of their non-Scottish friends such as Frank O'Meara) through direct patronage and indirect encouragement and recommendation. It seems likely, therefore, that Guthrie took with him to London an introduction to Pettie secured by one of his three cousins.

Pettie dissuaded the young Guthrie from seeking a place in a Parisian *atelier*, assuring him that he would learn as much in London. As one of Pettie's pupils, Guthrie was drawn into the circle of Scottish artists working in London and he came to know W. Q. Orchardson RA HRSA (1832–1910), Thomas Graham HRSA (1840–1906) and John Robertson Reid (1851–1926). Although most of his London pictures were the costume pieces that Pettie and Orchardson would have encouraged him to paint, it seems likely that Guthrie was strongly influenced by the ruralist subjects of Reid. Certainly, following the rejection of his painting *The Unpublished Tragedy* (untraced) by the Royal Academy in 1881 (a picture apparently much praised by Pettie[6]), Guthrie turned entirely from such narrative themes to the rustic subjects of farmworkers and their way of life that were to occupy him throughout the 1880s.

Walton had few of the early struggles with his family that beset Guthrie. He was born in 1860, one of twelve children, and several brothers and sisters also took up careers in the arts: his youngest brother, George (1868–1933), became a designer and architect and a sister, Constance (1866–1960), was to become a well-known Glasgow 'lady-artist'. His father was a keen amateur painter, and although he might not have chosen art as a profession for his son he posed no real objections to his studying at Dusseldorf Academy in the winter of 1876–7. He returned to Glasgow to enrol in the Glasgow School of Art under Greenlees but, like Guthrie, he spent much of his time with painters of similar aims and temperament at the St Mungo Society.

One of Walton's brothers, Richard – an architect – moved to Newcastle-upon-Tyne to set up a new practice. There he met, and later married, Judith Crawhall, the daughter of Joseph Crawhall, a rope manufacturer, who was also something of an amateur artist. On a visit to Newcastle E. A. Walton met Judith's brother, Joseph Crawhall Junior, and the two immediately became friends. Crawhall Senior was a friend of Charles Keene (1823–91), the cartoonist for *Punch*, and often supplied him with ideas – both verbal and pictorial – for his magazine contributions. He later published *The Compleatest Angling Booke that Ever was Writ*, an illustrated volume of the 'chapbook' format. Given this keen and practical involvement with the visual arts, it is not surprising that the elder Crawhall did not object to his son's ambition to be a painter. He did not, however, direct him towards an Art School[7]; nor does he seem to have used his

contacts with Keene to attach him to any of the major London painters with whom the artist was on close terms. Crawhall himself undertook to train his son, placing particular emphasis on the skills of draughtsmanship. In addition he encouraged the young artist to develop his visual memory so that he could work later from minute or hurried sketches made on the spot.[8] It is interesting to note that on the only recorded occasion that any of the Boys met Jules Bastien-Lepage (1848–84) – who was to become their hero and chief source of inspiration during the 1880s – his advice was to study the subject carefully and then make as many notes as possible from memory.[9] The young Crawhall did succumb eventually to formal training but not until the autumn of 1882 when he enrolled in the studio of Aimé Morot (1850–1913) in Paris. By this time his artistic ideas must have been pretty much settled through his association with Walton, Guthrie and Henry in Glasgow and he left Morot's after only two months and returned to Glasgow.

Crawhall, Walton and Guthrie spent the summer of 1879 together and were to repeat the experience at various times over the next two or three years. Crawhall and Guthrie also kept in touch in London where the latter lived until 1881. Crawhall was a frequent visitor to Guthrie's house in Maida Vale and the two artists even collaborated on pictures[10]: Crawhall's portrait appeared in Guthrie's *The Unpublished Tragedy*, which was later acquired by a Newcastle collector.[11] Walton often visited them in London and they were together again during the summers in Scotland. In 1881 all three were joined at Brig o' Turk, in the Trossachs, by another young man who was enrolled at the Glasgow School of Art, although he seems to have actually been employed as a clerk in Glasgow during the day.[12]

George Henry was born in Ayrshire in 1858 but little is known of his early life, about which he was quite reticent in later years. In some ways Henry was the most rebellious of the Boys. His letters to Hornel[13] in later years show a healthy disregard for the conventions, although he was careful not to embarrass Hornel's mother by taking down to Kirkcudbright any of the models with whom he happened to be living. As a painter he produced the one painting to come out of Glasgow at this time which challenged the most advanced work being produced anywhere in Britain – *A Galloway Landscape* (1889; see p.223) – and together with his friend E. A. Hornel (pl.7) he was one of the few British artists to visit Japan, staying there for over a year in 1893–4. As the final member of this second coherent relationship under the umbrella of the 'Glasgow School', however, he was very much the junior partner in 1881, despite being the oldest of the four.

The third group of young men who are central to the development of the new painting in Glasgow were a disparate crowd, but they had one crucial factor in common – they had all trained in Paris or worked at a small French village, Grez-sur-Loing. Grez was an old village on the River Loing which became an artists' colony in the 1870s and 1880s much as Barbizon had been twenty years earlier. Several British artists, writers and musicians[14] found inspiration there, in particular four young men from Scotland – John Lavery (pl.8), William Kennedy (pl.9), Alexander Roche (pl.10) and Thomas Millie Dow (pl.11).[15]

Lavery was born in Belfast in 1856 but, after being orphaned, was brought up on a farm in Ulster and then moved to stay with relatives in Saltcoats in Ayrshire.[16] After running away to Glasgow on more than one occasion – working as a clerk in a railway office and a pawnshop – he was apprenticed to a Glasgow photographer and portrait painter, J. B. McNair. He also enrolled at the Glasgow School of Art about 1876 where his natural talents as a draughtsman received little encouragement. It is interesting to note that one of the Boys, at least, had a professional awareness of the capabilities of photography as it seems likely that several of them used the new medium as an aid to drawing or composition in the coming years. Lavery was not afraid to acknowledge his use of photographs to supplement or even replace the model[17] but few of his friends were as frank about their dependence on the camera.[18] In 1879 Lavery was released from his apprenticeship and set up on his own as a portrait painter (and, perhaps, photographer). His early work is by no means unconventional, in fact he was almost a trainee 'Gluepot' specialising in costume pieces and portraits which show little awareness of the French and Dutch paintings then being shown at the Glasgow Institute or the various dealers' galleries in Glasgow.

In his own words, Lavery had a stroke of luck when his studio in Glasgow was burned down in 1879. He had fortunately insured it for £300 and with his compensation he set off for London and enrolled at Heatherley's Art School. After a year in London – by his own account lonely and unfruitful – Lavery returned to Glasgow. In November 1881 he was elected to the Glasgow Art Club (along with W. Y. Macgregor) and later the same month he set off for Paris and the Académie Julian.[19] The painter John Guthrie (no relation of James) was also in Paris and wrote to a friend in Glasgow saying that there were

quite a host of Glasgow pupils in the studios of Paris. Many of them . . . attend the atelier of Julian : [he goes himself] to Gérôme's and [is] the only Scotchman at present under the famous master.[20]

The Académie Julian was unlike the other *ateliers* in Paris, and certainly different from the Beaux-Arts, in that Julian, whose name it bore, was not its true master and the young men who used it certainly did not attend to study at his feet. It was open to all, provided only a room with a model and the company of one's fellow aspirants, but, most important of all, it was visited by many of the leading *Salonniers* who provided swift judgement upon the young men's work and the occasional glimpse of true professionalism in some rapid sketch or words of advice. The attraction for Lavery at Julian's was undoubtedly Bouguereau, a painter of the *grandes machines* which found annual acclaim at the Salon. Lavery realised that there was a right way and a wrong way of achieving the success that he so desperately needed and he set about emulating the successful painters who came to oversee the young artists at Julian's. Lavery was always ambitious and looked to his masters to see that their pupils' interests were cared for at the big exhibitions. In 1883 his hopes were answered when his picture *Les Deux Pêcheurs* was hung on the line at the Salon.

The Salon picture was painted *en plein air* but when Lavery had returned to Glasgow for a few months in the late summer of 1882 he was still painting costume and historical pictures such as *Monsieur le Troubadour* (see p.53). He

possibly met Guthrie in Glasgow that year but in the winter he returned to Paris. The following summer he discovered Grez along with William Kennedy, Thomas Millie Dow and Alexander Roche – three young Scots who had also been in the Parisian *ateliers*.

William Kennedy had enrolled at a Paris studio before Lavery in 1880. He was born in Glasgow in 1859 but was brought up by his brother, a master baker in Paisley, after being orphaned. He studied at Paisley School of Art and possibly at the Glasgow School of Art[21] and began to exhibit at the Paisley Art Institute in 1877, showing local landscapes and pictures of life in west coast fishing villages (none of these has been traced). In Paris he studied under Bouguereau, Fleury, Bastien-Lepage, Collin and Courtois and his first French painting to be exhibited at home was *The Public Washing Place, Auvers-sur-Oise*, shown at Paisley in 1881. In 1882 he visited Fontainebleau where he painted more landscapes.[22] Kennedy's output continued in this vein until he went to Grez, where the peasants he had first sketched in the fields at Auvers were replaced by the children of the village playing in the streets and gardens.

Kennedy probably accompanied Lavery to Grez; they had met late in 1881 or 1882 when the latter arrived in Paris.[23] In the studios and cafés of Paris the British and American artists kept closely in touch and Kennedy would also have met Alexander Roche and Millie Dow and, no doubt, the latter's great friend and idol, William Stott of Oldham (1857–1900). Alexander Ignatius Roche was also born in Glasgow, in 1861, and after leaving school began to train as an architect. This brought him into contact with the Glasgow School of Art, where he attended classes in architecture, but later he abandoned his new profession and enrolled in the painting classes. At the end of 1881 he left Glasgow for Paris and we know that he was in Lavery's company in January 1882. Like Lavery he studied at Julian's, but Boulanger and Lefebvre were his masters, not Bouguereau whom Lavery had admired. Later he was to move to the Ecole des Beaux-Arts under Gérôme where he probably met Millie Dow. His early pictures at the Glasgow Institute (1881 and 1882) were local landscapes with titles which ominously suggest the kind of 'Gluepot' scenery painting that he was shortly to turn against – *Bute, Autumn in Bute, The Craw Clachan*. His subject-matter slowly turned to figure pieces and then to *plein-air* paintings, hastened, no doubt, by his contact with Stott of Oldham and the other British painters working at Grez.

Thomas Millie Dow was not a Glaswegian. He was born in 1848 at Dysart in Fife, the son of the Town Clerk, and was destined for a career in law, which he studied in Edinburgh.[24] He did not complete his apprenticeship but left Scotland for Paris to train as a painter. He enrolled at the Beaux-Arts under Gérôme and later studied with Carolus-Duran and at Julian's. The exact dates of this are not known but it seems likely that he was at the Beaux-Arts before the spring of 1879 for it was at this date that an American artist, Abbott Thayer, left Europe to return to the United States after studying at the Beaux-Arts; Thayer and Dow became friends in Paris and then Dow visited the United States and stayed with Thayer at Peekskill and Cornwall on the Hudson in the winter of 1883–4.[25]

Dow's work was never powerful in handling or subject-matter and his early paintings (or at least those shown at the Institute up to 1883) indicate a quiet and

thoughtful attitude towards his new profession – *Mill Sluice*, *Autumn Evening*, *The Village School*, *Chrysanthemums*. In Paris he met and became a close friend of William Stott. Stott, who adopted the suffix 'of Oldham' to help distinguish him from his fellow Lancastrian Edward Stott, was most highly regarded by the young British painters in Paris and was to become something of an idol for many of the Glasgow Boys – a home-grown Bastien-Lepage who formed a link for them with Whistler and other avant-garde painters working in London. At Grez with Stott, Millie Dow would have absorbed the quiet harmonies and powerful compositions, allied with a certain sense of the allegorical, which are a hallmark of Stott's painting. These qualities had a profound effect upon Dow, although, in Caw's words, his paintings

were less virile in conception and less vigorous and masterful in handling, while their greater abstraction and more definitely decorative intention had affinity with the later phase of Stott's art rather than with the qualities then dominating it, and seem to suggest that he in turn influenced the other.[26]

In the early 1880s, these three groups of young painters worked not in ignorance of each other, yet certainly not as one united and unified brotherhood. Those of them not studying in Paris could meet regularly in the winters in Glasgow; but during the summers, when most of their work was done, they returned with their particular friends to the groups I have outlined above. Considered together, they formed the nucleus of the group of painters we now call the Glasgow Boys (or the Glasgow School) but they were not the only artists to be associated with that phenomenon. Several other painters – for instance, E. A. Hornel, and Robert Macaulay Stevenson (pl.12) – were to play substantial roles in the later history of the Boys and will be encountered shortly but there were, working alongside those artists we have already met, two or three painters who formed no clearly defined ties with particular groups within the School or who were able to pass freely from one group to another.

Alexander Mann (pl.13) was born in Glasgow into a prosperous merchant family.[27] He first of all joined his father's firm, Mann Byers, but in 1877 left for Paris where he studied at Julian's; in 1881 he moved to the studio of Carolus-Duran where he remained until 1885. He exhibited at the Glasgow Institute for the first time in 1879 and at the Salon in 1882. Like most painters of his generation in Paris, Mann was an eclectic and in his work can be seen traces of Millet and the Barbizon painters and of Bastien-Lepage and the naturalists, alongside the more traditional, or at least the more popularly acceptable, mannerisms of his academic masters. Mann displays all of these influences without being overwhelmed by any single one of them. His art is perhaps characterised by a rich young man's lack of zealous commitment, but in Glasgow it was still admired by the young Boys for its obvious awareness and acceptance of many of the current French ideas which they were bravely beginning to emulate. Mann did not spend enough time in Glasgow to become closely involved in the day-to-day development of the new School but of his summers in Scotland he spent that of 1881 at Stonehaven (a favourite with the Boys)[28] and in October 1882 he was at Collieston, near Aberdeen, with Millie Dow (whom he had almost certainly met in Paris) at the same time that Macgregor and Walton were at

Stonehaven.[29] His development, however, can be charted by his submissions to the Institute. Despite his apparent distance, the Boys came quickly and loudly to his defence in 1886 when the Hanging Committee of the Glasgow Institute 'skied' his painting *A Bead Stringer, Venice* and removed from it the plaque it had been awarded at the Salon the previous year (a *Mention Honorable*). The plaque was replaced and the painting displayed more advantageously after public complaints from Guthrie and his friends.[30] Although the Institute catalogues give him a Glasgow address (136 Wellington Street) for the years 1885–8, he spent much of his time travelling on the continent of Europe and further abroad and after his marriage in 1887 he settled in Berkshire, effectively cutting himself off from further significant contact with the Boys.

James Nairn was much more closely involved with the gradual development of the Glasgow painters but he left the city in 1889 for New Zealand[31] in an attempt to stave off the illness which brought him an early death in 1904 and which probably prevented him from playing a more substantial role in the history of the Boys. Born in Lenzie in 1859, nothing is known of his early training, if he had any other than membership of the St Mungo Society which he and Henry clung to after their repeated rejections by the Glasgow Art Club. Along with Henry he formed another artistic society, the Pallett (sic) Club[32] but he seems to have gained acceptance by the Art Club in 1883 (before Henry, surprisingly) as he showed three pictures in its 1883 exhibition,[33] two of which suggest that he was at Eyemouth with Henry that year, when he could also have visited Guthrie at Cockburnspath. After being elected as a Member, he was asked to contribute a painting for illustration in the *Glasgow Art Club Book* of 1885 (*West Regent Street, Glasgow*; see p.176) and was also involved in the series of mural paintings made by the Boys for the 1888 Glasgow International Exhibition.[34] The following year he took part in a much-vaunted project to provide more decorations for public buildings by making wall-paintings for Broomloan Hall and the Prisoners' Aid Society, Glasgow (both untraced).[35] The results had a mixed reception but Nairn's painting was reckoned to be the most successful.[36] He was also something of a humorist, making caricatures of the Boys which were published weekly in *Quiz* in the later 1880s. His best surviving 'Glasgow School' pictures show him as a landscapist working very much in the early Henry manner but too little survives to give us a clear grasp of his contribution to the group.

There remains one further major figure who was to make an important contribution to the work of the School. He was not a Glaswegian, indeed he lived most of his early life in Edinburgh from where he used to visit the Boys in their stronghold in the west. Arthur Melville (pl.14) was born in Loanhead-of-Guthrie in Angus in 1855 but his family moved to East Linton near Edinburgh when he was still a small boy.[37] Melville was sent to work as a clerk in Dalkeith but his persistence with his painting and his success in gaining acceptance by the Academy in Edinburgh persuaded his family to let him study art as a career. For two years he worked with the Edinburgh artist James Campbell Noble RSA (1846–1913) and then in 1878 he moved to Paris. He had no doubt found Edinburgh restricting, although he was from an early age reasonably successful in selling his pictures to its inhabitants, and after the acceptance of his painting

A Cabbage Garden (see p.112) by the Royal Academy in 1878 he decided that Paris held more for him than staying in either Edinburgh or London.

Julian's *atelier* attracted him as it had so many British painters and during the summer of 1878 he discovered Grez where he was to settle the following year. Melville was a gregarious, energetic and lively character who soon responded to the particular atmosphere of this village which had so many attractions for the new school of painters. He became friendly with Robert Louis Stevenson[38] and his work developed along lines which were to make it particularly appealing to the Boys in the 1880s. His oils remained low in tone, seeking out the values – *les valeurs* – which were so much the cornerstone of the *atelier* training which he received in Paris. At the same time his watercolours became more fluid and blotchy ('blottesque' was the word coined by one critic to describe them) with a strength of colour not usually seen in his early oils. In 1880 he set off for Egypt where he filled his sketch-books with the notes which were to enable him to produce a masterly series of pictures even after his return to Paris and later, in the late summer of 1882, to Edinburgh.

The following year he was to visit Guthrie and his friends at Cockburnspath in Berwickshire where Guthrie had set up a studio, emulating Bastien-Lepage in his search for a place where the painter could be accepted on the same terms as any other artisan in the village, not mending shoes or selling seed-corn but recording the everyday life of the society in which he lived. Guthrie and Melville became firm friends and when Guthrie decided to stay on in the village after all his Glasgow friends had returned to the city for the winter Melville came to see him and stay with him and his mother. He also became a familiar figure in the Glasgow studios of the Boys in the following four or five years, although he seems to have resisted attending the informal classes given by Macgregor in his studio.

Melville must have seemed a giant of a figure to the Boys. He was well travelled, successful at the Academies and with buyers and yet did not dilute his principles for the sake of public acclaim. Above all, his work displayed the qualities of experiment and modernity, without the slavish acceptance of the values of any one particular painter or school, which must have epitomised for these young painters the aims that they themselves sought. Melville did not need to settle in Glasgow – wherever he was the Boys saw him as one of their own.

CHAPTER 3

Gluepots and Teasels

'Aye! Yon's the man that's put up the price o' purple' was a cry which summed up the attitude of these young men to the battalions of landscape painters who controlled the artistic Establishment in Scotland.[1] The improvement in physical communications in the Highlands, combined with the popularity of the writings of Sir Walter Scott and Queen Victoria's often-expressed love for Scotland, brought about an influx of tourists who expected to be overwhelmed by the loneliness and the majesty of the great Highland set-pieces. In painting, a whole new school of landscapists had grown up to satisfy the urgent demand for drawing-room panoramas showing the heather-clad glens, the wildernesses of the north and west and the placid waters of the romantic lochs.[2] Horatio McCulloch RSA (1805–67) produced the archetypal Victorian paintings of Scotland (pl.15 & 16) that have remained in the popular consciousness as *the* image of the wild countryside outside the great Scottish cities. Loch Lomond, Glencoe, Loch Achray, Loch Coruisk, the Trossachs and the other natural wonders of Argyll, Perthshire and points north became McCulloch's stock-in-trade. He was not alone – no less a figure than J. M. W. Turner made the Scottish 'grand tour' and produced a memorable series of watercolours of the Clyde and the Western Isles – but he was probably the most talented of a group which included the Revd John Thomson of Duddington HRSA (1778–1840), James Giles RSA (1801–70) and Arthur Perigal RSA (1816–84).

Perhaps the most famous Victorian vision of the Highlands, however, was painted by an Englishman, Edwin Landseer – *The Monarch of the Glen* (1851). Landseer's style (if not his success which was helped not a little by his popularity with Queen Victoria) echoed that of McCulloch and the Scottish painters of that generation. While to be seen in the 1850s as followers of McCulloch might have seemed rather old-fashioned, landscapists such as James Docharty (W. Y. Macgregor's master) and Sam Bough RSA (1822–78) refined the sense of the dramatic of their masters and endowed the grandeur of their scenic pictures with a touch of humanity and even romance. Splendid as many of these pictures are, to the Boys they were all theatrical backcloths, survivals from an earlier age, painted without capturing the true value of the landscape, which could as much have been Switzerland as Scotland. The search for scale and effect seemed to be everything – reality, or *actuality*, played a lesser, almost non-existent, part in their representation of landscape.

These Scottish *grandes machines* dominated the Academies in the 1850s and 1860s, only to be overtaken by a new style of landscape painting in the 1870s and 1880s. This was characterised by an awareness of the power of nature and its

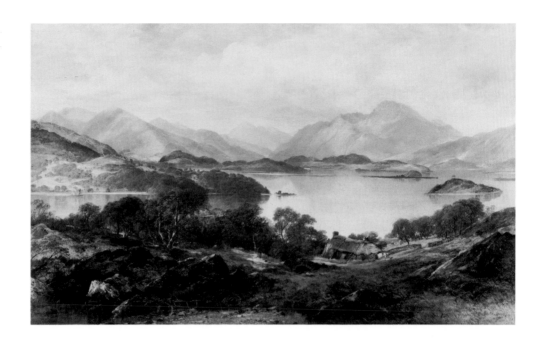

15
Horatio McCulloch
Loch Lomond
1861
Canvas, 84.5 × 135.9
Glasgow Art Gallery

ability to change our perception of a given locale in differing weather. Storms – of rain, snow and wind – vie for our admiration against the clarity and strength of the west coast sun, a contest of which David Farquharson ARA ARSA (1839–1907), Peter Graham RA (1836–1921) and John MacWhirter (1839–1911) never tired. Their more mellifluous views of the Scottish landscape joined those of McCulloch and others in the boardroom, museum and country house, both north and south of the border.

The attitude of the Boys to all of this is captured in an anonymous piece in *The Scottish Art Review*. One of them, probably Paterson or Macaulay Stevenson, wrote a tongue-in-cheek account of his assimilation into the Royal Scottish Academy.[3] Today such a contributor might well be sued by the easily identifiable butt of his remarks but a hundred years ago this seemed reasonably tame:

For the next few years I never was out of sight of an Academician. Wherever one had gone for his summer's work, there I went also. First it was a figure landscape man, who dotted in little figures which were evidently the result of prolonged and earnest study of the family of Noah as represented in a shilling edition of the ark. By much insidious flattery I made him my friend and learned the secrets of his puppets, till you couldn't tell the difference between his pictures and mine. Then it was the pure landscape man – a painter intended by the gods to manufacture panoramas to a piano accompaniment – but who splashed great canvases with hills like dumplings and rocks like bonnet boxes. His art was more difficult, for nature gave no hint of it, but he had only one recipe, and that I also mastered in time. Then I went for sunsets, glorious effects that might have come from the dyeworks; and after that for marine pieces – with stage billows like regiments in line – which were so easy once you had learned the stereotype for waves.

These acres of painted heather, its lurid purple contrasting against the greys and dull browns of the rocky hillsides, were rivalled on the walls of the Academy or the Institute only by the mawkish sentimentality of the subject-pictures

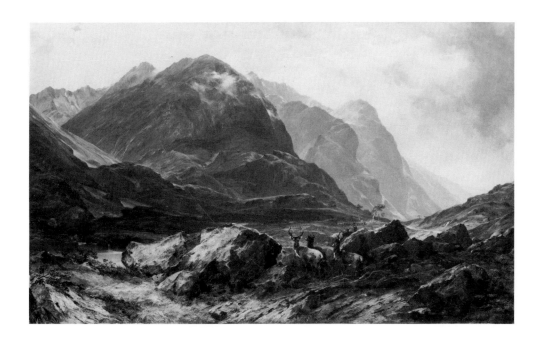

16
Horatio McCulloch
Glencoe
1864
Canvas, 110.5 × 182.9
Glasgow Art Gallery

which were so popular with many Victorian collectors. This was a field in which the 'Gluepots' of the Glasgow Art Club excelled. Every year the Glasgow Institute made its profits from the sale of these 'story-pictures' – episodes from the time of the Cavaliers, flirtations between noble lords and their serving-wenches, excursions into the shabby homes of the 'poor but honest' lower-classes with an emphasis on the sickly charm of the children to be found there, usually with a preference for defenceless orphans or sad-eyed cripples. In each of these paintings was to be found the all-important moral. It was as if the rich, middle-class collectors who bought these pictures felt that they could spend their wealth in such a 'profligate' (or un-Calvinist) way only if some social point was being made (pl.17–19).

The leading practitioners of such painting in Glasgow were Duncan MacKellar RSW (1849–1908) and Alexander Davidson RSW (1838–87), both stalwart members of the Art Club. Their pictures followed a tired and worked-out seam which had had its honourable beginnings in the work of David Wilkie, half a century earlier. In Caw's words:

informed by less intellectual grasp of subject, or marked by inferior taste or feebler technique . . . the work of a number of other men whose subjects range from historical or quasi-historical to domestic incident is less interesting.

The Boys would have seen it as exploiting the predicament of the people it portrayed for there was little, if any, genuine sympathy for the plight of the poor to be found in any of these pictures. This is not to say that the Boys, themselves, in their choice of agricultural labourers for the subjects of many of their own paintings, found a socialist virtue in the circumstances of their models but nor did they trade upon the sympathy of a wealthier, and possibly conscience-ridden, clientele for the purchase of their work.

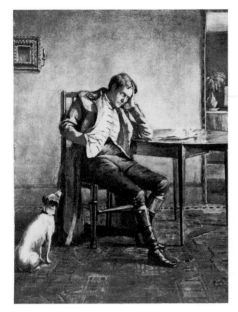

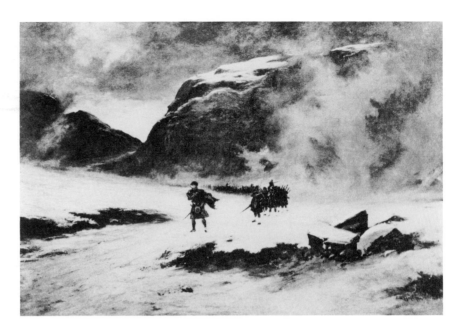

17
Duncan MacKellar
Come at last!
c.1884
Canvas
Untraced

18
James A. Aitken
The March of Montrose
c.1884
Canvas
Untraced

With a shallowness of subject-matter came a shoddiness of technique. A dependence on the oily and sticky medium, megilp, to give the pictures some body and the ready-made patina of age inspired the Boys to christen these painters 'Gluepots'. How appropriate then that in the publication in 1885 of the *Glasgow Art Club Book*, Alexander Davidson chose to be represented by a painting of a little girl whose grandfather is inspecting her broken doll[4] (pl.19); as William Buchanan has pointed out its subtitle could only have been 'A' doot it'll need the Gluepat'.[5] With such an emphasis on content, however shallow, rather than technique or other painterly qualities it is not surprising that the least-talented of Glasgow's painters made a reasonable living. It is even less surprising that they should defend their work (and at the same time attack the work of their artist-critics) by attempting to exclude from the walls of the Club or Institute anything which challenged it.

In this they had some success in keeping out local artists who threatened their cosy grasp of matters artistic in Glasgow. They perhaps did not see quite the same threat in the presence on the Institute's walls of more paintings by artists resident in London or abroad. In any case some credit was no doubt to be gained from appearing to acknowledge the latest developments in the south, but to condone them by encouraging the young local painters with similar leanings would have been courting too close an examination of their own hackneyed work. To some extent, also, the selection of work by non-Scottish artists may well have been in the hands of the lay members of the Institute Council who seem to have been more adventurous and far-sighted in their patronage of London-based Scots, Dutch and French painters than MacKellar, Davidson, Docharty and the others may have wished. It was through this more catholic selection of pictures for the annual Institute Exhibitions that Guthrie, Macgregor and the Boys first saw that there were other worthwhile movements in painting which were passing Glasgow by. There were artists such as John Pettie and W. Q. Orchardson who

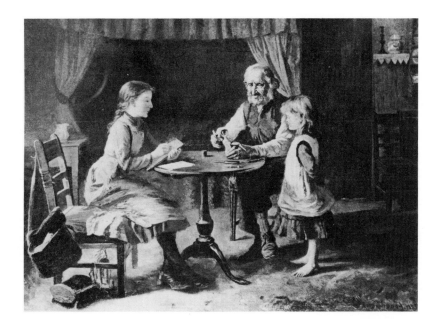

19
Alexander Davidson
The Broken Doll
1885
Canvas
Untraced

could treat the subject picture in an accomplished manner. Their more painterly handling was much admired by the Boys, even if their subject-matter could be just as stilted as that of the Gluepots. As we have seen, Guthrie was to study under Pettie and in London he would have come into contact with Orchardson and several other of the expatriate Scots who had sought, and found, fame and fortune in the south. In London, too, he would have seen more of the work of a painter who was to become something of an idol for the Boys and on whom in later life, usually as portrait-painters, several of them were to model themselves.

James McNeill Whistler (1834–1903) rarely sent his pictures to the Institute in the 1870s but pictures on loan occasionally appeared in Glasgow or Edinburgh. The Boys no doubt followed his charismatic career, particularly his encounter with John Ruskin in 1878–9. Whistler's writings on art in general, and his *Ten o'Clock Lecture* in particular, were to help the Boys formulate many of their own beliefs for the future of modern painting. Whistler's rejection of incident in favour of a more careful selection of subject was particularly pertinent for the Glasgow painters. His dismissal and suppression of the non-essential was much emulated in Glasgow and the correctness of his approach was ratified, in the Boys' eyes at least, by the kind of work seen at the Institute which came from France and Holland. Macaulay Stevenson summed this up in the aphorism 'Aspect is Subject'.[6]

Whistler's tonal harmonies, his feeling for the decorative aspects of composition and his radical approach to the *mise-en-scène* of his figures within the frame of the canvas, his open acknowledgement of the developments in French painting (even if he did not accept them all as the equal of his own advances) made him a demi-god in the eyes of the Boys.

They did not, however, immediately emulate his subject-matter, for they were more attracted to that of a number of French and Hague School artists who had shown in Glasgow. The suppression of incident, anecdotal and historical subjects

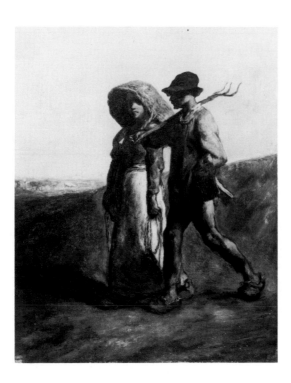

20
Jean François Millet
Going to Work
1850–1
Canvas, 55.5 × 46
Glasgow Art Gallery

from these paintings and their replacement by a more matter-of-fact realism had an immediate appeal for the younger Glasgow painters. Millet, Frère, L'Hermitte, Breton, Dupré, Israels, Maris[7] and several others chose to depict the life of the peasant classes of their native countryside, deliberately electing not to make it more acceptable to the buying-public by incorporating the moralistic stories with which the Gluepots embellished their genre pictures. These painters saw an inherent dignity in the lives of their subjects and although very few of them managed to remove all traces of sentiment from their work their intention was to present the day-to-day lives of peasants as honest and credible subjects for modern painters. Gleaners, shepherds, field-workers, carters, ploughmen, sowers, harvesters – all replaced the traditional Salon subjects for the group of painters working in the Barbizon Forest in the 1850s and 1860s. These paintings could be of single figures or groups of two or three sharing a communal task, as in Millet's *Sower*, *The Angelus* or *Going to Work* (pl.20), which was in James Donald's collection in Glasgow. They could also take the form of the more elaborate compositions that were popular with many of the Salon *pompiers*, but with a subject devoted to some dramatic incident in the life of the village such as Breton's *Fire in a Haystack* (Coll: Detroit Institute of Arts). Labour became a subject in its own right, no longer an adjunct of some genre or history painting. These painters chose their subjects from everyday life and justified their right to do so, much as Whistler justified the artist's right to paint any subject which caught his attention, whether or not it had the approval of society. Their paintings, however, symbolised the life of the peasants, going beyond the mere recording of their daily tasks and becoming icons of a new awareness of the plight of the rural classes. In the case of Millet, in particular, these paintings were a

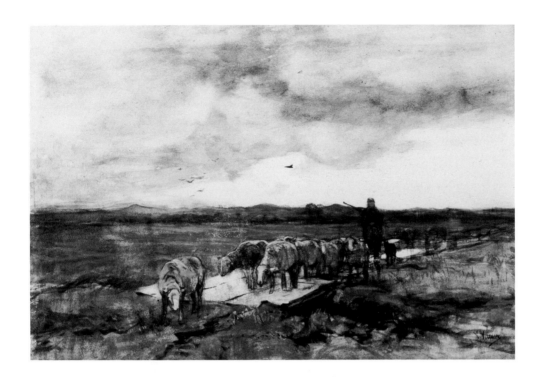

21
Anton Mauve
A Shepherd and Sheep
Watercolour, 31 × 46
Glasgow Art Gallery

synthesis of the lives of his subjects. He worked by choosing the elements of rural life which satisfied his desire for content as well as composition. The results, therefore, symbolise a human condition as much as any specific happening in the lives of the peasants who had become the subject-matter of his pictures.

The Hague School painters (pl.21) followed a similar path although their work rarely, if ever, contained any of the political overtones sometimes found in the Barbizon paintings. Their subjects also remained on a more intimate scale, more concerned with domestic life, than the elaborate compositions that so fascinated Breton and other Frenchmen. There was, however, a tendency to sentimentalise the plight of the poor that was usually avoided by the French but which no doubt appealed to many collectors in Glasgow where these paintings became extremely popular. What would have attracted the attention of the Boys was the muted colour range that these painters used, again having an affinity with Whistler, and their choice of simple domestic subjects rather than historical or anecdotal genre. What was also common to both French and Dutch painters was a tendency to place their figures on the frontal plane of the canvas, making them dominate the composition and causing them often to be silhouetted against a receding landscape or a low horizon. Nowhere was this particular device to be used so effectively as in the work of a young French painter called Jules Bastien-Lepage.

Where Millet was concerned with the general, a synthesis of rural life, Bastien-Lepage applied himself to the particular. Millet's paintings reflected the life of the peasants in rural France but Bastien-Lepage chose one particular task, performed by one particular person at a specific moment and recreated it on his canvas. He achieved his aims with the aid of a prodigious talent, a facility envied by many a *Salonnier* – but then, in the eyes of many, Bastien-Lepage was no

more than that himself.[8] The basic tenet of his belief was that he could achieve
the realism he sought only by painting *en plein air*. Bastien-Lepage was gifted
with an assured talent as both draughtsman and painter, qualities which were
carefully honed through an academic career as a pupil of Cabanel in Paris.
Expected to win the *Prix de Rome*, his failure drove him back to his home village
of Damvillers where he developed his own form of realism – an almost
photographic *plein-airisme* known as naturalism. He began to paint the people of
his village, not as the rustic icons of Millet, but as they were – real people doing
real tasks within the village community. His subjects are identifiable as members
of his family, neighbours working in the fields, the children of the village or
itinerant beggars. This sense of identity is very strong in all of his works and he
employed a number of artistic devices to emphasise the reality of his material.
Above all is the sense of immediacy with his subject that he achieves by bringing
his figures up to the very edge of his picture plane. His models stand on the frame
of his paintings, almost ready to walk out of them. They are placed against a
landscape background which Bastien-Lepage painted from a standing position
as he believed it to be crucial in our understanding of the relationship of figures to
their surroundings. His grasp of aerial perspective was much criticised but he
defended it vehemently:

Look, my Wood-cutter in the last Salon was reproached with want of air ... Well, here we
are in a wood, and the trees are still without leaves, yet look how the little figure stands
out from the undergrowth of trees and bushes. There is a great deal of routine and
prejudice in that criticism of the perspective of my pictures done in the open air. It is the
criticism of people who have never looked at a landscape, except crouching down or
sitting. When you sit down to paint, you naturally see things quite differently from the
way you see them standing. Sitting, you see more sky and you have more objects – trees,
houses or living beings standing out sharply in silhouette against the sky, which gives
the illusion of a greater distance and a wider atmosphere. But it is not in this way we
generally see a landscape. We look at it standing, and then the objects, animate or in-
animate, that are nearest to us, instead of being seen in profile are silhouetted upon the
trees, or upon the fields, grey or green. They stand out with less clearness, and sometimes
mix with the background, which then, instead of going away, seems to come forward. We
need to renew the education of our eye, by looking with sincerity upon things as they are
in nature, instead of holding as absolute truths the theories and conventions of the school
and the studio.[9]

In many of his paintings the figure defines the size of the canvas by filling it
completely; in a similar way the landscape around the figure is defined by the
size of brushstrokes used to depict it. Detailed marks are used to render
the foreground grasses or stones; broader, square brushes model the middle
distance; and a series of softer, less definite strokes indicate the far distance.
Perspective, therefore, is indicated by a change of handling rather than by any
pictorial indication of recession. The central figure of these paintings, as in *Pas
Mèche* (see p.66) for instance, cuts across all these changes in brushstroke and
they are therefore emphasised by a vertical reference point to the foreground
which can be charted by the handling of the figure. Other similar reference points
are often introduced by the use of vertical features having their origin at the
bottom of the picture, and therefore in the frontal plane of the composition. Such
features included trees and tall grasses but a favourite motif which was much

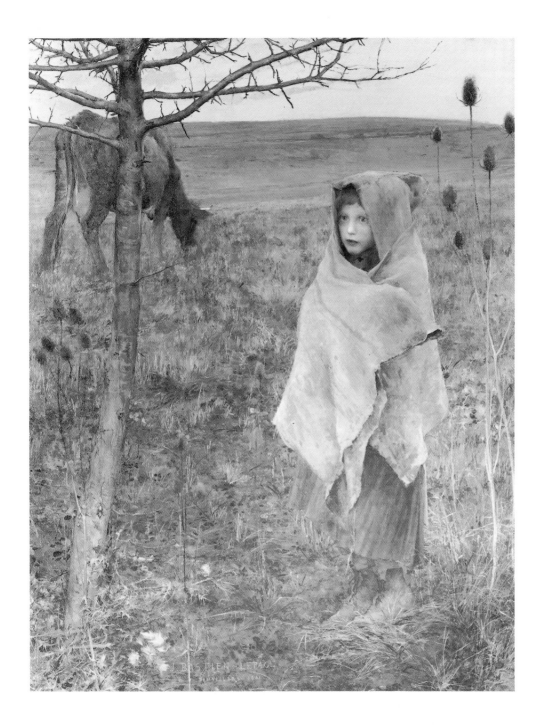

22
Jules Bastien-Lepage
Pauvre Fauvette
1881
Canvas, 162.5 × 125.5
Glasgow Art Gallery

emulated by Bastien-Lepage's British followers was a tall teasel (pl.22).

All this is rendered in a half-light, the light of a grey overcast sky. Bastien-Lepage was not aiming to capture the essence of changing light which fascinated his Impressionist contemporaries. He could not work fast enough in his chosen style to complete his picture in the light of a sunny day when shadows and values changed rapidly and so he had to wait for periods of grey weather when the value of the light remained more or less constant. His work often has, therefore, a

consistent clarity of vision which can seem unreal. It is the clarity of the photographic image and, as Sickert noted, his paintings have many of the hallmarks of being aided by the camera. Every detail in the foreground of these paintings is painted with some precision, albeit with a certain boldness of handling which was usually softened for the most important parts of the composition – the subject's face and hands – where a much more detailed and finely polished technique, virtually *trompe-l'oeil*, was used in order to achieve a more subtle emphasis. This emphasis on fact suggested to many observers an austere detachment, which was contrasted with Millet's obvious concern for the plight of his subjects. The accusation most commonly made was that sentiment had been subjugated to technique – for Bastien-Lepage had undoubted skills which made his work seem facile and shallow to a generation who had only recently accepted the advances of the Realists and who were now trying to come to terms with the work of the new *avant-garde* – the Impressionists. Popular with the Salon-going public he might have been, but Bastien-Lepage incurred the, perhaps jealous, disdain of many of his peers.

He also, however, gathered around him a staunch band of supporters, both at home in France and in Britain, where his work was shown regularly in the early 1880s (in Glasgow as well as London). Bastien-Lepage's main apologist in Britain was undoubtedly (Sir) George Clausen (1852–1944). He had been one of the first British painters to react to Bastien-Lepage's new style and he was later to be invited by the Boys to defend Bastien-Lepage against, among other things, this charge of a lack of feeling[10]:

Now, whereas Millet's art was intensely spiritual, concentrating on the *motive* of his pictures, and in every case subordinating the facts of nature to the expression of sentiment; in the case of Lepage, although he is commonly allowed to be a most consummate painter in his rendering of *facts*, his claims to feeling, sentiment, and that spiritual quality which makes fine art, as distinct from lifeless imitation, are not so readily allowed him. And yet it seems to me that he is as strong, at least, in sentiment as in execution. And it is on this question of sentiment – of the painter's relationship to his subject – that the work of Lepage takes, perhaps, its greatest importance.

Of the many interesting characteristics of Lepage's work, perhaps the most remarkable is his sympathetic intimacy with his subject. Although the human interest is always dominant, yet nothing escapes him – nothing is trivial or unimportant. One reads in his works the life-history of the workaday human beings he painted – the brilliant actress, the man of the world, the tramp, the peasants of his native village – all his personages are placed before us in the most satisfying completeness, without the appearance of artifice, but as they live; and *without comment, as far as possible, on the author's part*. And it is in this loving, yet impartial presentation that I think Lepage stands on new ground. Millet tells us his view of life, Lepage does not; and, although it is impossible to desire a fuller revelation of character than he gives, he gives it for itself, his own view is not put forward. We can but guess it.

It was this apparent detachment from his subject that initiated much of the criticism that was directed at Bastien-Lepage. Without the dignified sentiment of Millet, it was said, Bastien-Lepage's paintings were merely a bravura display of technique for its own sake. His technique certainly attracted many of the younger painters in Britain. Most of them merely grafted it on to Victorian senti-ment and produced *plein-air* subject-pictures from their village headquarters at

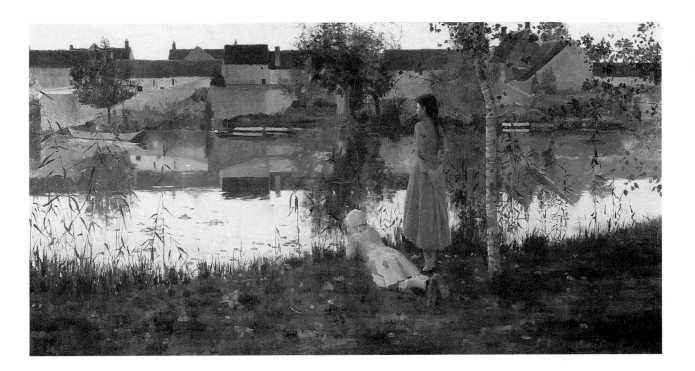

23
William Stott of Oldham
The Ferry
c.1882
Canvas, 109.2 × 214
Private Collection

Newlyn in Cornwall. Others, including Clausen, H. H. la Thangue (1859–1929) and the Glasgow Boys (notably Guthrie, Walton, Henry, Lavery and Crawhall) took up Bastien-Lepage's vision, his concept of naturalism as a valid and novel answer to the impasse which they believed to be facing the artists of the 1880s.

For the group of English and Scottish painters studying in Paris at the beginning of that decade there was a much more tangible link with naturalism provided by one of their countrymen – William Stott. Stott had an immediate response to the work of Bastien-Lepage when he first encountered it in Paris. He met Lavery, Roche, Kennedy and Millie Dow in Paris and it was perhaps he who introduced them to Grez-sur-Loing. Certainly, by 1882, when these expatriate Scots were just beginning to feel their way towards grasping the naturalist brush, Stott was already producing full-blooded naturalist paintings at Grez. These were not tentative sketches or studies but major canvases intended for, and hung, at the Salon. *The Ferry* (pl.23) of 1882 was also chosen by The Fine Art Society for an exhibition in London in that year of works from the Salon by British and American painters. The cool light, the verticals of trees, grasses and the girl in the foreground echo similar devices in Bastien-Lepage's compositions. Stott's exaggeratedly horizontal composition, with its emphasis on roof-tops below a narrow fringe of sky, was in turn to be the inspiration for a number of Franco-Scottish works of this period. Stott's paintings were available in London for those of the Boys who had stayed at home but in 1883 his *The Bathers* (pl.24) was shown at the Glasgow Institute where it would have made an undoubted impression on Guthrie, Walton and Henry.

Stott's work had another affinity with that of Bastien-Lepage which can also be traced among some of the Glasgow painters. In his *Jeanne d'Arc écoutant*

les Voix (Coll: Metropolitan Museum of Art, New York), Bastien-Lepage introduced an overt symbolism into his painting. Similarly, in many of his peasant subjects there is an element of symbolism which is by no means so obvious. I think this latent symbolism is also to be found in these naturalist pictures by Stott, particularly in *The Ferry*. In his later work Stott's symbolism is much more apparent resulting in a series of allegorical or mythological subjects which combine a *plein-air* aspect with a pictorial content of nymphs and goddesses, probably inspired by the work of Puvis de Chavannes.[11] A further link with Glasgow was made through these paintings, for one of Stott's closest friends in France was Millie Dow (whose portrait Stott painted) who was later to produce very much the same kind of paintings, populating them with naked figures out of Celtic myth.

To bring the wheel full circle, Stott also provided a direct link for the Boys with Whistler. He was a close friend of the 'Master' and supported his brief reign at the Society of British Artists. This direct contact with Whistler of one so close to the Boys must have had its effect upon their view of his painting, and it may also have helped bring their work to Whistler's attention before he and Stott parted company in 1887.[12]

As young men in the late 1870s, however, the Boys were by no means yet aware of all these trends in modern painting. In Paterson's words:

[they] banded themselves together to fight what they considered the narrow outlook and provincial aims and attainments reflected in the canons of art among the accepted painters of the day.[13]

They did not, in fact, 'band together' but trod two or three separate paths which did not merge until 1885. Their researches took them outside Glasgow and they eagerly devoured the new fashions of Paris and London, seeing in them some salvation for art in Scotland and a way forward for their own ambitions.

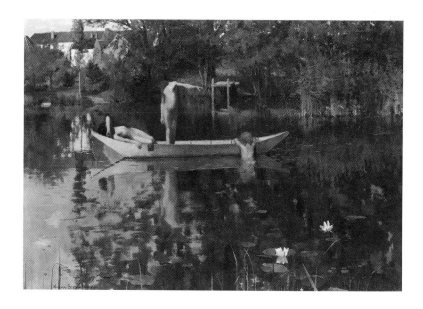

24
William Stott of Oldham
The Bathers
c.1882
Canvas
Staatsgemaldesammlungen,
Munich

CHAPTER 4

En Plein Air

Of the paintings which Macgregor and Paterson produced together on their visits to the east coast in the summers of 1877–82 very few now survive. Almost all of them were landscapes, however, although Paterson exhibited a number of works with somewhat Gluepot-like titles at the Glasgow Institute in the early 1880s.[1] Paterson's French training, with its emphasis on the accurate rendering of tonal values and relationships, no doubt had its influence on Macgregor, and the latter's strong sense of draughtsmanship, encouraged by his teacher Legros at the Slade, would have rounded off Paterson's education. The two painted together at Nairn in 1880 and 1881 and exhibited their pictures at the Institute in the following years. The titles of these paintings suggest a gradual departure from the usual themes of exhibition landscapes towards a seeking-out of simpler, more realist subjects. For instance, Macgregor was showing views of the harbour at St Andrews in 1878, and *Home from the Herring Fishing* in 1879 – both not untypical of much landscape painting of the period – but four years later was producing more down-to-earth subjects in *The Mill-pond, Dunnottar* (1882, pl.25) and *Stonehaven* (1882, pl.26). In both of these works the cooler tones of *plein-air* painting are much in evidence alongside an acceptance of the validity of the uneventful as a proper subject for an artist.

One work of this period, however, does point towards an interest in realism beyond the simple landscapes of St Andrews and the north-east. In 1881 Macgregor was commissioned to paint an interior of a joiners' shop in Argyle Street, Glasgow (pl.27). Certainly, Macgregor had not chosen to paint something quite so prosaic before (and rarely did he again) but the fact that he accepted such a commission and that he treated it as a serious and fit subject displays an awareness of the relevance of such matters to modern painting. Urban labour as a subject was not at all uncommon in France but most, if not all, of the French realist paintings which had been exhibited in Glasgow by this date were concerned with rural life. There was a dignity attached to these representations of rustic labour which no doubt made them acceptable to the Scottish collector, but few artists seem to have tried to attract his attention by recording the conditions in which many of his own workforce would have spent their daily lives. Macgregor's painting, however, does not attempt to pass comment on the scene it portrays but acts as a straightforward record of a particular workshop. It remains an almost unique work in the Glasgow School in its concern with the life of the industrial city; with the exception of Macgregor's original version of *The Vegetable Stall*, only Lavery's sketches of the 1888 Glasgow International Exhibition and a group of works by Nairn returned to the subject. Stylistically it

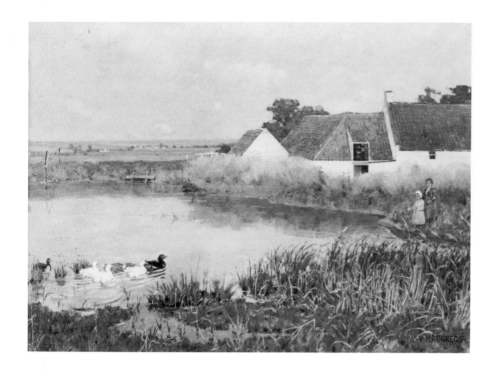

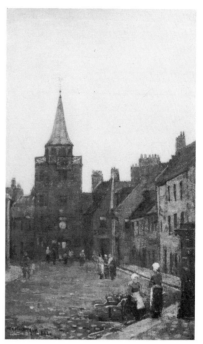

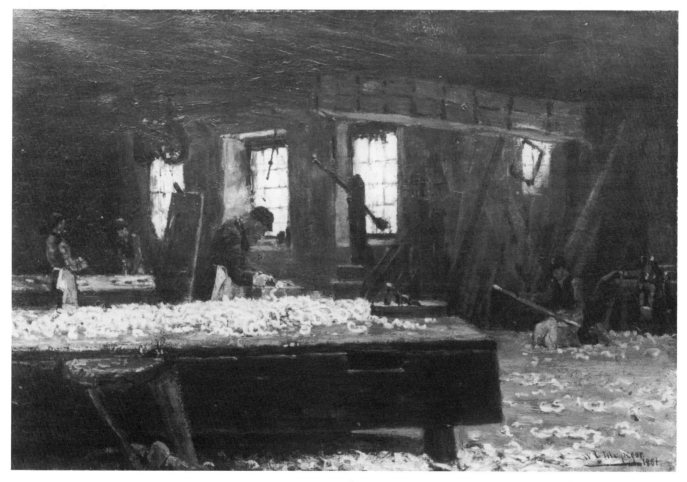

25
W. Y. Macgregor
The Mill-pond, Dunnottar
1882
Canvas, 89 × 122
Perth Museum and Art
Gallery

26
W. Y. Macgregor
Stonehaven
1882
Canvas, 51.5 × 31.5
Sir Norman Macfarlane

27
W. Y. Macgregor
A Joiners' Shop
1881
Canvas, 46 × 71
Private Collection

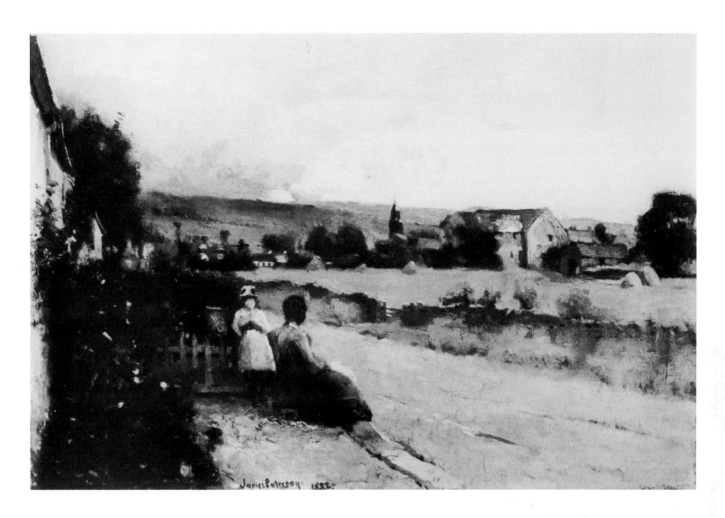

28
James Paterson
Moniaive
1882
Canvas, 35.5 × 53.5
Private Collection

is equally interesting for it demonstrates a broader handling than is evident in Macgregor's landscapes of that year. The strong contrast between the shadowed workshop and the patches of sunlight is untypical of Macgregor but the bold brushstrokes which give the painting much of its vitality presage the handling of his masterpiece, *The Vegetable Stall* (see p.75), painted two years later. His own pride in the picture can be assessed from Macgregor's decision to send it to the Royal Scottish Academy in 1882 where it was accepted and hung alongside his pastoral landscapes of the north-east of Scotland.

Paterson's *Moniaive* of 1882 (pl.28) displays a more French attitude towards landscape painting than that of his friend but the broad handling and sympathetic use of figures in the composition reflect his awareness of Macgregor's advances. Figures were to appear in a number of Paterson's early landscapes, probably with Macgregor's encouragement, for the latter considered himself, thanks to his Slade training, superior to many of his Glasgow contemporaries in this respect. It was presumably to encourage their grasp of life-drawing that he set up his informal classes in his Glasgow studio at 134 Bath Street, to which most of the Boys would be attracted from about 1882–5. The only important member of the group who seems not to have attended, besides Melville, was Guthrie and it

29
E. A. Walton
At Ballantrae
1881
Canvas
Untraced

30
E. A. Walton
At Rosneath
1878
Canvas, 29 × 40
Angus Maclean

was his success at the Institute in 1884 with a major figurative painting (*To Pastures New*; see p.74) which may have caused Macgregor to reject figure work and concentrate largely on still-life and landscape from 1884.

Although there must always be a tendency to divide the Boys into discrete groups centred on Macgregor and Paterson on the one hand, and Guthrie and Walton on the other, there is some evidence to show that things were not as finely drawn as this. The columns of *The Bailie* and *Quiz* chronicled the comings and goings of Glasgow's artistic community in much the same way as gossip-columnists now chart the lives of pop-stars, footballers and royalty. In 1881 we are told that 'W. Y. Macgregor is at present on the Stinchar [near Ballantrae].'[2] A fortnight later he was joined by Walton (pl.29), and Alexander Mann settled at Stonehaven for the summer.[3] Macaulay Stevenson set up at Luss on Loch Lomond where he was reported as 'doing very promising work'.[4] The following year Walton, after spending the summer at Crowland with Guthrie and Crawhall, was at Stonehaven where he joined Macgregor,[5] who had earlier been working at Portsoy with R. W. Allan[6]; Alexander Mann and Millie Dow were nearby at Collieston.[7]

Guthrie and Walton had formed a friendship in the winter of 1878–9 and agreed to spend the following summer together. On their first expedition they took young Joseph Crawhall with them to Rosneath in 1879. Again, few paintings of this period have survived – Caw does not even list any Rosneath subjects in his biography of Guthrie.[8] An earlier painting by Walton, also of the Gareloch, shows the rather dark tonality that he then favoured (pl.30). It also shows that, even at this early date, he was prepared to choose an unspectacular aspect of the famous Firth of Clyde, instead of the grand vistas of the sea lochs and hills that most of his contemporaries would have chosen. In contrast to this Rosneath painting is a larger work of a similar subject – an upturned boat, a theme which Walton returned to several times at the beginning of his career (pl.60). In this picture, however, the darker tones of *At Rosneath* have been replaced by a brighter palette. This latter painting, being somewhat larger and considerably more finished, was almost certainly painted in the studio from small oil sketches or watercolours and may well be the picture which Walton submitted to the Glasgow Institute in 1880, *A Summer Morning* (pl.60). It is difficult to assess what Guthrie's work would have been like at this date as Caw lists no pure landscapes from this period and few of his subject-pictures have been traced. Caw does refer frequently to the blackness of several of his early subject-pictures and it seems more than possible that any early landscapes would have been dark in tone and would have had some similarity with Walton's *At Rosneath*.

In the autumn Guthrie returned to London where he resumed his attempts to gain entry to the Royal Academy by painting in the manner of his mentor, John Pettie. It was almost as if he had a dual identity, for Pettie's and Orchardson's subject-matter seems far divorced from the kind of pictures that Walton (and presumably Guthrie) had been painting in Scotland during that summer. In 1880 Guthrie and Walton met again for the summer, probably with Crawhall (who had become a close friend of Guthrie in London during the previous winter) and they returned to Garelochside and also paid their first visit to Brig o' Turk in the

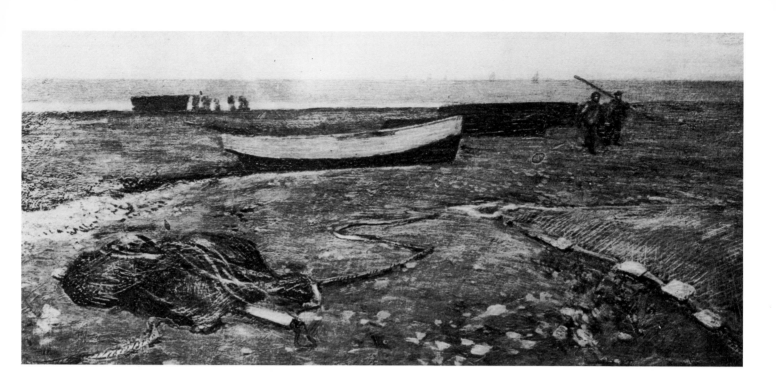

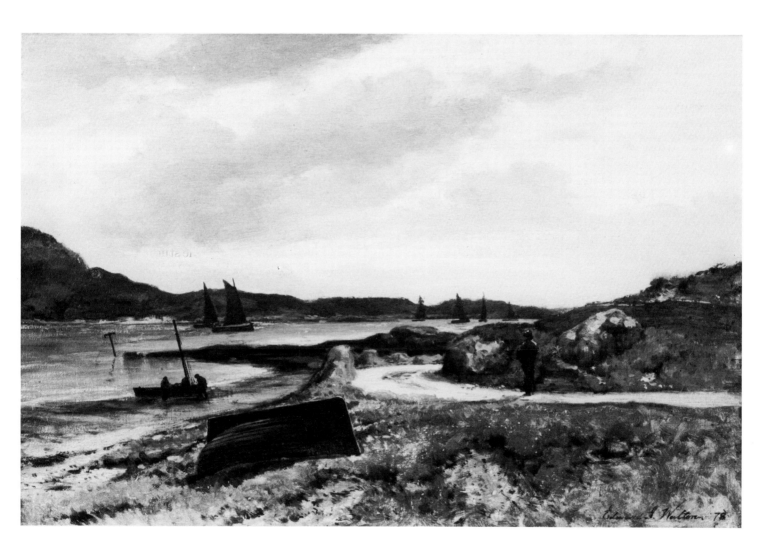

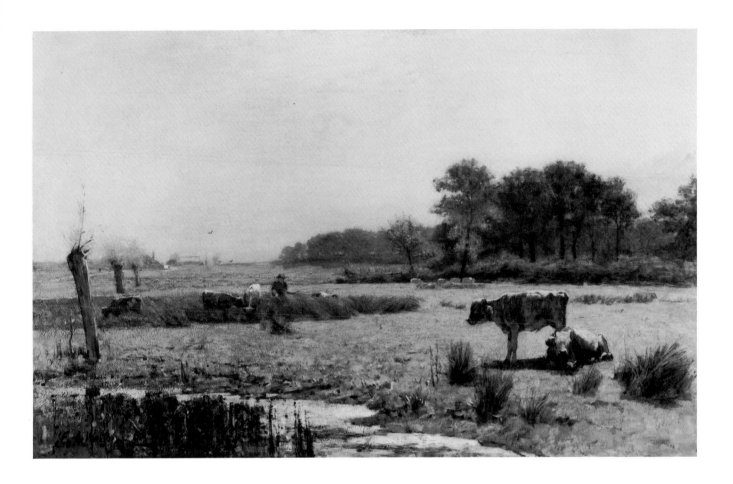

31
E. A. Walton
A Surrey Meadow,
Morning
1880
Canvas, 76.8 × 121.9
Glasgow Art Gallery

Trossachs. Again, there are few, if any, identifiable works surviving from these visits other than Guthrie's *The Camp in the Woods* (dated 1880, Private Collection), a rather dark and indistinct canvas which points to an academic approach to landscape painting. Walton did not spend the whole of the summer in Scotland: a number of paintings of Surrey meadows document a visit to the south of England, to Shere, with A. K. Brown (another Glasgow painter). *A Surrey Meadow, Morning* (pl.31) shows Walton using a brighter palette that had appeared in *Summer Morning*; it also confirms a particular way of looking at landscape and extracting from it specific themes that is first encountered in the 1879 paintings. A long, low format, with a low horizon, grazing cattle, a farmworker going about his daily business – all were to become regular features of Walton's work in the next few years. The full sunlight, highlighted on the backs of the cows and on the tree trunk suggest that this was not a true *plein-air* painting in the same sense as his later works were to be – it was almost certainly painted in the studio – but it is more advanced in its outlook and techniques than any comparable work by Guthrie of this date. It is unlikely that by 1880 Walton knew of the work of Bastien-Lepage, but the clump of tall grasses in the foreground and the tree to the left, breaking the horizon, all suggest that Walton would have readily seen affinities in his work even at this early date.

Guthrie again resumed his London mantle in the autumn when he returned to a large canvas in the manner of Pettie which the latter assured him would find favour with the Academy. *The Unpublished Tragedy*, painted in the winter of 1880–1, was rejected by the Academy, however, much to the surprise of Pettie, and this rejection seems to have given Guthrie the resolve he needed to turn his back on what several of his Glasgow friends probably saw as sophisticated Gluepot painting. There is no doubt that Guthrie was sincere in his attempts to breach the walls of the Academy but his rejection hurt him bitterly. The painting is now lost[9] but a sketch of it remains on the back of a scrap of a letter (pl.32); it shows three men in historical costume seated around a table discussing a play obviously written by the figure on the right. The central figure was modelled by young Crawhall, perhaps the reason for its later success in Newcastle. Caw describes it as having a cool and blackish colour, with a heavy clumsy touch. Its subject, if not its handling, betrays the hand of Pettie; indeed, another sketch in a letter of the same period (pl.33) shows Guthrie at work in the studio painting another costume piece; it bears the caption *I am turning my attention to Elizabethan subjects*. In fact, following his intense disappointment at the picture's treatment by the Royal Academy Guthrie turned his back on such costume painting and returned to Scotland with his mother.

In April 1881 Guthrie was living at Helensburgh[10] but he was to spend much of the summer with Crawhall in Northumberland and then at Brig o' Turk in the Trossachs. Walton joined the two of them there and a newcomer to their group was George Henry, who had probably met Walton at the St Mungo Society the previous winter (although Walton and Guthrie were by now members of the Glasgow Art Club). Brig o' Turk had long been an artists' village; thirty years earlier it had been the backdrop to the beginning of the romance between John Millais and Effie Ruskin when they stayed there while Millais painted the portrait of her husband John. For the panorama painters it had proved an ideal base, close to the hills and lochs of the Trossachs but easily reached from Stirling and Glasgow. Guthrie and his friends, however, were more interested in the village itself than the famous countryside which surrounded it. The work they produced there in 1881 is all concerned with the life of the village, its cottages and back gardens and lanes, the hillside crofts of surrounding glens and the people themselves. Out of this visit was to come a major painting, the most important work that any of the Boys had yet produced and one which pointed in a new direction for them all – *A Funeral Service in the Highlands* (see p.51).

Some of the earliest surviving works by Henry date from this visit to the Trossachs. Despite his relative inexperience (compared to Walton and Guthrie, although he was a year older than the latter) he seems to have readily grasped the ideas behind much of his friends' work. The tonality of his pictures is low in key (pl.36) and the subject-matter quiet and unexceptional, yet even in these early works there can be seen an underlying sense of pictorial pattern which bolsters his compositions and gives them a clarity and solidity sometimes lacking in the pictures of his colleagues. A general lowness of key seems to be the most common factor in the work of these four young painters when they met for the summer of 1881, although Walton had demonstrated that he knew how to use a wider

32
James Guthrie
Sketch for
'The Unpublished Tragedy'
1880
Ink, 5.1 × 5.7
Glasgow Art Gallery

33
James Guthrie
'I am turning my attention
to Elizabethan subjects'
1881
Ink, 7.2 × 9.6
Glasgow Art Gallery

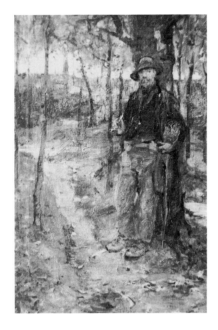

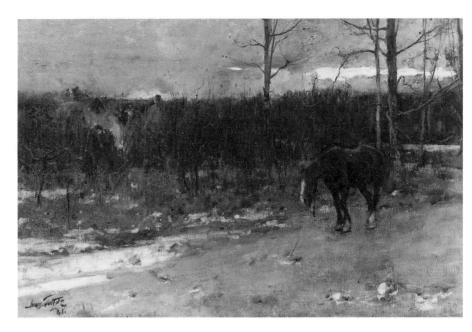

34
James Guthrie
Paid-off
1881
Canvas, 61 × 40.5
Private Collection

35
James Guthrie
Gypsy Fires are Burning for
Daylight's Past and Gone
1881
Canvas, 61.3 × 92
Hunterian Art Gallery,
Glasgow

36
George Henry
The Cottage on the Hill
c.1881
Watercolour, 24 × 34.5
Sir Norman Macfarlane

37
James Guthrie
The Cottar's Garden
1881
Canvas, 28.5 × 61.5
Private Collection

range of colour. Caw remarked upon the blackness of *An Unpublished Tragedy* and this dependence upon rich blacks, combined with a fullness of tone and a subdued palette, typifies many of Guthrie's paintings made at Brig o' Turk. Several of them were quite small, such as *The Cottar's Garden* (pl.37), full of the cabbages which were almost to become a leitmotif of Glasgow School painting during the 1880s. *Paid Off* (pl.34) and Walton's *The Wayfarer* (see p.71) depict rural types, but without any outspoken comment on the plight of the rural poor. Walton's painting is particularly interesting, developing the bright colour and strong tones of the previous year's paintings in Surrey.[11] It contrasts strongly with the more subdued works of Guthrie and Henry, strangely so in the light of suggestions that Walton is supposed to have made to Guthrie while the latter was working on *A Funeral Service in the Highlands* during the coming winter. This contrast is equally strongly seen in *Gypsy Fires are Burning for Daylight's Past and Gone* (pl.35), one of Guthrie's major submissions to the Institute in 1882, all of which were painted at Brig o' Turk.[12] The overall dark tone, heightened by a deliberate choice of a nocturnal subject, visually obscures a scene which, by its very lack of any dramatic focus, is already difficult to read. This lack of incident is typical of many of the Trossachs pictures. Even in Guthrie's major exhibit at the Institute, *Sheep Smearing* (untraced, known only from a line drawing in the Institute catalogue, pl.39), he chose to set the subject in a darkened barn thus further limiting the narrow range of colours and tones used.

 Not all of the paintings of 1881 are as dark as these. In *The Pedlar* (pl.38) Guthrie introduces several new elements – a heightened tone with brighter colours, combined with an attempt at a more elaborate figure composition in an outdoor setting. To some extent the subject draws heavily on his experiences in London with Pettie but although the composition is unresolved (Guthrie actually cut the painting in half at some date) we can see in it the seeds of various

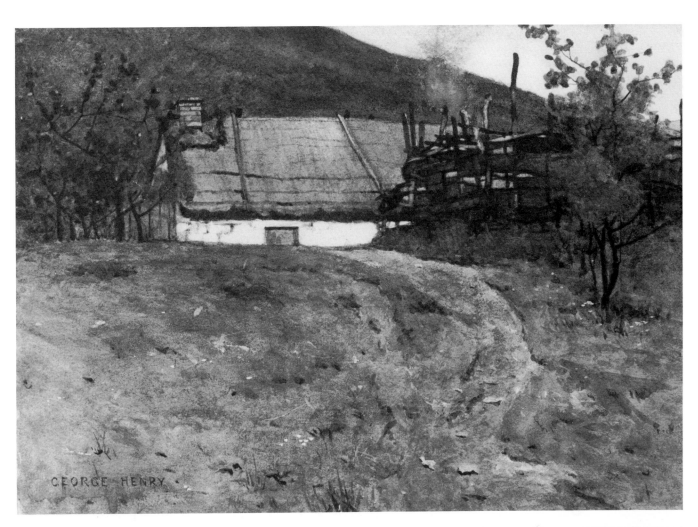

38
James Guthrie
The Pedlar
1881
Canvas, 47 × 61
Private Collection

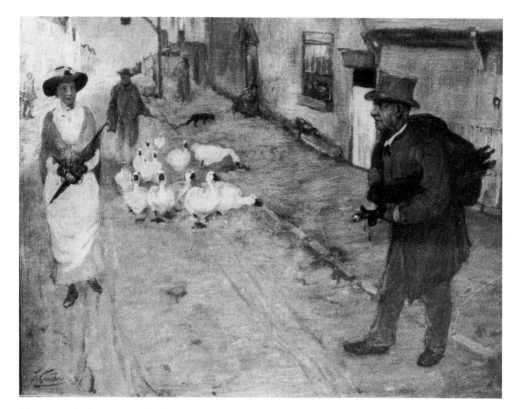

39
James Guthrie
Sheep Smearing
(line illustration from
Glasgow Institute catalogue)
1881
Canvas, 91.5 × 152.5
Untraced

40
Robert McGregor
Gathering Stones
c.1876
Canvas, 68.6 × 127
City Art Centre, Edinburgh

41
Robert McGregor
Doing the Provinces
c.1879
Canvas, 73.7 × 137.2
Glasgow Art Gallery

ideas and theories which were to be repeated in several of his more successful
plein-air paintings over the next five years. By cutting the picture in half,
Guthrie was isolating the figure of the pedlar and several of his later works
are concerned with single figures, or at the most two, against a landscape
background. There is a sense of frozen movement in the composition, seen most
clearly in the pose of the pedlar, while the geese conduct a disorderly progression
down the street. This disparity between the various elements of the composition
caused Guthrie to destroy several later works where similar problems were
encountered and not resolved. There is also the slightest of suggestions that the
pedlar, drawn as he is in greater detail and with more assurance than the other
figures, was painted with the aid of a photograph. This question of the use of
photography by the Boys is a recurring enigma which will be encountered again,
but at this date only Lavery was known (by his own admission) to have used
photographs in this way. What *The Pedlar* also shows is Guthrie's awareness of
the value of incident in a certain kind of 'ruralist' painting that was popular in
both Scotland and England.

Although *The Pedlar* is very much a subject picture in the Pettie tradition it
takes its subject from contemporary life and not from historical romance. Caw
points out that Guthrie would have been aware of similar works by John
Robertson Reid, a Scot who had settled in London and who had found popular
success in the Royal Academy with rural genre paintings. These have an element
of 'realism' about them in that they take their subjects from modern life but they
still display an anecdotal approach in their content. They take episodes from life
in the English village and make pictorial matter out of it. The main difference

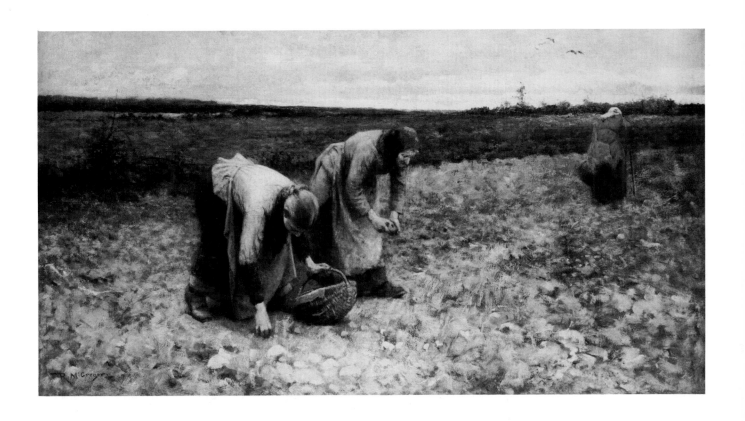

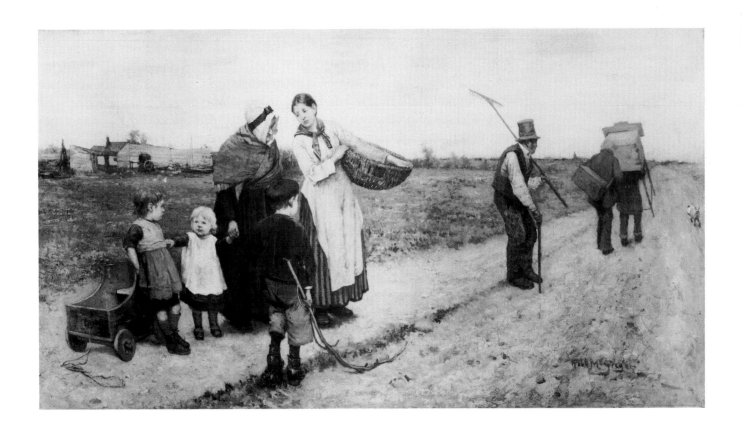

between these pictures and those, say, of Pettie and Orchardson seems to be only one of period – they depict incident which is contemporary rather than historical, with the main characters dressed in the contemporary manner of the poor rather than the costumes of earlier times. *A Country Cricket Match* (Tate Gallery), *Toil and Pleasure* (Tate Gallery) and *Lost and Found* (untraced[13]) all depend on anecdotal subjects for their *raison d'être*. This 'soft' realism may have been one of the sources for works such as *The Pedlar* and Walton's *Wayfarer* but both artists must have been aware of the work of other painters who had espoused the brand of realism which found favour at the Royal Academy in the 1870s.

Macbeth, Holl, Herkomer and Legros would all have been known to Guthrie and an awareness of their work could equally well have predisposed him towards the rural subject picture, anecdotal or not which led to his realist works of 1881.[14] *A Funeral Service in the Highlands* goes beyond the work of most of these artists and, I think, points to a new sensibility on Guthrie's part. As the son of a minister the subject of a funeral would no doubt have struck a chord of memory in Guthrie, for it was, above all else, a serious subject for an aspiring painter of modern life. It was also, however, a major task for a young man who had had no formal training and who often found difficulty in resolving the compositional problems of paintings involving groups of figures. David Murray (a founder member of the Glasgow Art Club and no friend of Guthrie and his fellow painters) exhibited a painting of the same title in 1876 which may have had some bearing on Guthrie's choice of subject as may Holl's funeral pictures.[15] It seems more likely, however, that his handling of the composition was inspired by the work of a slightly older painter who also spent the summer of 1881 at Brig o' Turk.

Robert McGregor (1847–1922)[16] had been exhibiting paintings depicting rural life since the mid 1870s, both at the Royal Scottish Academy and the Glasgow Institute. It is likely that Guthrie and Walton would have been familiar with his work for it would have had several attractions for them. Although he had not studied abroad McGregor painted in what he called a French manner; that is he showed a distinct preference for tonal values at the expense of colour, although his work was perhaps nearer to the Dutch painters than the French *plein-airistes*. His choice of subject-matter and his approach to it must also have shown the Boys that there was a way to respectability through the choice of realistic subjects (for the Boys were not outright rebels and they always hoped for financial as well as artistic success). McGregor did not scorn incident in his work but his subjects are never anecdotal or overly sentimental. *Gathering Stones* (pl.40) records the tedious and hard work of the rural poor without making political comment on it and without invoking undue sympathy on the part of the viewer. *Doing the Provinces* (pl.41) records the visit of a travelling sideshow to a village without elaborating the event into the catalogue of village types that so often was to be found in the work of painters such as Robertson Reid.

Guthrie and Walton may have sought out McGregor in Brig o' Turk and the brighter tonality of *The Pedlar* may owe something to McGregor's work. Certainly, Guthrie's last Brig o' Turk painting, *A Funeral Service in the Highlands* (pl.42) responds very much to McGregor's approach to realism as a subject for modern art.

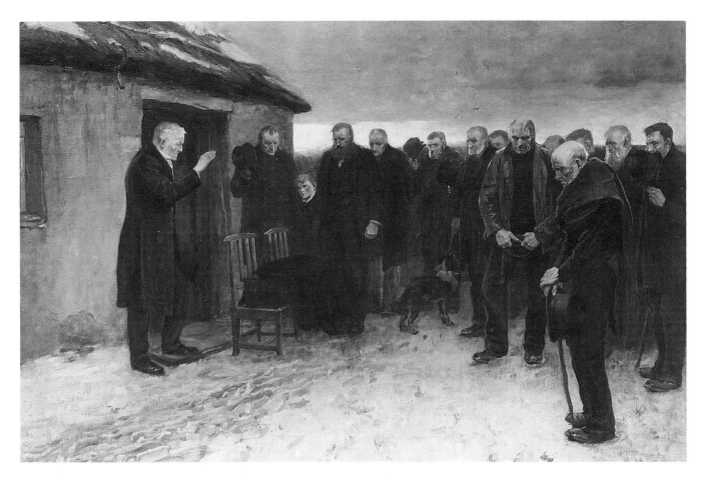

42
James Guthrie
A Funeral Service in
the Highlands
1881–2
Canvas, 129.5 × 193
Glasgow Art Gallery

Long after most of the other visiting artists had left for their city studios, Guthrie and Walton were still to be found in the village. The first snows of winter were falling when Guthrie witnessed an event which was to have a considerable emotional effect on him and which, at the same time, he saw as a powerful subject for a realist painting. A young boy, the son of a villager who had shown Guthrie and Walton some kindness, was drowned and the artists were saddened by the boy's death in the same way as the rest of the village. Guthrie attended the funeral, a simple service in the Highland fashion, taken outside the boy's home and attended only by the men of the family while the women stayed inside the house. Guthrie may have been reminded of his own childhood – of his father officiating at other funerals – and the scene outside the farmhouse, in the snow, was hurriedly sketched in after the service in preparation for a large painting. He painted the head of the minister before he left the village but most of the work on the painting was done in Helensburgh during the winter of 1881–2.[17] Lacking a studio of his own in Helensburgh, where his mother was living, Guthrie was lent the large studio of John G. Whyte,[18] a well-known amateur artist, whose son was the model for the boy in the painting. Other figures were modelled by porters and fishermen and the painting was ready to send to the Royal Academy at the end of March 1882.

43
George Henry
Brig o' Turk
1882
Canvas, 30.4×47
Glasgow Art Gallery

The largest surviving work by Guthrie, *A Funeral Service in the Highlands* was certainly his most ambitious composition to date. His handling of the compositional problems of a group of fourteen figures is most skilled, given his youth and relative lack of experience with such a complicated subject. The handling is bold and fluid, particularly in the foreground but the tonality is dark, unlike that of *The Pedlar* which was painted a little earlier. According to Caw,[19] the painting was virtually completed in a higher key when it was seen by Walton, who suggested that it be darkened to its present tone. Whatever Walton had in mind, it was a reversal of the general direction of Guthrie's work and it carried over into the next few paintings he was to finish during the summer of 1882. Perhaps Walton felt that the subject called for these changes, as the darker tones undoubtedly contribute to the mood of sadness which prevails in the picture. It is not, however, a mood of deep pathos but the dignity of a village community accepting the tragic loss of one of its young members. There is probably no other subject which is more suitable for a realist painter and Caw suggests that the work is more akin to the 'black realism' of Courbet than the *plein-air* work of Guthrie's later hero, Jules Bastien-Lepage.[20] It has been suggested that *A Funeral Service in the Highlands* owes a direct debt to Courbet[21] but it seems

almost totally impossible for Guthrie to have seen his *Burial at Ornans* before finishing his own painting.[22]

Henry showed some of his Brig o' Turk paintings (pl.43) at the Paisley Art Institute in December 1882, where they must have looked quite advanced alongside the works of other young painters who were soon to become associated with the Boys. Lavery was represented by several of his costume pieces, often dark in tone, which would not have been out of place in an exhibition of Gluepot work. Lavery was an ambitious young man, both for fame and fortune, and he was content at this time to provide the market with what it most wanted. His later conversion to *plein-airisme* is, therefore, the more interesting, for he was to adapt his new style, through careful choice of subject, to satisfy those he identified as the most likely buyers. At Paisley in 1881 he showed *Forgotten* (no 5), *The Song of Love* (no 37), and *Faust* (no 216), a version of the painting shown at the Glasgow Institute in 1882, where it would have seemed very old-fashioned next to Guthrie's *Sheep Smearing*. Lavery would not have been able to make the comparison, however, as by the time the Institute opened he had left for Paris. In his first year in France, his work underwent little change in content. *A Conquest,* 1882 (pl.44)[23] and *Monsieur le Troubadour* (pl.45) display a continuing

44
John Lavery
A Conquest
1882
Canvas, 61 × 50.8
Glasgow Art Gallery

45
John Lavery
Monsieur le Troubadour
1882
Canvas, 53.2 × 35.4
Private Collection

fascination with costume subjects which were undoubtedly successful for their painter. Lavery went to Paris with Alexander Roche, whose early work is unknown, but before they left Glasgow they are likely to have seen the French painting – *A Public Washing Place, Auvers-sur-Oise* (now untraced and not known from contemporary illustrations) – which William Kennedy showed at the Paisley Art Institute in 1881.

Kennedy was still painting typical Gluepot pictures, however, for at the Glasgow Institute in January 1883, he showed *Flirtation* (no 285, Private Collection), a subject-picture handled in a distinctly French manner. It shows Kennedy's acceptance of French *atelier* practice in the rendering of tonal values at the expense of full colour but its subject – a girl fetching water from the pump and passing coy glances at an admirer hiding on a nearby balcony – is no real advance on other Glasgow work. Few, if any, of these paintings would have caused Guthrie to reconsider the position he had recently arrived at with *The Pedlar* and *A Funeral Service in the Highlands*. The latter had been accepted at the Royal Academy and, although not specifically praised by the critics, it received no adverse comment. The path that he and Walton had chosen seemed to have no serious objectors and together they set out to consolidate the progress of a very satisfying year.

CHAPTER 5

To Pastures New

In 1882 Guthrie, Walton and Crawhall set out to find new sites for the summer's painting. At some point during the year Guthrie was to visit Yorkshire and also spend time with Crawhall at his home in Newcastle; Walton was to visit Stonehaven with W. Y. Macgregor and also Winchelsea, but these excursions were probably made on their return from Crowland, a small village in Lincolnshire, where all three spent the summer months. It is not known why they chose Crowland, although it may have been at the suggestion of A. K. Brown who had visited the village in 1878 and who had spent part of the summer of 1880 with Walton in Surrey. Crowland was a picturesque village with the ruins of a large medieval monastery but the surrounding countryside is flat and relatively featureless. It was perhaps for that very reason that they went to Lincolnshire. Its lack of panoramic views and grand vistas kept away the usual group of landscape painters and the repetitive scenery would have offered the Boys no temptations to depart from their chosen path as the Trossachs might have done. The three young men were able to concentrate on their work without either the distractions of other painters or the questioning of their intentions by villagers long-used to the annual invasion of artists who would have painted much more 'suitable' subjects than the life of the village itself. At Crowland they clarified the ideas which had been developed at Brig o' Turk the previous year. Fieldworkers, casual labourers, quiet corners of the village and isolated farms became their stock-in-trade. Not only was the content of their pictures firmly settled, however, but also the manner in which they were painted.

Another attraction of this flat fen country must have been the quality of the light. In the west of Scotland the clouds hurry across the sky driven by an ever-present wind which causes rapid changes in the value and intensity of the light. For some painters, such as William McTaggart, this was a virtue to be sought after and many of the best of his paintings were made at Machrihanish, where the breakers come in from the Atlantic driven by a constant breeze which brings with it just the kind of fleeting effects of light which delighted McTaggart. The intensity of colour in his paintings, combined with a handling developed to capture these transient effects of the sun, has caused McTaggart to be dubbed a Scottish 'Impressionist'. Guthrie and Walton would have been aware of his work and almost certainly shared the general appreciation of it that was common to the more forward-looking painters of their generation. Their own chosen path, as we have seen, was towards a more tonal approach to painting, working *en plein air* which ideally required the more consistent light of the east coast. Gradually, however, the influence of the full-sunlight painting of McTaggart was to become

obvious in some of Guthrie's Crowland paintings which were produced towards
the end of the year.

Only a few of the paintings made or begun at Crowland have survived. The
earliest of these are likely to have been painted in a similar manner to the work
finished in Helensburgh over the previous winter. Despite its date of 1883, I
think that *The Wash* (pl.46) owes its dark tonality to *A Funeral Service in the
Highlands*. It was worked on presumably in the studio in Helensburgh during the
winter of 1882–3, when it was signed and dated, but the other Crowland subject
which Guthrie painted at Helensburgh over that winter (*To Pastures New*) is so
different that the only conclusion that can be drawn is that *The Wash* was
started, and substantially finished, shortly after Guthrie arrived at Crowland in
the early summer of 1882. The picture does not seem to have been exhibited in
the 1880s, which may indicate that by the time it was finished he saw that it was
already old-fashioned.

The composition of *The Wash* is quite different from any of the Brig o' Turk
paintings in its *mise-en-scène*. Guthrie had perhaps intended to develop a single
figure from *The Pedlar* when he cut the painting in half but he had already
produced one or two other paintings in which a single figure dominates the
canvas. The first of these was *The Highland Shepherd*, painted in 1880 and
bought by Mr Whyte (Private Collection, USA). This was followed by two
decorative canvases, *Winter* (Private Collection) and *The Shepherd Boy* (Coll:
Andrew McIntosh Patrick). These were painted in 1881 and both are relatively
large (100 cm × 43 cm); Caw makes no comment on their history (in fact, he
makes no reference to *The Shepherd Boy*)[1] but they were possibly intended as a
pair, and may have been part of a larger scheme, perhaps a series of seasons or
similar subjects. These are both very static compositions but in his *The Pedlar*
and *The Wash*, Guthrie is concerned with the movement of the figures within the
canvas. Each picture has a strong diagonal emphasis, either in the line of the
street or the road which crosses the fields, which emphasises the progress of the
figures across the picture plane. Gradually, Guthrie was to change the emphasis
of his figure paintings, to make them more static, monumental almost, in a
manner which indicates a close study of the work of Bastien-Lepage.

It seems unlikely that Guthrie was consciously aware of the work of Bastien-
Lepage before the summer of 1882. *The Wash* displays the bold, almost coarse,
handling similar to that of *A Funeral Service in the Highlands* (which also
points to a date of mid-1882 as the beginning of work on the picture). Other
paintings made that year show a gradual change in handling and the use of a
brighter palette and, in the figure paintings, a definite move towards the type of
composition favoured by Bastien-Lepage. *Crowland Bridge* (pl.47) shows an
early stage in this development, with the use of square brushes to give a firm and
highly visible brushstroke which is graduated in size to create the perspective.
The tone of the picture is brighter and more even and, combined with the quality
of the handling, points to a new attitude to *plein-air* painting on Guthrie's part.
These changes suggest some recent contact with French painting but, after
Pettie dissuaded him from visiting Paris in 1878, Guthrie had had no direct
contact with developments in France.

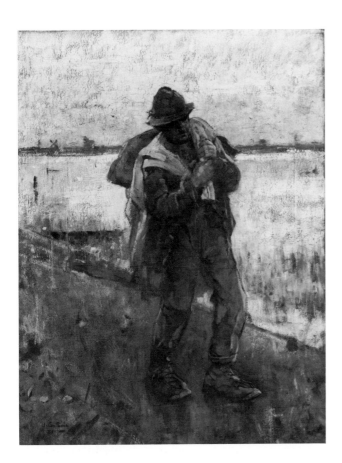

Caw suggests that Guthrie possibly visited Paris in 1882[2] but does not elaborate on whether this was before or after he went to Crowland. It is only a hypothesis on Caw's part, however, and he produces no evidence – letters, drawings, conversations – to support his claim. For someone who knew Guthrie well after 1885 it seems strange that they did not discuss together what would have been an important step in a young painter's life. Guthrie did not have to go to Paris to see the work of Bastien-Lepage, however, or that of any of his English contemporaries who were working in Paris at the time, because in 1882 Bastien-Lepage was extensively shown in London, as was a group of works by British artists which had been hung in that year's Salon.[3] Bastien-Lepage had first shown in London at the Royal Academy in 1878 and again the following year. On both of these occasions he showed portraits, which Guthrie may not have registered on his visits to the Academy. In 1880 a group of seven of Bastien-Lepage's recent paintings formed a major part of the Grosvenor Gallery's Summer Exhibition but Guthrie was in Scotland and probably did not see the show. Had he done so, he would almost certainly have become a convert to Bastien-Lepage's vision of nature two years before his eventual acceptance of the young Frenchman's manner in 1882. One of the Grosvenor Gallery exhibits, *Les Foins* (pl.48), was singled out for particularly vicious attention by the critics. If Guthrie did not see it in 1880 then he and Walton must later have made a point of searching out all illustrations of Bastien-Lepage's work for it was an image which

46
James Guthrie
The Wash
1883
Canvas, 93.5 × 72.5
Tate Gallery, London

47
James Guthrie
Crowland Bridge
1882
Canvas, 30.5 × 25.5
Private Collection

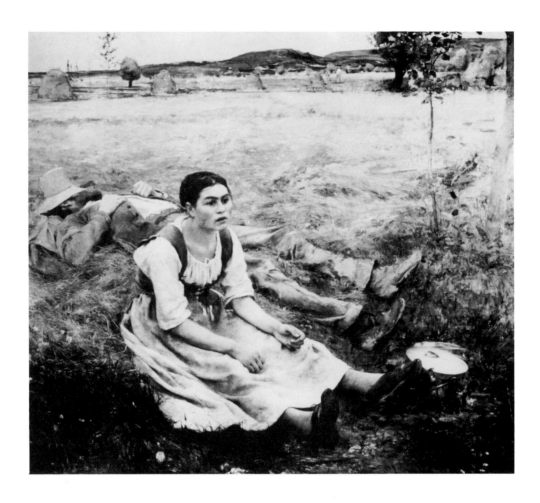

48
Jules Bastien-Lepage
Les Foins
1877
Canvas
Musée d'Orsay, Paris

49
James Guthrie
Study for
'Fieldworkers,
Crowland'
1882
Pencil, 26.8 × 22.8
National Galleries of
Scotland, Edinburgh

was to have a profound effect on their work. It depicts a young peasant girl, sitting at rest at the edge of a field, with her legs stretched out in front of her and her hands in her lap. The critics found it repulsive[4] but these two Glasgow painters were to use the same pose in several of their paintings between 1882 and 1885. In 1881 he showed again in London, at Tooths and the French Gallery, but Guthrie is likely to have been in Scotland on both occasions.

In the summer of 1882, however, Guthrie would almost certainly have made a visit to London to see his Royal Academy exhibit, *A Funeral Service in the Highlands*, and is unlikely to have missed the four paintings by Bastien-Lepage which were on show in the London galleries. At the Academy Guthrie would have realised that his painting was already *passé*. Even if Bastien-Lepage was not there in person his English followers were well represented. Stanhope Forbes' *A Street in Brittany* (Coll: Walker Art Gallery, Liverpool) would have summed up for Guthrie the differences between his own work and that of these other young painters who had been studying in France.[5] Outside the Academy, at Tooths and the United Arts Gallery, Guthrie would have found the source of all this new work in a display of recent paintings by Bastien-Lepage; and at The Fine Art Society he could have seen a group of paintings by young British artists which had just been included in the Paris Salon. Bastien-Lepage's *Pauvre Fauvette* (see

p.35), *Pas Mèche* (see p.66), *Le Mendiant* (see p.68) and *La Petite Coquette* are at the root of the change in style in Guthrie's painting that appears to have taken place in the middle of his visit to Crowland in 1882. Crawhall, too, probably saw these paintings as his own work that was produced at Crowland has a distinct naturalist manner. They would surely have studied Bastien-Lepage's handling – his use of brushstrokes and a differing consistency of paint to create an aerial perspective; his placing of the figure within the canvas; the use of trees and tall grasses as pictorial devices to help relate the foreground of the composition to the frontal plane of the picture. Above all they would have recognised his selection of individual figures from everyday life, with few distractions from their surroundings or other 'studio-props', as the ideal which they had been gradually approaching in the work produced at Brig o' Turk in the previous year. To achieve this verisimilitude, however, Bastien-Lepage had painted in a cool, grey *plein-air* light; although they willingly accepted his emphasis on the accurate rendering of tonal values Guthrie and Walton, in particular, were not to reject the traditional Scottish concern for colour.

If we accept that Guthrie visited London from Crowland, the changes in his work are immediately apparent, for no other identifiable Crowland paintings are in the style of *The Wash*. A large painting of fieldworkers (112 cm × 75 cm) is now

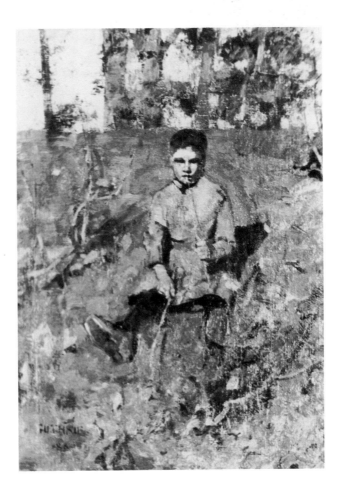

50
James Guthrie
Boy with a Straw
1882
Canvas, 38.8×29
Private Collection

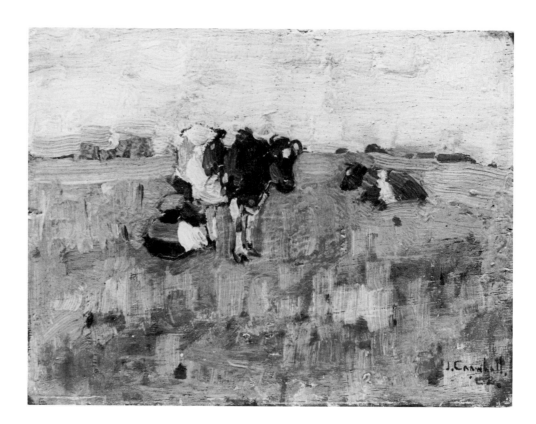

51
Joseph Crawhall
The Milkmaid
1882
Panel, 15.5×20.5
Sir Norman Macfarlane

lost but a drawing in a sketch-book is probably related to it (pl.49). It shows
Guthrie experimenting with an arrangement of figures which take up the full
length of the canvas, with the figure in front having the same provocative stance
as the barge-boy in *Pas Mèche*. Like many large canvases involving several
figures, however, it was put to one side when Guthrie encountered insuperable
compositional problems. His lack of formal training showed up most in his
recurring inability to resolve such problems and a number of promising paintings
were eventually dismembered or destroyed altogether. On a smaller scale he
concentrated on paintings of single figures such as *The Lincolnshire Harvester*
(untraced) and *Boy with a Straw* (pl.50). Here we see the pose of the figure from
Les Foins repeated for the first time in this painting of a young boy sitting on a
grassy bank. Although undoubtedly a *plein-air* painting, it is painted in full
sunlight with strong shadows and a bright blue sky, seen above the high horizon
that was so common a feature of Bastien-Lepage's paintings. According to Caw,[6]
however, the original study of geese with their young keeper, which was to be the
basis of Guthrie's most significant Crowland painting, was lower in tone, but as
he records that it is dated 1883 it may have been a study made in Helensburgh
during the coming winter when Guthrie completed *To Pastures New*.

 One could assume a similar reaction on the part of Crawhall, but as very little
of his work from before 1882 survives it is difficult to make such direct
comparisons. Certainly, much of his work in oil seems to date from his visit to
Crowland but like Guthrie he probably finished the larger paintings in his studio
over the winter, working from studies made *en plein air*. *The Milkmaid* (pl.51) is

one of these studies and it clearly shows his flair for oil paint, a medium which he was virtually to forsake for watercolour within the next few months. The fluidity of the paint, which has a creaminess not found in the work of his friends Walton and Guthrie, is missing from the much larger painting, *A Lincolnshire Pasture* (see p.70), which Crawhall sent to the Royal Academy in 1883, the same year that Guthrie's *To Pastures New* was hung at the Academy. *A Lincolnshire Pasture* shows Crawhall slightly ill at ease with such a big canvas. There are no figures in the painting, as Crawhall's interest in animals is, for the first time, given the full scope of an exhibition-size canvas. Although it has all the hallmarks of a successful Glasgow School picture there is a certain awkwardness about the composition which one never finds in Crawhall's watercolours. It could be attributed to youth and inexperience, as he was only twenty-two, but perhaps his uneasiness about attempting such an ambitious work was behind his decision to enrol in the studio of Aimé Morot in Paris in the autumn of 1882. Morot was well known as an animal painter but Crawhall seems not to have settled into the *atelier* system and stayed in Paris for only two months. It was probably on his return that he began *A Lincolnshire Pasture*, which may have been painted in Glasgow during the winter of 1882–3, as it seems unlikely that it could have been painted in isolation in Newcastle.

Guthrie's visit to Newcastle resulted in a delightful little painting of Joe Crawhall and his sister, Judith, seen *contre-jour*, looking across the breakfast table into the sunlit garden beyond (pl.52). *Tête-à-Tête* is an intimate scene which contrasts sharply with another of Guthrie's paintings of this date, probably painted in the latter half of 1882 and certainly after his visit to London that year. *Miss Sowerby* (pl.53) seems to be Guthrie's first commissioned portrait and it is a picture which shows his debt to another artist whose work he could have seen in

52
James Guthrie
Tête-à-Tête
1882
Panel, 18.5 × 27.5
Private Collection

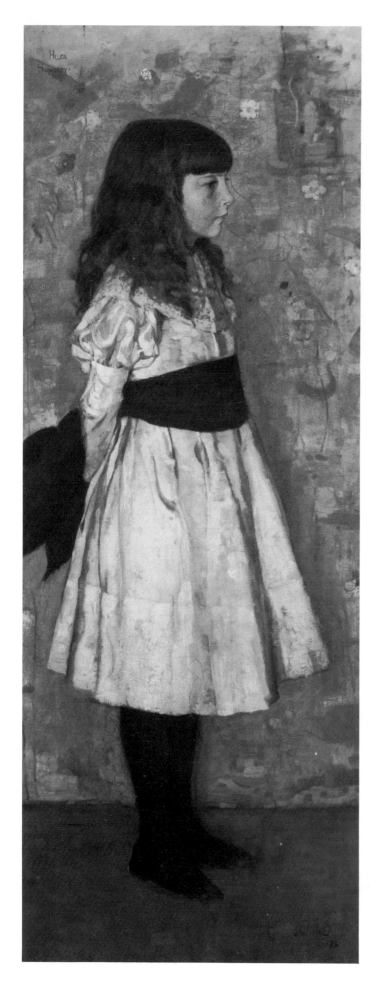

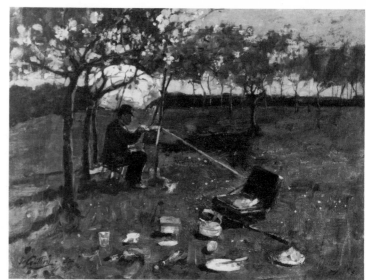

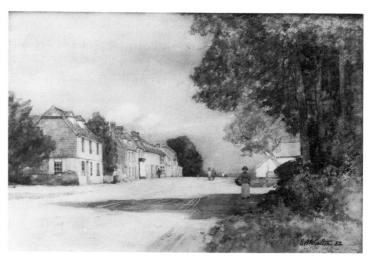

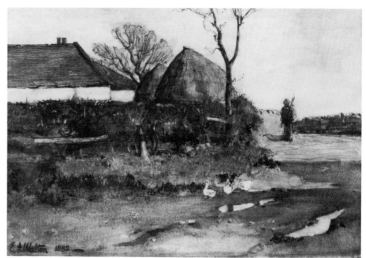

53
James Guthrie
Miss Helen Sowerby
1882
Canvas, 160 × 61
Andrew McIntosh Patrick

London that summer, James McNeill Whistler. Whistler's portraits and figure paintings from the 1870s form the basis of this study of a young girl. The placing of the figure within the canvas and the use of a patterned, but undefined, backdrop show a knowledge of Whistler's work that Guthrie, or any of the Boys, had not displayed before. The texture of the backcloth, the way that the girl is silhouetted against it, and the simple but effective pose, indicate a skill and feeling for portraiture which had not been evident in any of Guthrie's earlier paintings and he was later to return to portrait painting when the more difficult problems (for him, anyway) of *plein-air* compositions seemed insuperable. For so important a work, it is odd that so little is known about its history, particularly about the family who commissioned it and where it might have been painted. It has been suggested that it was painted in London.[7] This seems unlikely, given what is known of Guthrie's whereabouts in 1882. It seems more probable that it was painted in Newcastle or in Glasgow after he returned there in the late autumn, or alternatively at Poppleton in north Yorkshire where he produced a small oil-sketch of himself painting *en plein air* (pl.54).

Back in the city he would have met up again with Walton, newly returned from his visit to Stonehaven with Macgregor. Few major oils by Walton survive from 1882 and his output can be traced only through a small group of finished watercolours. Walton was the first of the Boys (excluding Melville for the time being) to have produced a considerable body of work in watercolour; even Crawhall had not been as prolific, or at least as successful. His colour is strong and bright but Walton still shows an awareness of the importance of achieving an accurate tonal rendering of his subjects. One of these, *Winchelsea* (pl.55), is a study for an oil of the same subject which Walton showed at the Royal Academy in 1883.[8] The full sunlight and strong shadows counter the more tonal rendering of *Spring* (pl.56) and other watercolours of that year. His success with the medium no doubt encouraged the series of views of Helensburgh which were painted over the next two or three years. In these he confirmed his position as a leading watercolourist in the group – alongside Melville and Crawhall – who was soon to come to the fore through his mastery of the medium.

Walton had probably agreed to join Macgregor's informal classes in his studio at 134 Bath Street in Glasgow; Guthrie remained distant from this informal gathering of young painters which also included Lavery, Paterson, Nairn and Henry. Guthrie could keep in touch with the latest developments in the work of the younger painters through the Glasgow Art Club, in particular through the series of informal exhibitions of Members' work that were arranged from time to time. In November 1882, for instance, Lavery showed a series of figure subjects which had been painted in France[9]: *Out of the World*, *Pour les Pauvres* ('a striking French subject'), *Little Emily* and *His Portrait*. Most of these are lost but a drawing from 1882 (pl.57) shows a new boldness in technique and, again, an awareness of Whistler's work in such portraits as that of Carlyle (see p.289). Lavery had returned from France in August[10] and must have been impressed by the advances in the work of his contemporaries who had stayed in Scotland. Guthrie showed some of his Crowland pictures at the Art Club in December[11] alongside Lavery's *A Conquest*.[12] Henry, however, had no such opportunity, for

54
James Guthrie
Poppleton, the Artist at Work
1882
Canvas, 34.5×54.8
Hunterian Art Gallery,
Glasgow

55
E. A. Walton
Winchelsea
1882
Watercolour, 34.5×52
Sir Norman Macfarlane

56
E. A. Walton
Spring
1882
Watercolour, 25×35
The Fine Art Society

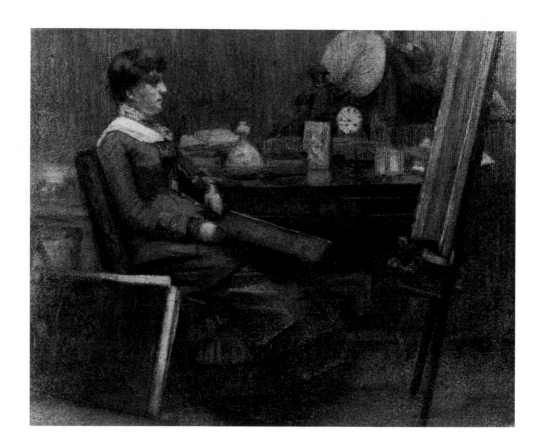

57
John Lavery
Her Portrait
1882
Black chalk, 25.9 × 33
Glasgow Art Gallery

his attempt to join the Club in November 1882 failed[13] and he had to depend on the Pallett Club, formed by members of the Black and White Club and the St Mungo Society, as a venue for his work before the next Institute exhibition at the beginning of 1883. Henry, working alone at Brig o' Turk and on the Firth of Clyde, had made considerable progress during the year. *The Head of the Holy Loch* (pl.58) is a well-conceived composition, not strong in colour but having a definite sense of design in the way that the path down to the water's edge is made to snake across the canvas, causing the viewer to be led into the centre of the composition where a narrow strip of water divides the picture horizontally into two parts. Henry had the painting accepted for the Glasgow Institute in 1883, where Guthrie's *A Funeral Service in the Highlands* was also shown, but it was probably not their own work which was to interest the Boys so much that year as two paintings[14] by men from outside Glasgow.

Guthrie, Crawhall and, probably, Walton would already have seen one of these paintings in London during the summer of 1882. William Stott's *The Bathers* (see p.38), which had been awarded a medal at the Salon in 1882 and then shown at The Fine Art Society, received mixed reviews from the Scottish critics. Its obvious French sources were noted by all of them but not always in a complimentary manner. Guthrie would have had more time to study it in Glasgow but it would seem to have had a more positive effect on Lavery, who was about to return to France. *The Bathers* was painted at Grez in 1882, along with *The Ferry* (see p.37) which also received a medal and which similarly was shown

at The Fine Art Society. The cool harmonies of pale green and grey which dominate both these paintings, and their wider view of the landscape than is normally seen in paintings by Bastien-Lepage, could well have struck a chord with Guthrie who was at this time working on *To Pastures New*. Its strong horizontal emphasis may well owe much to *The Ferry*, which must have captured for all the young members of the Glasgow School the essence of French *plein-air* painting as seen through the eyes of one of their compatriots. Lavery would probably have seen this painting in France at the Salon of 1882 as it must have been of crucial importance to him. Certainly, his knowledge of it is reflected in many of the paintings he was to make at Grez over the next two years. The clear horizontal emphasis given by the shape of the canvas is further strengthened by the repeated horizontal lines of the river and its banks and the roofline of the cottages in the distance. These lines are countered by the diagonal of the girl lying on the grass and the verticals of her companion and the tree which rises from the foreground and disappears out of the top of the painting – a favourite motif of Bastien-Lepage which was to be emulated by most of his British followers, Guthrie, Walton, Clausen, Lavery and la Thangue among them. The critics were not kind to *The Bathers*; most of them noticed it but usually only to regret its wholehearted acceptance of 'Frenchness' by one of the younger generation.

58
George Henry
The Head of the Holy Loch
1882
Canvas, 59.1 × 89.5
Glasgow Art Gallery

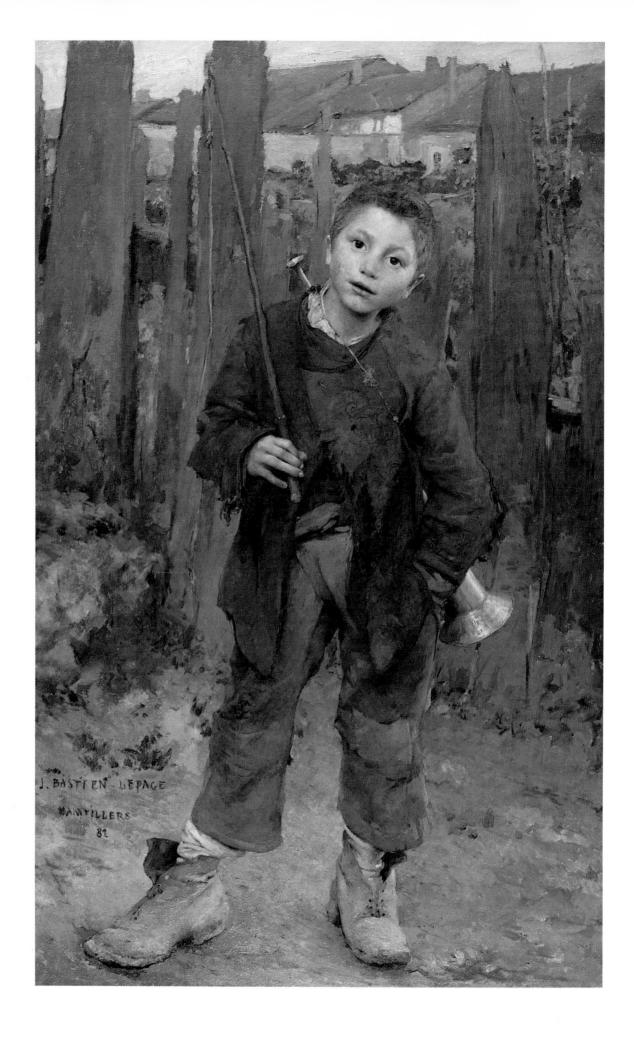

60
E. A. Walton
A Summer Morning
1879
Canvas, 61×91.5
Sir Norman Macfarlane

59
Jules Bastien-Lepage
Pas Mèche
1882
Canvas, 132.1×88.3
National Galleries of
Scotland, Edinburgh

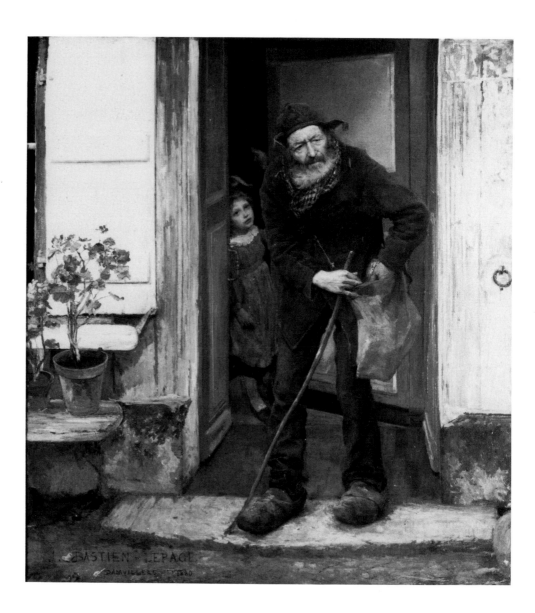

61
Jules Bastien-Lepage
Le Mendiant
1880–1
Canvas, 199 × 181
Ny Carlsberg Glyptotek,
Copenhagen

The second painting which would have caught the Boys' attention was a work by Bastien-Lepage himself, *Le Mendiant* (pl.61). It was given the place of honour in the main Gallery and virtually every review of the exhibition paid attention to it. The critics were fairly evenly divided in their attitudes to the painting. Some saw in it a great masterpiece, full of pathos and sensitive observation, finely handled with a dexterity that all artists should be proud of. Others compared it unfavourably with Millet's *Going to Work*, also in the exhibition, finding it lacking in genuine sympathy either for the sturdy beggar it portrayed or the plight of the rural poor in general; its cool tones were thought to be too extreme and the whole composition was criticised for its unnatural arrangement and studio atmosphere. Its price, £1260, also attracted much comment (it was the most expensive painting in the Exhibition), but only the painting's detractors thought it unreasonable. It was the subject of satirical articles in the weekly

press and, more importantly, it became the central theme of a paper given by Guthrie's friend, Mr Whyte, to the Dunbartonshire Art Club, entitled 'The Limit of Finish in Art'.[15] More column inches were devoted to it than any other work in the Exhibition and even those of the Boys who were unable to make regular visits to the Institute could hardly have failed to have been aware of its impact.

The critics were particularly complimentary to Guthrie's *A Funeral Service in the Highlands* and made encouraging remarks about the work of Macgregor (*Stonehaven* and *The Mill-pond*), Dow (*Tramps at Sundown*), Nairn (*The Fish Sale*) and Melville (*An Egyptian Sower*). For Guthrie and Macgregor in particular, who were deeply involved in painting new works that spring which would confirm their own pre-eminence within the group, these notices would have had a special significance. Guthrie was busy at Helensburgh in Mr Whyte's studio on *To Pastures New* (pl.64), a painting which took the tentative reaction to Bastien-Lepage that we have seen in the Crowland pictures of 1882, and transformed it into an important statement in the development of naturalist painting in Britain. It is also strongly in antithesis to *A Funeral Service in the Highlands*, which had just been so unequivocally praised in Glasgow, in its tone, handling and, above all, its colour. Caw gives details of some studies for the painting[16] which were probably made in Crowland but it is not known whether the large canvas was also begun in Lincolnshire or whether it was entirely a studio production. The strong horizontals of Stott's *The Ferry* are evident in a low horizon and the adoption of Bastien-Lepage's square brush entails the use of his method of painting the foreground in some detail with a broader handling for the further distance and the sky. The full sunlight, however, with the resultant high key are very different from the cool *plein-air* tone of the Frenchman's work. The sun is behind the viewer and the strong shadows thrown diagonally across the composition help give a definite impression of movement to the progression across the canvas of the troop of geese and their keeper. In cutting off the left-hand goose by the edge of the canvas Guthrie emphasises this movement by creating a space outside the picture into which an unknown number of birds have already passed. Similarly, on the right of the canvas we are very aware of the space that the procession has just left. This pictorial indication of movement, achieved by cutting figures integral to the composition, was very new to Scottish painting.[17] Its source, like the similar devices used by Degas and other French painters, was probably photography but there is no evidence that Guthrie used photographs in the same way as, say, George Clausen did in his naturalist work of this date. The low horizon, which is cut by the curves of the necks of the geese, also contributes to the sense of steady movement. This gentle movement, in itself, contrasts with the static quality of many naturalist paintings which have been dubbed 'Kodak-realism' because of the photographic quality both of the tone of the paintings and their impression of frozen movement.

However many studies he had, Guthrie was unable to work without models. He prevailed upon Mrs Whyte to lend him her daughter for the goose-girl and she obtained a live goose for him, alongside which he added a stuffed example which was no doubt more manageable over the long winter months cooped up in the studio. Guthrie's aim was to complete the picture in time for the sending-in day

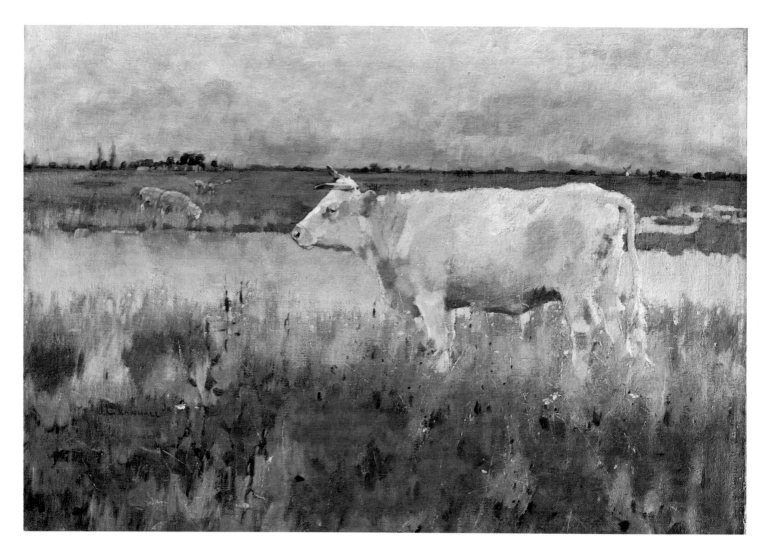

62
Joseph Crawhall
A Lincolnshire Pasture
1882
Canvas, 91×127
Dundee Museum and Art
Gallery

63
E. A. Walton
The Wayfarer
1881
Canvas, 46×30.5
Angus Maclean

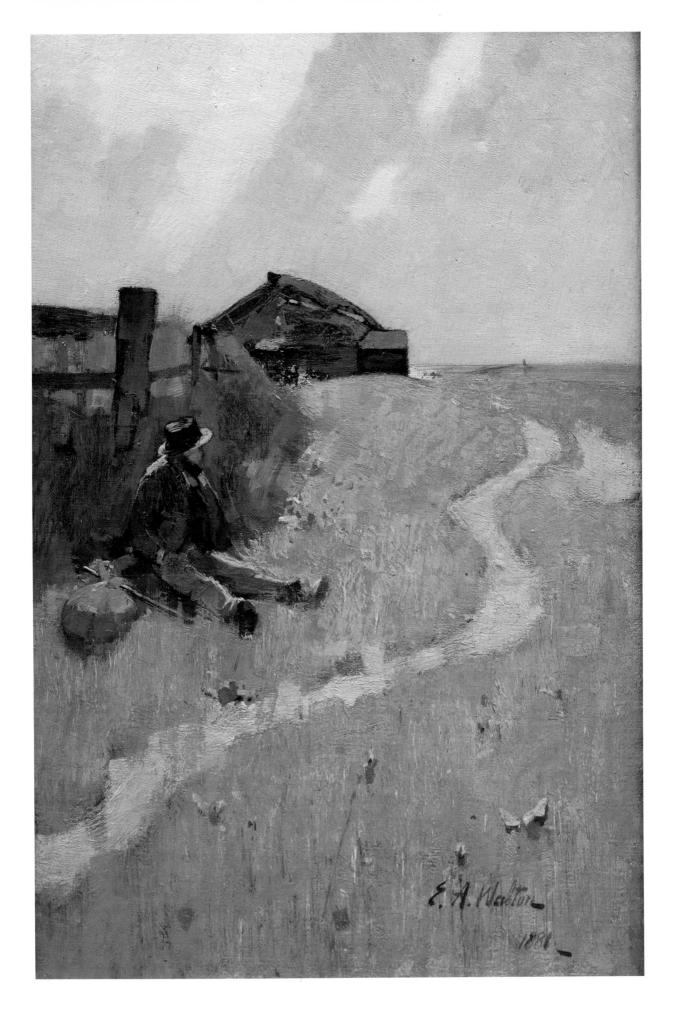

at the Royal Academy, where it was duly accepted and included in the Summer
Exhibition in 1883.

The painting suffered mixed fortunes in London. It was included in *Academy
Notes*, which would have given Guthrie some pleasure and would have brought
the picture to public notice, but it was not well hung. A Glasgow critic, writing in
The Bailie, repeated the story for the benefit of his local audience:

This year's Royal Academy joke has been perpetrated by the aid of James Guthrie's
'goose picture'. It, the picture, which represents half a dozen geese waddling along a
village green, is entitled *To Pastures New* and has been hung immediately above the door
to the Refreshment Room. The application, if not very refined, is sufficiently obvious. It
has amusingly been the occasion of abundant laughter on the part of visitors.[18]

This seems particularly vindictive compared to the encouraging words which the
same journal printed earlier in the year:

James Guthrie has sent to Burlington House a large picture, the subject of which offers a
marked contrast to his last year's *Highland Funeral*. It represents a girl driving a flock of
geese along a road in Lincs. The road runs right across the foreground of the work; the
long flat of the fen country stretches away in the distance; and overhead is a blue sky
flecked here and there with a white cloud. Mr Guthrie has sought for an effect of sunlight
thrown strongly on the objects in his picture, and as the girl and the geese are life-size the
tout-ensemble is a wonderfully strong and striking one.[19]

The columnist in *Quiz* tried to walk a tightrope between these two divergent
views:

James Guthrie is a young man who attempts much and is always fairly successful. His
picture, five feet long and three feet high, of a girl driving geese *To Pastures New*, is hung
over the door leading to the Refreshment Room, and it is the only Glasgow picture which
has the honour of being illustrated in *Academy Notes*. The colour is good, but the
composition, especially the handling, is more suggestive of decorative than of purely
pictorial work. There is a greater absence of modelling than is justifiable. Indeed, it
appears as if the artist had striven to keep the broad and striking effect rather than been
trying to infuse naturalistic tone into his picture. It is clever, very clever, but were its
cleverness less obtrusive it would be a much finer work of Art.[20]

'Clever' was to become a term of scorn for this and other Glasgow critics in the
coming months and it was freely applied to many Glasgow School paintings. The
painting, however, was unsold and it returned to Glasgow.

While Guthrie was painting in Helensburgh, Macgregor was hard at work on a
picture of a barrow-girl counting up her day's takings from her vegetable stall.
The Bailie again chronicled the comings and goings of the Boys and also suggests
that this is the same painting that is now known as *The Vegetable Stall* (pl.66),
which bears the date 1884:

W. Y. Macgregor has taken a house at Crail for five months[21] [and] has completed his
large picture of a vegetable stall and he goes to Fife for four or five months . . . That
picture, by the by, is really a remarkable work. It represents a stall covered with
cabbages, stalks of rhubarb, onions, a basket of potatoes, and other vegetables. At one
end sits a life-sized, nicely posed female figure, busily engaged in counting up her day's
drawings. The work is amazingly strong in colour and is broad and realistic in
treatment.[22]

An X-ray examination of the painting in the National Gallery of Scotland has revealed this figure of a girl at the right-hand side of the composition, sitting, as the article describes, at the edge of her stall counting her takings. The knife lying on the empty table and the bundle of leeks in the foreground fill the area previously taken up by her body and hands, and the wooden framework supporting the onions has been transferred from the opposite side of the composition to fill the lacuna left by her head.

Can it have been a coincidence that both Guthrie and Macgregor were simultaneously working on similar sized canvases, each with a strong horizontal emphasis and each containing a life-sized figure? Guthrie and Macgregor were never close and Guthrie was not a regular attender at Macgregor's classes in his studio. There was no doubt some rivalry between them – Macgregor, having a personality which apparently led him to assume a superiority over his Glasgow *confrères*, possibly considered Guthrie's training as inferior to his own. For his part Guthrie probably saw himself as the only younger painter to have attempted a serious work on a grand scale (*A Funeral Service in the Highlands*) which had had some degree of public recognition while most of his contemporaries were still limited to small works such as Macgregor's Stonehaven landscapes. It is unlikely that Macgregor could have kept his picture a secret, as his studio was almost open-house to the Boys but Guthrie's painting was hidden down at Helensburgh, out of easy access for studio-visitors. That being so, I think that there is no evidence to suggest a contest between the two artists to produce a major statement, which both of these paintings are. Their experiences of the last two years had been consolidated and confirmed by the works of Stott and Bastien-Lepage in the Institute in 1883 and both painters were working in the figurative tradition. Something caused Macgregor to remove the figure of the girl from his painting, however, and I think it likely that it was in no small part due to the differing critical reactions to his and Guthrie's paintings of 1883.

The figure of the girl was crucial to the original concept of the painting and, indeed, our understanding of it in its present form. It is not, as has been said many times, a contrived still-life within that long and worthy tradition. Even though a realistic approach to the discipline of still-life painting had been developed by French painters such as Bonvin and Ribot, this picture stands outside the mainstream of still-life work. As a realist subject, it is difficult to explain the intention of the artist as the painting now presents itself. None of the Boys had attempted such an ambitious, almost abstract, subject before and it is doubtful that Macgregor, who was a fairly conservative character, wanted to make some social point by choosing to paint a picture consisting solely of vegetables. The original existence of the figure of the girl answers many questions, in the same way that her removal poses just as many again. Had the figure remained, the painting would have been another rare example of a realist subject taken from urban life. As it stands, it is difficult to consider the subject at anything more than its face value – a still-life of vegetables painted in a realist manner. At whatever level we assess the painting, however, it remains one of the major achievements of the Glasgow School, a work of great character and achievement rivalled by only a few other pictures of the period.

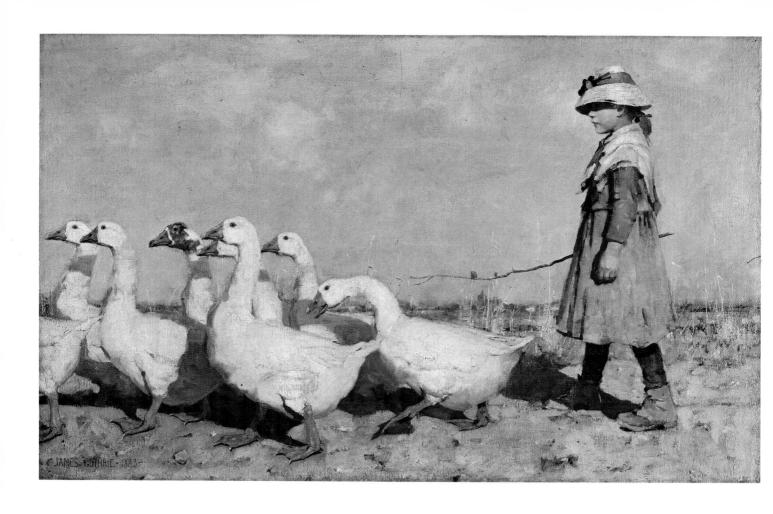

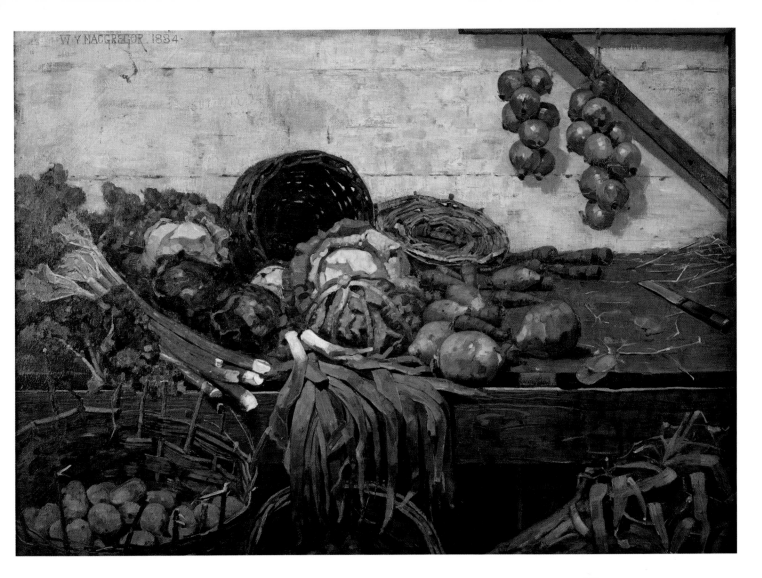

66
W. Y. Macgregor
The Vegetable Stall
1883–4
Canvas, 105.5 × 150.5
National Galleries of
Scotland, Edinburgh

64
James Guthrie
To Pastures New
1882–3
Canvas, 90 × 150
Aberdeen Art Gallery

65
W. Y. Macgregor
Crail
1883
Canvas, 91 × 150
Smith Art Gallery and
Museum, Stirling

Macgregor had painted other still-life paintings before *The Vegetable Stall*. In 1882 he had shown a study of apples at the Institute (which he also sent to the Royal Academy in 1883), which had been well received by the critics, but it seems likely to have been painted on a much smaller scale. Paterson recalls another painting of dead game dating from the same period as *The Vegetable Stall*, but Paterson's memory for dates is not always to be relied upon and neither of these paintings can now be traced.[23] *The Vegetable Stall* was not, however, originally conceived within this format of pure still-life painting. Had the figure of the girl remained the vegetables themselves would have been rightly recognised as a superb piece of painting but the picture would have been assessed as a figurative work comparable with the paintings of Bastien-Lepage, Stott of Oldham and Guthrie. It was a realist subject, just as the goose girl was a realist subject for Guthrie, painted on a life-size scale in the manner of Bastien-Lepage. As such it was a brilliant concept, taking for its subject a street trader – a metropolitan subject – thus breaking with the rustic naturalism of Guthrie and the other Boys. Although the girl is now gone, we can guess at the manner of her handling from studying the rest of the canvas, just as we can assess the likely quality of the figure by looking at Macgregor's other large figure painting of that year, *Crail* (pl.65). This view of the main street of a fishing village in the East Neuk of Fife where Macgregor spent the summer of 1883 is his most ambitious figurative painting. It was painted *en plein air* and, like *To Pastures New*, is high in key and clear and bright in colour. The figures of the villagers, however, are no real improvement on the stumpy manikins of *Stonehaven*, which was a much smaller painting where the figures played no real part in the composition. Compared to the confident pose and handling of Guthrie's goose girl, these villagers are awkward and insubstantial, belying Macgregor's claims to have an understanding and grasp of the difficulties of life-drawing.

If the figure in *The Vegetable Stall* was at all similar, it is not surprising that Macgregor had second thoughts about it and that he should remove her before submitting the painting to public view in 1884. By that time he could well have seen Guthrie's *To Pastures New*, after both he and the painting returned to Glasgow, or, more likely, he saw Guthrie's *A Hind's Daughter* (see p.91) at the Institute in the spring of 1884 and then decided to amend his own painting. Surprisingly (or perhaps not in view of Macgregor's second thoughts about the picture) *The Vegetable Stall* was not exhibited in the 1880s either at the Institute or the Royal Scottish Academy, although Macgregor seems to have sent it to the Royal Academy in 1884 but it was not accepted.[24] *The Vegetable Stall* cannot, therefore, be considered as part of the genre of still-life painting. I think that Macgregor could not bear to destroy the picture completely, and with it some of his best passages of painting, but after he changed it I believe that he felt that its *raison d'être* had been totally obscured. A still-life painting on this scale would have been unusual even for the supposedly rebellious Glasgow Boys and Macgregor seems to have been content to keep the painting in his possession for the rest of his life. Despite all these considerations it remains his masterpiece, boldly handled with a mastery of tonal painting that few of his friends were ever to match. 'Hack the subject out as you would were you using an axe, and try to

realise it; get its bigness'[25] was the advice he reputedly gave to his fellow artists. Here he has done precisely that to produce one of the most impressive Scottish paintings of the nineteenth century.

Only one other important painting of Crail survives, *A Cottage Garden, Crail* (pl.67), which is in some ways a more successful work than his large painting of the village street. It is certainly more within the accepted canon of Glasgow School painting in its depiction of vegetables in their more natural state – growing in a garden. Again, it is bright and clear in colour, painted in full sunlight. *Crail* has the strong shadows that Guthrie introduced into *To Pastures New*; such strong light is new to Macgregor's work, but he is unlikely to have seen Guthrie's painting before settling in the village for the summer. He could possibly have gone to see it at the Royal Academy, where his own painting of apples was hung, but it is more likely that he heard of the colouring and lighting of the painting from mutual friends or even from the public accounts of the painting, which, as we have seen, made specific reference to the strong shadows thrown across the geese. *Crail* and *The Vegetable Stall* are very different in their handling of light and tone but they show that Macgregor was willing to experiment and perhaps learn from his colleagues' work. His acceptance of Guthrie's superiority as a figure painter (if that is what, in fact, did happen) caused him to give up figure painting from that year and to concentrate solely on landscape painting for the rest of his life.

67
W. Y. Macgregor
A Cottage Garden, Crail
1883
Canvas, 40.5×63.5
Private Collection

68
Alexander Roche
An Interruption
1884
Canvas, 46 × 68.5
Private Collection

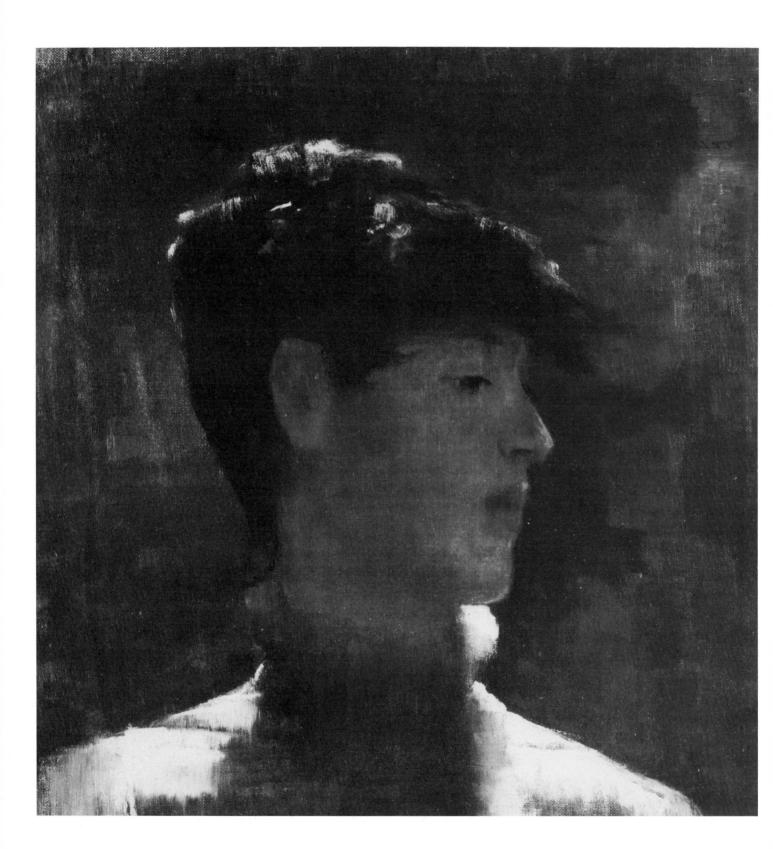

Grez and Cockburnspath

The gradual separation into two distinct groups of the Glasgow men who went to France and those who stayed in Scotland became more distinct in 1883 and the following year. In both countries the Boys began to seek out painting-grounds where they could put into practice the ideas about naturalist painting which were implicit in the work of Bastien-Lepage. Many of his later paintings were produced in his home village of Damvillers, where he knew all the local people who were to appear in his pictures and where he was accepted as a member of the village, not a curiosity to be ogled and sniggered at. Guthrie, in particular, felt a similar need to be accepted by a village community so that he could study its day-to-day activity in order to make truly realist paintings, based on his genuine knowledge of the life of the village. Cockburnspath in Berwickshire became his Damvillers where he rented a house, staying through the winter and not returning to the city (be it Glasgow, Edinburgh or Newcastle), as did Walton, Henry, Melville and Crawhall. In France, Lavery decided to visit Grez-sur-Loing in the summer of 1883. As we have seen, Stott of Oldham and a number of other British, American and Irish painters were already established there and it may be that Dow, Kennedy or Roche had visited the village before Lavery. Whatever the order of events, Lavery was to discover for himself the delights of this Fontainebleau village, returning in 1884 to spend almost all of the year there.

The new work which he had seen in Glasgow in the autumn of 1882 inspired Lavery's own attempts at *plein-air* painting, which almost immediately resulted in success at the Salon in 1883. *Les Deux Pêcheurs* (untraced) was bought by the father of the sculptor Saint-Marceaux[1] but it was not noticed by the critics, although Lavery recalled how well it was received by his fellow artists.[2] It was painted at Nogent-sur-Marne during the early part of 1883, before he left Paris for Grez. Despite the loss of the picture its style and handling may be guessed at by studying two other works dated 1883, which were probably painted after *Les Deux Pêcheurs* but before his departure for Grez. *Portrait of a Woman* (pl.69) was probably an *atelier* set-piece, a *contre-jour* designed to test the young painter's grasp of values.[3] The differences between this painting, the contemporary *A Quiet Day in the Studio* (pl.72), and pictures such as *A Conquest* point to a readiness on Lavery's part to forsake Gluepot subjects and accept the wholly different aims of his Scots and English contemporaries – both those in Scotland and in France. Unfortunately, the lure of easy sales back home of more traditional subjects prevented Lavery from wholeheartedly grasping the nettle of new advances. At the Paisley Art Institute in December 1883, for instance, he was to show a mixture of conventional subject painting (*Ye Faire Beautye and Ye*

69
John Lavery
Portrait of a Woman
1883
Canvas, 45.5 × 45.5
Andrew McIntosh Patrick

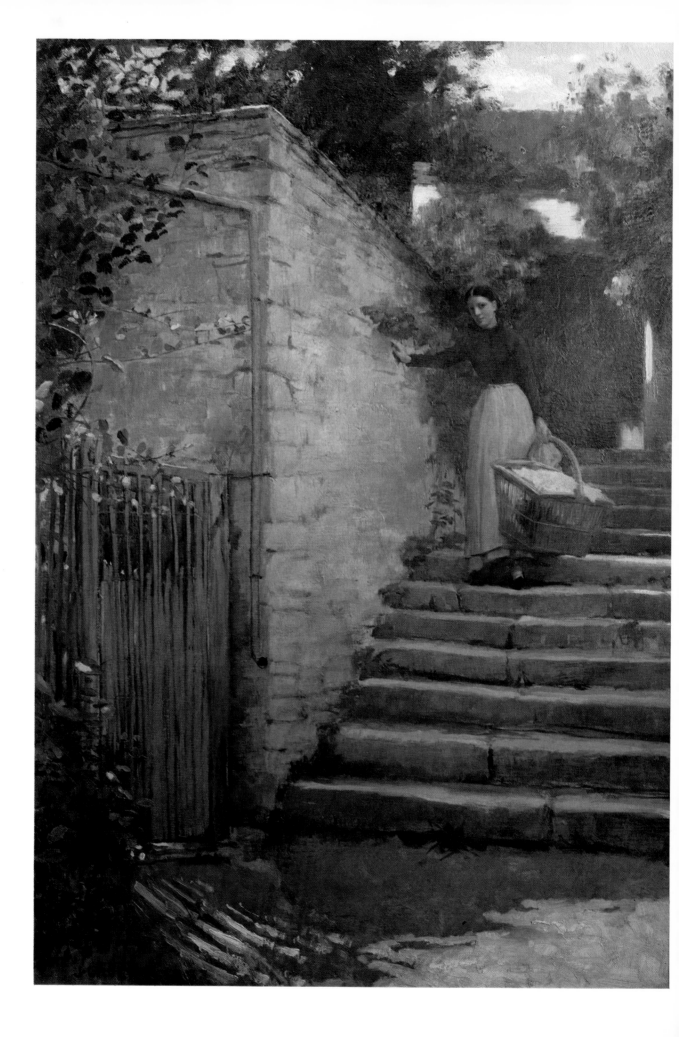

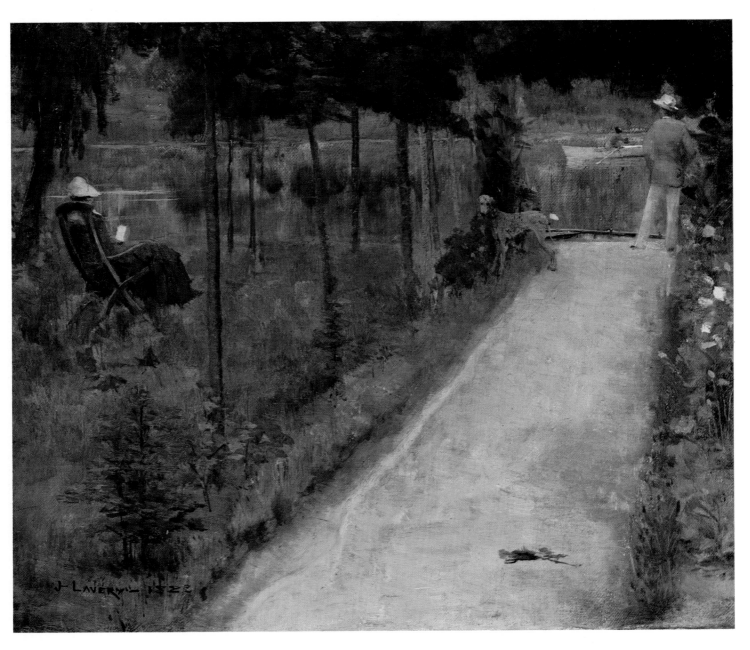

71
John Lavery
A Grey Summer's Day, Grez
1883
Canvas, 19 × 24.3
Andrew McIntosh Patrick

70
John Lavery
La Laveuse
1883
Canvas, 63.5 × 44.5
Private Collection

72
John Lavery
A Quiet Day in the Studio
1883
Canvas, 41.9 × 52.1
Glasgow Art Gallery

Darke One) and the much more innovative (*A Passing Salute*). The latter painting, known also as *The Bridge at Grez*[4] (pl.73, untraced, formerly Coll: Carnegie Institute, Pittsburgh), is based firmly upon the paintings of William Stott in handling, subject and size.

The success of Stott with two paintings of Grez in the Salon, at The Fine Art Society and at the Glasgow Institute must have impressed Lavery for he, above all the other Glasgow artists who were to work there, responded most directly to the attractions of the village and the opportunities it offered to meet painters with similar aims and ideals. *A Passing Salute* has the same long format of Stott's *The Ferry*, the same emphasis on the horizontals of the river and its banks, and the incidental involvement of figures which, as in Stott's painting, are used as compositional foils to the dominant horizontals of the composition. As one of Lavery's most significant works the loss of this painting is particularly unfortunate as illustrations of the picture are not good enough to draw firm

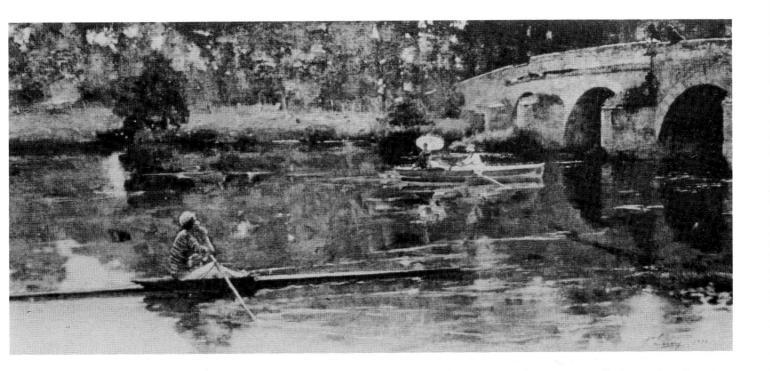

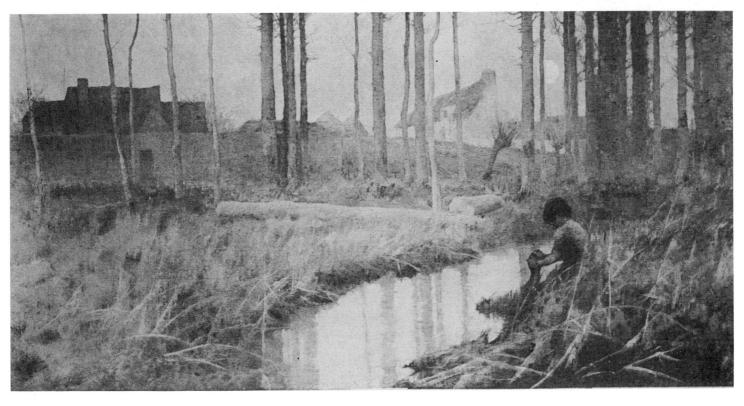

73
John Lavery
A Passing Salute:
The Bridge at Grez
1883
Canvas
Untraced

74
Frank O'Meara
Evening in the Gatinais
1883
Canvas
Untraced

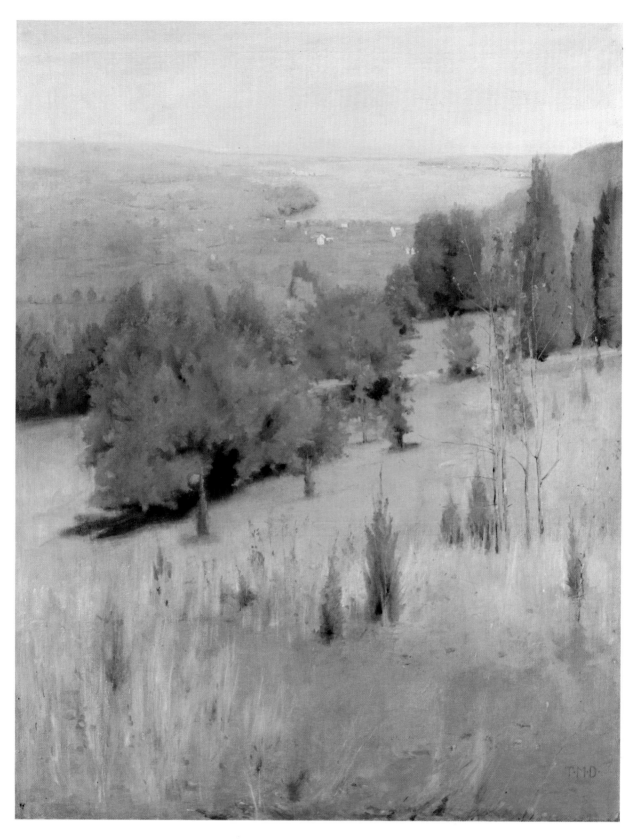

75
Thomas Millie Dow
The Hudson River
1884
Canvas, 123.2 × 97.8
Glasgow Art Gallery

76
William Kennedy
Spring
1884
Canvas, 67.6 × 52
Renfrew District Museum
and Art Gallery, Paisley

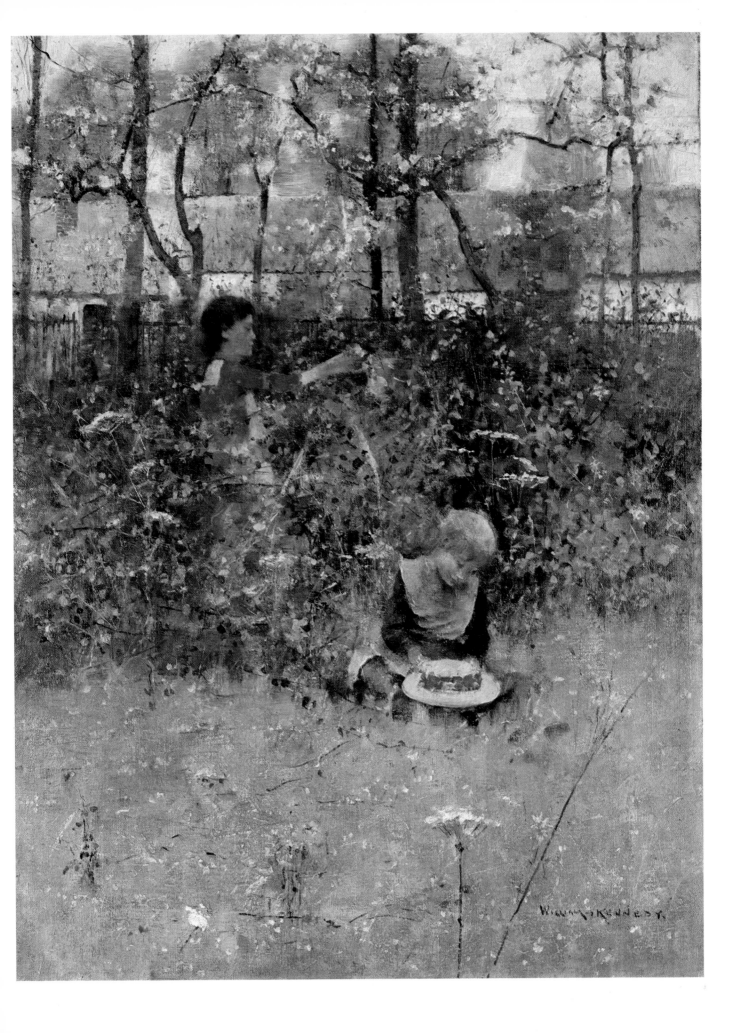

conclusions about its handling. The background in *A Passing Salute* seems to have been painted loosely, which perhaps betrays Lavery's first encounter with the work of Frank O'Meara (1853–88). O'Meara, like Stott, was well established in Grez and Lavery, as a fellow Irishman, would have been drawn towards him. It is possible that on this first visit to Grez he saw O'Meara's *Evening in the Gatinais* (pl.74), which was finished in the summer of 1883 and then sent to the Liverpool Autumn Exhibition and afterwards directly to Glasgow, where it was shown at the Institute at the beginning of 1884.[5] If he failed to see the picture in Grez then Lavery would certainly have seen it at the Institute before he left Glasgow to return to France.[6] It was a painting which all the Boys would have regarded with admiration and one which would have remained available to them in Glasgow, as it was bought by James Gardiner, a Glasgow shipowner and cousin of Guthrie who was to become one of the more reliable patrons of the younger generation of Glasgow painters. Lavery came to know O'Meara quite well and it may have been he who wrote the obituary notice which appeared in *The Scottish Art Review*[7]:

He was quick to recognise the capacities for decorative landscape treatment in the *plein-air* development which has reached such special manifestations in the hands of Puvis de Chavannes and Cazin, and, in another way, by those of Lepage . . . By the many British students who have since gone to France, O'Meara was recognised as one who had early set out in the 'new movement', which is now so wide in its influence – the movement towards a treatment of landscape with special regard to atmospheric planes, the various tones thus searched out lending themselves to a strongly realistic, yet beautifully decorative treatment, in harmony with the modern spirit, which demands scientific truth, yet has not lost sight of Nature's loveliness, which is capable of noble pictorial treatment, without the extreme conventionalism that some schools of painting have regarded as essential . . . Simple, broad and *true* [*Evening in the Gatinais*] happily illustrates the aim of the younger painters of today – to combine realistic fidelity with decorative beauty.

O'Meara's untimely death is especially to be deplored in view of the fact that when art conditions are at such a low ebb in Ireland, one of the few men who might yet have done something to better these conditions has been taken away . . . It was his hope, had he lived, to be enabled, in his native land, to devote himself, in the ripe years of his manhood, to doing something to better the art conditions of his country, and thus help to make it possible for an Irishman to be true to art without the necessity of expatriating himself.

If Lavery, an Ulsterman by birth, was indeed the author of this eulogy his latter remarks may have had some personal significance for he had the previous year spent some time in Larne[8] and would presumably have been aware of the situation in Ireland and conscious of his own position as an expatriate painter.

Fortunately, several other pictures survive which were painted on that first visit to Grez which more clearly indicate the general direction that Lavery's work was to take. The most substantial of these is *La Laveuse* (pl.70), a painting which clearly indicates Lavery's acceptance of *plein-air* principles and which, although the main figure is standing in shadow, also shows his admission of the value of clear sunlight in such paintings. Much of Stott's and O'Meara's work is painted in the cool light of an overcast sky but Lavery may have heard of Guthrie's use of full sunlight in his naturalist painting *To Pastures New*; although he did not often paint in full sun, nor did he altogether ignore its

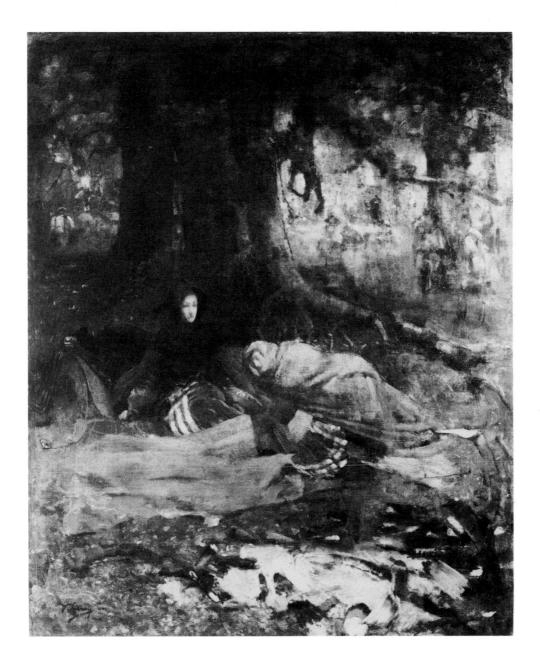

77
John Lavery
Dawn after the Battle of
Langside, 14 May 1568
1883–7
Canvas, 126.8 × 106.5
Private Collection

possibilities. *La Laveuse* is composed of a series of strong diagonals – the line of
the rising steps, the rake of the drainpipe and the top of the wall – painted not in
dull colours but in a harmony of green, blue and soft beiges. Highlighted in these
more equal tones are spots of colour, white and red in the honeysuckle and red in
the roofs of the house behind. This compositional emphasis on diagonals with a
subtle harmony of greens enlivened by touches of vermilion appears again in *A
Grey Summer's Day, Grez* (pl.71). This painting, however, takes as its subject a
pleasant riverside garden, with a lady seated in a comfortable chair, reading,
while an elegantly dressed man stands at the river's edge watching the boaters.

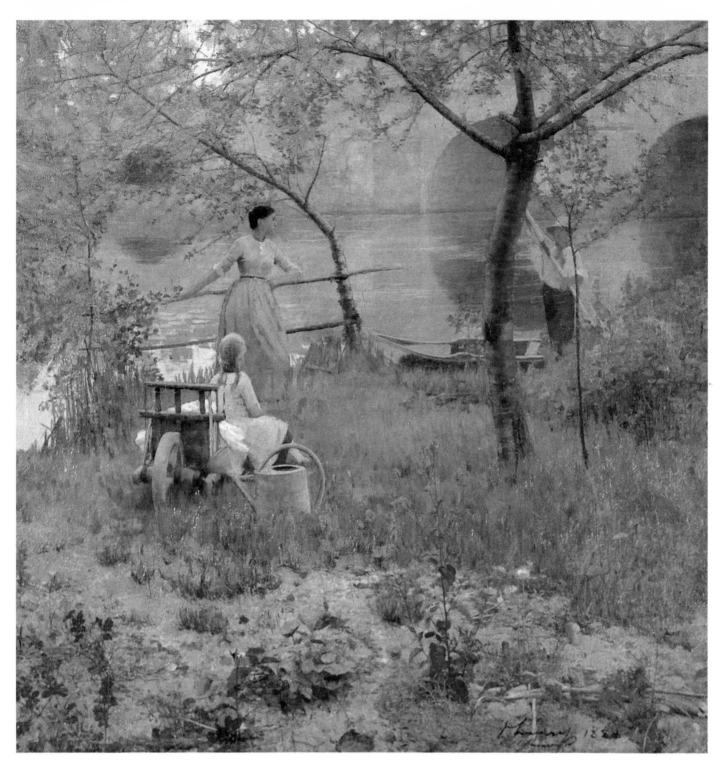

78
John Lavery
On the Loing:
An Afternoon Chat
1884
Canvas, 150.8 × 150.8
Ulster Museum, Belfast

79
James Guthrie
A Hind's Daughter
1883
Canvas, 91.5 × 76.2
National Galleries of
Scotland, Edinburgh

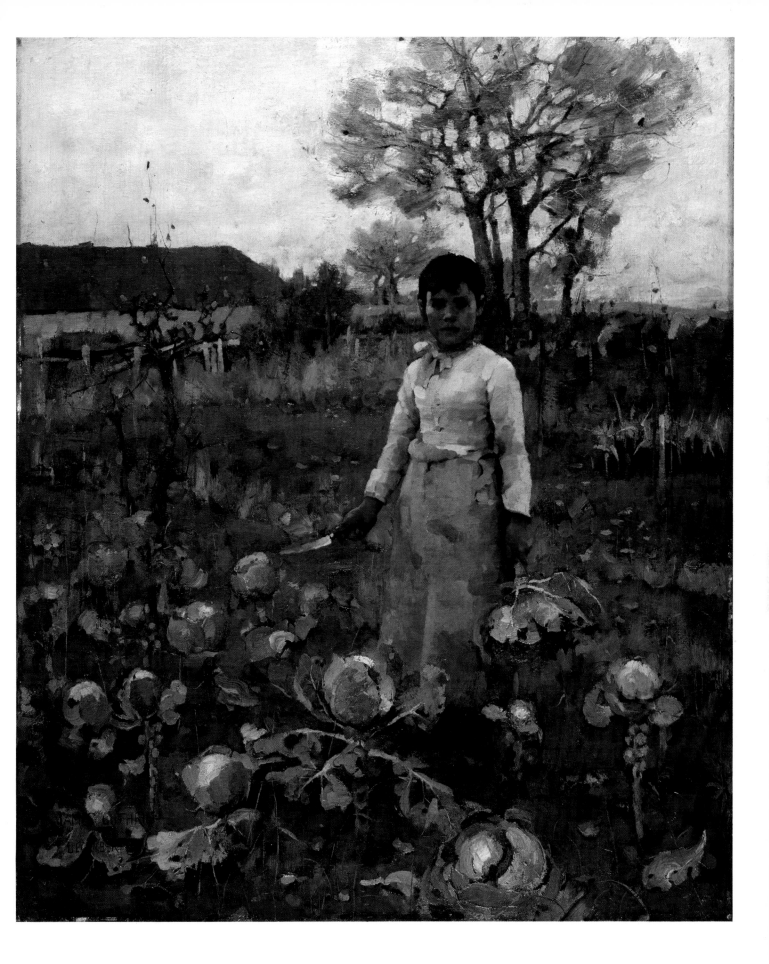

It is the first example of Lavery's middle-class realism, which at Grez co-existed in his painting alongside works such as *La Laveuse* and *Return from Market* which followed the more typical rustic realism of Millet and, in Scotland, of Guthrie.

In 1883 Lavery also began work on a theme which was to occupy him, on and off, for most of the decade. *Dawn after the Battle of Langside, 14 May 1568* (pl.77) could be dismissed on the evidence of its title alone as another of Lavery's costume pieces. Unlike many of his anecdotal works, however, this is a painting serious in its intention of making a valid modern statement about a historical event. The scene Lavery chose to depict was that of Mary, Queen of Scots, sheltering under the yew trees at Rosneath.[9] Lavery was fascinated by the legend of Mary Stewart and was to start work in 1886 on a companion picture intended to be shown at the Glasgow International Exhibition in 1888 – *Night after the Battle of Langside* (untraced). One of the special displays at the Exhibition was devoted to Mary, and Lavery took a great deal of trouble to re-create historical detail in an exact way.[10] Lavery stated that he conceived the *Dawn* as a *plein-air* painting[11] and, as it seems very unlikely that he could have begun it in the first few weeks of 1883 before he returned to France, we can assume that work on the painting began after he had returned to Scotland in the late summer or early autumn of that year. He almost certainly did not complete it in 1883, despite the date which appears alongside his signature.[12] It seems likely that he returned to the picture or reworked some of it about 1886 when he began its companion piece. The tonality and palette are very similar to *A Quiet Day in the Studio* which was painted in Paris in the early part of 1883 but the soft handling of the figures and trees in the background recall his treatment of the foliage in the Grez paintings made earlier that summer. It even more resembles the handling of the middle and distant passages in his major work of 1884 – *On the Loing: An Afternoon Chat* (pl.78).

Surprisingly, *Dawn after the Battle of Langside, 14 May 1568* has very few of the compositional devices which are to be found in almost all of the Lepage-inspired paintings of this date. The most common of these was the use of a tree or tall grasses in the foreground, against which the rest of the composition is ranged to create its spatial depth. It seems possible, however, that the plume of smoke from the embers of the fire was originally much more obvious than it is now; it seems to have been painted in scumbling which is either lost or obscured under a layer of varnish. This column of smoke would have acted as a very subtle pointer to the perspective of the painting, replacing the tangible motifs of Bastien-Lepage and Stott with a more atmospheric indicator of aerial perspective. Another variation on Bastien-Lepage's 'trees' is the broken sapling in the right foreground. It represents the remains of the bushes which would have supplied the wood for the fire and Lavery emphasises its position in the frontal plane of the painting by showing the exposed young wood, ripped apart by a soldier's sword, and painting it in a much lighter tone than the surrounding earth. Again, the tonality of the rest of the painting has perceptibly changed since it was painted and the whiteness of the exposed wood now seems isolated and out of harmony with the rest of the foreground, making it difficult to judge the success of the painter's

intention, which was probably to use the heel of the branch to point towards the sleeping girl who was partly hidden by the plume of smoke. It was a very brave concept, unique in Lavery's work, but, like his persistent use of diagonals in contemporary paintings it shows a degree of individuality and an ability to experiment which his earlier genre painting did not predict.

O'Meara may have had some influence on both the choice of subject, or at least its handling, and the compositional devices which Lavery used. *Towards the Night and Winter* (pl.80) was a painting which O'Meara must have begun in Grez in 1884 while Lavery was in the village. It was later shown in Glasgow at the Institute in 1885, which may have been about the time when Lavery returned to

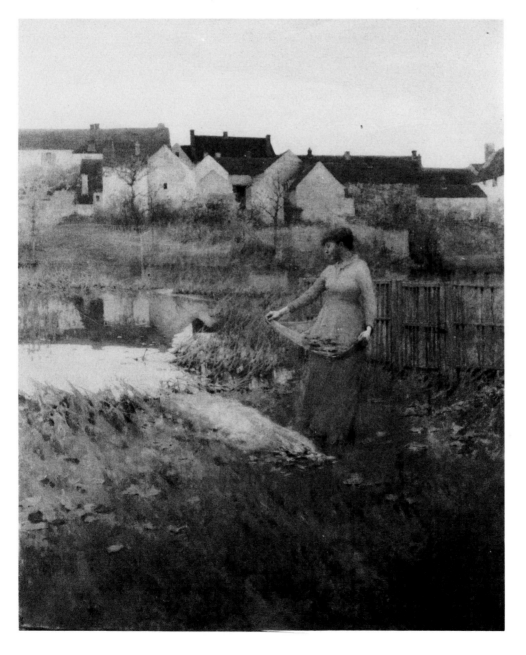

80
Frank O'Meara
Towards the Night and
Winter
1884
Canvas, 147 × 122
Hugh Lane Municipal Art
Gallery, Dublin

81
Arthur Melville
Red Poppies
1885
Canvas, 56 × 76
The Fine Art Society

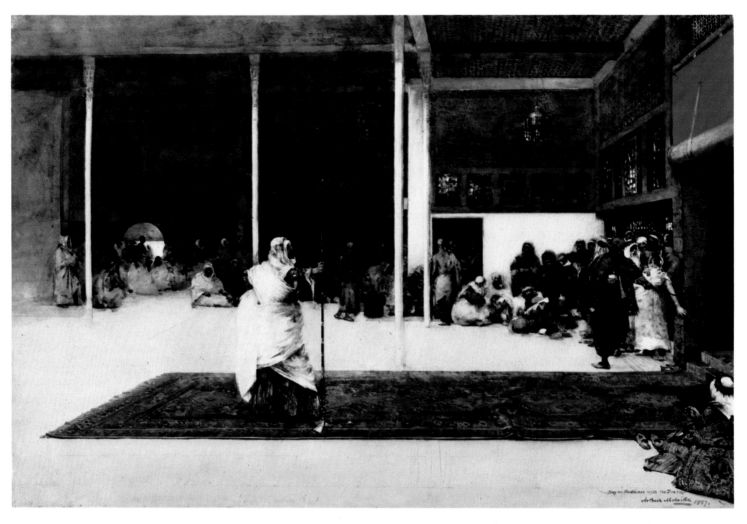

82
Arthur Melville
Awaiting an Audience with
the Pasha
1887
Watercolour, 67 × 100
Mr and Mrs Tim Rice

Dawn after the Battle of Langside, 14 May 1568. Was it at this moment that he introduced or emphasised the fire in the foreground, emulating the burning leaves in O'Meara's painting? O'Meara's admiration of the work of Puvis de Chavannes may also have been of some importance in Lavery's decision to paint an actual historical event. Puvis' allegorical work, treated in a modern manner, was behind several of O'Meara's paintings, for he was one of the few naturalist painters to attempt to convey a particular set of moral values through his pictures. Stott and Millie Dow were later to move away from naturalism towards a more mystical or allegorical subject-matter which was similarly based on the

83
William Stott
Girl in a Meadow
1880
Canvas, 72 × 57.5
Tate Gallery, London

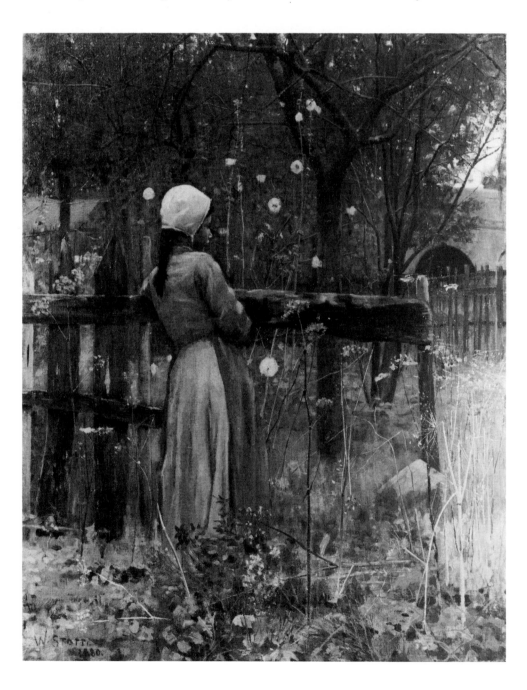

work of Puvis. Lavery did not follow these two artists in their move away from naturalism and his return to historical subjects could just as easily be attributed to the influence of Bastien-Lepage, whose picture of Joan of Arc was painted in his usual *plein-air* manner. The qualities of peaceful contemplation which exist in O'Meara's paintings are, however, much closer to the feeling of Lavery's *Dawn after the Battle of Langside, 14 May 1568*, and even his *Night after the Battle of Langside*, in their attempts to show the desolate plight of Mary after her defeat at Langside when her future seemed hopeless.

Lavery probably left *Dawn after the Battle of Langside, 14 May 1568* behind in Glasgow when he returned to France in 1884. He seems to have spent most of the year in Grez where he painted a series of naturalist pictures which show him reaching the pinnacle that had earlier been occupied by Stott and O'Meara. The most important of these, *On the Loing: An Afternoon Chat* (pl.78; known also as *Under the Cherry Tree*), firmly establishes Lavery's place as a naturalist painter and relates him more closely to the work of Guthrie, Walton and Henry at Cockburnspath. The general inspiration is the work of Bastien-Lepage and Lavery follows the master's usual formula – foreground detail, softer tones and brushwork in the middle distance and background, finer handling of faces and hands and the use of a tree to help integrate the spatial planes of the composition. A much more specific reference, however, can again be made to Stott, whose *Girl in a Meadow* (pl.83) contains most of the features of *On the Loing: An Afternoon Chat*. The pose of the two figures, leaning on the fence, is almost identical; so is the relationship between the horizontals of the fence and verticals of the cherry trees, which are arranged in both paintings against the curves of the arches of the bridge. The detail of the weeds and grasses in the foreground is also an important element in Stott's painting; even the tall stalk of the cowbane in the foreground has been identically placed by Lavery. Acknowledging these influences does not belittle Lavery's achievement as the painting is a polished and satisfying statement, equalled, among the many other artists who worked at Grez, only by Stott and O'Meara.

Two other works dating from 1884 show how completely Lavery had absorbed the naturalist ethos. *The Return from Market* (pl.84) is a daring composition using waterlilies as the foreground and a complicated arrangement of diagonals to give a sense of movement to the punt being steered towards the river bank. In *The Principal Street at Grez* (pl.85) he displays his ability to handle full sunlight in a small canvas which explored a theme common to both the Scottish and 'French' Boys – one of their number at work *en plein air*, usually seen under an umbrella, but here simply seated in the street of the village, hard at work.[13] Lavery painted a number of similar pictures throughout 1883 and 1884; one of them, depicting a lady-artist at work under a white umbrella, was shown at the Glasgow Art Club in 1883 as *A Pupil of Mine* (no 151).

Several of the works produced in Grez are now lost but some of them were exhibited at the Institute in 1885 after Lavery had returned to Glasgow. The critics were not unstinting in their praise of *On the Loing: An Afternoon Chat* but not everything was so well received. The *Glasgow Herald* reviewer was typical[14]:

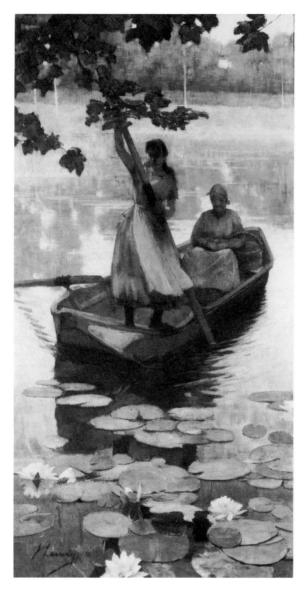

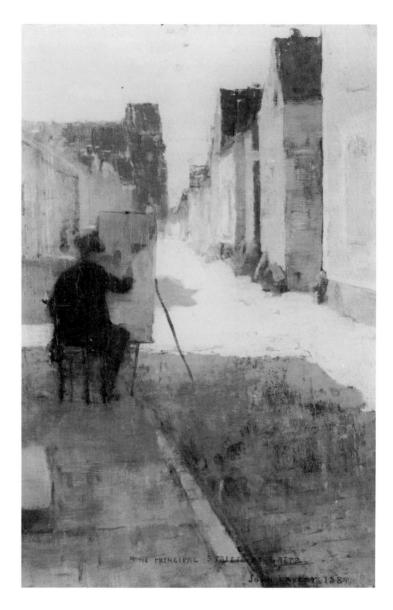

84
John Lavery
The Return from Market
c.1884
Canvas, 118.8 × 62.3
Private Collection

85
John Lavery
The Principal Street at Grez
1884
Canvas, 32.5 × 23
Private Collection

J. Lavery, a Glasgow artist, who alternately surprises and disappoints us, has four pictures in the exhibition in which his ambi-dexterity is again brought into play. Taking them in the order of the catalogue *The Maid was in the Garden hanging out the Clothes* (no 271) is wholly unsatisfactory both in feeling and in execution. A maid who assumes such a lackadaisical air while hanging out clothes may be expected to give a very poor account of them in practical fashion, and the artist who so projects his subject against a white sheet that we cannot tell which is maid and which is linen is too daring by half. *The Model* (no 668) is a slight thing, not improved by its novel basis and *The Bridge at Grez*, while good in colour and not wanting in interest, is sketchy and defective in drawing. The young artist, as we take him to be, standing on the bridge is a glaring instance of careless draughtsmanship. Mr Lavery's success of the year is *On the Loing: An Afternoon Chat* (no 697), a large canvas, in which, except that we find repeated here a curious liking for horizontal lines, there is nothing but excellent work, air, space and light and colour and pleasant feeling all going to make up a picture of undoubted charm. The foreground is filled with a special care, its verdure warmed with touches of yellow and scarlet bloom.

Despite this praise Lavery did not sell *On the Loing*; nor does he seem to have sold *The Maid was in the Garden*, a picture where he seems to have resorted to, in title at least, an element of 'Gluepottery'. The 1885 Glasgow Institute exhibition contained several of the best Glasgow School paintings, including Guthrie's *To Pastures New* and it was the sight of these collected together which Lavery says caused him to decide to stay in Scotland,[15] where he saw distinct advances on the work then being produced at Grez. Lavery was not the only one of the 'French' Boys to return in 1885 – Kennedy and Roche settled in Glasgow too, and Dow had already left and had been to the United States. The new developments in Glasgow were perhaps not the only spur to leaving France: in the summer of 1884 the French had introduced examinations in French language and history for foreign students wishing to enter the Ecole des Beaux-Arts.[16] In common with many other British painters, Lavery left for home rather than face the rigours of a system which was being deliberately engineered to exclude them.

Although William Kennedy's series of Fontainebleau paintings, which he exhibited in his home town of Paisley from 1882, are untraced, several drawings survive in a sketch-book which show that his subject-matter was un-compromisingly realist (pl.86 & 87).[17] Whether these drawings of peasants working in the fields were translated into paintings can only be conjecture but they certainly show the underlying influence of Millet. Kennedy did not exhibit at the Glasgow Institute in 1881 but this comment from the review of the exhibition in the *Art Journal* could equally well have applied to him[18]:

Among the younger artists of Glasgow and the west of Scotland there are several from whom good things may be expected. One word of caution to them: wherever they study let them endeavour to preserve their own individuality. One or two who have evidently been working in Paris seem to aim at obtaining with a rush the effects of Corot and Millet,

86
William Kennedy
Girl with a Basket
1882
Pencil, 19.8 × 11
Glasgow Art Gallery

87
William Kennedy
Pea Pickers,
Auvers-sur-Oise
1882
Pencil, 11 × 19.8
Glasgow Art Gallery

and quite forget the years of patient labour through which the great men passed before their style became fixed. Feeling and breadth are not to be acquired through carelessness and slapdash.

There is by no means as much evidence of Kennedy's stay in France as there is of Lavery's years there. Apart from *Flirtation* one of the earliest French pictures to survive is *Les Derniers Jours des Tuileries*, 1883 (pl.88) which he sent to the Glasgow Institute in 1884. It is a rare subject for this date, a nocturne. It was Whistler who introduced the Boys to the delights of night and twilight subjects, as he did for so many other young painters. Here the lights of the gardens reflect in the wet streets in much the same way as Whistler's fireworks glowed in the night sky and reflected their patterns into the Thames. *Les Derniers Jours des Tuileries* is not, however, the most accomplished of compositions, ranging its activity in a series of vertical planes like stage-sets across the width of the canvas. This certainly helps convey a feeling of movement as the figures and carriages hurry across the square through the hazy light but the sketchiness of the handling denies the greater skills that Kennedy was to display in coming months. That he was a prolific worker, despite the small number of paintings which survive, can be seen from the catalogues of the local exhibitions. At the Paisley Art Institute in 1882 he showed five paintings, including *Les Enfants des Champs* and *French Pastorals*. The following year there were six pictures, including three with specifically French titles: *La rue de Barbizon*, *Clair de Lune*, another nocturne; *French Scene*; and *Une Tête Parisienne*; other subjects were often

88
William Kennedy
Les Derniers Jours
des Tuileries
1883
Canvas, 29 × 54.5
Private Collection

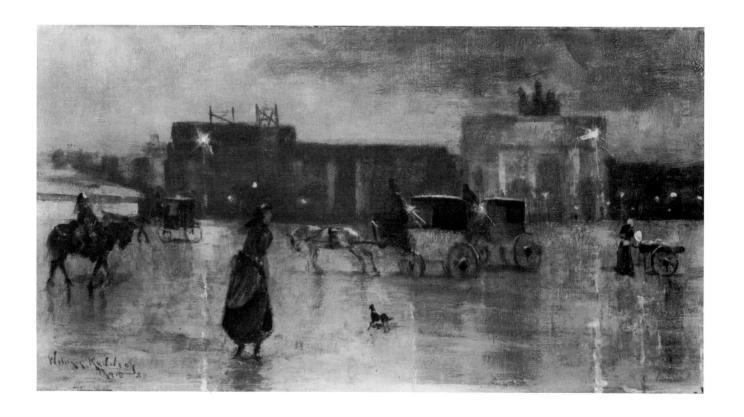

89
*Photograph found in
William Kennedy's
French Sketch-book
Glasgow Art Gallery*

portraits of local businessmen, perhaps arranged through contact with his brother, a master-baker.

In 1884 there were four probable French subjects, two of them patently realist – *Haymaking* (no 27); *Unloading* (no 38); *Farmyard Meal* (no 149); and *L'Église à Cayeux-sur-Mer* (no 161). Included in the collection of sketch-books and similar material at Glasgow Art Gallery is a group of photographs of rural labourers; one of these (pl.89) depicts a family of haymakers who were possibly the subject of the now-lost *Haymaking*. Even if the photograph dates from the next decade when Kennedy was to spend several summers in Berkshire where he painted a number of ruralist pictures, it certainly shows that he was prepared to collect such material, in the same way as Clausen used photographs in his work, which he took to supplement, rather than supplant, the *plein-air* sketches that he also made.[19] Photography suggests itself as a likely aid or source for many of the Boys' realist paintings but there is very little evidence that they made serious use of it. Except in these photographs in Kennedy's possession, in various references to the use of photographs in letters between Henry and Hornel, and as admitted by Lavery before he left Glasgow for France, there exists no clear evidence to confirm any hypothesis about the use or influence of the new medium in the Boys' paintings of the 1880s.

Three paintings clearly indicate the extent of Kennedy's absorption of Bastien-Lepage's naturalist technique by the mid-1880s. These all seem to have been painted at Grez where he worked alongside Lavery in 1884. *A French Grandmother* (pl.90) is perhaps a study for a much larger painting, in the same way that Guthrie was to make studies in both oil and pencil of the heads of the children in *Schoolmates* (see p.130). The strong colour and high key suggest a

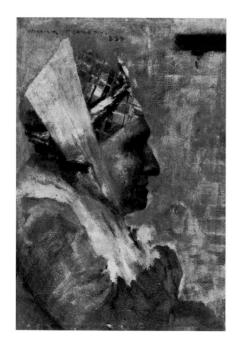

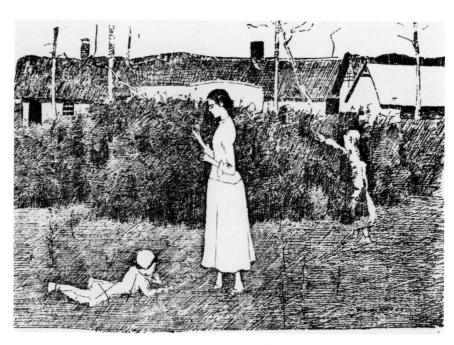

90
William Kennedy
A French Grandmother
1884
Panel, 24.2 × 16.9
Hunterian Art Gallery,
Glasgow

91
William Kennedy
Mademoiselle Cunégonde
(line illustration from
Glasgow Institute catalogue)
1884
Canvas
Untraced

knowledge of Guthrie's Crowland paintings as well as the more even-toned paintings of the established Grez painters such as Stott and O'Meara. The two other works are on a larger scale but unfortunately only one of them survives to give us an indication of the full extent of his acceptance of naturalist principles.

The village of Grez and its people are the subject of both paintings – *Mademoiselle Cunégonde* (pl.91) and *Spring* (pl.76). Despite the loss of the first painting, a drawing of it included in the *Illustrated Notes* of the 1885 Institute exhibition shows it to have a number of similarities with *Spring*, and both pictures owe much to the emphasis on compositional horizontals that was typical of Stott's Grez paintings. In both pictures the canvas is divided horizontally into a series of bands – grass, hedge, roofs and sky – against which the figures of the children and young women are arrranged. This slightly stagy format is a rather more sophisticated version of the composition of *Les Derniers Jours des Tuileries*, where movement is frozen but where colour plays a much more important role. *Spring* is certainly not a monochromatic *plein-air* picture, having an overall high key and touches of bright colour similar to those in Lavery's *A Grey Summer's Day, Grez*. Lavery's interpretation of Bastien-Lepage is also evident in Kennedy's painting, particularly in the very detailed foreground of *Spring* which is painted rather scratchily in the manner of *On the Loing: An Afternoon Chat*. In these French paintings by Kennedy and Lavery can be seen the common threads of style and content that had been present in the work produced at Crowland by Guthrie and Crawhall. It seems reasonable to expect also that the work which Roche and Dow produced at Grez would be similar in its selection of village life as its subject and an assimilation of the French handling of Bastien-Lepage and Stott. Unfortunately, none of their paintings which can be definitely dated to

their months in France has been traced but from some of the work which Dow produced in the United States in 1883–4 it is possible to assess the impact of Grez on his painting.

Dow went to the United States to visit his friend Abbott Thayer whom he had met in France in 1879. Thayer left Europe that year and he and Dow began a correspondence which was to continue for some years. Although we have few identifiably French pictures to assess Dow's development as a naturalist painter we can assume a ready acceptance of the methods and approach of William Stott who became a close friend of Dow. In *The Hudson River* (pl.75), we can see some of those principles applied to a much more colourful scene than Dow would have seen at Grez – the vivid autumn colours of the north-east of America. It is a painting almost unique in the Glasgow School in its spatial depth, a distant view over the valley to the great river with trees and houses blending into each other in a subtle harmony of russets, soft greens and purples. Only Paterson was to approach the scale of this panorama in some of his paintings of Moniaive and its surrounding hills and burns, but even his paintings of the 1880s have a degree of focal intensity which was more typical of the general attitude of the Boys to landscape painting. The effect of soft focus in parts of *The Hudson River* may seem at odds with the Bastien-Lepage-inspired naturalism that one expects of these Grez painters but there are elements in the composition which betray the artist's training. The bare saplings, for instance, painted in some detail and silhouetted against the more distant areas of the composition, help define the recession of the landscape in a way which recalls strict naturalist practice. Most of the *plein-air* paintings encountered so far have not attempted to convey a view into the far distance; the recession in the compositions tends to be comparatively shallow and is rendered in a series of flat planes, one behind another. Because of the distances involved in the scene which Dow chose to paint, and the fact that the landscape falls away from the viewer instead of rising up in front of him, Dow was forced to develop an alternative method of conveying the spatial relationships between the different areas of the canvas. Although the clarity of the light indicates that this is a *plein-air* painting, there is hardly any of that clear detail which has become so commonly associated with those pictures. Only the saplings have any typical detail in their handling and Dow achieves his naturalist effect purely by skilful handling of tones and colour to create an aerial perspective which leads the viewer back into the distance with the thinly painted river not differentiated at all in handling from the surrounding fields or the clear sky which it meets at the horizon. Unlike most of the Boys, Dow has taken a conventional landscape and painted it in a naturalist manner, rather than select a tighter, more blinkered aspect. Although he does not seem to have worked in pure landscape again on the scale of this painting, his later pictures show a similar break with the usual iconography of Glasgow School painting.

At the Glasgow Institute in 1885 Dow showed *The Hudson River* alongside *Twilight at Rye* and some paintings of flowers. The following year he exhibited *Spring*[20] (pl.92), which attracted more attention from the critics than had *The Hudson River*. This painting appears to be the first in a series of allegorical subjects to which Dow was to devote most of the rest of his life. It shows quite

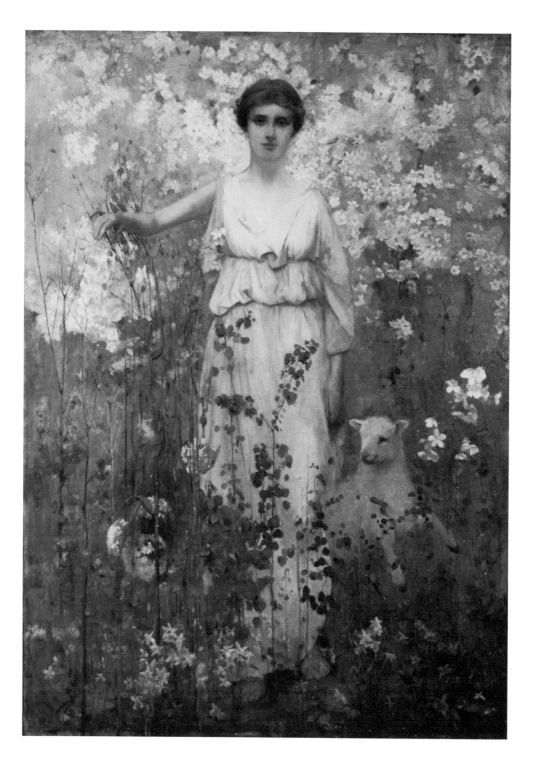

92
Thomas Millie Dow
Spring
1885
Canvas, 135 × 99
Ewan Mundy Fine Art

clearly Dow's commitment to the naturalist cause. Its pale tonality and
foreground detail in the grasses and flowers is clearly related to Lavery's *On the
Loing: An Afternoon Chat* rather than to Guthrie's paintings which are usually in
a higher key. The critics, who were quick to point out the deficiencies in drawing
of the girl's right arm, made no comment on the use of blatantly naturalist

handling in such an allegorical subject. Dow could not even cite Bastien-Lepage as inspiration, for the symbolism of *Jeanne d'Arc écoutant les Voix* is secondary to the choice of a supposedly factual occurrence which could therefore justifiably be painted in a realist manner. Similarly, in his paintings of Mary Stewart, Lavery chose actual episodes from history and then painted them with a realist technique. Dow's decision to paint traditional subjects having no factual basis in a clearly realist manner was a radical step. It links him to the Newlyn painters who continued to work in the conventions of Victorian genre painting while adopting a naturalist palette and technique in an attempt to make their work seem more modern and advanced. Their lack of faith in the pure naturalist creed was not shared by Dow, however, who genuinely wished to widen the content of naturalism, an aim in which he was supported by his friend, William Stott. Stott's nymphs and Venuses found their Celtic counterparts in Dow's kelpies and sirens and both painters began a gradual drift away from naturalism in search of a less-detailed manner more in keeping with the growing symbolist content of their work. As his work grew away from that of the rest of the Boys, Dow found that he no longer needed to remain in close contact with them and he became one of the first to leave Glasgow (and Scotland) and took up semi-permanent residence in St Ives.

93
Alexander Roche
The Dominie's Favourites
(line illustration from
Glasgow Institute catalogue)
1884
Canvas
Untraced

 Alexander Roche's early career, much of which was spent in France, is relatively obscure. In 1884, however, he showed a French subject, *Ma Petite Soeur*, at the Glasgow Institute. This was probably painted at Grez which he had visited with Lavery but he returned to Scotland in 1884 to spend some time, possibly the whole of the summer, in Dumfriesshire. The result of this was a very large picture which he sent to the Institute in 1885, *The Dominie's Favourites* (pl.93; now untraced; known only from a line illustration in the exhibition catalogue). It was the largest painting in the exhibition, over 5 ft × 9 ft and clearly identified Roche as a member of the growing group of Glasgow artists who were seen by the critics as painting in an overtly French, that is, naturalist, manner:

A. Roche's *The Dominie's Favourites* (no 591) – girls sitting on a bench outside the schoolroom conning their lessons – is also too slight a subject for so large a canvas. Moreover, although the arrangement of the girls in line, with photographic coincidence of heads and knees, finds a precedent even in the high idealism of Burne-Jones (as in *The Hours*), we cannot help thinking that it is inartistic and lacks the grace of true grouping.[21]

The critic of *The Bailie* was more impressed:

One of the most striking if not, indeed, one of the most audacious pictures painted during the recent season in Glasgow is *The Dominie's Favourites* of A. Roche. This is a life-sized group of young girls, seated on a bench placed against the bare rough wall of a Dumfriesshire cottage. The wall is dead white and is represented in brilliant sunshine.[22]

The references to brilliant sunshine suggest that another of the French-trained Glaswegians was more attracted by the work of Guthrie on his return from Grez than by the *plein-air* paintings of his French *confrères*. One painting from 1884 which has survived confirms that Roche was attracted by the challenge of painting in full sunlight. *An Interruption* (pl.68), was painted

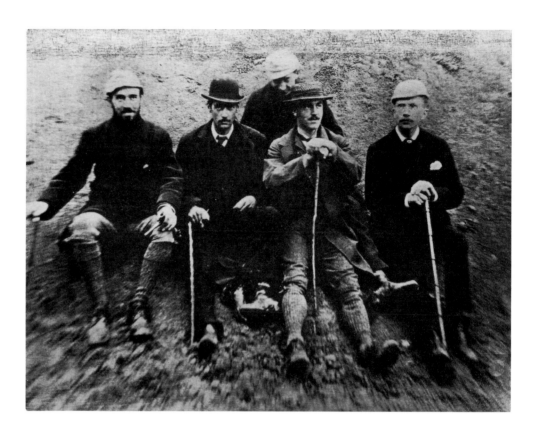

94
The Boys at Cockburnspath,
1883(l-r): E. A. Walton,
Crawhall, George Walton,
Guthrie, Whitelaw Hamilton

probably in Scotland, judging by the forms of the buildings in the background, and its strong colours – greens, whites and vermilions – give some idea of the likely appearance of *The Dominie's Favourites,* albeit on a smaller scale. Too little is known of Roche's work of the mid-1880s, however, to make definite assumptions about his methods of painting. Certainly, he seems in some of his work of the next few years to be aware of the more decorative elements of Henry's painting and of Guthrie's portrait techniques, an area in which Roche was increasingly to apply himself. Like Kennedy, it appears that he was as prepared to accept the different approach to naturalism that Cockburnspath gave to Guthrie and his circle as he had been to accept the new developments in realist painting that he had first encountered in Paris at the beginning of the decade.

In the early summer of 1883, according to Caw, Guthrie and Walton set out first of all for Fife, but not finding anywhere to their liking they moved south to Cockburnspath.[23] It was not an area known as an artists' colony but Guthrie and Walton were not actually the first Glasgow painters to discover it. In 1882 James A. Aitken had spent the summer there, bringing back with him 'a sketch-book filled with drawings of bold headlands . . . and sleepy, old-world fishing villages'.[24] Aitken was no friend of the Boys; he was a prolific painter of landscapes in the Gluepot tradition and a senior member of the Art Club who was active in excluding the 'wilder' elements of the new School for as long as possible. With or, more likely, without his encouragement Guthrie and Walton set off for

Cockburnspath at the end of May.[25] While Guthrie remained there with his
mother throughout the winter, Walton returned home to Glasgow in October.[26]
During the summer, or in 1884, they were joined by Henry, J. Whitelaw
Hamilton, T. Corsan Morton, Crawhall, Arthur Melville and probably Nairn
(pl.94). Even Macgregor paid a visit to nearby Dunbar in 1884[27]; he was
accompanied by Henry who certainly went on to Cockburnspath and perhaps
Macgregor went with him. Paterson, as one of the more senior of the group of
Boys who remained in Scotland, is alone in that he does not seem to have made a
call on the tiny east coast village.

Guthrie found lodgings, together with Walton and Crawhall, with a Mrs
Robertson, near the inn, but early in 1884 he eventually moved with his mother
into the factor's house at Dunglass while the rest of the group, when they
returned for the summer, found temporary lodgings in the village. It seems that
there were times when hardly a house there did not have its resident artist; that
this was not an entirely unknown phenomenon in other Scottish villages can be
seen from a cartoon published in *Quiz* (pl.95).[28] Caw's description of the village
that so appealed to the Boys is worth repeating for it has changed so much in the
last hundred years:

Cockburnspath, called Co'path locally, is situated some seven or eight miles from
Dunbar, in the narrowing belt of cultivated country between the higher pastoral uplands
of the Lammermoors and the bold rocky coast along the North Sea. Wind-swept and

A NEW ORGAN OF CRITICISM.

Jimms.—"Ou, A DINNA KEN WHITHER THEY'RE ILE OR WATTER PENTIN'S. TAMMAS IS A HAND AT THAE THINGS,
FOR 'E HAD A PENTER BODY STOPPIN' WI' 'IM LAST SIMMER."
Tammas (smelling the work of art).—"THIS IS AN ILE PENTIN', ONYWAY!"

95
Cartoon by 'Twym'
'A New Organ of Criticism'
1882

somewhat austere in aspect, but with gently swelling contours running seaward like great rolling waves, and with the woodlands crowding into the deep intersecting deans for shelter, though here and there mustering in groups in the hollows or venturing in thin lines of sentinel trees along the hedgerows, the surrounding landscape has spaciousness and dignity and a character quite its own. The post road from Edinburgh to London, after running parallel with the shore from Dunbar, skirts Bilsdean, with its cottages and tinkling waterfall, and then a mile or more after crossing the high bridge over the romantic wooded Dean at Dunglass, swings inland and uphill. Here on a slope, with a white-washed verandahed Inn on the highway, the village lies. Approached by a few yards of side road, with a clump of ash and plane trees at the entrance, the red-tiled and occasionally blue-slated cottages cluster round an oblong square, with an old Market Cross towards the lower end. Pends lead to other cottages in gardens behind, where, on a green knowe to the east, a Pre-Reformation church with squat and narrow round tower stands above a hollow in which a bush-fringed pond twinkles. As a rule quiet pervades the square, for it is off the main road and there are few visitors; but for a few summers in the early eighties nearly every cottage had an artist lodger and easels were to be seen pitched in the gardens or the square, in the fields close by, or near the little harbour in the rocks below the cluster of white cottages at the Cove, perhaps half a mile away.[29]

Cockburnspath obviously offered Guthrie the opportunity to immerse himself in the life of a village and to become an accepted part of it. That his mother left Helensburgh to live with him there showed how serious they both were in developing his career as a painter, no matter what the inconveniences and disadvantages of giving up their life in town for this relatively primitive Scottish village. Guthrie worked hard there, seeking out true realist subjects in the surrounding countryside, on the farms and in the village itself. In three years he established himself – in my view – as the ideological as well as the artistic leader of the Boys, and produced the majority of his important paintings there. At the same time, he encouraged a number of the younger artists by his example, several of whom came to maturity while painting at his side. The most obvious example is George Henry, who made substantial advances in the summers spent at Cockburnspath, which freed him from the constraints of his art school training and pointed the way to his own individual style developed later at Kirkcudbright. Crawhall and Walton both progressed alongside Guthrie, and all three were to learn much from the example of Arthur Melville who also benefited from the company of like-minded young men of the kind who were in short supply in his native Edinburgh.

The most striking change in Guthrie's first Cockburnspath paintings is the move away from painting in full sunlight. Only in a very freely handled sketch, *Hard at it* (pl.98), is there the same clear sunny sky that is such a crucial element in the success of *To Pastures New*. If nothing else, however, the picture confirms that Guthrie still worked *en plein air* even if the majority of his Cockburnspath pictures were to be painted under a sunless sky (pl.97). Compared with *The Cottar's Garden* (see p.47), painted in 1881 at Brig o' Turk, Guthrie now seems a master of the fluid handling of paint which came so naturally to Melville and Lavery. The strong brushstrokes and clear, bright colours immediately convey the heat and coastal breezes that have induced the artist to set up his umbrella on the clifftops. The umbrella was used primarily to maintain an even tone of light on the canvas but it undoubtedly also kept the painter cool; perhaps if he took off

96
James Guthrie
'When Autumn Winds so
softly Breathe'
c.1884–5
Ink, 15.9 × 9.8
Glasgow Art Gallery

97
James Guthrie
'Fine Weather
for my 50 × 30'
c.1883–4
Ink, 14.2 × 12.7
National Galleries of
Scotland, Edinburgh

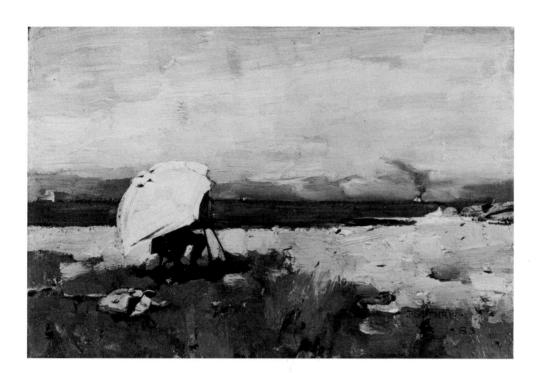

98
*James Guthrie
Hard at it
1883
Canvas, 31.1×46
Glasgow Art Gallery*

99
*James Guthrie,
E. A. Walton and
Joseph Crawhall
'Heads bodies and legs'
c.1883–4
Pencil, 17.5×11.6
National Galleries of
Scotland, Edinburgh*

his formal city jacket he would be more comfortable but it seems that a certain standard of appearance had to be kept up as one rarely sees more casual dress either in other paintings of the artists at work (see p.62) or even in the sketches and cartoons they drew in their private sketch-books or letters (pl.96). 'Heads, bodies and legs' was a favourite pastime with Guthrie, Walton and Crawhall and the hand of each of them can be seen in the drawing of the artist at his easel (pl.99). Whatever their mode of dress, all of these drawings confirm the by now standard practice of working in the open air, even if some work was done later in the studio in the evening, or even much later when the painters returned to Glasgow for the winters.

In his first few months in Berwickshire Guthrie made a number of sketches, such as *Hard at it*, which he may have intended to work up into large paintings. One of these is *Potato Pickers, Thorntonloch* (pl.100), a freely handled study of a group of farm labourers under a cool sky. Not since *A Funeral Service in the Highlands* had Guthrie attempted such an elaborate composition involving a group of figures. As in the earlier painting the figures are strung out across the canvas, and although there is a greater sense of movement within the composition it does not seem to be a real advance. Caw[30] records a large and unfinished painting, *Pitting Potatoes* (untraced), which he dates to 1884–5 and which may have been based on this small study. These more elaborate figure compositions gave Guthrie a great deal of trouble in later months at Cockburnspath and almost caused him to turn away from painting altogether. Certainly, the work of 1883 is mostly preparatory in nature and there are few fully developed ideas which have survived. *Field Work in the Lothians* (pl.101) is probably another of these preparatory studies. It concentrates on a single figure,

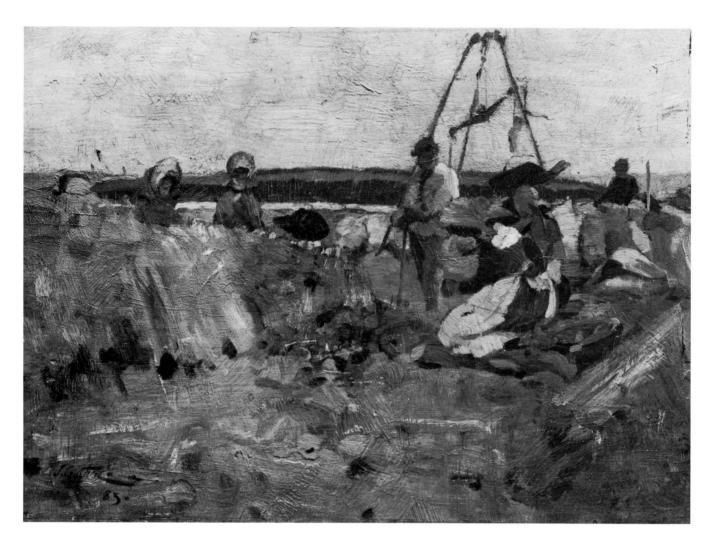

100
*James Guthrie
Potato Pickers,
Thorntonloch
1883
Canvas, 24×32
Private Collection*

again seen in clear light, but not in full sun. Guthrie has adopted a rather unusual viewpoint and the viewer looks down on the girl who is silhouetted against the golden tones of the cornfield, which is separated from the purplish-blue sky by a black hedge forming the horizon. In his most successful painting of 1883 Guthrie concentrated on a single figure, a young girl seen in her father's garden, in a work which builds on the sympathetic rendering of the girl in *To Pastures New* but adds to it a degree of realism not yet encountered in his painting.

In a return to the Bastien-Lepage-inspired concept of single-figure compositions Guthrie painted a study of one of the village children: *A Hind's Daughter* (pl.79). The 'hind' was a skilled farm-worker, probably in charge of the teams of great horses which provided much of the power on these small farms. He was provided with a cottage by his employer and in this painting Guthrie has shown his daughter cutting cabbages. The subject itself, or at least the setting of the painting – in a cabbage patch – had become a classic image in Scottish realist painting and, to a lesser extent, in a form of populist literature which was later dubbed sweepingly the 'kailyard school'. Melville had had one of his first popular

successes with a painting of a cabbage garden (pl.102); Guthrie had painted a similar village garden at Brig o' Turk in 1881 (see p.47); Harry Spence, who was on the fringe of the group, painted a cabbage patch in 1882 (pl.103); Robert McGregor and W. Y. Macgregor both painted cabbage gardens (see p.78); Henry was to paint perhaps the same Cockburnspath garden in 1885 (see p.153); and in later years the subject appeared several times in Hornel's early Kirkcudbright pictures. None of these paintings, however, has the power and presence of the simple stance and gaze of the hind's daughter. She is shown having just straightened up from cutting the cabbage stalk and is looking openly at the artist (and the viewer) as if questioning his interest in her trivial task. John Robertson Reid had painted a similar subject in 1878 which Guthrie might have known, *The*

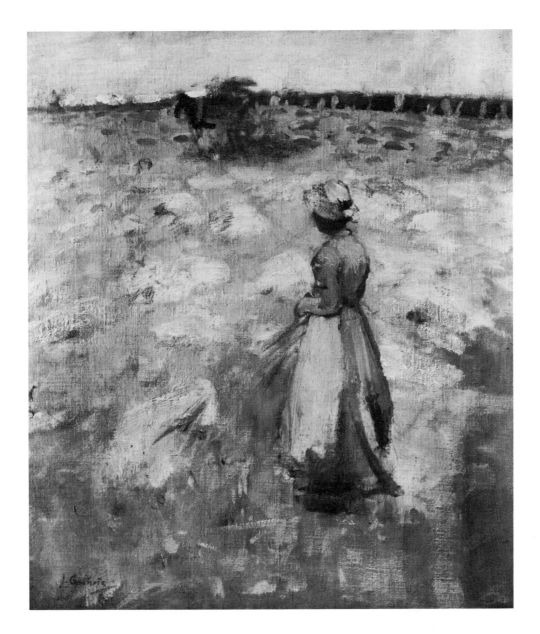

101
James Guthrie
Field Work in the Lothians
1883
Canvas, 67.5 × 59.5
Private Collection

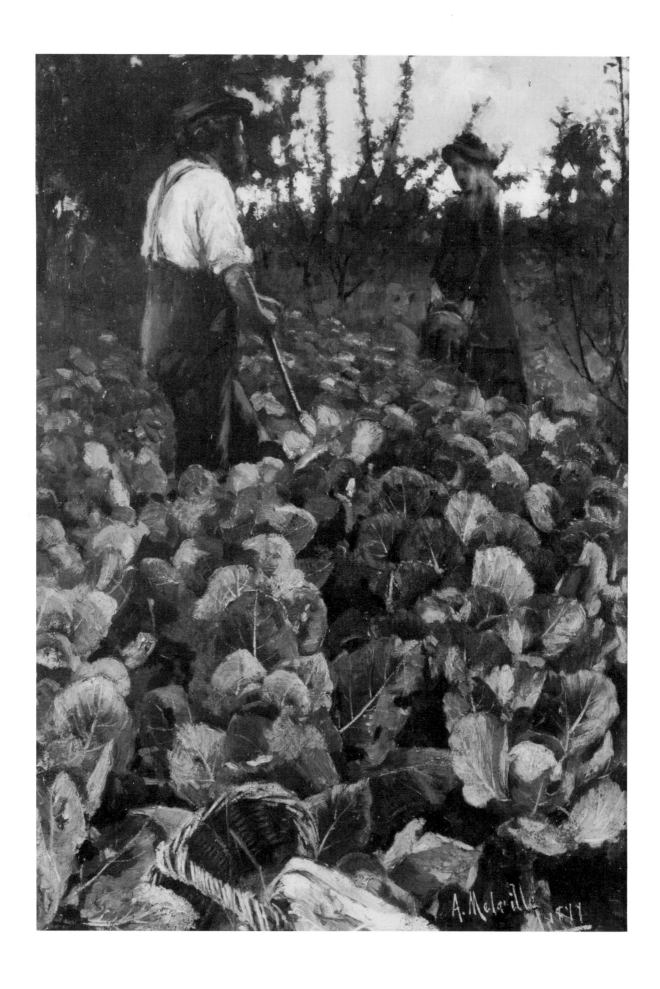

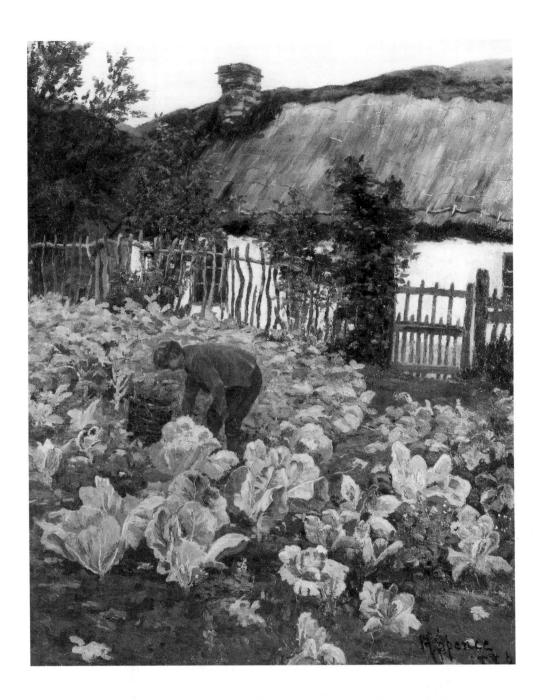

103
Harry Spence
In the Cabbage Patch
1882
Canvas, 61 × 51
Private Collection

Old Gardener (pl.104). This shows Reid in a surprisingly naturalistic mood, adopting a pose for the old man which is broadly similar to that used by Guthrie in his later picture. In fact, this is an altogether untypical picture for Reid but one which would have interested Lavery and Kennedy as well had they known it: his handling of the foreground and the foliage behind the gardener bears considerable resemblance to similar passages in later Grez paintings made by the Glasgow men in the mid-1880s (see pp.82 & 87).

Broadly handled, *A Hind's Daughter* differs clearly from Guthrie's *To Pastures New* in its tonality and the presentation of the subject. The Crowland painting

102
Arthur Melville
A Cabbage Garden
1877
Canvas, 45 × 30.5
Andrew McIntosh Patrick

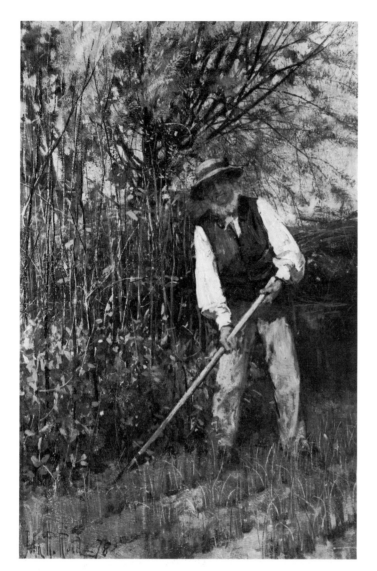

104
John Robertson Reid
The Old Gardener
1878
Canvas, 46 × 30.5
Private Collection

105
Arthur Melville
Paysanne à Grez
1880
Canvas, 52 × 30.5
Private Collection

has a brilliant sunny sky lighting the geese and the figure of the girl, with strong shadows creating a pictorial *chiaroscuro*, and the arrangement of both geese and girl along the frontal plane of the painting is novel and not so obviously related to Bastien-Lepage's compositions as is *A Hind's Daughter*. The clear, bright light of the latter is achieved without showing the sun or a blue sky (which is perhaps hinted at through the flash of blue on the blade of the knife) but there are no shadows, no attempt to depict perspective through modelling but a more conscious reliance on the creation of depth through the handling and the distinct changes of brushstroke. Other French elements in the composition are the placing of the figure in a silhouette against the garden, with a high horizon at the height of the girl's head. This creates a steeply foreshortened perspective, emphasised by the relative detail of the foreground cabbages compared with the more loosely handled hedge and soil behind the girl. The horizon cuts through the girl's head, isolating her dark hair against the paler sky; and the vertical

movement created by her body is continued by the trees which rise behind her shoulder, contrasting with the more horizontal emphasis of the line of the hedge, fence and roof which all help to create the horizon itself.

Despite the obvious references to Bastien-Lepage, Guthrie seems to have arrived at a style which is a personal synthesis of a number of disparate factors which were then attracting the attention of several groups of painters in Britain. Along with George Clausen, Guthrie was able to formulate his own reaction to French realist and naturalist painting and to create something which was peculiarly his own. Unfortunately, he was unable to sustain it beyond half a dozen or so pictures of the quality and scale of *A Hind's Daughter* before he succumbed to the problems of large-scale composition which had bedevilled his earlier costume paintings and which had also been present to some degree at Crowland in 1882.

In earlier winters Guthrie had had the companionship of Walton in Helensburgh to sustain him while working on his large Academy pictures. In the winter of 1882–3, while Guthrie remained at Cockburnspath his friends all returned to the west. Fortunately, not just for Guthrie but for the new Glasgow

106
Arthur Melville
Seated Peasant Girl, Grez
1879
Watercolour, 56 × 38
The Fine Art Society

107
Arthur Melville
The Turkish Bath, Paris
1881
Watercolour, 76 × 56
Private Collection

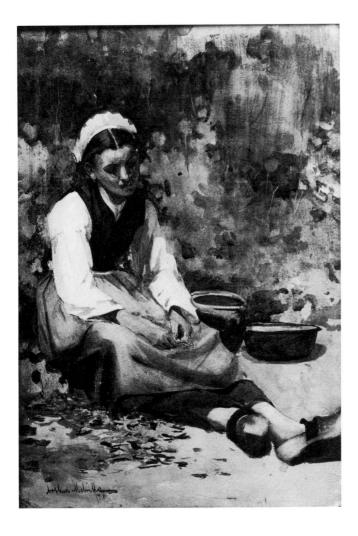

movement as a whole, a new painting companion appeared to give him support throughout the winter. Arthur Melville had returned to Scotland in 1882, settling in Edinburgh where he began to make his reputation as both a figure painter with a series of portrait commissions and as a painter of oriental subjects, based on the hundreds of sketches he had made on his visits to Egypt and the Middle East in 1880–2. Melville had already been attracted to Grez and Barbizon (pl.105 & 106) in the late 1870s and was fully aware of the latest developments in French painting. His understanding and acceptance of the importance of tonal values in modern painting was modified by his reaction to the intense light and colour he encountered in Africa. Back home in his studio he translated his impressions of the heat and light of Egypt and Arabia into a series of powerful oils and watercolours. In these he was to emphasise the dramatic contrast between the strong light and the cool shade that is created in Arabic architecture as a defence against the extremes of heat. His work took on an almost Islamic texture in its feeling for pattern which he emphasised by his choice of palette and his fluid technique. A sense of the drama of Arab life was combined with his already evident interest in dramatic interiors, first seen in *The Turkish Bath* (pl.107), painted in Paris in 1881. *An Arab Interior*[31] (1883) contrasts the cool and dark interior of a house with the bright light which filters through the screened windows to highlight a foreground table.

The drama and ritual courtesy of everyday life fascinated him and his reaction to it is seen at its best in *Awaiting an Audience with the Pasha* (pl.82). Despite its date of 1887, this watercolour is almost certainly based on a work of the same title which Melville exhibited at the Dudley Gallery in 1883. In 1882 Melville had spent several weeks as a guest of a Pasha near Mosul, in what is now Iraq. He had been attacked and robbed in the desert and the local Pasha had offered him hospitality until he recovered. Scenes as this would have been daily occurrences in the palace and Melville must have obtained enough material for many such pictures during his stay. His response to the stylised patterns of Arabian artefacts – carpets and shutters – combined with his skilful handling of a grand interior make this one of his masterpieces. Melville has created a tension in the composition which probably reflects the formality, and perhaps uncertainty, of the occasion; it is achieved through a skilful contrasting of strongly patterned elements such as the large rug in the foreground with the open spaces of the courtyard, which in turn offer a brightly lit counterpoint to the shadowy recesses of the hall in the background. Overlaid on the whole composition is the simple trabeated structure of the palace, the straight lines of which echo the plain rectangle of the rug in a syncopation of rhythms and pictorial pattern. This emphasis on pattern within the composition, not just in pictorial elements such as rugs and wall-hangings, but in the overall effect of the painting was to have a specific and keen attraction for some of the younger members of the Glasgow School, especially George Henry, who first came to know Melville at Cockburnspath before he became a regular visitor to their Glasgow studios.

Melville, too, responded to Guthrie and the latter's acceptance of Bastien-Lepage in his search for a new and valid subject-matter. His *An Egyptian Sower* (pl.108), which was exhibited at the Glasgow Institute in 1883, shows that he had

108
Arthur Melville
An Egyptian Sower
1881
Canvas, 91.5×65
The Fine Art Society

not forgotten his French training, nor was he unaware of Bastien-Lepage's fascination with single-figure compositions on a large scale. At Cockburnspath he turned temporarily away from eastern subjects and chose to paint his own ruralist subject, a large canvas entitled *Audrey and her Goats* (pl.109). It was a painting which was to occupy him on and off over the next six years before he

109
Arthur Melville
Audrey and her Goats
1884–9
Canvas, 204.5 × 213.5
Tate Gallery, London

exhibited it (to almost universal critical disapproval) at the Grosvenor Gallery in London in 1890. There is another echo of Bastien-Lepage in this painting, an awareness of the symbolist qualities of his *Jeanne d'Arc écoutant les Voix*. Albeit on a much smaller scale and, in the final version, more loosely painted than Bastien-Lepage's painting there is a similarity between the pose of the girl and that of Joan and a similar magical element in the appearance of Touchstone – a more solid character than 'the Voices'. Other parts of the composition betray Melville's readiness to follow Guthrie's clear example in the acceptance of such French motifs as the tree in the left foreground which rises through the height of the painting acting as a pointer to its perspective. The use of square brushes, typical in Glasgow School and other naturalist painting, can be seen underneath the later impasto, added as the painting was reworked, several times, after Melville had left Cockburnspath. He was to carry on working on the painting until almost the last moment before its first showing in 1890, perhaps never satisfied with the, by then, richly coloured surface.

Two letters from Melville to Mr Whyte in Helensburgh[32] give some insight into the months he spent with Guthrie:

110
Arthur Melville
Evie Sanderson
1884
Canvas
Untraced

Co'path, March 14th [1884]

My Dear Whyte,

Though I am rather late in replying to your extremely kind letter I am not the less flattered that you should have taken my part so strongly. I fancy I shall require to join the Watercolour Society soon. I let the RSA know that I should not send to their exhibitions any more. I may be pardoned for considering that my work deserves better places than they have got.

I never was so cut up in my life as when I found my *Call to Prayer* hung on the portrait line; it is a positive insult and I am greatly obliged to you for telling me candidly what you thought. Well! enough of that.

My 'Touchstone' [*Audrey*] has turned out immensely finer than I expected. I have this moment come from working all over it to some purpose but am quaking about the size of it. Guthrie is having very hard work for his picture; I hope he will have it finished in time. Walton and he desire to be kindly remembered to you.

In fact, Melville did not send to the Scottish Watercolour Society, of which Whyte was a founder member and staunch supporter, until 1885 and he did not break off all contact with the Royal Scottish Academy as he threatened in his

letter, continuing to send work there throughout the 1880s. The picture Guthrie was trying to finish was probably *Pitting Potatoes* (untraced). In another letter to Whyte, dated as 1883 by Mackay but more likely, judging by the references to Guthrie, to have been written at the end of 1884, he wrote:

Guthrie and I are pegging away and doing pretty well. Guthrie has had rather hard times this year but is beginning to do capitally. My big picture is within a month of being finished and I should like you to see it [*Audrey*]. About the Watercolour Society I am afraid I must say no. I have already too many Societies to send to and I find it expensive. Thanks very much for your kind remarks. I am off to London for good in February.
 Wishing you a Happy Christmas . . .

From this letter we can see how *Audrey and her Goats* was dragging on and Melville did not, after all, leave for London the next year – in fact, it was 1889 before he finally left Scotland. The picture which Guthrie was having some success with was *Schoolmates* which he was just unable to complete in time for the Institute of 1885.
 Not all of Melville's painting at that time was in a rustic mood. One of his more unusual pictures was a fine oil, *Red Poppies* (see p.94), a bold and brilliant study in strong clear reds set against a dark background. A comparison with Macgregor's *Vegetable Stall* shows the different approach to painterly problems that the two men took; but it was Melville who was to become the more influential for the younger men in the group. He continued to produce his eastern watercolours and received a number of commissions for portraits from an Edinburgh family which did not find universal critical approval. One of these, *Evie Sanderson* (pl.110), was shown at the Glasgow Institute in 1885 where it firmly established Melville's role as an Honorary Glasgow Boy. The critics, however, were less impressed:

To judge by the oddity of the frame in which he has enclosed it, A. Melville might be supposed to have deemed it necessary to challenge attention for his *quasi* portrait subject, entitled *Eva*. Yet the quaint little figure, in white ruff and black dress turned back at the neck with greenish-grey, with pale roses in the hand and a heap of similar flowers on one side, might have been safely left to assert itself by the rich and sober harmony of its colouring. Needless to say that, preoccupied as usual with tones and values, the artist has not concerned himself with the minuter details of form.[33]

The difficulties facing Guthrie that Melville hinted at were not to become too pressing until the latter part of 1885. Throughout the previous year Guthrie had moved from strength to strength culminating in his classic naturalist painting, *Schoolmates* (pl.119). In this picture Guthrie achieved a truly individual form of naturalism. The cool grey light of French *plein-air* work is replaced by a warm sunlight with soft shadows. The composition is not as static as, for instance, those of Bastien-Lepage and the picture recalls the steady movement across the frontal plane of *To Pastures New*. Guthrie worked on the picture throughout 1884, producing a number of drawings and oil sketches (pl.111 & 112), and probably alternating between this and the large canvas *Pitting Potatoes* which was to remain unfinished. He had intended *Schoolmates* to be ready for the Institute exhibition of 1885 but it was not finished in time:

Guthrie . . . was unable to complete the picture he intended for the Institute in time for

'sending-in' day. It is termed *Schoolmates* and represents a group of children – two girls and a boy – returning from school. Whether as regards colour or handling or *technique* generally this is the most perfect work Mr Guthrie has yet produced.[34]

Having missed the Institute, Guthrie dispatched the picture to the Royal Academy but it was rejected and not shown publicly until the Institute of 1886.

Guthrie had no doubt been encouraged by the generally favourable reception of *A Hind's Daughter* at the Glasgow Institute at the beginning of 1884. It appeared with a number of other key Glasgow School pictures but none of the critics made more of the links between them other than this rather shallow observation:

A most curious development of the 'sincerest form of flattery' to be found in the present exhibition consists in imitating a certain style of signing the artist's name. But if the present style of imitation should spread, there will soon be such a dead level of uniformity that our artists will produce the impression of being a race of block-printers. [These signatures in block capitals] may be found dancing on the cabbages in the foreground of Guthrie's *Hind's Daughter*, in the *Farm* of G. F. Henry, *Late Again* of Lavery and many others until it culminates as a most striking object in the W. Y. Macgregors of Crail. Let us hope this species of signature will not increase so as to hide the pictures altogether.[35]

111
James Guthrie
Study for 'Schoolmates'
1884
Canvas, 35.5 × 28
Private Collection

112
James Guthrie
Study for 'Schoolmates'
1884
Pencil, 26.8 × 22.8
National Galleries of
Scotland, Edinburgh

Guthrie would no doubt have been aware of the likely impact of the 1885
Glasgow Institute which was particularly well supplied with the latest of the
Boys' paintings. It was an exhibition where the hitherto disparate strands of
Scottish naturalism came together to display the enormous strides that the
movement had taken in the previous three years. Guthrie was represented in this
exhibition by *To Pastures New*, which was having its first Glasgow airing, but
there is no doubt that he would also have dearly wished to show *Schoolmates* as
well. Despite Lavery's praise for Guthrie's only exhibit, which, he later said, had
convinced him that the future for naturalist painting lay in Glasgow and not
Paris[36] (which may have been only partly true because, as has been noted earlier,
Lavery and all of the non-French students in the Parisian *ateliers* were to be faced
with new examinations in French before being allowed to continue their studies
at the Ecole des Beaux-Arts). To have shown *Schoolmates* as well would have
been a triumph for Guthrie for in this picture, as in no other by the Boys that had
been seen in Glasgow, he achieved a genuine step forward. The handling is a
much more personal response to the problems of depicting naturalist subjects
under a sunny sky and the painting is less dependent on the tricks and formulae
of French naturalism than anything else he had yet painted. Perhaps there is
something of the influence of Melville in the even brushwork and more obvious
awareness of the value of colour. Certainly, there is a greater homogeneity of
surface than in *A Hind's Daughter* which offers less of a distraction to the
harmonies of colour which are such an important element in the success of the
painting.

A similar kind of brushwork is to be found in the picture which was to occupy
Guthrie for most of 1885 and on into 1886. The presence of Melville by his side
and later of Hornel and Henry almost certainly accounts for the more obvious
feeling for pattern in the composition of *In the Orchard* (pl.120). Guthrie's earlier
paintings are marked more for their balance of line and tone, as Caw described
them, than for their feeling for the more decorative qualities of pattern in their
composition. In this last major picture to be started at Cockburnspath can be
seen many of the gradual changes towards a kind of painting with which Guthrie
was basically not in sympathy and it acts as a pointer to the strains which almost
caused him to give up his career and return to a more straightforward profession
in medicine or the law.

In a sketch-book used by Guthrie at Cockburnspath (Coll: National Galleries
of Scotland) there are a group of drawings for a major painting. It seems to have
given him some trouble, particularly in the resolution of certain basic decisions
about the composition. Certainly, there are more drawings for this painting than
any other which has survived and they show how the basic idea was changed
before arriving at the final format. *In the Orchard* was begun in 1885 at
Cockburnspath but not finished until the following year, having in the meantime
travelled with Guthrie to Glasgow and Kirkcudbright. One of the preparatory
studies in the sketch-book (pl.113) shows that he first of all considered the
painting as a vertical composition with one of the two girls standing, holding a
basket into which the second seated girl is throwing apples. In the final version
the canvas was turned on its side and the standing girl seems to be portrayed as

113
James Guthrie
Study for 'In the Orchard'
1885
Pencil, 26.8 × 22.8
National Galleries of
Scotland, Edinburgh

being younger and shorter than her counterpart in the drawing. The seated girl is shown placing an apple in the basket, thus reducing the sense of movement in the composition and making it much more static. The quality of the paint surface, consisting of thick layers of pigment, is witness to some of Guthrie's indecision. Any evidence of extensive use of square brushes is lost beneath the over-worked surface of the foreground and the foliage under the trees. Only in the trunks of the trees at the left is there any real indication of the kind of handling of *A Hind's Daughter* and *To Pastures New*. The colour, also, is different, richer in hue and warmer in tone. One is reminded of *Audrey and her Goats*, which Melville also reworked in a similar manner; could Guthrie have been affected by his indecision or was the underlying problem more serious? As Caw suggests, there are also other changes in this painting than those of straightforward handling. Caw sees for the first time in Guthrie's rustic paintings a suggestion of sentiment, a hint of the studio machines of the Academicians. There is no doubt a change in emphasis, admittedly slight, in this painting but I feel that it is not a dilution of Guthrie's principles towards 'Gluepottery' but more the first steps in the general move away from naturalism which affected almost all the Boys in the latter half of the decade. These changes in emphasis occurred partly because of the various alterations which the composition underwent, where Guthrie possibly lost the original feeling for a *plein-air* subject as the canvas changed in his different studios in Cockburnspath, Glasgow and Kirkcudbright; partly also because Guthrie seems to have had a much greater awareness of the importance of pattern in the composition, an awareness probably encouraged not only by Melville but also by Henry and Hornel in Kirkcudbright. This change of emphasis from *plein-airisme* to decorative effect may also have diverted Guthrie's intentions away from Bastien-Lepage's uncommenting naturalism towards a gentle symbolism that was to become a key factor in much of the later work which the Boys were to produce after visiting Henry and Hornel in Galloway.

Although *In the Orchard* is now recognised as one of Guthrie's major works, and was also well received by the contemporary critics, the history of its making underlies an extremely difficult period in Guthrie's life. I think that the training he had had with Pettie and Orchardson in London, such as it was, had led him to believe that the supreme challenge for an artist was a complex figure subject. He had had some success with this type of complicated composition, emphasising the interaction between several figures, in *A Funeral Service in the Highlands*, but he had not successfully completed a similar work since 1881. At Crowland he had begun a large painting of fieldworkers[37] which remained unfinished at his death (115 cm × 75 cm; untraced). A drawing in a sketch-book possibly relates to this painting (see p.58); it shows a man standing with a scythe while other figures can be made out behind him. It has distinct similarities with Bastien-Lepage's figure paintings but Guthrie was unable to resolve the composition, or, more simply, he decided to concentrate on *To Pastures New*. *Pitting Potatoes* was another large figure composition[38] which remained unfinished (75 cm × 140 cm; untraced) but it was another Cockburnspath picture which caused Guthrie the most problems. Caw describes *Fieldworkers Sheltering from a Storm* as a large canvas (about

150 cm × 180 cm) which Guthrie destroyed after making several changes to it at Cockburnspath in 1885.[39] Caw records Guthrie's predicament and its solution:

Left alone when his friends returned to their town studios, Guthrie's life in Berwickshire during the winters was much less social and artistically very lonely. This had its reactions, and one morning late in 1885 his cousin James Gardiner, a Glasgow shipowner, between whom and the artist, who was some thirteen years younger, there was a special bond of sympathy, received a post-card from him asking for a new University Calendar. Puzzled as to what this might imply, he showed it to his younger brother, W. G., and said that he thought he had better write and inquire. 'No,' was the reply, 'what you should do is to go and see him.' That afternoon, or next morning, James Gardiner went to Cockburnspath. He found Guthrie very depressed. He had been painting a big picture (about the size of *In the Orchard*) of fieldworkers sheltering from rain under a tree and it simply would not come. When the lights were right, the shadows were wrong, and when the shadows were right, the lights were wrong. And in disgust he had put his foot through it. So he had decided to give up painting and, returning to the University, to take up law or medicine. His cousin, however, dissuaded him – he was an artist born, he told him, but he had been tackling a problem too complicated for his present capacity, without anybody to discuss his difficulties with and had lost heart. What he required was congenial company and a fresh start. And he finished by saying, 'Come back to Glasgow and I'll give you a commission to paint my father's portrait.'[40]

The problems which were described as being insuperable for Guthrie were more related to the tonality rather than the composition, and they indicate a return to painting in full sunlight with pictorial *chiaroscuro*, as in *To Pastures New*, rather than the more even-toned work of earlier years at Cockburnspath. Whatever the reasons for giving up the painting, the immediate solution – portrait painting – was to have far-reaching effects on Guthrie's later career. As a portrait painter he was rarely faced with the problems of accommodating several figures within a single canvas and, when the occasion arose later with the commission to paint a large group-portrait of *The Statesmen of the Great War*, the same problems returned, magnified a hundredfold but this time he was very much in the public eye and had to find a solution.

The same kind of problems do not seem to have beset his friends Walton and Crawhall, who were to use the time spent at Cockburnspath to resolve any question they might have had about the direction their own work should take. Crawhall had returned from Aimé Morot's studio in Paris at the end of 1882, presumably having decided that a conventional academic training in large-scale animal compositions was not for him. He spent part of the summer of 1883 at Cockburnspath and possibly returned there over the next two or three years. He imitated the success of *A Lincolnshire Pasture* with a similar painting, *Landscape with Cattle* (pl.114), the date of which is not easily deciphered but seems most likely to be 1883 or 1885. Stronger in colour than the Crowland painting it shows that Crawhall had not yet totally given up oil for watercolour, a medium in which he was to excel. The red roofs of the Berwickshire cottages help form the dominant line of the horizon and the static pose of the cows is broken only by the swooping flight of the swallows between them.

This seems to have been one of the last oils which Crawhall painted; for the rest of his life he was to concentrate on watercolour and pastel. *The Duckpond* (pl.124) is one of the earliest of the Cockburnspath watercolours and shows how the oils

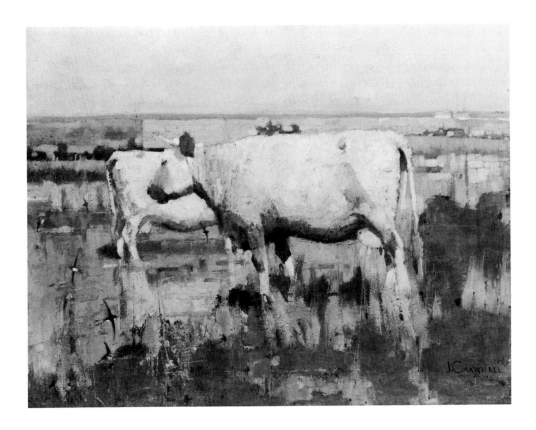

114
Joseph Crawhall
Landscape with Cattle
1883/5
Canvas, 43 × 57.8
Glasgow Art Gallery

were gradually translated into the new medium. This is also a picture which shows how much Guthrie and Bastien-Lepage had influenced Crawhall, as he has allowed figures to become an important element of the composition. No other surviving works of this date use figures in such a manner and animals and birds dominate his later paintings. There are few other works which can be definitely attributed to his visits to Cockburnspath; his real interests lay elsewhere, as a portrait of Crawhall by Walton (pl.125) confirms.

It is not known exactly when Crawhall first visited Spain and Morocco, which were to figure prominently in his later work, but in the background of Walton's portrait, where Crawhall is seen leaning against the back of a portrait-length canvas, there appears a painting of a bullfight. Posters advertising bullfights are shown sticking to the back of the canvas and above them Walton has made a lengthy inscription. Part of this, which was later obliterated, reads *Madrid '84*; the rest of it reads *Joe Crawhall, The Impressionist, By E. A. Walton, The Realist*. 'Impressionist' was not a term the Boys often used to describe themselves and both of the labels were probably meant to be taken lightheartedly (at some later date they were both obliterated).

It may be supposed that it was Arthur Melville who inspired Crawhall's visit to Africa. Melville's eastern paintings with their strong colours and fine sense of pattern would certainly have appealed to Crawhall, all the more so because they were painted mainly in watercolour which had become Crawhall's favourite medium. Melville was not to visit Spain until six years later, however, by which time Crawhall was well established in Tangier which he visited almost every year

from the mid-1880s until 1894. Lavery, Melville, Kennedy and others from
Scotland were to follow Crawhall, and Tangier at times must have had a distinct
Scottish contingent, consisting not only of painters as one of the most
flamboyant figures there was the radical aristocrat, adventurer and writer, R. B.
Cunninghame Graham. He and Crawhall spent much of their time together in
Tangier, attracted to each other by a shared love of horses and riding which they
both practised with an almost professional skill; Crawhall became, ten years
later in Yorkshire, a gentleman jockey with his own Arab mount.

Most of his later painting is concerned with animals and almost all of his best
works feature horses. Very few of them are dated but *The Forge* (pl.128) must
date from before 1887, when it was shown at the Royal Scottish Society for
Painters in Watercolour (RSW). *The Forge*, which was probably painted about
1885, shows Crawhall's fascination with unconventional compositions; looking
from the dark stable into the heat and light of the forge is a novel and highly
effective solution to a subject which was far from uncommon. This is an
impressive watercolour, painted on the scale of an oil painting – a scale which
Crawhall never seems to have attempted again in this medium. Other works are
much more intimate and Crawhall adopted a much more tightly controlled
handling and viewpoint in many of his studies of birds and horses. There is,
however, not only a change in medium and handling between his Crowland and
Cockburnspath pictures and those of later years, there is also a distinct change in
feeling and intent. Until the mid-1880s, Crawhall fitted well into the pattern of
Guthrie's and Walton's work with a firm grasp of naturalist principles as
preached by Bastien-Lepage and modified by the Boys. His later work is not
'realist', however, and perhaps this was behind Walton's jokey inscription on his
portrait of Crawhall. He is not, either, the 'impressionist' that Walton implies.
He became very much his own man, a quiet, rather lonely man, who had little to
say in company – 'The Great Silence' (or, less kindly, 'Creeps') he was nicknamed
by his friends. His painting reflected his own introspective nature and gradually
drifted away from the mainstream of the new movement but, unlike that of
many of his Glasgow friends, its quality was never diminished.

E. A. Walton, fond as he was of Guthrie and equally committed to the new
style that the pair of them had developed, did not break his routine of returning
to the town as autumn gave way to winter in 1883. It was a routine he repeated
all the time that Guthrie stayed at Cockburnspath, spending about six months of
the year with his friend and then returning to Helensburgh and Glasgow. A
number of his most acclaimed works from this period are now lost, *Pastoral* and
Berwickshire Uplands among them, which Caw and others considered as
representing much of the best of his Cockburnspath work. Several paintings,
both oil and watercolour, survive, however, and they and contemporary
accounts enable his contribution to be assessed alongside Guthrie's. Walton's
fascination with beached boats as a subject continued in one of the earliest of his
surviving Berwickshire pictures. *The Fishing Village* (pl.115) is probably a view
of the tiny harbour called Cove at Cockburnspath (it is possibly the same picture
as that exhibited at the RSW in 1883 as *Sea-side Village*, no 92). It is not bright in
colour but its strong tonality is typical of Guthrie's and Walton's approach at

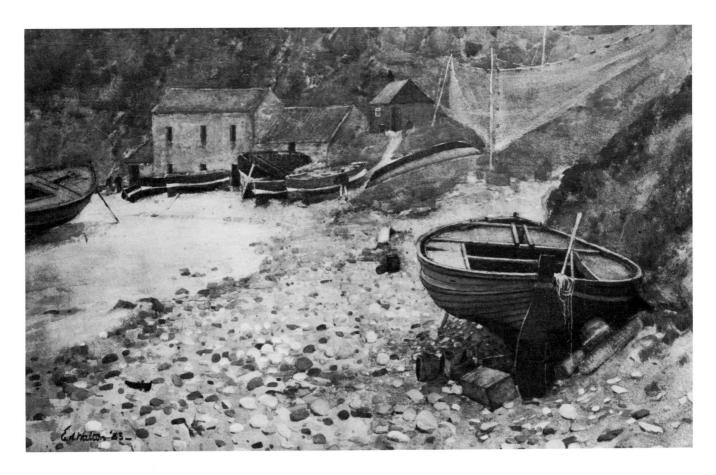

115
E. A. Walton
The Fishing Village
1883
Watercolour, 34.3 × 47
Private Collection

this date. Changes in his style, however, became apparent in another watercolour, *Pastoral*, which was noticed by the critics. The reviewer at *Quiz* was unequivocal:

I have heard it much praised already, nor have I heard it spoken of in any other manner, but while admitting its undoubtedly fine quality of tone, and rare suggestive and artistic treatment, I cannot speak of it otherwise than in terms of the strongest condemnation. The work has been carried out so far as to enable the spectator to understand that the artist meant to portray a few sheep grazing on the hillside; while a few daubs of colour in the background are intended to indicate human habitations. We have put up with enough of this cheap cleverism during the past few years and that the public want no more it has been clearly shown.[41]

Following such a bitter attack is a clear statement of encouragement and praise for his other pictures in the exhibition! *The Bailie* considered *Pastoral* a major work and in its review of his other paintings at the RSW described his views of east coast cottages (presumably *On the Coast of Berwickshire* and *Moorland*) as being filled with a 'sunlight almost blinding'. The following year Walton sent *Pastoral* to the Royal Academy, where it was noticed by the critic of the *Art Journal*:

A rolling hill of long grass, parched to almost flaxen whiteness, and showing to what an extent scumbling of paper may become.[42]

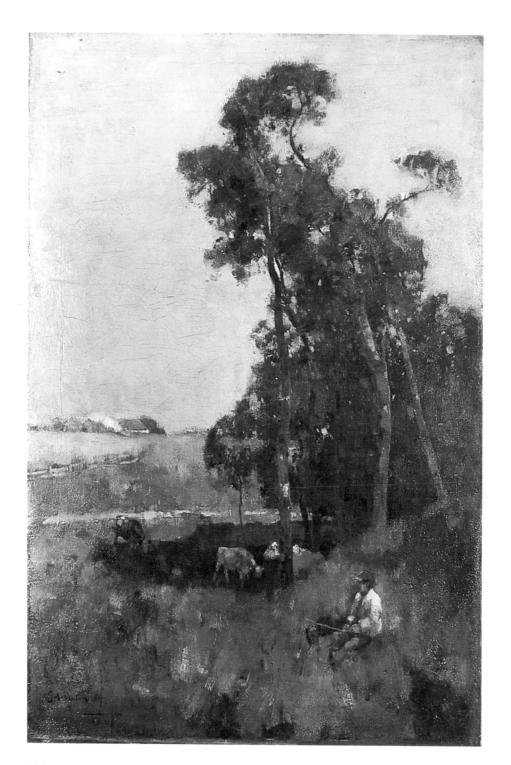

116
E. A. Walton
Noon-day
1882–4
Canvas, 92 × 61.3
Hunterian Art Gallery,
Glasgow

117
E. A. Walton
The Cowherd
c.1882
Pencil, 14.7 × 20.2
Hunterian Art Gallery,
Glasgow

118
E. A. Walton
The Donkey Cart
1884
Watercolour, 26 × 18.5
Private Collection

Sadly, this picture is now lost but it shows how Walton treated watercolour as a serious medium for exhibition pictures, even at this early stage in his career.

A confusing aspect of Walton's work, however, is his repetition of titles. Simple and generic titles such as 'Pastoral', 'Fieldworkers', 'Landscape' and 'Portrait' make it difficult to know whether he is showing the same or different pictures in the exhibitions. His habit of reworking paintings, re-dating them and giving them new titles further confuses any attempt at imposing a chronology on these early paintings. For instance, *Noon-day* (pl.116) was exhibited in the Glasgow Institute exhibition in 1883 but it is now clearly dated '1884'. It cannot be a Cockburnspath picture as it must have been painted in 1882 (because the sending-in day for the Institute was in early January), although the red-roofed cottages on the horizon usually indicate a Berwickshire subject. Another painting in the same exhibition is entitled *Annandale's Garden*; Annandale was the name of the farm where Guthrie's mother's family came from and *Noon-day* possibly records a visit which he and Walton could have made at the end of 1882. The pose of the cowherd is strongly reminiscent of the tramp in *The Wayfarer* (see p.71), which itself derives from Bastien-Lepage's *Les Foins* (see p.58). Like Guthrie's first sketches at Cockburnspath, this picture is freely handled with a strong tonal arrangement, but unlike those pictures it is painted in bright sunlight with clearly defined shadows. Strong contrast between light and shade is common to several of Walton's Berwickshire paintings, where he took the greatest advantage of the patches of shadow and dappled light that the clumps of trees growing on the hillsides gave him. Even in sketch-book drawings of this date a clear scheme of *chiaroscuro* can be seen. The drawing, *The Cowherd* (pl.117), is probably one of the preparatory studies for *Noon-day*, and *The Young Shepherd* (Coll: Hunterian Art Gallery) is probably a related work.

Another key work of this period is *Autumn Sunshine* (pl.129) which is dated '1884' although it seems to have been shown at the Glasgow Art Club in 1883. A painting entitled *Autumn Sunshine* was also shown at the Institute in 1883 but no illustration of it survives, and it seems likely to have been a different work. The Art Club picture was entitled *Midsummer* and the line drawing of it in the catalogue corresponds almost exactly with the picture now known (from an old label on its frame) as *Autumn Sunshine*, the only identifiable differences being the addition of the trees at the right in the dated painting. Perhaps Walton reworked the picture and then added the later date but in all other respects a date of 1883 is consistent with other paintings made during Walton's first visit to Cockburnspath in 1883.

The clear contrast between light and shade, accentuated by the patches of shadow on the brightly lit grass and the silhouettes of the shaded trees and cows against the sunlit sky, is more successful in its handling than *Noon-day*. The critic of *The Bailie* was emphatic in his judgement:

[Walton] has caught not a little of the power and the brilliancy of the greater school of Dutch landscapists in his *Midsummer*.[43]

The rural theme of these paintings is carried on through the work of 1884. At the Royal Academy in 1884 he showed, besides *Pastoral*, an oil entitled *Winter*

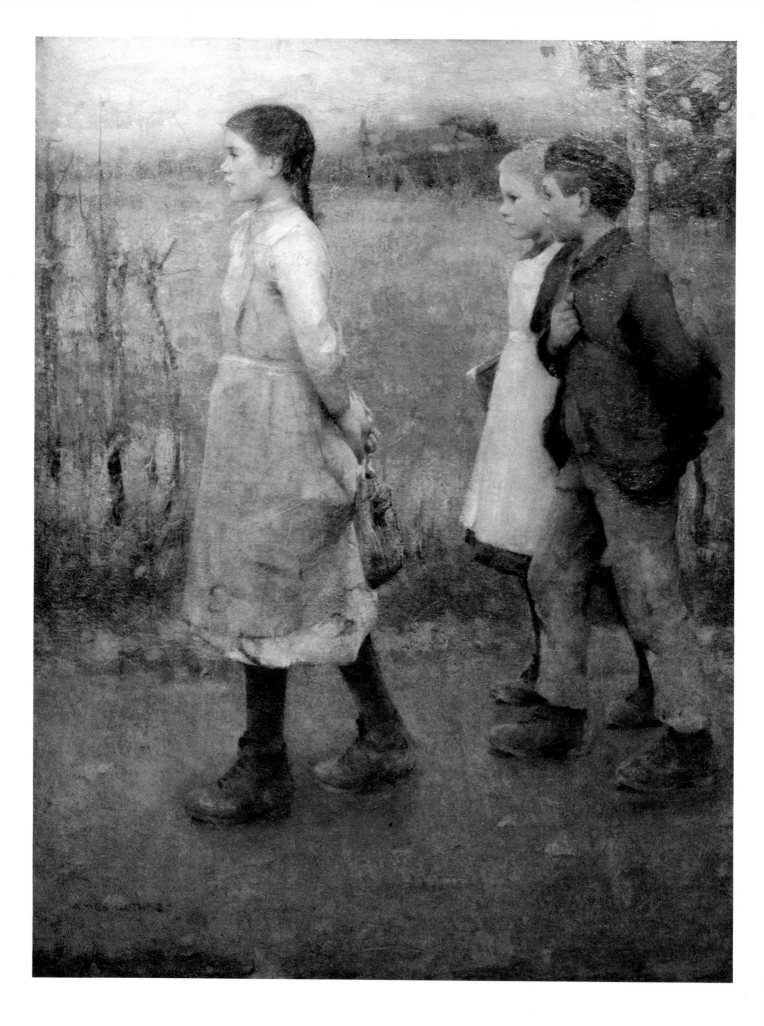

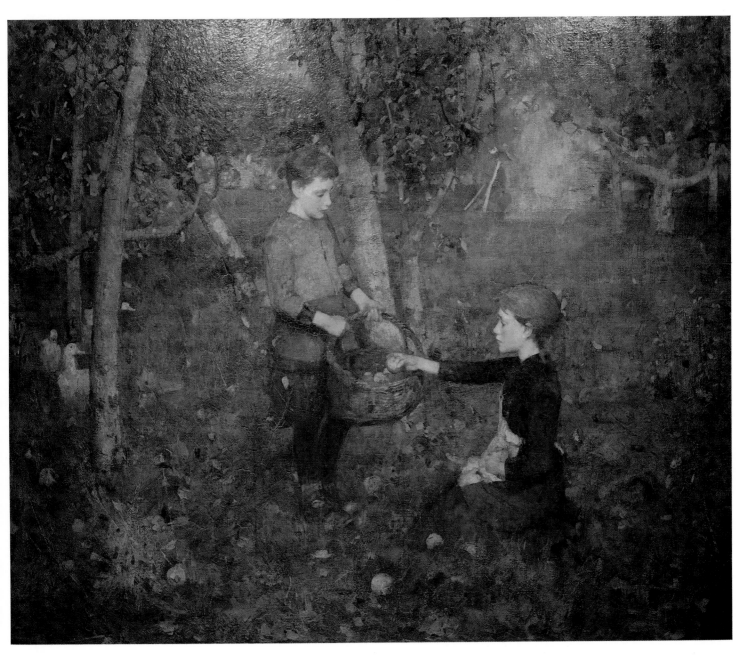

120
James Guthrie
In the Orchard
1885–6
Canvas, 152.5 × 178
Private Collection

119
James Guthrie
Schoolmates
1884–5
Canvas, 137 × 101.5
Musée des Beaux-Arts,
Ghent

Pasture (untraced) and in the Institute in 1883 he had also shown paintings of rustic life, *Potato Field* and *Noon-day*. At the Institute at the beginning of 1884 he showed *Berwickshire Uplands*, *Bean Harvest* (both untraced) and *A Berwickshire Fieldworker*. Given Walton's propensity for re-working and re-dating his pictures, this latter work may be identical with the painting of the same title, but dated 1884, now in the Tate Gallery (pl.131). More strongly coloured than some of the paintings of previous years, it shows Walton emulating Guthrie's figure compositions, with its high horizon and the figures of the girls placed against a steeply rising background of the field. The flash of blue light on the sickle which the girl is holding echoes a similar touch of blue on the knife in Guthrie's *A Hind's Daughter* (see p.91). This is one of the most important of Walton's Cockburnspath paintings and one in which his commitment to realism, choosing his subject from everyday life, is seen at its most unequivocal.

Cockburnspath continued to provide subjects for watercolours: *Market Day*, *The Windmill*, *The Donkey Cart* (pl.118) in 1884; *Landscape*, *Pastures*, *The Herd*, *Feeding Fowls* in 1885. In 1886 he showed *The Herd Boy* (pl.132) at the RSW. In this fine watercolour Walton has chosen a brightly lit format and has delighted in the use of clear and strong colours. This is one of his most powerful watercolours and he can now be seen deliberately choosing to produce finished works in the medium, giving it the importance that Melville and, gradually, Crawhall did for their exhibition works. Significant changes in his compositions over the previous two years had led him to experiment with bold arrangements in the placing of his figures; here the boy is on the frontal plane of the picture recalling the pose of the two children in his Cockburnspath masterpiece, *A Daydream* (see p.151). The reviewer at *Quiz* considered *The Herd Boy* to be his most important exhibit that year; this praise was grudgingly given, however, as it was followed by a parting criticism: '[the boy] is no more a herd boy *naturel* than the man in the moon'.[44]

Another of these watercolours, *Grandfather's Garden* (pl.121), must have been considered by Walton to be a substantial work judging by the price he placed on it at the RSW in 1884 – 45 guineas. This was half as much again as the second most expensive watercolour *Pastoral* for which he asked 28 guineas. There is a group of drawings which relate to this picture (pl.122 & 123) and which give us some insight into Walton's method of working at Cockburnspath. They show that he made quite careful preparatory studies on a small scale which would presumably have been at his side when he began work on the finished version. Through these drawings he could experiment with the composition but he still seems to have painted the final watercolour out-of-doors. At the very least it was begun outside, although it may have been taken to the studio for completion; no preparatory sketches in watercolour have survived from this period which suggests that the medium was used only for finished, *plein-air*, works. *Grandfather's Garden* shows the emergence of new themes in Walton's painting which were to have a bearing on much of his later work. The first is the change of scene from fields and farmworkers to the more domestic setting of a garden. Guthrie had used a garden for the setting of *A Hind's Daughter*, but the emphasis had been quite definitely on the symbolism of the kitchen garden and its role in the life of a simple rural family. A more important change is the establishment of

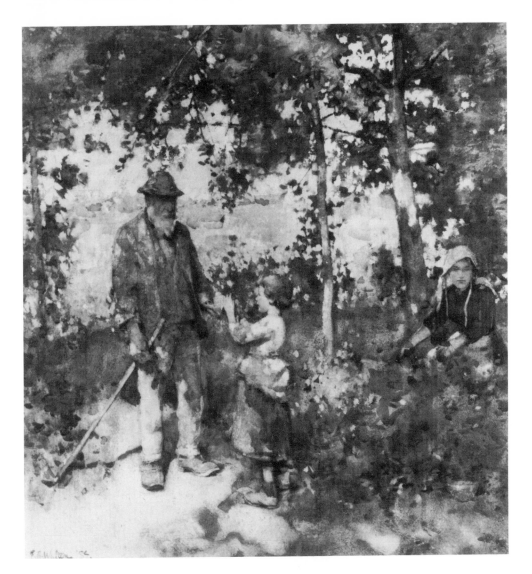

121
E. A. Walton
Grandfather's Garden
1884
Watercolour, 57 × 53.5
Private Collection

122
E. A. Walton
Study for
'Grandfather's Garden'
1884
Pencil, 13.2 × 11.4
National Galleries of
Scotland, Edinburgh

123
E. A. Walton
Study for
'Grandfather's Garden'
1884
Pencil, 11.9 × 19.6
National Galleries of
Scotland, Edinburgh

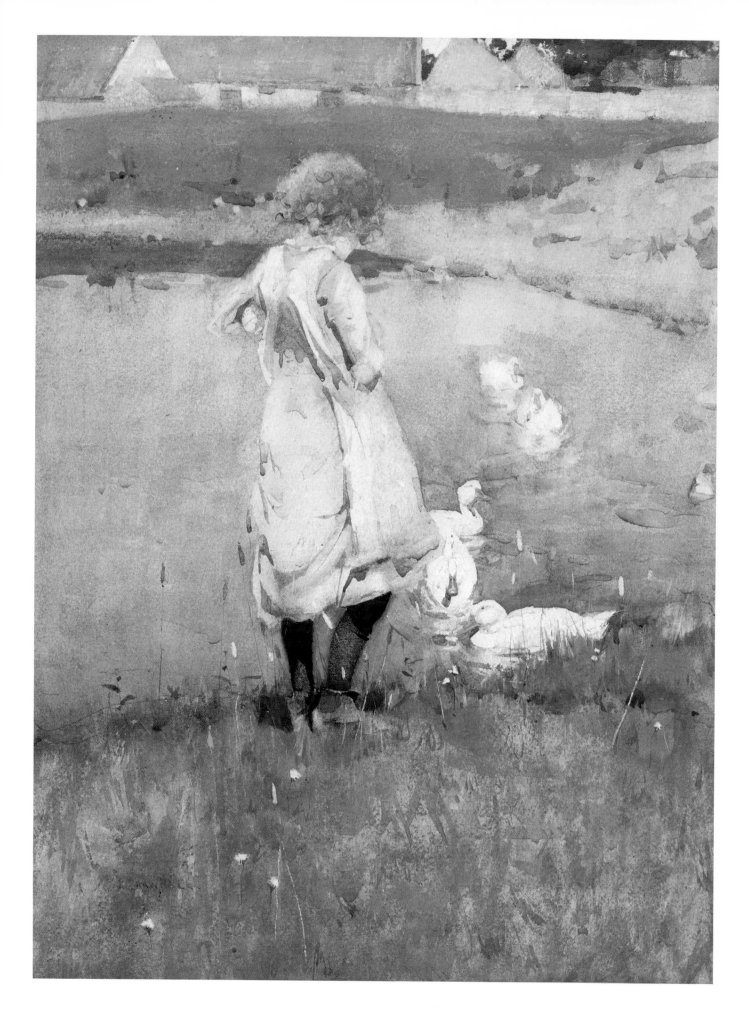

124
Joseph Crawhall
The Duckpond
c.1883
Watercolour, 39.5 × 30.5
Private Collection

125
E. A. Walton
Portrait of Joseph Crawhall
1884
Canvas, 73.6 × 37
National Galleries of
Scotland, Edinburgh

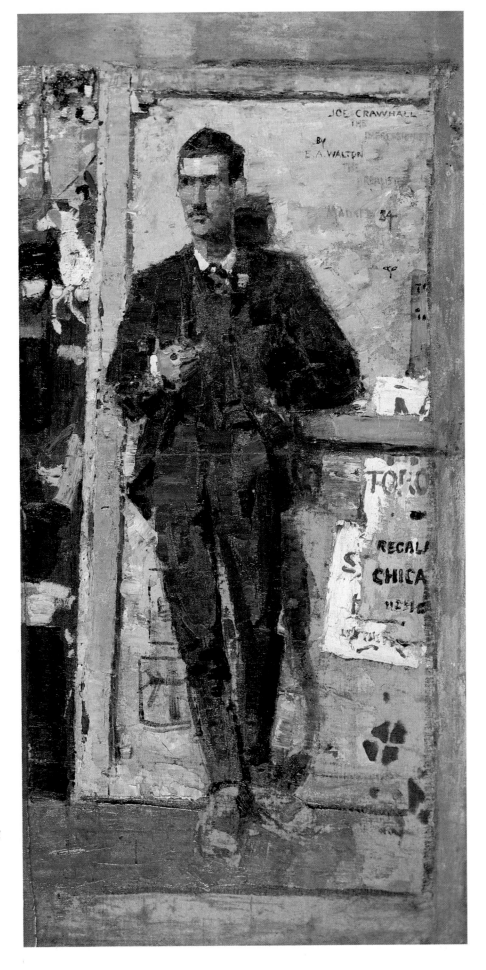

126
E. A. Walton
Springtime, Upper
Helensburgh
1883
Watercolour, 33.5 × 52
Private Collection

a relationship within the picture between the old man and the child; it almost hints at the false sentiment of the Gluepots. In Guthrie's works at Cockburnspath it was not until he started on *In the Orchard* that he introduced any sense of dialogue or communication between his figures. Even the children in *Schoolmates* retain a distance from each other.

Walton had adopted the same stance in his other rustic paintings; there is, for instance, little interaction between the figures in *Berwickshire Fieldworkers*. Without actually painting incident or the kind of anecdotal subject that the Gluepots of the Art Club were so fond of, Walton gradually began to introduce a relationship between the figures which more and more populated his paintings from 1883, gradually displacing the pure landscapes for which he had previously been best known. Nowhere is this seen better than in the series of watercolours he began in 1883 which show the streets and inhabitants of Helensburgh, the little town at the entrance to the Gareloch which was a second home to several of the Boys.

Hitherto, the Boys' subject-matter had mainly been concerned with rustic realism; village life and farmworkers had become their stock-in-trade, based very much on the example of Millet and the Barbizon painters and Bastien-Lepage. The latter, however, had introduced other subjects into his repertoire –

127
E. A. Walton
At Rosneath
1883
Watercolour, 33.6 × 49.4
Glasgow Art Gallery

portraits, both of rural types and society figures, and city life, mainly that of the working classes. At home in Helensburgh for the winters, Walton found a new form of realism in the day-to-day life of the ladies of the town, deserted by their husbands and brothers who caught the early trains or ferries to their offices in Glasgow or across the Clyde at Greenock. Lavery, on his return to Glasgow in 1885, was to turn to similar subject-matter, realising that middle-class life was just as valid a realist subject as that of his French peasants, but with the added advantage that the subjects of these paintings were far more likely to buy them than were the village girls of Grez. Walton also intended to sell his paintings of the daily life of Helensburgh, which were almost all watercolours, but his subjects were mainly his family and friends and the pictures had not been commissioned by those who appeared in them.

The first of the Helensburgh series to appear were purely views of the town or its surrounding pastures such as *Springtime, Upper Helensburgh* (pl.126), *At Rosneath* (pl.127) and *The White Cloud* (Coll: Hunterian Art Gallery). *Winchelsea* (see p.62), painted in 1882, is a precedent for the series of townscapes with figures, but the Helensburgh series is, on the whole, much more adventurous in composition and technique. One of the first of these pictures was *Victoria Road, Helensburgh* (pl.136). It contains a number of Glasgow School 'trade-

129
E. A. Walton
Autumn Sunshine
1883–4
Canvas, 53.4×71
Hunterian Art Gallery,
Glasgow

128
Joseph Crawhall
The Forge
c.1885
Watercolour, 63.5×55.5
Sir Norman Macfarlane

marks', such as the foreground tree and a clear representation of tonal values, but above all it is Walton's choice of subject which makes the picture stand out from his other work. The composition, with its emphasis upon the concentric curves of road and footpath, punctuated by the verticals of the trees and the figure of the girl walking towards the viewer, creates a sense of movement and pattern that is quite new in Walton's work and which was only rarely, and often accidentally, seen in the work of the other Boys at this date. In 1884 Walton showed this watercolour at the Royal Academy where it was hung on the line; he must have been particularly proud of it as he chose to send it to the Munich Secession in 1893, continuing his habit of showing important watercolours in Germany which had begun with *The Herd Boy* and *The Donkey Cart* in 1890.

In 1885 a number of similar subjects were shown at the RSW: *An Afternoon Walk*, *A Morning Outing*, *A Morning Errand*. The following year he exhibited *A Suburban Villa* and *At Helensburgh* (pl.130). One of the 1885 RSW exhibits may have been the picture now known as *En Plein Air* (pl.137), one of the most ambitious of the series. Again, several Glasgow School motifs appear – the strong verticals (telegraph poles), a high horizon with the two main figures ranged against the sharply rising plane of the street – but the deliberate emphasis on the pattern formed by the lines of the composition, vertical, horizontal and diagonal, confirm the changes seen in *Victoria Road, Helensburgh*. Walton, in fact, was not to be the artist who fully developed this new feeling for decorative effect – that was to be very much the province of Roche, Hornel and Henry – and neither was he to make as much of genteel realism as Lavery, but in one particular aspect he was to introduce the Boys to a new area of realist work in which he retained an interest for the rest of his life.

At the Glasgow Institute in 1885 Walton exhibited a painting simply entitled *Portrait* (no 613; untraced). There is no record of the sitter nor any known illustration of the painting but it was followed in subsequent years by a number of other portraits, often just as tantalisingly titled, which received critical acclaim. Few of these have been traced, partly because their uninformative titles give no clue to their whereabouts, and partly because most of them seem to have been painted for the artist's own pleasure and were not commissioned, making it even more difficult to trace sitters or buyers. This was not the first time that Walton had submitted a portrait to the Institute; the previous year, according to *The Bailie*, he had had another portrait ready at sending-in day but it does not seem to have been accepted for the 1884 exhibition. This picture was, in the words of the critic of *The Bailie*, 'nothing less than a masterpiece.'[45]

An article in *Quiz* throws some light on a portrait which Walton showed at the Institute in 1886 (pl.133):

'Damn him, how various he is' exclaimed Gainsborough once of Sir Joshua Reynolds, and a somewhat similar remark might be applied to Mr E. Walton in respect of two important pictures which just now hang in his studio. Mr Walton is a clever painter, but never we suppose, till now, has he achieved anything that will give him the reputation he deserves. For one thing his mannerism has always been against him. There was always some poetry and some wit, however little, in his work, but it suggested too much – or rather it

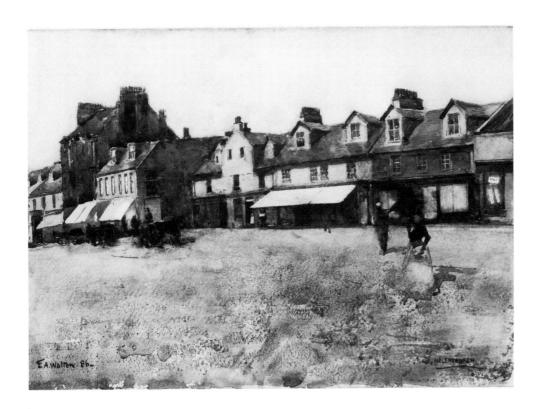

130
E. A. Walton
At Helensburgh
1886
Watercolour, 25 × 25.2
Hunterian Art Gallery,
Glasgow

suggested too little – and left too much to the imagination of others, and nothing of the sort can be said against the portrait which Mr Walton intends sending to the Institute. Here he excels himself – he has realised all he has worked for. It has also, we doubt not, been a labour of love, for it is a picture of his mother. There is nothing laboured about it, although the artist has bestowed remarkable pains upon his study – power and strength and feeling are all here. The deep background harmonises finely, and some well-painted woodwork gives an added richness to the surroundings.[46]

The critic of *The Bailie* held a similar opinion:

One of the more noteworthy pictures of the present exhibition of the Institute is a portrait by E. A. Walton. Indeed, for what may be termed the more artistic qualities of Art, Mr Walton's work is altogether excellent and altogether satisfactory. Hitherto his pictures have been, in some measure, tentative in their character. Now he seems to have acquired full mastery over his own style – to be able to think out of his own thoughts in a fitting manner on canvas.[47]

Guthrie exhibited his portrait of the Revd Andrew Gardiner (pl.134) in the same exhibition and it can be seen to have a great deal in common with Walton's portrait of his mother. They are both exercises in tonal painting, remaining in the realist tradition through their bald statement of facts presented in a manner which clearly links them to the search for tonal values which had dominated the realist works of 1880–5. The critic of the *Scotsman* saw both similarities and differences:

Thoughtful work has been put by E. A. Walton into his portrait of a lady, the cold, sombre tones of which are not likely to attract many sitters. The portrait of the Revd Dr

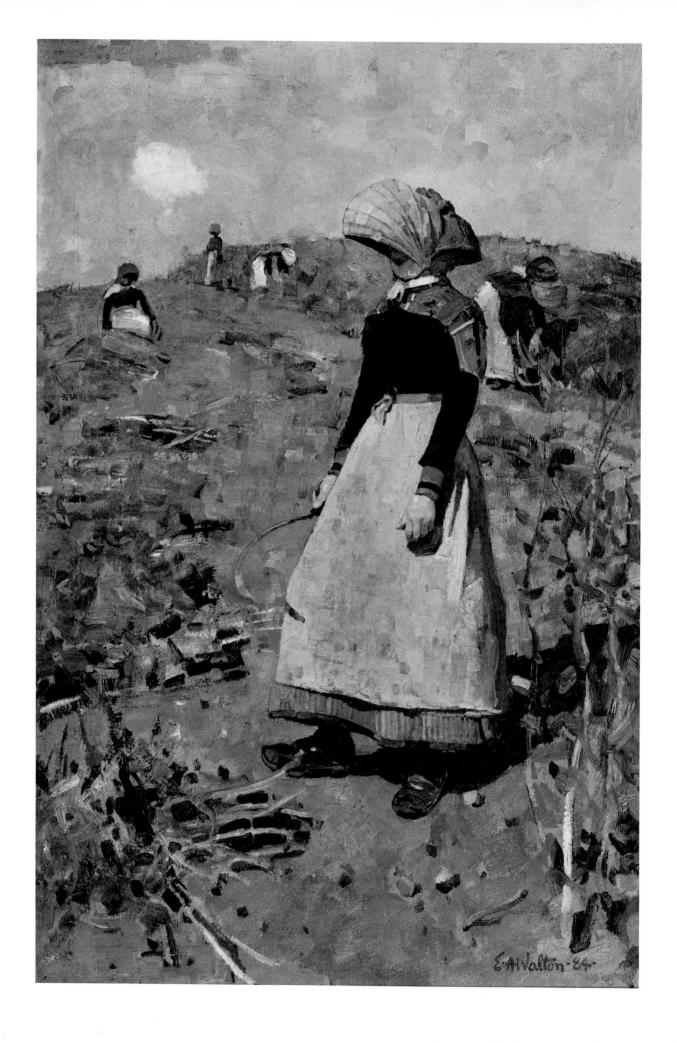

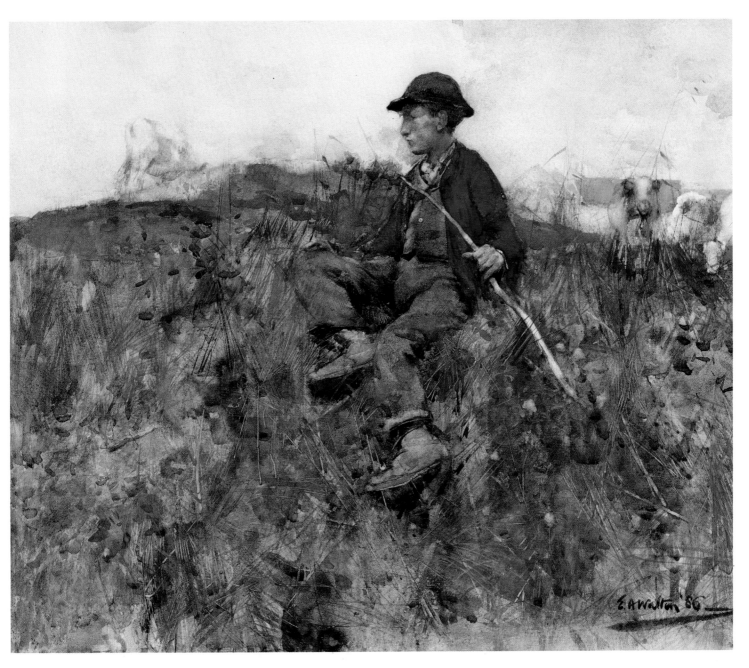

132
E. A. Walton
The Herd Boy
1886
Watercolour, 53.5 × 57
The Fine Art Society

131
E. A. Walton
A Berwickshire Fieldworker
1884
Canvas, 91 × 61
Tate Gallery, London

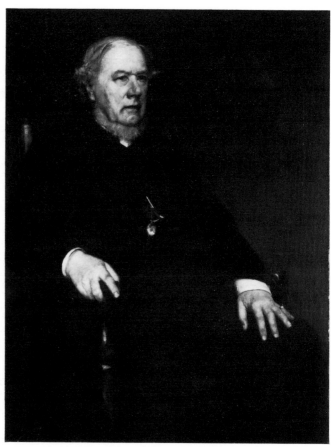

133
E. A. Walton
The Artist's Mother
1885
Canvas, 129 × 103.5
National Galleries of
Scotland, Edinburgh

134
James Guthrie
Revd Andrew Gardiner DD
1885
Canvas, 124.5 × 91
National Galleries of
Scotland, Edinburgh

Gardiner, Edinburgh, by James Guthrie is, though not so pronouncedly, of the same school; but all that can be said of it, on account of the position in which it has been hung, is that a very faithful likeness has been caught.[48]

It seems likely, as Walton approached the subject of portraiture before any of his friends, that Guthrie's portrait of his uncle (commissioned by his cousins while he was in the depths of despair at Cockburnspath) was influenced by the portraits which Walton began to show in 1884. Whatever the exact order of things, there is little doubt that Walton's first portraits, culminating in *The Girl in Brown* (pl.135), which was much praised at the New English Art Club in 1888, were much finer than any similar thing which Guthrie had attempted by that date. With the exception of *The Girl in Brown*, none of his other portraits of this date was illustrated in the contemporary journals, and only his portraits of his mother and of the US Consul, Francis Underwood (Private Collection), survive to give us any real indication of their appearance. The latter was exhibited at the Institute in 1887 and confirms the *Quiz* critic's appraisal of the portrait of his mother.

Although it is in a different medium, there is one picture which casts some light on Walton's portrait technique. *The Gamekeeper's Daughter* (pl.145) is dated 1886 and may be the picture that was exhibited at the RSW that year under the

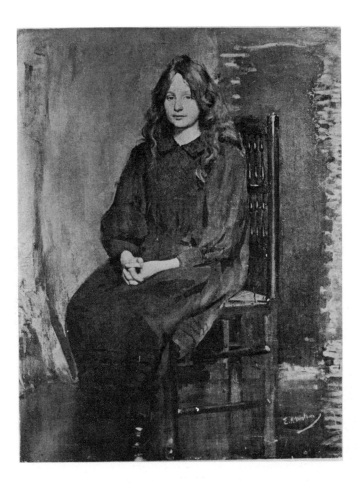

135
E. A. Walton
The Girl in Brown
1888
Canvas
Untraced

title *Phyllis*. The positioning of the sitter within the canvas, the open approach to the subject and the strong tonal arrangement all reflect the comments of the Institute reviewers – power, tonal harmony and a strong feeling for his subject. The strength of colour seen here, however, may be accounted for by the medium as Walton's watercolours are usually clear and bright if not achieving Melville's intensity of hue. It was presumably through contact with pictures such as this by Walton, however, rather than Melville's more exotic subjects, that George Henry turned his attention to figurative watercolours, producing a number of similar studies throughout the later 1880s.

In 1885, the last year that he was to visit Cockburnspath, Walton began work on a painting which was perhaps his first true attempt at a large-scale exhibition picture. Guthrie had always seen his path to public recognition as lying by the route of the traditional exhibition painting, a serious statement on an impressive scale. This was no doubt a relic of his early association with Pettie and Orchardson, whose lives were geared to the annual production of several large paintings which would hold their own on the walls of the Academies alongside the similar exercises of their rivals. *A Funeral Service in the Highlands, To Pastures New, Schoolmates* and *In the Orchard* were Guthrie's response to this tradition. Walton, however, had never really embarked on a similar composition, most of

136
E. A. Walton
Victoria Road, Helensburgh
1883
Watercolour, 33.6 × 51.4
Private Collection

137
E. A. Walton
En Plein Air
1885
Watercolour, 44.5 × 59.7
Sir Norman Macfarlane

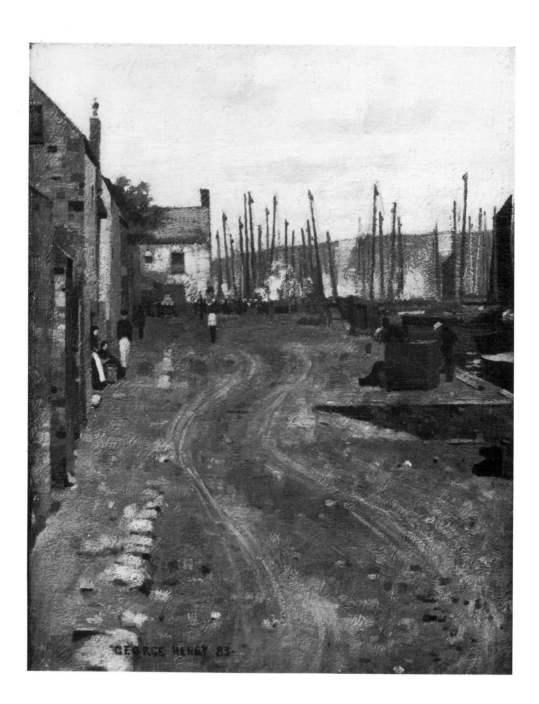

138
George Henry
Eyemouth
1883
Canvas, 38 × 30.5
Angus Maclean

his work being on a domestic or more intimate scale. *A Daydream* (pl.140) is probably the first painting Walton ever produced on this scale and it takes its place alongside *To Pastures New*, *The Vegetable Stall*, *Schoolmates*, *A Hind's Daughter* and *On the Loing* as one of the most important British paintings of the decade. The foreground and the overall tonality may owe something to Lavery's Grez masterpiece, *On the Loing*, but the composition is spatially more complicated than that picture or, indeed, any other Glasgow School work so far encountered. The scale of the two figures of the children and their positioning so

close to the frontal plane of the canvas is a bold step for a painter whose previous pictures had been more modest in intention. A subtle tension of movement is created by the poses of the children: the girl sits upright but her legs and feet define a strong diagonal as they project towards the viewer; the boy's body disappears behind the bank as the line of his back echoes the diagonal of the girl's legs but this time in a receding rather than advancing line. This contrasting movement is tempered by the now almost obligatory verticals of birch trees and the dominant horizon which effectively creates a silhouette of the girl's head against the pale background while the boy's head is ranged against the grassy bank. The brushwork and handling is typical of the naturalist works of Guthrie and Lavery, detailed in the foreground and in the hands and faces of the figures, becoming looser and less defined elsewhere to create a perspective in what is otherwise a very restricted, almost blinkered, aspect of the landscape. What distinguishes the painting from similar essays by Guthrie (or even Bastien-Lepage, the pose of whose haymaker in *Les Foins* closely resembles that of Walton's girl) and marks it as clearly a work by Walton is the painting of the two cows in the background. Nothing happens in any of Guthrie's naturalist pictures which might distract attention away from the central focus of the composition. Here, Walton has introduced a secondary subject of cows trampling through the undergrowth which, given the size of this painting, could almost stand on its own merits alongside his other pictures such as *Autumn Sunshine* and *Noon-day*.

Although begun *en plein air* at Cockburnspath the painting was completed at Helensburgh in the autumn of 1885[49] and was hanging in Walton's Glasgow studio in January 1886. According to reports in *Quiz* and *The Bailie* the picture was not sent to the Institute in 1886 but was reserved by Walton for the Royal Scottish Academy or the Grosvenor Gallery in London. If he did, in fact, send it to Edinburgh then the Academicians rejected it; nor does it seem to have been shown in the Grosvenor's summer exhibition. Its public debut was in Glasgow at the Institute in 1887. Most of the reviewers noticed it and their reaction was generally favourable. Guthrie's *In the Orchard* was hung in the same room at the Institute that year and the reviewers consistently compared the two paintings and usually made the same criticism, that both pictures were larger than the subjects deserved. Otherwise, the fluidity of handling and strength of colour of *A Daydream* were both commended. Walton, however, rarely worked on this scale again and began a gradual move away from naturalism towards a style more related to the harmonies of Whistler, a painter who began to wield a far greater influence than even Bastien-Lepage over Walton, Guthrie and Lavery.

Like Walton, George Henry had not exhibited pictures of the scale of most of Guthrie's public offerings. Although he had been at Brig o' Turk with Walton and Guthrie in 1881 he had not followed them to Crowland or worked elsewhere with them in 1882. He was, however, attracted to Cockburnspath and exhibited a series of Berwickshire subjects over the next two or three years. In 1883 he spent part of the summer at the fishing port of Eyemouth, not far away from the Boys at Cockburnspath whom he would certainly have visited. James Nairn, his friend and fellow member of the St Mungo Society, probably went with him; certainly, Nairn exhibited one Eyemouth picture at the Art Club in November 1883, *Old*

139
James Paterson
Autumn in Glencairn
1887
Canvas, 101.5 × 127
National Galleries of
Scotland, Edinburgh

140
E. A. Walton
A Daydream
1885
Canvas, 139.7 × 116.8
Andrew McIntosh Patrick

141
George Henry
Playmates
1884
Canvas, 68.5 × 114
Private Collection

Barracks, Eyemouth (no 60, untraced). Henry showed two Eyemouth paintings at the Institute in 1884, *A Street in Eyemouth* (no 425, untraced) and *Eyemouth* (pl.138). This latter painting shows the clear influence of Guthrie in its pure colours, use of square brushes and the thickly laid paint in which the marks of the brushes are left very clear. Henry was one of Macgregor's 'pupils' at his Glasgow studio during the winter of 1883–4 and the following spring *The Bailie* noted that Macgregor and Henry ('an artist of great promise') had left Glasgow for Dunbar, while Guthrie and Walton were already further south.[50] Perhaps Macgregor then accompanied Henry to visit them, although the relentless chronicler of artistic movements noted that he returned to Glasgow from Helensburgh, alone, while Henry returned separately from Cockburnspath.[51]

Gradually, Henry began to gain his independence while painting alongside Guthrie and Walton. In his most important picture of 1884, however, he still shows an indebtedness to Guthrie, both in technique and in intent. *Playmates* (pl.141) seems to owe much in subject, tone and handling to Guthrie's *To Pastures New* and *Schoolmates*. The choice of children as a subject for what was Henry's first large-scale exhibition painting cannot have been accidental; its clear, bright sunlit setting, like Roche's *The Dominie's Favourites*, is directly related to Guthrie's personal response to naturalism. The critics, however, recognised its allegiances to the new school as well as the relative inexperience of its creator:

A similar feeling for harmony, acquired, we fancy, by contact with the French school, is manifested in . . . G. Henry's broadly painted *Playmates*, whose colour arrangement consists in the apposition of soft flesh tints, blue frocks and white pinafores upon a background of grey wall.[52]

Elsewhere we find a disregard of the actual necessities of canvas in George Henry's *Playmates* (no 523), a couple of girls playing at 'chucks', with a background of sunny wall space, against which, as in cool relief, some pot plants grow in rather straggling fashion.

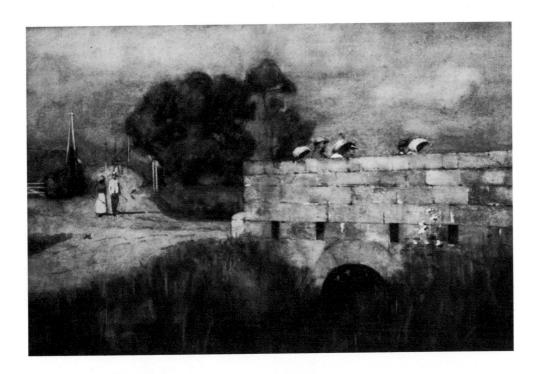

142
George Henry
Fieldworkers Crossing
a Bridge
1884
Watercolour, 29 × 44.5
The Fine Art Society

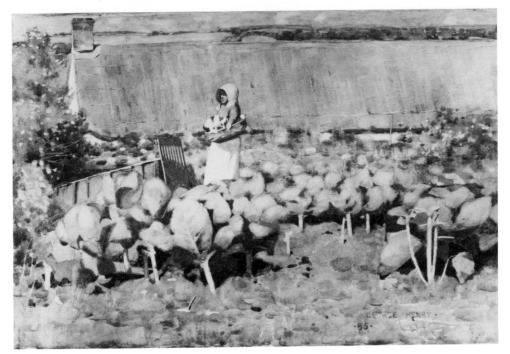

143
George Henry
A Cottar's Garden
1885
Watercolour, 29.3 × 44.5
Hornel Trust, Broughton
House, Kirkcudbright

When Mr Henry takes child-life for his theme he might contrive to throw a little animation into the faces of the girls, who, in the present instance, are sober beyond their years.[53]

Henry's feeling for the decorative aspects of composition and the greater emphasis which he was to place on pattern are already apparent in the picture.

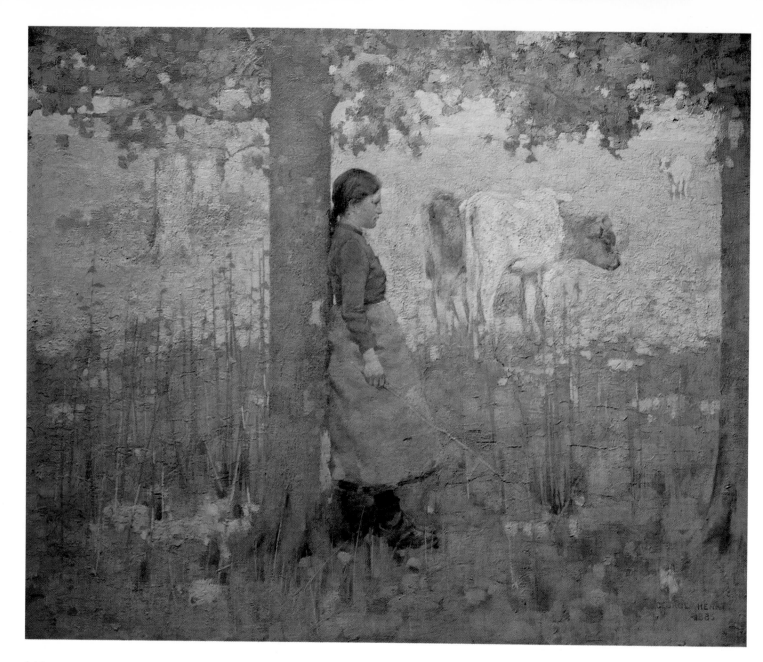

144
George Henry
Noon
1885
Canvas, 51 × 61
Private Collection

145
E. A. Walton
The Gamekeeper's Daughter
1886
Watercolour, 43.5 × 34.5
Glasgow Art Gallery

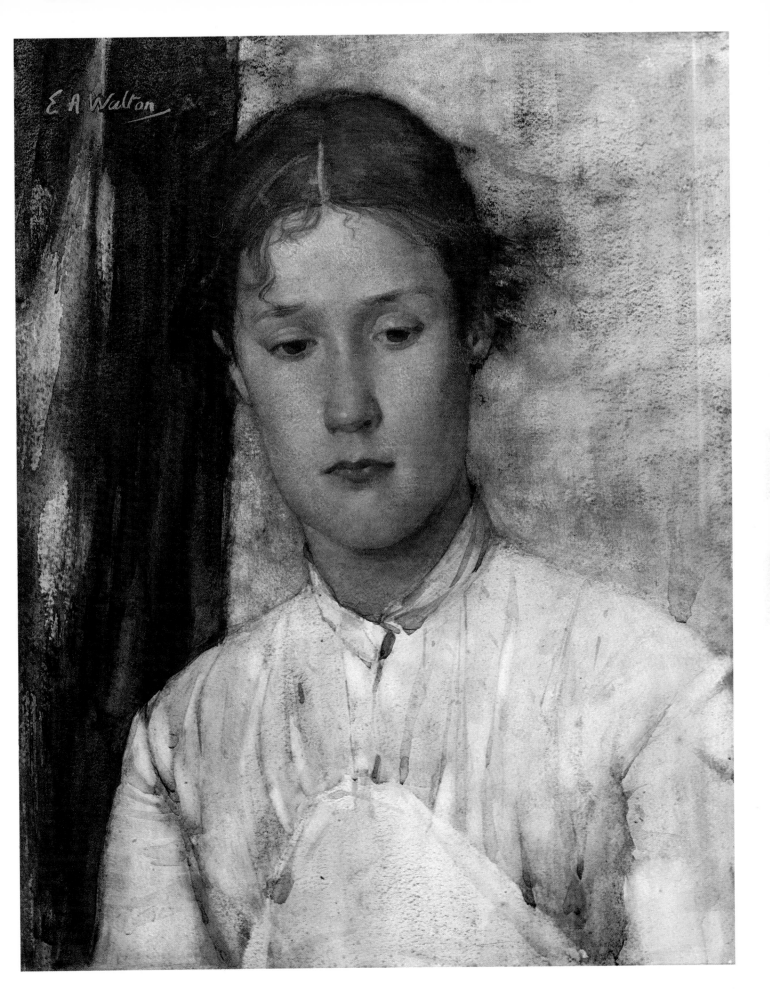

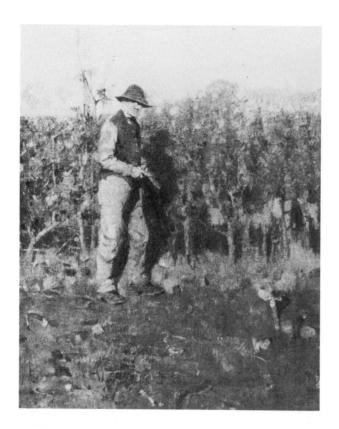

146
George Henry
The Hedgecutter
1886
Canvas
Untraced

147
George Henry
Study of a Girl
1885
Pencil, 19.8 × 17.8
Hornel Trust, Broughton
House, Kirkcudbright

That it was well received by the Boys, if not the critics, is shown by Macgregor's purchase of the painting as an Art Union prize at the Institute.

The following year Henry returned to Cockburnspath where his work began to show a maturity and clearer sense of direction. He had already shown a skill in the handling of watercolour in his Brig o' Turk days and his earliest Cockburnspath paintings return to the medium. His subjects were the familiar ones of labourers and fieldworkers (pl.142), again following Guthrie and Walton. In a version of that Glasgow School 'trademark', a cabbage patch (pl.143), he showed that he could produce work in the medium which could stand comparison with the fine Helensburgh subjects that Walton was producing. There followed a series of rustic subjects, a form of quiet realism depicting cow-girls, field-labourers and the like which made great play on the intensities of light and shadow *en plein air*. *The Hedgecutter* (pl.146) was bought from the Institute by James Gardiner in 1887.[54] Its colour and tone were probably similar to *Noon* (pl.144), Henry's best surviving *plein-air* work after *Playmates*. The drawings which Henry made of the girls (pl.147 & 150) who appeared in *Playmates* and *Noon* show an indebtedness to Guthrie, who had made similar studies for *Schoolmates* and presumably for his other naturalist paintings. The composition of *Noon*, however, shows Henry making deliberate use of light and shade and compositional props such as the trees to create a strong sense of pattern within the framework of a naturalist painting. *Noon* may not have been painted at Cockburnspath, as it was in 1885 that Henry first met a young man from

Kirkcudbright who persuaded him to spend some time in Galloway during the summer. E. A. Hornel learned much about the latest developments in painting from Henry and one of his earliest naturalist pictures, *Resting* (see p.182), may have been painted at Henry's side. Guthrie certainly spent part of 1885 in Kirkcudbright, along with Corsan Morton who was also at Cockburnspath that year. Henry was to return to Berwickshire in February 1886[55] to spend two weeks with Guthrie before the latter gave up his house and returned to Glasgow.

148
Thomas Corsan Morton
1859–1928

149
J. Whitelaw Hamilton
1860–1932

150
George Henry
Studies of a Girl
1885
Pencil, 22 × 12.6
Hornel Trust, Broughton
House, Kirkcudbright

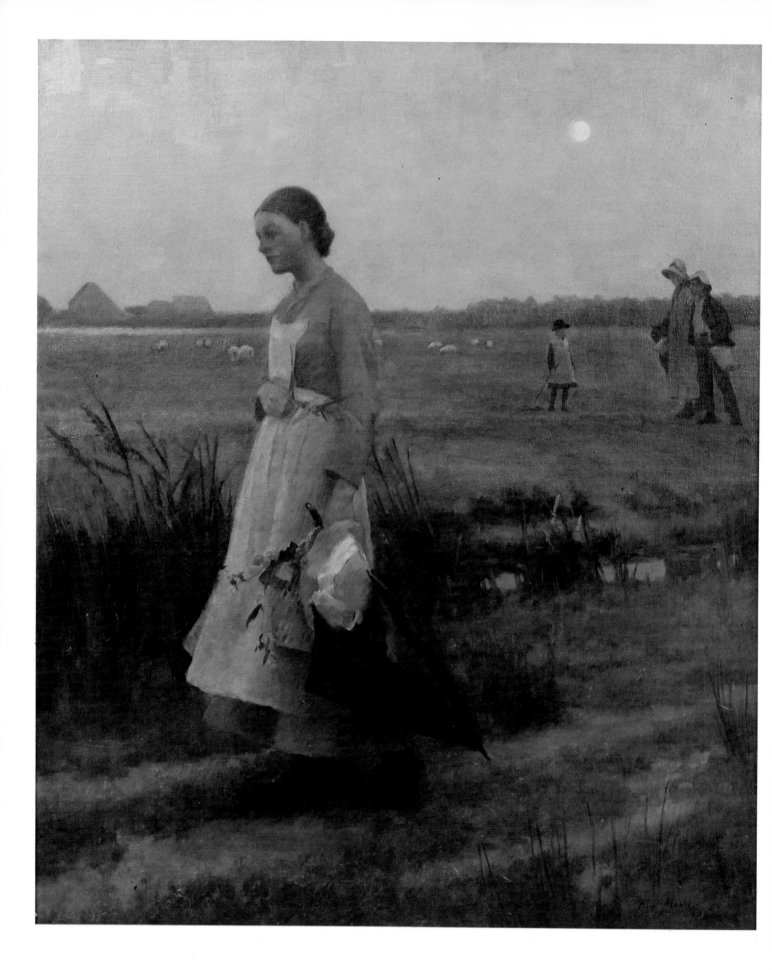

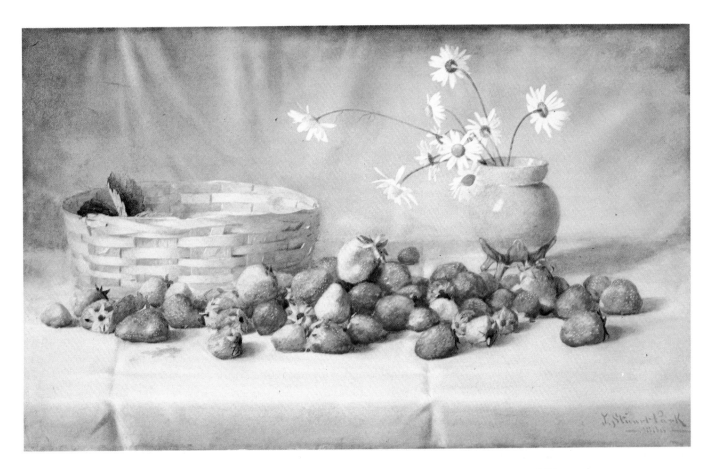

152
Stuart Park
Strawberries
1886
Watercolour, 40 × 67
Sir Norman Macfarlane

151
Alexander Mann
Hop-pickers Returning
1883
Canvas, 117 × 96.5
Hunterian Art Gallery,
Glasgow

154
Thomas Corsan Morton
The Duckpond
c.1885
Canvas, 38 × 35
Angus Maclean

153
Thomas Corsan Morton
An Autumn Day,
Berwickshire Coast
1885
Canvas, 34 × 60
Angus Maclean

Thomas Corsan Morton (pl.148) and J. Whitelaw Hamilton (pl.149) were the final two Boys to settle in Cockburnspath for their annual painting seasons *en plein air*. None of Hamilton's Berwickshire pictures has survived and only two by Morton cast any light on his contribution to the new work of the mid-1880s. *An Autumn Day, Berwickshire Coast* (pl.153) shows a fairly typical Glasgow School scene, with sheep as woolly in form as those that Walton was often accused of painting. A more interesting picture is his *Duckpond* (pl.154), an altogether tighter composition, making good use of the strong sunlight and dappled shade in a manner that Guthrie had given up by this date in favour of a more even-toned canvas.

As at Grez, Cockburnspath helped the Boys to develop a way of working that was part of the mainstream of modern painting, but at the same time was peculiar to those few painters with the particular talents to take advantage of what was on offer. At Grez that was a tradition, admittedly a fairly young one, and a school of young painters who were prepared to share the ideas they themselves had developed with the young Scots painters. At Cockburnspath, Guthrie, Walton and Melville had to forge their own way, overcoming or by-passing the various problems which beset their work, resolving their difficulties among themselves as there was no one else to turn to for help. By 1885, both groups had advanced far enough and along similar lines to recognise that the way forward lay by pooling their experiences in a return to the city which they had all left three years earlier.

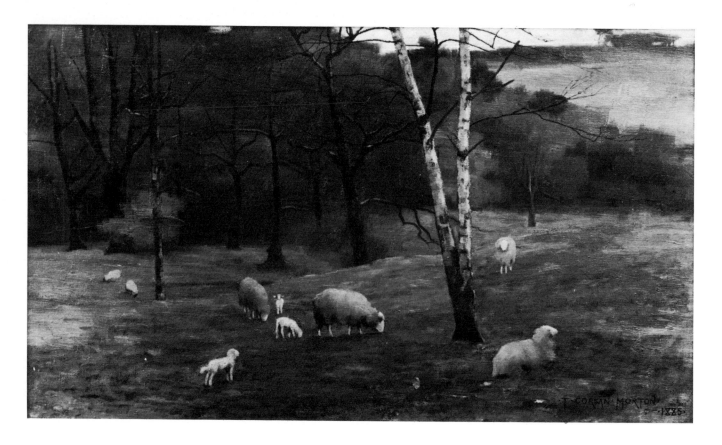

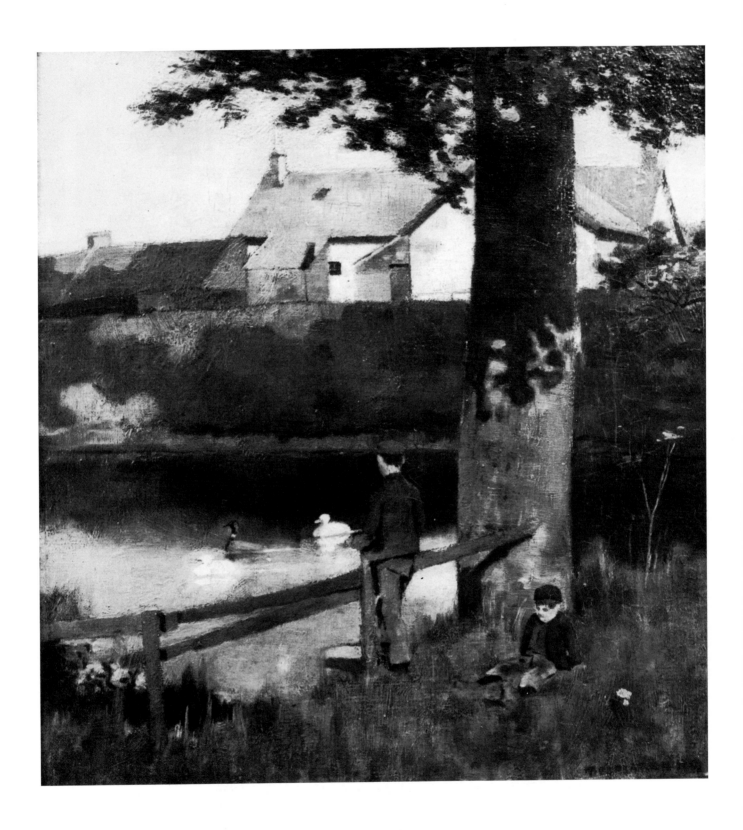

155
James Paterson's winter
studio on the Craigdarroch
Water, Moniaive
Paterson Family

156
W. Y. Macgregor (left) and
Alexander Roche at James
Paterson's studio, Moniaive
Paterson Family

157
George Henry (left) and
James Paterson at
Paterson's studio, Moniaive
Paterson Family

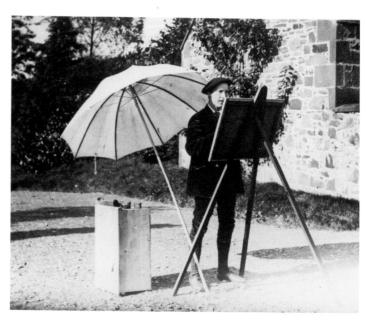

158
James Paterson, 'en plein
air', at Kilniess, Moniaive
Paterson Family

Moniaive and Glasgow

James Paterson continued to make annual visits to the Paris *ateliers* until the winter of 1883. He does not, however, seem to have joined the other Boys at Grez; nor is he recorded among those who made Cockburnspath their summer home in the years 1883–5. Although his early friendship with W. Y. Macgregor had resulted in a number of joint painting excursions to the east coast, the two spent less time together from about 1882. Paterson was still a frequent visitor to Macgregor's life-classes in his Glasgow studio but he began to spend his summers in Moniaive, a Dumfriesshire village sitting at the junction of the Craigdarroch and Dalwhat waters. His first visit there was in 1879 but one of his earliest surviving paintings of the village dates from 1882 (see p.41). From this year onwards he was to spend more of his time at Moniaive and in 1884, after his marriage to Elizabeth Grier Ferguson, Paterson settled in the village.[1]

Paterson was the first of the Boys to marry; it was a step which was to distance him from his younger, less inhibited friends. He and Macgregor had always seemed a little aloof from the rest of the group. Partly this was to do with age, partly to do with character. They corresponded for many years after they had both left Glasgow, their friendship sustaining them against the cooling of their relationships with the rest of the Boys. Macgregor's assumed superiority over his fellow artists, implicit in his Glasgow life-classes, did not endear him in later years to his peers. When he was forced by poor health to leave Glasgow in 1885 it was Paterson who kept him in touch with what was happening in the city for the other painters were poor correspondents. Paterson, similarly, incurred the dislike of the Boys, particularly Hornel and Henry, who felt that he tried too hard for respectability – harder even than Guthrie, whose aspirations were often mocked by his young friends at the Glasgow Art Club. Paterson's marriage and his new-found responsibilities towards his family did cause changes in his attitude towards the Boys and, indeed, towards painting itself. Being so far away from Glasgow he was kept up to date, as was Hornel to a certain extent, by hearsay, rumour and letters; but, unlike Hornel, he did not have a confidant such as Henry to keep him abreast of the latest nuances of style or status. His ambition was reflected in his championing of the new magazine, *The Scottish Art Review*, which, following its failure in 1889, lost the Boys money; Paterson could possibly afford the money but few of his friends could.

There was also one other major difference between Paterson and the other major Glasgow painters: he was primarily a landscapist, to whom figures were incidental in the production of his paintings, while the majority of his friends were more concerned with figure painting. His love of landscape, and his

undoubted skill in capturing its moods, drew him to Moniaive rather than Cockburnspath. The gentle east coast fields and farms had little of the appeal of the tumbling waters of the glens around Moniaive and none of the drama of the changing seasons. Paterson was not, however, attracted to landscape in the same way as the panorama painters of the 1850s and 1860s. He was certainly at his best painting vistas but they are seen as real and not romanticised views. His French training gave him a keen sense of tonal values and he sought them out on his canvases, bringing realism to his large-scale paintings of the Dumfriesshire countryside.

An unexpected bonus for the historian has arisen from Paterson's early domesticity. It has meant that, with the exception of the papers kept by Hornel, there has survived a larger number of private papers from the period than is usual with the Glasgow Boys. These mainly take the form of transcripts of letters from Macgregor which were compiled by Paterson in later life as the basis of a lecture about the early history of the Boys. In addition there are a number of photographs of his studio, his family and friends, and the landscapes he chose to paint. He was a keen amateur photographer, using the camera to provide him with additional material which would be of use to him in the studio. It also possibly helped him with the problems of bringing realism to landscape painting through a concentration on its tonal values rather than on its purely pictorial, or picturesque, aspects. A black and white photograph would give him a ready guide to the distribution of tones within the landscape helping in the selection of the relevant and the discarding of the unnecessary which was so important a part of his approach to landscape painting.

These photographs did not replace *plein-air* painting, however, but acted as a form of sketch-book which was additional to the oil and watercolour studies made on the spot. His conviction that *plein-airisme* was the source of any movement forward in modern painting was held so deeply that he even went to the trouble of building his own winter studio on the Craigdarroch so that he could continue to paint out-of-doors while snow lay on the ground (pl.155). His camera also recorded the visits of his friends to his house, Kilniess, at Moniaive. A wedding present from his parents, this small cottage on the outskirts of the village was enlarged by the Glasgow architect, J. J. Burnet, to provide a family home and a new studio. W. Y. Macgregor was certainly a visitor (pl.156); Paterson also photographed George Henry's visit (pl.157), presumably before their friendship cooled towards the end of the decade. He, or his brother Robert, also took his own photograph, posed in front of the sketching easel in the open air. Dressed in velvet jacket, with knickerbockers and beret, he cuts a dash as the gentleman painter; note also the ubiquitous white sketching umbrella (pl.158). A photograph of his wife in her wedding dress (pl.159) suggests that the fine portrait he painted of her wearing the dress (pl.160) may also have been painted with the assistance of the camera. As one of the first of his portraits it is a fine achievement, capturing the nervousness of the sitter in a painting which displays the artist's knowledge not only of Whistler but also his clear assimilation of French practice and theory. It seems unlikely that Guthrie or Walton saw the picture before painting their first realist portraits in 1885; judging by the *Revd*

Andrew Gardiner (see p.144) and Walton's portrait of his mother (see p.144), Paterson's painting has more colour and a more refined sense of harmony. The Whistlerian setting is also more sophisticated and elegant and had Paterson decided upon a career as a portraitist he would undoubtedly have achieved success similar to that of Guthrie, Walton or Lavery.

Paterson chose, however, to pursue his love of landscape and immersed himself in the village of Moniaive and its surroundings just as Guthrie did at Cockburnspath. It was the glens and burns which became the centres of Paterson's paintings, not the villagers themselves, although they occasionally find some role within the pictures. In the mid-1880s he painted a group of landscapes which summarise his aim of rendering a realistic representation of the local countryside. He painted the quiet paths alongside the rivers as well as the grander vistas along their upland tributaries. In all of them he achieved a quiet and pleasing tonal harmony and a quality of realism which does not depend for its effect on the naturalist formula which some of the Boys adopted from Bastien-Lepage. Paterson paints a wider vision of the landscape than the more restricted, circumspect approach of Guthrie, Walton and Lavery. Foreground detail,

159
Eliza Ferguson (Mrs James Paterson) in her wedding dress
1884
Paterson Family

160
James Paterson
The artist's wife, Eliza Ferguson, in her wedding dress
1884
Canvas, 91.5×61
Mark Paterson

161
James Paterson
Moniaive
1885
Canvas, 102 × 152.5
Private Collection

verticals carefully placed in the frontal plane of the canvas, perspective indicated through handling rather than recession – all these devices which were so much a part of the Grez and Cockburnspath naturalism could not be used in paintings which showed hills, fields and rivers in their true relationships and on a scale which demanded different methods. This is not to say that Paterson did not devise his own formulas, his own shorthand and methods of adding interest to pictures which made a virtue of the uneventful. The photograph of his winter studio shows the most commonly used format of these pictures – the receding diagonal of the riverbank, rising at a near-vertical angle into the centre of the painting to lead the eye deep into the composition. The line of the river is often repeated in parallel ranges of fences or footpaths, occasionally by a line of trees. In *Dunglaston* (pl.163), painted in 1884, he used several such features to create a composition which seems to make too much of the search for movement, or rather an attempt to prevent stagnation of the design. The fences, the curve of the lane, the shapes and patterns of the roofs of the houses break up the gentle vision of the landscape itself in too excessive a manner. The following year saw Paterson resolving some of these problems and achieving a quality in his work which approaches and sometimes equals that of Guthrie and Walton.

In at least two paintings of 1885 the movement of the viewer's eye towards the

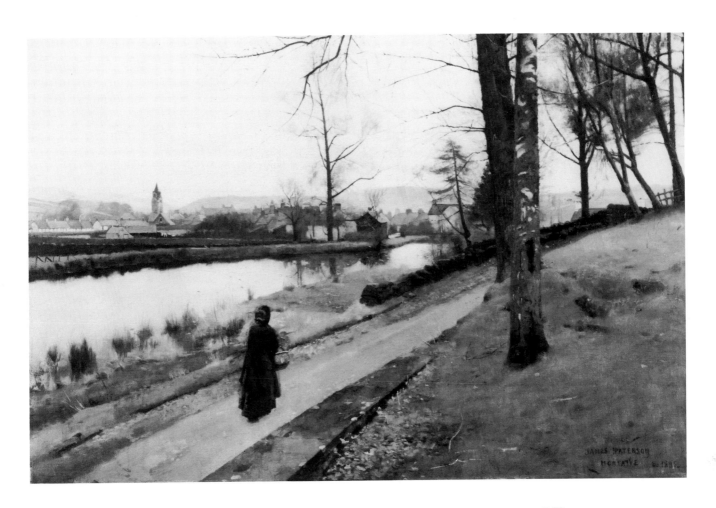

162
James Paterson
*The Last Turning, Winter,
Moniaive*
1885
Canvas, 61.3 × 91.4
Glasgow Art Gallery

163
James Paterson
Dunglaston
1884
Canvas, 48.3 × 75
*Smith Art Gallery and
Museum, Stirling*

horizon is assisted by the presence of figures who are shown walking away from the foreground into the distance. *Moniaive* (pl.161) and *The Last Turning, Winter, Moniaive* (pl.162) both employ this device, introducing a figurative detail to what are otherwise classic landscape compositions. The former picture is very close in design to a reversed print of the photograph of the winter studio, which shows how Paterson was at least aware of the benefits of photography even if he cannot be shown to have made direct use of it. Printing a negative in reverse was a favourite ploy of Hornel's after 1900, but in his case it was more to make up for lack of inspiration than for any experimental purpose. These two paintings show Paterson recording his landscapes in a matter-of-fact manner. They are realist in a different way from the work of the Cockburnspath painters, making a pictorial statement about the reality of nature and landscape and not about the reality of life of its human inhabitants. In *Autumn in Glencairn* (p.150) Paterson omitted the figure and it was replaced by a rather more dramatic concept of landscape than is usual at this date. The reflection of the clouds in the water makes its surface stand out from the surrounding autumnal colours and the same light is shown on the top edges of the rails of the fence. The sharp recession of the fence is also unusual, but it serves to lead the eye deep into the composition, echoing the line of the river. When it was shown at the Glasgow Institute in 1888 one reviewer recognised it as Paterson's most important painting to date:

In the large scene, *Glencairn in Autumn*, Mr Paterson gives us the most important and successful landscape work that he has yet produced. The picture is excellent in its sense of space and distance; in the free but expressive and sufficient handling of the embrowned leafage of the trees; in the treatment of the hurrying cloud masses and, very especially, in the detailed, but most delicate and lovely, rendering of their heaped masses, rosy and grey, in the quiet mirror of the foreground water.[2]

It remains one of the finest of this group of large paintings of Moniaive, many of which have disappeared after being sold in Europe at the exhibitions to which the Boys were invited in the 1890s.

Paterson stayed in Moniaive until 1897, when he moved to Edinburgh, returning to the village only for a few weeks during the summers. The move was for family reasons, and, no doubt, the realisation that to pursue an artistic career in the capital city was likely to be more profitable than remaining in the country. He presumably believed that he had fulfilled the intentions of his writings of the early 1890s when he justified his decision to remain at Moniaive:

When a painter loses touch with reality he is in a perilous state. No definite course of life and study can be specified, but there was some suggestiveness once given that to paint landscape, and find out for oneself its possibilities, it were well not to flirt with a new neighbour each recurring summer, but to marry metaphysically some well-chosen space, seeking not the obvious picturesque, but allowing nature's features gradually to find their way to the heart, and thence issue in sentient artistic expression.[3]

It was a translation of Guthrie's sentiments about the life of a village into the more abstract concept of studying nature through its varying effects upon one site. It gave Paterson's work, however, the same intensity and direction that his colleagues and friends had experienced and, like them, when the spur was removed the impetus gradually fell away.

164
Alexander Mann
Still Life
c.1881–2
Canvas, 65 × 92.5
The Fine Art Society

Alexander Mann spent much of the early 1880s in France, where he visited Grez and presumably renewed old Glasgow acquaintances. Mann's financial independence must have set him apart from the other Boys, as only Macgregor and Paterson had any real financial backing from their families. Perhaps this was part of the reason for Mann's distance from the rest of the group – he did not share their struggle for acceptance, their need to sell pictures in order to live, and he also had the resources to travel. His love of travel and the indulgence of this love to some extent meant that he was never very long in any particular place and never achieved that total immersion in village life that Guthrie, Walton, Lavery and Paterson found necessary in their attempts to produce work in a modern manner. There are, however, a number of paintings which show that Mann assimilated some of the teachings of Bastien-Lepage and that he was a skilful practitioner in the French method – the search for *les valeurs*.

An early still-life (pl.164) shows Mann working in the tradition of Bonvin and Ribot, and also hints at his knowledge of the work of Cazin. Macgregor's *The Vegetable Stall* (see p.75) may owe something to its strong and clean handling, to its immediacy of effect and tonal realism. It is, however, very much a posed still-life and lacks the spontaneity and realism of conception of *The Vegetable Stall*. If it is obviously a studio work, then a group of paintings of 1883–4 show his grasp of *plein-airisme* and the value of taking subjects from rural life. *Phyllis* (pl.166) is in the mould of single-figure compositions which so appealed to Guthrie and which ultimately stem from Lepage. It is very much a tonal *plein-air* painting, very French, but it does not altogether avoid involving the viewer with the subject in an anecdotal way. In this it is similar to *Idling on the Sandhills, Forvie*

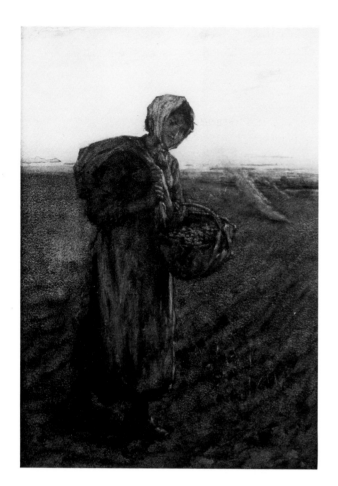

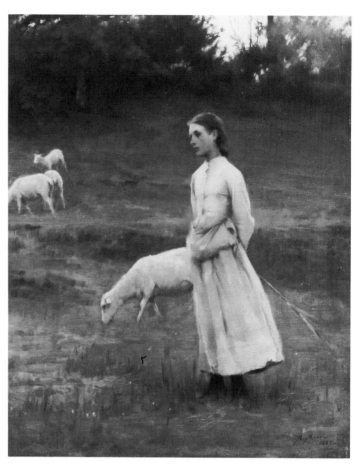

165
Thomas Austen Brown
Homewards
1887
Watercolour, 51 × 35.5
The Fine Art Society

166
Alexander Mann
Phyllis
1883
Canvas, 68.5 × 53.5
Private Collection

(Coll: Aberdeen Art Gallery) which was painted in 1882 and which depicts two young girls on the sand-dunes. The elder of them is leaning against her wicker basket, the weight of which seems to have tired her, while the other plays games in the sand to her amusement. The element of incident is also present in this picture, which otherwise is very much in the tradition of what is now known as the Glasgow School; Mann's years in Paris and his not inconsiderable talents actually gave him a precocity over Guthrie at this date. The impact of Guthrie's works of the next few years was, however, never apparent in Mann's work, although in one painting he approached the canon of Glasgow realism: *Hop-pickers Returning* (pl.151) is a large picture which is the most considerable statement that Mann was to make in the 1880s. There is still some of the emotional involvement with the subject that is visible in *Phyllis* but it is not so near the surface; the composition is more assured and the handling is his masterpiece of tonal painting. The painting was shown at the Glasgow Institute in 1884 along with *Idling on the Sandhills, Forvie* but neither seems to have aroused critical attention.

Another strongly realist work, *The New Baby* (pl.167), shows Mann's ability to construct a painting in a very professional manner. Again, however, a degree of sentiment that is not usually apparent in Glasgow School works reduces its

impact. In some ways Mann can be likened to many of the Newlyn School painters who used the new 'naturalist' style to dress up the popular historical or incident pictures so well-loved by Academy audiences. Mann did not have to paint in this way in order to sell his work, although the public were likely to find it slightly more palatable than Guthrie's realism. He never seriously tried to sell a picture in his life so we can draw the conclusion that he either did not understand the finer points of what the Boys were trying to achieve or that, having understood and seen where it led, he decided to deliberately adjust his version of realism and develop a personal style. Whatever the answer, while there is no doubt that the Boys found Mann an agreeable fellow traveller he did not settle down into their ranks. After his marriage in 1887 (at which Millie Dow was his best man) he moved to England and his contact with the Boys gradually diminished.

Other painters whose association with the Boys was temporary or transient began to make their appearances in Glasgow at this time. A number of men espoused the cause of naturalism in the mid-1880s and the Boys may have looked to them as allies. Thomas Austen Brown was an Edinburgh painter who may have visited Cockburnspath while Guthrie was there. His work is very much in the mould of Robert McGregor, painting rural characters in a tonal manner,

167
Alexander Mann
The New Baby
c.1886–8
Canvas, 129.5 × 155
The Fine Art Society

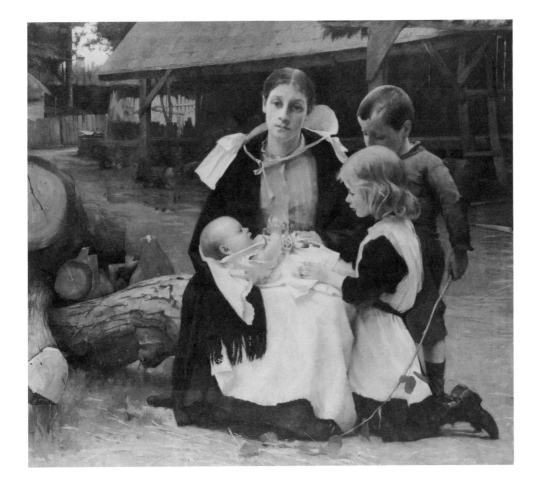

eschewing incident but not adopting the rather more detached outlook of Guthrie and Walton. *Homewards* (1887, pl.165), is typical of his work in the 1880s. In his choice of a single-figure composition he follows French and Glaswegian precedent but the landscape background is only hinted at with no real attempt to make a serious statement about naturalist painting. He continued in this vein for several years, a fellow traveller like Mann rather than a full-blooded member of the group. Interestingly, his portraits seem much closer to the realist format arrived at by Guthrie and Walton in 1885 but from about 1890 his work becomes more painterly, not dissimilar to the later pictures of Kennedy and Henry whom he met at Cambuskenneth where he painted from 1888. Caw quite correctly saw in his work the influence of Millet and Maris, whom he would have been able to study in some depth at the Edinburgh International Exhibition in 1886.[4] He also realised that Brown never achieved the intensity of involvement with his subjects that is so apparent in the work of the Glasgow men and which ultimately prevented his assimilation by the Boys.

Whitelaw Hamilton had visited Guthrie at Cockburnspath in 1883 but he was still only an amateur painter at the time. In 1887 he was in Paris, studying under Dagnan-Bouveret and at Aimé Morot's. His involvement with Guthrie came about through his Helensburgh connections – his sister Maggie was helping Mrs Guthrie keep house at Dunglass – and it would have been on the advice of the Cockburnspath men that he went to train in France. His work is difficult to place within the recognisable strands of Glasgow School painting. Often very tonal – he painted a fine series of Clyde nocturnes – it never has the realist bite of the best of Guthrie and Walton. In later years, beginning in the 1890s, his love of landscape begins to give more direction to his painting, which may point to the influence of James Paterson, whose brother Alexander married Maggie Hamilton in 1897.

Three other young men who were to make their own substantial contribution to the second phase of Glasgow School painting first made their exhibiting debuts in the mid-1880s. Stuart Park (pl.168) is best known for his series of flower paintings, which he produced almost continuously from about 1888 until his death in 1933. In later years they became extremely repetitive, relying on a well-tried formula of pansies, roses and violets shown against a dark background; some of these pictures border on abstraction and many of them are very pretty but they do not uphold the promise of his early flower paintings. When the work of the Boys took a noticeable step towards the emphasis on the decorative value of pattern, when a strong sense of design became a new hallmark of Glasgow pictures, Park's exquisite paintings of roses at the end of the 1880s seem a secure part of the new style. In the mid-1880s, however, his work was more tentative. He was born in Kidderminster, the son of a carpet designer. He studied in Paris and Glasgow and began to exhibit at the Institute in 1883. Little is known of these early pictures other than their titles except for a watercolour of strawberries dated 1886 (pl.152) which was shown at the RSW that year. The detail of the fruits and flowers follows a long-established watercolour tradition but the tonality of the picture and the lightness of touch sets new standards. There is still some uncertainty of design in the composition but the basic format of his beautiful paintings of roses (see pp.254 & 255) can be seen in embryo.

168
*Stuart Park
1862–1933*

David Gauld (pl.169) was also to exhibit publicly for the first time in 1885. His early career is sketchy[5] but he seems to have worked as an apprentice lithographer, studying part-time at the Glasgow School of Art from 1882 to 1885. In 1887 he took a job as an illustrator on the *Glasgow Weekly Citizen* and his first pictures were exhibited at the Paisley Art Institute in 1885. These included views of St Monance in Fife, a painting entitled *Twilight* and an interior scene. None of these is now known and it is difficult, therefore, to know how they relate to the group of figure subjects that Gauld produced in the latter years of the decade. These latter paintings link him more closely with the proto-symbolist work of Hornel and Henry in Kirkcudbright. They emphasise the decorative qualities of the Galloway painters, perhaps not surprisingly as Gauld was to become a successful designer of stained-glass at the same time and some of his ideas for his new medium seem, not unnaturally, to have spilled over into his painting. In 1885, however, he was only beginning to make his mark in Glasgow but there is no clear indication of his attraction to or friendship with any particular faction of the new Glasgow School. He continued this rather distant relationship with the Boys and, with the exception of Macaulay Stevenson, his most lasting friendships seem to have been outside the group, even outside the main painting community in Glasgow, and more with architects or designers such as John Keppie and Charles Rennie Mackintosh.

One painter who did have a major role to play in the later history of the Boys was Robert Macaulay Stevenson. Although not perhaps the most original or inspired painter within the group (and certainly not the youngest, being born in 1854 and therefore five years older than Guthrie) he acted as its – unofficial – spokesman after about 1888. He was a keen activist in artistic politics within Glasgow, eventually becoming a contributor to *Quiz* (as was Guthrie for a short period at the end of the 1880s), and saw it as his calling in life to confound the Gluepots and orchestrate the gradual taking-over of the Glasgow Art Club by the 'new men'. His painting in the mid-1880s follows the lines set down by Guthrie and Walton in their Brig o' Turk pictures: tonal harmonies and a search for the 'values'; realist subject-matter concentrating on rural life; and open acknowledgement of the theories and practice of the French school, particularly the Barbizon painters of landscape and especially Corot. Corot's atmospheric landscapes soon took over from the more naturalist paintings of his Glasgow friends as the main inspiration of his work in the later 1880s. *Sunset on the River* (pl.170) is one of the earliest of Stevenson's paintings in this new style and shows how he adapted Corot's more limited palette adding to it strong reds and greens which are typical of the younger Boys, especially Hornel and Henry, with whom Stevenson was particularly close. His literary talents, his contacts in the Glasgow business world (his brother, Sir Daniel Stevenson, was a successful businessman who became Lord Provost of Glasgow and who was called upon several times to bail Macaulay out of financial ruin) and his vociferous criticism of the ideas behind *The Scottish Art Review* (and, by implication, of Paterson, its main protagonist) led him to assume the editorship of the magazine for several of its early issues. Lavery called him the prophet of the School and if he was not exactly that then he was certainly its main public advocate in the 1890s. In later

169
David Gauld
1865–1936

170
Robert Macaulay Stevenson
Sunset on the River
1887
Canvas, 76.2 × 45.6
Ross Harper

years – as he survived the longest-living member of the School by almost ten years, and, perhaps more to the point, did not forsake Glasgow in his old age – he became something of a symbol of all that the Boys had been in the 1880s – rebellious, cantankerous even, a contact with 'Jimmy' Whistler for a generation brought up on his *Carlyle* in Glasgow Art Gallery, a reminder of the time when Glasgow made a substantial contribution to the state of painting in Britain, and even the continent of Europe.

This was the Glasgow to which Lavery, and most of his Scottish friends who had been living in Grez, returned in 1885. At the Institute that year the Boys made not only an impact on the critics and collectors but also on themselves; they realised, I think, that they had begun to make a coherent statement about the future of modern painting and most of them returned to the city in the spring of 1885 in the belief that they could no longer be ignored by the artistic establishment of Scotland and they prepared for an assault on its bastions.

CHAPTER 8

Town and Country

For the first time, the Boys were to present a united front to their critics and admirers (though the latter were few) at the annual exhibition of the Glasgow Institute in 1885. They showed some of their most important paintings, pictures which had been produced as the result of a long distillation of the ideas which they had absorbed over the last four or five years. In all of the paintings can be seen their own concept of rustic naturalism which is at the heart of this first phase of their development. A brief list of the major exhibits gives a flavour of the exhibition: Henry's *Playmates* (see p.152); Paterson's *Autumn at Moniaive*; a Cockburnspath landscape and a portrait from Walton; *To Pastures New* by Guthrie (see p.74); Macgregor's *Pollards on the Tyne* (pl.171); *The Bridge at Grez* (see p.85) and *On the Loing – An Afternoon Chat* (see p.90) from Lavery; Millie Dow's *Hudson River* (see p.86); *Mademoiselle Cunégonde* by Kennedy (see p.102); and Melville's *Evie* (see p.119). In addition, Frank O'Meara's *Towards the Night and Winter* (see p.93) was also on show, lending support to the Boys and confirming the forward-looking attitudes that they displayed.

Another event, later in the year, showed how the Boys were gradually infiltrating artistic circles in Glasgow. The publication of *The Glasgow Art Club Book* (1885) marked a turning point in the Boys' relationship with one of the most conservative of the city's artistic bodies. For some time the artists of the club had resisted the admission of the Boys to their ranks but gradually they had been accepted, one by one. At the end of 1884 even Henry, who had been most frequently singled out for rejection, was enrolled along with Kennedy and Roche. Having breached its defences it is doubtful whether the Boys ever found it worth the effort as the majority of their fellow members were died-in-the-wool Gluepots and they would have found little in common with them. The eventual admission of lay members – Glasgow businessmen and collectors – would have been of interest as it provided the Artist Members with an ever-present circle of possible patrons but in the mid-1880s the main attraction of the Club was probably the warmth that its fires offered to a group of young men who otherwise might have shivered in the attic studios of Bath Street and West Regent Street. There was also the artistic respectability that membership of the Club conferred, but in 1885 there came the opportunity to appear in the new book of reproductions of members' work which was published that year.

Guthrie, Roche, Kennedy, Lavery, Macgregor, Nairn, Henry, Paterson and Walton were all included alongside some of the less adventurous members such as MacLaurin, Aitken and MacKellar. Nairn's picture, a view of West Regent Street (pl.172), seems particularly ill-at-ease alongside these costume pieces and

171
W. Y. Macgregor
Pollards on the Tyne
c.1884–5
Untraced

172
James Nairn
West Regent Street, Glasgow
1884
Canvas
Untraced

picturesque landscapes but it continues a theme which also appeared the same year in his exhibit at the RSW. *Notes in the Tunnel – Glasgow and District Railway* (untraced) sounds a far cry from rustic naturalism although Nairn's concern with a modern-life subject links it with the earlier realism of the School. *West Regent Street* suggests that Nairn may have painted several such pictures, based on recording his urban surroundings rather than those of the farms and rural subjects which he had painted earlier and to which he returned in 1886 on a visit to Arran.

Whatever the exact reasons for Lavery's decision not to return to France at the beginning of 1885 there can be little doubt that what he saw at the Institute must have offered encouragement to him in arriving at his final decision to stay in Glasgow and not immediately seek his fortune in London. Lavery seems to have spent the whole of 1885 in Glasgow and its environs instead of searching out a rural setting for his summer painting. He had sold only the two cheaper pictures at the Institute – *The Model* and *The Maid was in the Garden* – for less than £30 in total; the two large naturalist paintings did not sell. Lavery had been used to selling all his earlier pictures at the Institute but that was when he was painting costume pieces which appealed to a wider audience. Presumably with this in

173
John Lavery
Woman on a Safety Tricycle
1885
Watercolour, 35 × 52
Government Art Collection,
London

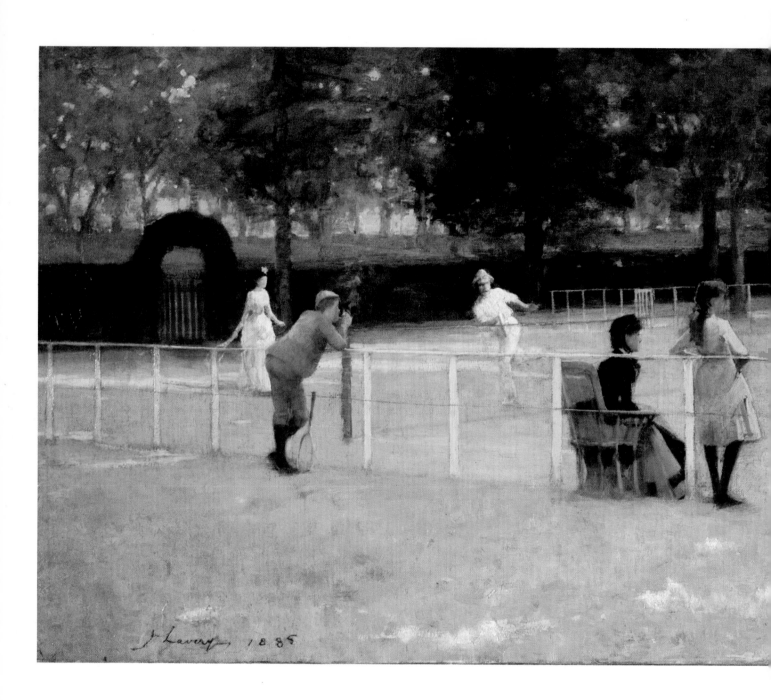

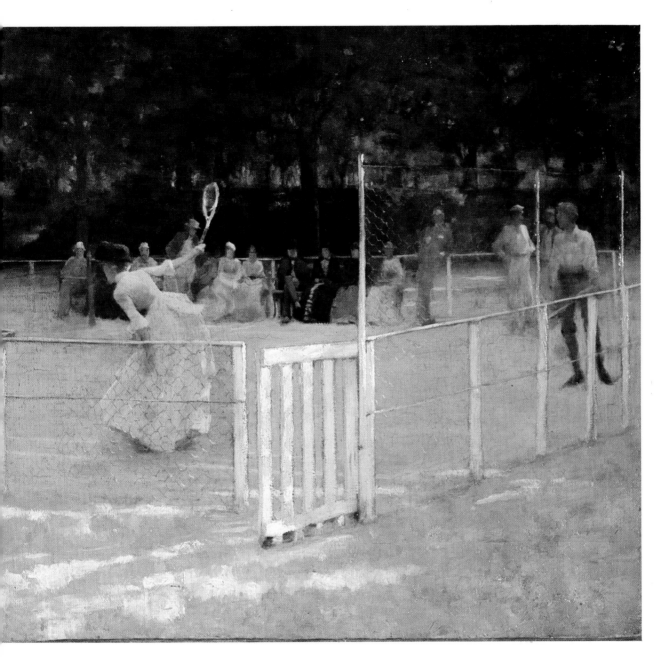

174
John Lavery
The Tennis Party
1885
Canvas, 77 × 183.5
Aberdeen Art Gallery

mind, and while remaining committed to *plein-air* methods, in the summer of 1885 he radically changed his subject-matter from rustic labourers to the daily life of the middle-class families who usually bought his pictures. It was undoubtedly a clever move by Lavery, to populate his paintings with his likely clientele but to retain the outward appearance of modernity which allowed the purchasers of his pictures to feel that they were advanced in their taste. They were now able to buy pictures in the newly fashionable naturalist style without having to hang in their drawing-rooms the paintings of peasants and labourers which were usually associated with the new style.

Lavery may have rationalised the change of content in later Glasgow School pictures but he did not originate it. Nairn's two paintings of 1885 show his similar awareness of scenes from modern life as suitable subjects for modern artists but it was almost certainly Walton who, unwittingly, directed Lavery towards his new work. Not only had Walton been painting scenes of daily life in Helensburgh for two years or more but, more importantly, they had been selling well and achieving good prices. These Helensburgh watercolours were probably the inspiration for Lavery's series of similar subjects such as *Woman on a Safety Tricycle* (pl.173) and *Au Bal* (Coll: Ross Harper). Unlike Walton, however, Lavery was to develop these themes beyond the limitations of watercolour and produce a large-scale exhibition picture in oil.

In May 1885 Lavery is recorded as having discovered the village of Cathcart in the south-west of Glasgow – 'Mr Lavery is charmed by Cathcart and is likely to have one or more pictures of it this year'.[1] The first of these pictures to be exhibited (at the RSW in 1885) was *A Rally* (pl.175) with the unusual subject of a lady playing tennis. Not only was the subject unexpected but the actual pose, of a player in mid-stroke, was novel for the Boys who hitherto had been concerned only with fairly static compositions. The picture was one of a series of studies related to a large painting, *The Tennis Party* (pl.174), which Lavery worked on through the winter of 1885–6 and showed at the Royal Academy in 1886.

The subject of a tennis match, although unusual, was not unique in Glasgow painting circles. In 1880 David Murray exhibited a painting entitled *Lawn Tennis* at the Glasgow Institute (no 549; untraced).[2] It has been suggested that Lavery might have conceived *The Tennis Party* as a deliberate affront to traditional tastes[3] but I think this is unlikely, although Lavery may have deliberately aimed at getting the maximum publicity from his choice of subject. Although Murray was classed as a Gluepot by the Boys, he shared their (and particularly Lavery's) strong sense of ambition. Like Murray, Lavery would have chosen the subject as one which would have appealed to the kind of collector he was seeking, just as the game itself appealed to the younger generations of the rich families he depicted in the painting. The picture itself, however, can not be dismissed as an elegant but insubstantial exhibition painting. It stands alongside Guthrie's Cockburnspath pictures and Macgregor's *Vegetable Stall* as one of the major achievements of the new School. It marks a change in technique for Lavery in that the foreground detail of many of the Grez paintings has been put aside and the spatial arrangement of the composition is much more complex than those relatively frontal compositions of 1883–4. It is

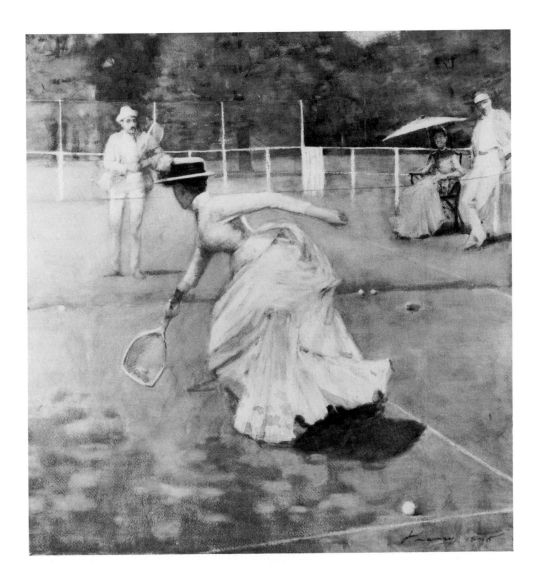

175
John Lavery
A Rally
1885
Watercolour, 65.9 × 63.4
Glasgow Art Gallery

also a picture which more than any other calls into question Lavery's use of the camera as an aid in arriving at the final composition.

Lavery had trained in Glasgow as a photographer's assistant with J. B. McNair; more importantly he had learned the trickery of the portrait photographer in the retouching (even repainting) of the negatives and prints which he had been specifically employed to carry out. He does admit to having used the camera as a short-cut to solving a difficult compositional problem when still a very young painter[4] but makes no further acknowledgement of it until his account of the painting of the large picture which records the visit of Queen Victoria to the Glasgow International Exhibition in 1888. When he was having difficulty in securing a sitting from the Queen he records that, if no sitting was forthcoming, he would prefer

a good untouched photograph . . . because while a painting expressed the opinion of the artist, the photograph expressed no opinion at all and gave me solid fact.[5]

176
E. A. Hornel
Resting
1885
Canvas, 38 × 28
Private Collection

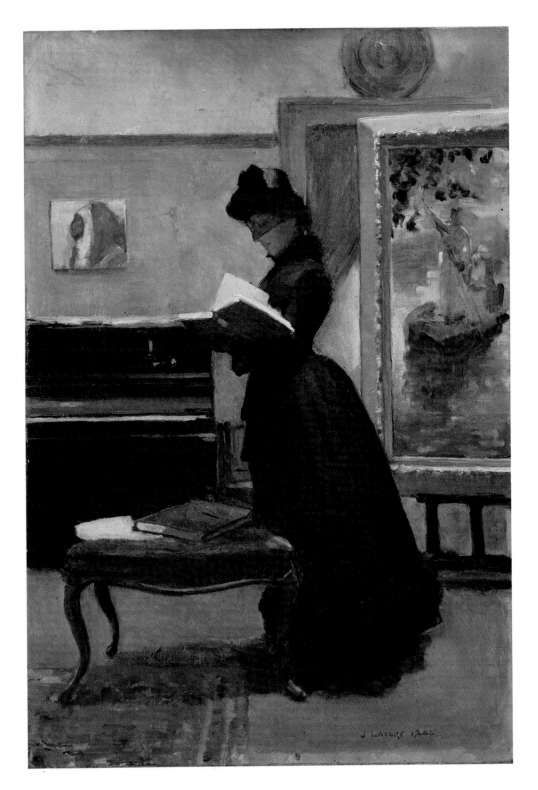

177
John Lavery
A Visit to the Studio
1885
Canvas, 33×23
Private Collection

While one can only speculate about Lavery's use of a camera there is the example of Bastien-Lepage which Lavery says was a great inspiration and which helped him develop his visual memory:

Always carry a sketch-book. Select a person – watch him – then put down as much as you can remember. Never look twice. At first you will remember very little, but continue and you will soon get complete action.[6]

Certainly there are a number of sketches, mainly in oil, which relate to the finished painting. In one of these he posed his figures in a way reminiscent of contemporary photographs but it may simply be the result of Lavery's close association with the new medium rather than evidence of his consistent use of it. Another of these studies suggests that he did not use the camera in its production as it contains a glaring error of perspective.[7] Whatever the exact circumstances, Lavery made a major statement in *The Tennis Party* which was to be acknowledged by the purchase of the picture by the Bavarian Government after it had been exhibited in Munich in 1890. The organisation of the composition has been described as 'spatial theatre'.[8] It was certainly one of the most spatially complicated Glasgow School pictures so far produced, but the artist was helped by the regularity of the framework which the tennis court imposed on him. By standing at one corner of the court he has been able to include most of the playing area in his field of view and the diagonals of the fences which define the court also help to counter and contain the movement of the players within it. The balance of the composition has been carefully achieved by the pairing of figures and groups around a central pivot of the girl and the two tall trees directly behind her. The man leaning on the fence, smoking, and the girl were both added to give weight to the foreground and to take some of the emphasis away from the players themselves. They also act as our guides into the upper part of the canvas where the black line of the hedge forms a barrier to prevent the movement in the lower half from invading the upper. It also serves to silhouette and therefore emphasise the racket of Miss MacBride on the right and her opponent on the left of the canvas who is seen dashing across the court to return her serve. This careful positioning of figures and natural elements within the composition echoes Bastien-Lepage's manner and Lavery's own earlier pictures made at Grez. One of these – *A Grey Summer's Day, Grez* (see p.83) – is similarly composed around a series of diagonals, making a framework within which the principal figures are arranged as in a tableau. The tall pole of the fence at the right foreground and the arrangement of the trees above the girl's head in *The Tennis Party* are both similar to the devices which appeared in those French paintings but which rarely make such a crucial appearance in later Glasgow works. The use of a square brush and the foreground detail which was usually to be found in the Grez pictures has not been repeated here. There is a similarity between the treatment of the trees in the distance and those in Lavery's painting of Mary Stewart (see p.89) which strengthens the case for that picture having been reworked about 1885–7.

Why Lavery sent the picture first to the Royal Academy in 1886 rather than the Institute is not known. It may simply not have been finished in time for the Glasgow sending-in day in early January but it seems just as likely that Lavery wanted to make an impact in London with what he justifiably considered an

important work. Unfortunately, the critics seem to have paid little attention to
it; certainly they did not comment in print upon the unsuitability or otherwise
of the subject. The *Athenaeum* critic saw it as little more than a large sketch,
'faithfully rendered, and broad, pure and true in tint and tone'.[9] When the
painting was exhibited in Glasgow in 1887, however, the local critics saw it not
only as a major work but as a change of direction for its painter. Nowhere was
there any criticism of the choice of subject:

Happily for himself and the sake of his art, J. Lavery is rapidly discarding the obnoxious
mannerism of the vicious French school, and in his most important contribution – *Tennis*
– there is little trace of his old-time mannerism, and a successful attempt at truer and
more legitimate painting. The figures on the tennis-lawn are well disposed and cleverly
drawn and Mr Lavery has been equally successful in imparting a fine, bright feeling both
to them and the landscape.[10]

Another critic also saw a change for the better (that is, a desertion of his French
style) in the new picture:

J. Lavery, during the earlier years of his professional career, was to a considerable extent
influenced by his French training, but he has now happily emancipated himself, in a
measure, from the thralldom of mannerism, although he has fortunately not forgotten
the lessons he learned in Continental studios in draughtsmanship. That this is the fact
will be readily recognised from his *Tennis*, a picture, by the way, which was deservedly
accorded a good position on the walls of Burlington House last year. There are tennis and
tennis matches, but in illustrating a court fringed with grand old trees Mr Lavery has
followed the bent of his artistic proclivities. The players and the ground, beautifully
flecked with sunshine, form a capital subject for the brush of an artist, while the pose of
the players forms a capital foil for the rich background. The accompanying [illustration]
. . . affords some indication of the 'go' and *abandon* which characterises the whole scene.[11]

The *Glasgow Herald* considered the picture superior in almost all respects to
Guthrie's *In the Orchard* and Walton's *A Daydream* which were also in the
exhibition:

We have an example of an artist refining yet losing nothing of his strength in J. Lavery's
Tennis, his Royal Academy picture of last year. Here the execution, if not thorough, is
carried much farther than in many of Mr Lavery's pictures. In other respects it is fine as
well as powerful work, whether we have regard to the cleverly suggested action of the
tennis-players, the well-considered grouping of the spectators, the play of light through
the foliage, or the spreading trees themselves.[12]

Despite such public praise the painting did not find a buyer in Scotland.

The excellence of *The Tennis Party*, not just as a realist picture but as a
supreme example of naturalist technique, was never surpassed by Lavery. He
continued to produce a series of pictures in 1885 and 1886 which are but thinly
disguised Gluepot subjects, given a cloak of modernity by his naturalist
handling. Most of them depict scenes from modern life, but their subjects are
almost anecdotal with little of the daring that was apparent in the choice of a
tennis match as a subject. These paintings are all attractive and well painted but
they lack the seriousness of purpose shown by several of the Boys. Among them
was *Convalescence* (1885, Private Collection), shown at the Institute in 1886

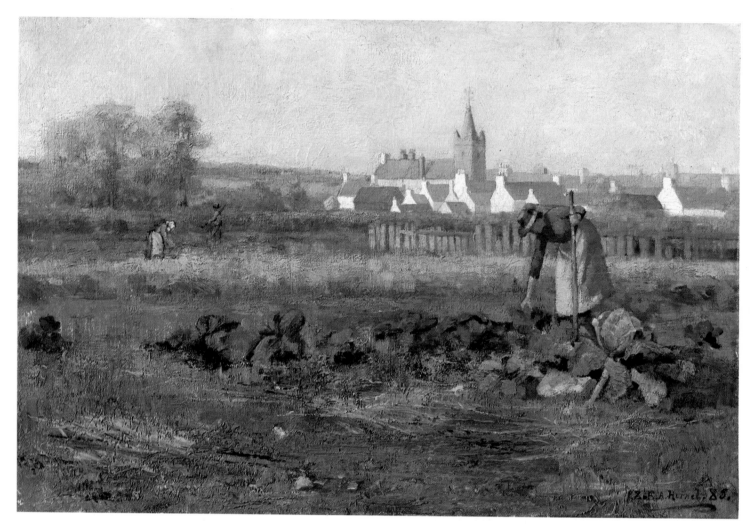

178
E. A. Hornel
In the Town Crofts,
Kirkcudbright
1885
Canvas, 40.6×61
Private Collection

179
James Guthrie
Old Willie,
a Village Worthy
1886
Canvas, 61×51
Glasgow Art Gallery

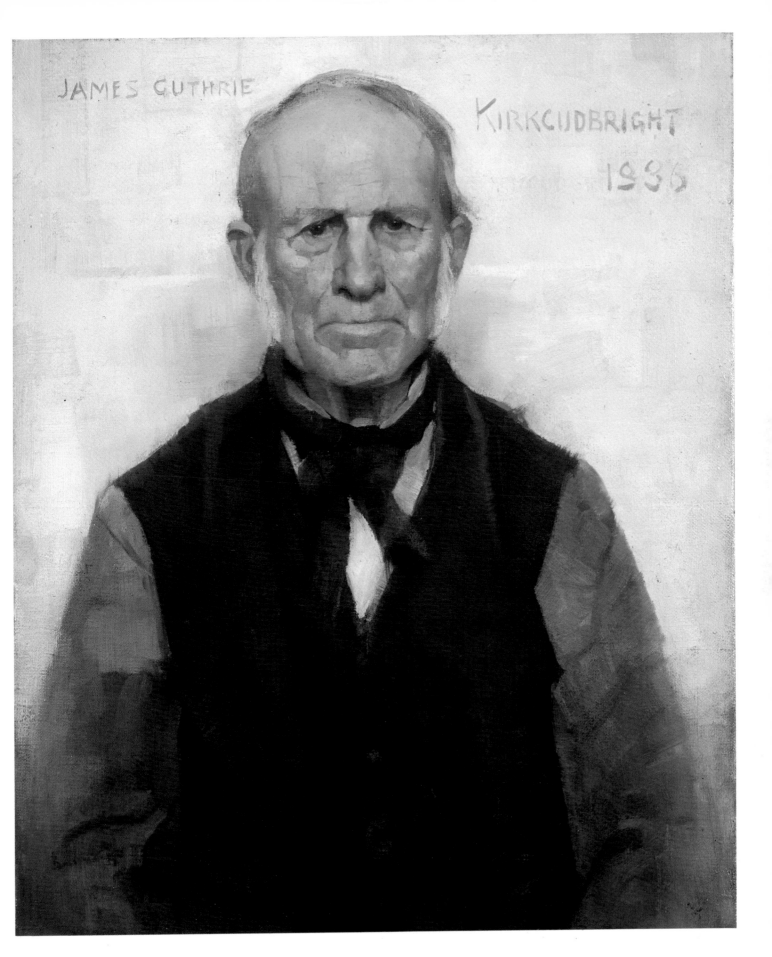

JAMES GUTHRIE

KIRKCUDBRIGHT

1936

along with *In Disgrace*, which showed a girl hiding in a greenhouse[13] (untraced). Although Guthrie's and Walton's realism was hardly political it did attempt to make some comment on the plight of the rural poor; the subject-matter itself justified the naturalist techniques used in their paintings but any moral tone which may have been present in their naturalist works is entirely absent from these paintings by Lavery. The means was justified by the end, and if painting in a naturalist manner was fashionable and appealed to a certain type of picture buyer then Lavery appears to have seen no reason why he should not paint more popular subjects in the same manner. In this he imitates the approach of the Newlyn painters, who had adapted a naturalist manner to their stock-in-trade of incident and anecdotal pictures, inspired by the English *plein-airistes* Clausen and La Thangue, who, like Guthrie and Walton, were more concerned with the true state of rural life.

Although the content of much of Lavery's work of this period is rather shallow, particularly the pictures intended for the big exhibitions, he was at the same time capable of producing the kind of paintings which mark him as one of the most talented of the Boys. Most of these are studies for larger pictures, such as the series of small sketches for *The Tennis Party*, which were painted quickly as a record of some particular scene; or they are more private and personal statements than the exhibition pictures, such as *A Visit to the Studio* (pl.177). In this small painting, which is typical of several others he produced in the later 1880s, Lavery displays his French training with its emphasis on tonal exactitude, and his admiration of Whistler. It is freely painted in a clearly tonal manner but with good colour; it was perhaps a speculative picture, perhaps intended for the lady who is its subject. Lavery's natural fluency as a painter is seen at its best in these small pictures; his own enjoyment in doing them is confirmed in later years when similar pictures were produced alongside the formal portraits and interiors which were intended for the Academies and Salons. The best of his later work is, I think, to be found in these informal sketches rather than his more formal exhibition pictures. Unlike Guthrie, he continued to paint these sketches until his death. Guthrie, on the other hand, from the mid-1890s until 1920 seems not to have painted a single picture that had not been previously commissioned, rarely painting for his own pleasure.

Although the Gardiner family had supported the Boys for several years by buying their pictures at the Institute and elsewhere, Lavery probably felt the need to find more independent patrons; the Gardiners were, after all, Guthrie's cousins and they paid more attention to him and his immediate circle of friends – Walton, Henry and Crawhall – than to the other Boys. Lavery had always been a supporter of the Paisley Art Institute, sending his work there from the early 1880s when his only company from within the Glasgow School had been such Paisley-born painters as Kennedy. In the later 1880s he capitalised on his contacts in the town by becoming friendly with the Fulton family, leading citizens who were to become Lavery's chief patrons in Scotland before he left for London in the 1890s. A series of portraits of the Fulton children with the family pets, a lively account of a concert at The Glen, the Fulton house in Paisley, all put Lavery on the road to becoming a successful portrait painter. It is interesting to

180
Arthur Melville
The West Front of
St Magnus Cathedral,
Kirkwall
1885
Watercolour, 54.5×76.3
Private Collection

note the different approaches of Lavery and Guthrie towards their future careers as portraitists: while Guthrie relied on formal commissions from banks and civic officials (probably engineered by the Gardiners), Lavery immediately established himself as a painter of women in a series of fine informal portraits.

The Tennis Party brought Lavery fully to the public's attention and he was to maintain his position as the best known, if not the best regarded, of the Glasgow School throughout the decade. Versatility becoming his watchword, he started work on a painting of Ariadne in 1887, described by *The Bailie* as 'one of the most daring pictures painted in Scotland'.[14] Whether this comment referred to the model's nudity or the artist's concept of the subject is not clear but it was certainly a picture which confirmed the artist's breadth of achievement. It was Guthrie, however, who was recognised by fellow artists, critics and collectors as the leader of the group and spokesman for those of the Boys who still followed the realist tradition. In 1885 he was still in Cockburnspath but in the summer he made a visit with Melville to Orkney. The latter produced a fine group of watercolours there (pl.180 & 183) but Guthrie seems to have painted nothing.

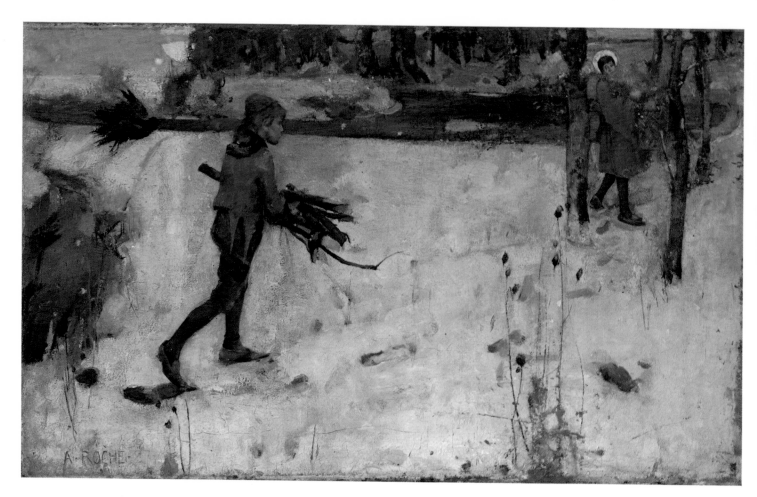

181
Alexander Roche
Good King Wenceslas
1887
Canvas, 45.8 × 76.2
Private Collection

182
William Kennedy
Stirling Station
1887
Canvas, 52 × 80
Andrew McIntosh Patrick

Whether this visit was a holiday for Guthrie, who was beginning to feel the strains of unfinished pictures, is not known but on his return to Cockburnspath he was again faced with the problems posed by his big painting of fieldworkers.

After their visit together to Orkney Guthrie and Melville saw less of each other. This was not through any cooling of friendship but was caused simply by Melville's travels abroad and by his growing conviction that he should leave Scotland for London and by Guthrie's return to the west during the following winter. George Henry slowly replaced Melville and, to a certain extent, Walton also as Guthrie's closest artistic contact. Henry, in turn, introduced Guthrie to a young man whom he had met in the autumn of 1885 who was to become a crucial figure in the development of the Glasgow School over the next decade. Henry's work was getting closer to Guthrie's in technique and content and his *Noon* (see p.154) is one of the finest of the Boys' Cockburnspath pictures. There was always in Henry's work, however, a bravura and gusto not to be found in that of most of his colleagues but it was to be encouraged and helped to flourish by his association with this newcomer, Edward Atkinson Hornel.

Hornel was one of the few of the Glasgow School who had studied in Edinburgh at the Trustees' Academy. He did not enjoy his years there, from 1880 to 1883, finding the teaching uninspired and mechanical and at the end of his session he left for Antwerp. There he studied at the Academy under Charles Verlat, receiving a thorough training which was very much on the lines of the *ateliers* which Paterson, Lavery *et al.* attended in Paris. He returned to Scotland in 1885, settling in Kirkcudbright which had been his parents' home before they emigrated to Australia where Hornel was born (in Bacchus Marsh, Victoria – as *Quiz* quipped, 'a suggestive but sober fact'[15]). His family returned to Kirkcudbright while he was still an infant and Hornel was to make it his base for the rest of his life. The 'capital' of Galloway, Kirkcudbright had long had an artists' colony, attracted to the town by its handsome buildings, its mild climate and the splendours of the Galloway hills and valleys which surrounded it. Although he was occasionally to rent a studio in Glasgow and also to become a member of the Glasgow Art Club, Hornel remained strongly attached to Kirkcudbright and was instrumental in the adoption of the town by the Boys in the latter years of the 1880s.

It is not known how he came to meet George Henry but it may have been in Kirkcudbright in 1885. Letters in the Hornel Trust suggest that Guthrie also visited Kirkcudbright in 1885 and it may be that Henry and Guthrie visited the town together, perhaps after the latter returned from Orkney. Whatever the true course of events, Hornel and Henry struck up a friendship which was to become one of the closest and one of the most artistically productive of the whole of the Glasgow School, culminating in a joint visit to Japan in 1893–4. In 1885, however, Henry led the way as his years in Cockburnspath with Guthrie and Walton would have placed him at an advantage over the younger Hornel. The latter would have probably been aware of naturalist painting from his time spent in Antwerp, and he would certainly have known the work of the Hague School, particularly Maris and Israels, before he returned to Scotland. Hornel would, therefore, have been receptive to the new work which he encountered on his

183
Arthur Melville
Kirkwall
1885–6
Watercolour, 36×55
Glasgow Art Gallery

return and was soon to adopt it in a small picture painted in 1885, presumably in Kirkcudbright and perhaps alongside Henry. *Resting* (pl.176) has many of the stylistic elements of Henry's painting *Noon* and it is possible that Henry painted *Noon* at Kirkcudbright rather than at Cockburnspath. Both paintings may have shared the same model, if not a local farm-girl then she was perhaps one of Hornel's sisters, which may be further evidence of Henry's visit to Kirkcudbright in 1885.

The change in Hornel's work is quite marked. A study of shrubby leaves and undergrowth dated 1883 (Coll: Angus Maclean) is much more mechanical and has all the signs of an Edinburgh training but in *Resting* and another picture of that year, *In the Town Crofts, Kirkcudbright* (pl.178), and a portrait of a bellringer of 1886 (pl.186), there is a lightening of the palette, a greater awareness of tonal values and the adoption of the naturalist technique and handling of Henry and the other Cockburnspath Boys. *In Mine Own Back Garden* (pl.187) displays considerable use of a square brush and a vigorous handling in the foreground which is suggestive of Macgregor's exhortation to 'hack the subject out'. That picture, however, is still relatively disorganised in its composition compared to Henry's work of the same period. Another picture of 1887, *Pigs in a Wood* (pl.185), is, by comparison, much more sophisticated and accomplished

184
Thomas Millie Dow
At the Edge of the Wood
1886
Canvas, 92 × 76.5
Andrew McIntosh Patrick

than any work to date. There is a stronger sense of design and pattern in the composition and the beginnings of Hornel's fascination with an enclosed subject. There is no indication of a horizon but a strong feeling of the claustrophobic enclosure of a dense wood. Hornel was to exploit this enveloping closeness of the forest for the rest of his artistic career but in the 1880s he is at his most inventive in his depiction of the differing textures of trees, undergrowth, leaves and shrubs in which are hidden a variety of animals and the occasional human figure. It is the beginning of a Glasgow School concern for pattern, colour and design in composition that was dubbed by several London critics in the 1890s 'the Persian carpet school'. The source of this new imagery was not Henry but it could well

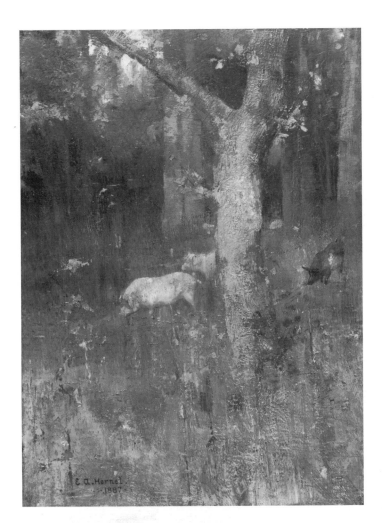

185
E. A. Hornel
Pigs in a Wood
1887
Canvas, 39 × 29
Andrew McIntosh Patrick

186
E. A. Hornel
Winefield Nellons,
the Bellringer
1886
Canvas, 61 × 51
Private Collection

187
E. A. Hornel
In Mine Own Back Garden
1887
Canvas, 40.6 × 30.5
Hunterian Art Gallery,
Glasgow

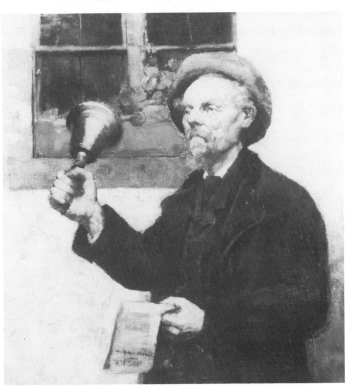

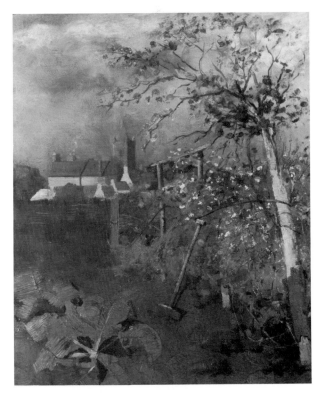

have been Millie Dow who paid an occasional visit to Kirkcudbright and who in 1886 had produced a similar study of a woodland glade, *At the Edge of the Wood* (pl.184). The colour and handling of Dow's painting differs considerably from Hornel's but there is the same sense of being completely surrounded by the trees, with no glimpse of the sky or other landmarks which would help to orientate the viewer. Henry drew Hornel's attention to Dow's landscape paintings in an undated letter which was probably written in the autumn of 1885[16]:

I have seen almost none of the Fellows' work here [Glasgow] as yet with the exception of Dow's and a very charming picture that Roche is painting. Dow has two landscapes, the most beautiful things I have ever seen. I don't know of any other Fellow who has managed to make one feel on seeing those pictures so much of the spirituality of nature. They are intense in this way. One especially seems to make you creep with the strong quietness and mystery of nature. They are pictures that will probably never see a public exhibition, at least until there is a revolution in art. I wish you could see those pictures as I cannot talk about them.

In *The Hedgecutter* (see p.156), Henry had begun to move towards the same narrow pool of vision, closing up on his subject, working in another cabbage garden, but placing him against a stratified background not unlike those used by Kennedy in *Mademoiselle Cunégonde* (see p.102) and *Spring* (see p.87). In *The Girl in White* (pl.188) (which is possibly the watercolour which was exhibited at the RSW in 1886 as *The Miller's Daughter*), Henry moved towards the enclosed format of Hornel's 1887 painting but there is still a strong sense of *mise-en-scène* with the girl placed against a series of horizontal strips – water, field, scrub and trees – against which her body is ranged vertically to aid perspective which is achieved, in typical Glasgow School manner, by changes in handling and brushwork. Henry painted a number of pure landscapes in the two or three years after 1885 but few have survived. In the letter to Hornel quoted above he asked Hornel to forward to him some photographs that he had taken in Kirkcudbright and which had been left there for printing by a friend of Hornel called Blair. The subjects of these are not known but Henry refers to them, or others, in several later letters. These photographs may have been intended to be used in connection with the landscapes – they certainly do not seem to have been of models as Henry wrote, in a letter datable to mid-1887, that he intended to bring his own model on future visits to Kirkcudbright.

In February 1886 Henry returned to Cockburnspath to visit Guthrie, staying for about three weeks. On his return to Glasgow he began work on a painting of Ariadne, perhaps the inspiration for Lavery's painting of the same subject. Writing to Hornel about it he joked about his choice 'the subject has, I believe, been pretty well painted but I see a new way. The figure will be life size with bacchanalian revels going on in the background.'[17] Pictures like this seem to have been painted to earn a living rather than as any serious attempt to broaden the Boys' approach to realism, naturalism or modern painting in general. He does, however, seem to have produced a number of allegorical pictures at the same time as his more typical naturalist works. For instance, there is a group of three Seasons in Paisley Art Gallery, painted about 1887, and *Quiz* recorded in September 1887 that he was at work on a large canvas of Beauty and the Beast,

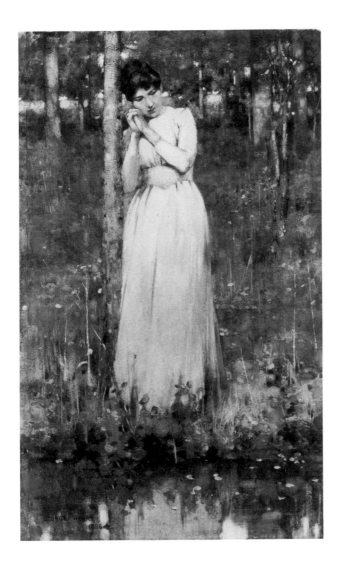

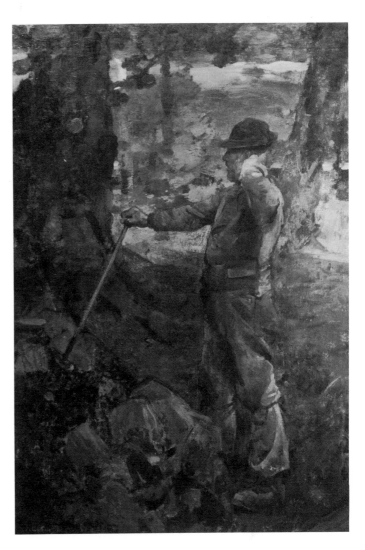

in the form of a fawn piping to a nymph.[18] Henry also turned to painting portraits as a means of settling his creditors and openly admits in his correspondence with Hornel to dashing off pot-boilers to pay the bills. It was to complete one of these that he later asked Hornel for a photograph 'of a tree with leaves and sunlight on them' that he needed to finish a painting.[19] Returning to Glasgow, Henry took a studio at 113 West Regent Street where he was pursued by his creditors and forced into painting that was less rewarding – intellectually at least.

Later in 1886, in August, Henry was with Hornel in Kirkcudbright. Guthrie and Thomas Corsan Morton joined them and stayed in Galloway for over a month. While he was at Kirkcudbright Guthrie began work on another large canvas, having just finished *In the Orchard*. This was *The Stonebreaker*, an encounter between a labourer and a man on a horse. There is no sketch or photograph of the complete composition but Guthrie appears to have arranged the figures one in each half of the canvas and then ran into difficulties in trying to relate the differing sizes and scales of the two parts. Eventually he cut the canvas in half and destroyed that of the horse and rider. The figure of the stonebreaker

188
George Henry
The Girl in White
1886
Watercolour, 60.3 × 37
Glasgow Art Gallery

189
James Guthrie
The Stonebreaker
1886
Canvas, 178.2 × 144.4
Renfrew District Museum
and Art Gallery, Paisley

was put on one side and seems to have been returned to in the 1890s and later in the 1920s (pl.189). Surprisingly, given the difficulties which Guthrie encountered with the rider, he shortly afterwards chose to paint a life-size equestrian portrait (*George Smith*, Private Collection) which was apparently a great success and was acclaimed both at the Institute and in Munich where he sent it in 1890. One of the Kirkcudbright pictures, however, shows that Guthrie had lost none of his skills in working on a small scale, although – given his concentration on larger paintings – he possibly considered it to be only a sketch. *Old Willie, a Village Worthy* (pl.179) is one of the masterpieces of the Glasgow School. Its clean light and colour and clear tonality reflect the straightforward attitude of both sitter and painter. Like *A Hind's Daughter* (see p.91), the subject is portrayed without emotion or fabrication, his natural dignity being as much the subject of the painting as his weatherbeaten features. It was to be the last of Guthrie's overtly naturalist paintings, in oil at least, for he was being offered more and more portrait commissions following on from the relative success of the portrait of his uncle, the Revd Andrew Gardiner (see p.144). One of the first of these was of Robert Gourlay, the manager of the Glasgow office of the Bank of Scotland. It was not a success, however, and was later cut down and consigned to a side room in the Merchant's House in Glasgow. The Gardiners had probably arranged that commission and to perhaps repair the damage to Guthrie's growing reputation they no doubt encouraged the next commission, in 1888, for a portrait of William Ritchie, a relative of Sir Frederick Gardiner's wife. This was followed by a commission of a different kind, unique in Guthrie's oeuvre but perhaps encouraged by another of the group, David Gauld, who was shortly to make his reputation as a designer of stained glass. In September 1887 *Quiz* records that Guthrie was at work on a series of stained-glass panels at Knockderry Castle, Cove, near Rosneath.[20] The subjects were the Heart of Midlothian and King Haakon's invasion of Scotland at Largs in the twelfth century. This was an unusual departure for Guthrie who was, perhaps more than the other Boys, careful of the dignity of his position as a painter and who was on the threshold of a respectable career as a portraitist. Lavery, conscious as ever of the value of publicity and social contacts, would not have thought twice and, given his continuing interest in historical subjects, it seems odd that he did not receive the commission; unless, as seems most likely, the commission came from one of the friends of the Gardiners.

Glasgow was, for the next two or three years, to become more of a base for the Boys than it had been in the first half of the decade. There were still sorties into the countryside, however, not only to Kirkcudbright but also to Stirling and Cambuskenneth where Kennedy had acquired a country studio after his return from France. The lure of Stirling for Kennedy lay partly in the presence there of Lena Scott at Craigmill, as Miss Scott was later to become his wife. In 1887 several of the Boys joined him for a few weeks during the summer and it was at this time that discussions began about formalising their loose association. Henry wrote to Hornel from Arbroath with news of one such visit:

I got your letter when going to Stirling on a visit to Kennedy ostensibly to stay a week, as he would be coming home by that time. I stayed a month! Weather wretched, only three

190
William Kennedy
A Piper
1885
Canvas, 45.8×30.8
Andrew McIntosh Patrick

painting days all that time – result, did nothing . . . I am here [Arbroath] just now to paint three small portraits, no money in them, blast them. The Flax Kings and Jute Gods of this place know how to spin out their money as well as their other commodities while we, the apostles of virtue and sincerity, the pioneers of culture, starve for want of a few crumbs from the millionaires' table. 'For of such are the kingdom of Heaven' I don't think so! If these people are there then I'm not going, and so to make sure, I am not a member of the Free Church . . . All the Boys are at Stirling – Kennedy, Guthrie (for a short time), Walton, Corsan 'Brother' Morton; the Josser [Harry Spence] and Macaulay even think of going there. Are any diggings to be got cheap and good at the Kirk? I might come down, as I don't tumble to Stirling somehow. Let us know, there's a good boy.[21]

191
James Nairn
I Dote on the Military – I
Ken-I-Dae: a caricature of
William Kennedy
1889

I DOTE ON THE MILITARY—I KEN-I-DAE.

In addition to the presence of Miss Scott, Kennedy was drawn to Stirling by his new attachment to the Army as a subject for his paintings. There was a large garrison at the Castle, as there was in Glasgow in the Maryhill Barracks, but at Stirling there was the added attraction for the artist of the sight of the soldiers on manoeuvres on the plain beneath the Castle walls. He does not seem to have exhibited his military subjects in public until 1889 (although at least one of them is dated as early as 1885, pl.190) but among his friends his obsession with the life of the garrison at Stirling Castle earned him the nickname 'The Colonel' (or 'Kurnel' as Henry wrote in his letters to Hornel). Nairn, who contributed a series of caricatures of the Boys to *Quiz*, drew Kennedy in uniform with the punning caption *I Dote on the Military – I Ken-I-Dae* (pl.191). In fact, Kennedy's submissions to the Institute continued in the realist vein of his French work although, as so little work of this period has survived, it's not certain whether his handling changed as much as that of the other Glasgow men who had been in France. In one painting, *The Apple Harvest* (untraced), painted in 1886 when it was shown at the Paris Salon, Kennedy caught the approval of the Institute critics, where it was shown in 1888. They were all unanimous in their praise, likening the picture in importance to the new movement alongside Guthrie's own orchard painting. They took little notice, however, of Kennedy's other Institute exhibit that year, *Stirling Station* (pl.182) although the reviewer for *Quiz* was more perceptive:

In Room II there is one picture which must strike even the casual observer as standing out from all the crude, garish paint around it – Mr Kennedy's *Railway Station*. It is one of the most remarkable pictures in the Exhibition, displaying the consummate knowledge of painting and artistic technique possessed by the artist; the drawing, linear and aerial perspective are most masterly; but it is in the exceptional skill which the artist shows in his treatment of colour that the picture is the most remarkable. The unity of effect obtained through the delicate harmonising of each colour in relation to the general colour scheme, the skilful management of the *chiaroscuro* and careful preservation of values in the lighting of the work, make it exceedingly interesting as an example of masterly, artistic craftsmanship, and well worth careful study, though the unusual truthfulness of the expression conveyed by the picture gives it almost a prosaic and commonplace effect, which is saved only by the admiration excited at the power and skill of the artist. We hope to see him ere long, manifesting his ability to conceive a great and noble subject worthy of his exceptional power of artistic expression, and carried out as successfully as this small work.[22]

This is a painting which falls into the Walton, Lavery, Nairn mould of urban realism. Lavery and Walton, however, were really concerned with the gentility of life among the middle-classes; by contrast, the working-class poor of the towns and cities rarely, if ever, appear in their pictures. Nairn had already exhibited a railway subject at the RSW which may have attracted Kennedy's attention but, in any case, the subject of the railway station was not new to British or French painting. What is new is Kennedy's combination of the choice of a realist subject combined with its depiction as a nocturne. The relevance of Whistler, his writings and his own nocturne pictures is much more apparent in Glasgow School painting at the end of the 1880s. Whistler would probably not have chosen such a subject for his own work, but the handling, the tonal harmonies and the choice of an evening setting for the picture all point to a new interest in Whistler's work

192
William Kennedy
The Deserter
1888
Canvas, 119.5 × 152.5
Glasgow Art Gallery

which began to replace that of the French masters, and particularly Bastien-Lepage. Another element of later Glasgow School painting is also apparent – the importance of pattern and design in the arrangement of the composition. The curve of the tracks is cleverly used to widen the platform in the foreground which, as it narrows, leads the viewer into the distance; the relative emptiness of the foreground and the tracks is contrasted with the crowding of the platform, but the crush of figures is contained within the line of the frontal plane of the picture and the dominant horizontal of the station roof. In later pictures Kennedy was to elaborate on the fluid handling of *Stirling Station* but he was never to synthesise all the differing aspects of French, Scottish and Whistler's painting so well as he did here.

His military subjects were usually on a smaller scale, concerned with the daily life of the soldiers in camp, on manoeuvres or at the garrison. Titles such as *In the Cooking Trenches, Waiting to Mount Guard, The Canteen – Mid-day* give a flavour of his contributions to the Institute from 1890 onwards. One of these, however, *The Deserter* (pl.192) was a more substantial work in both scale and content. In it Kennedy merged his military and realist themes, showing the soldier being led back in irons to the garrison. The viewer is forced to ask whether the family working at the side of the road know the reluctant soldier and this introduction of untypical sentiment is a lapse in Kennedy's usual detachment from such Gluepot preoccupations with anecdote and story-telling.

Coupled with these military scenes was a new interest in rural subjects, partly

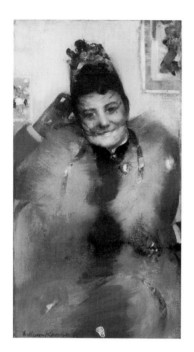

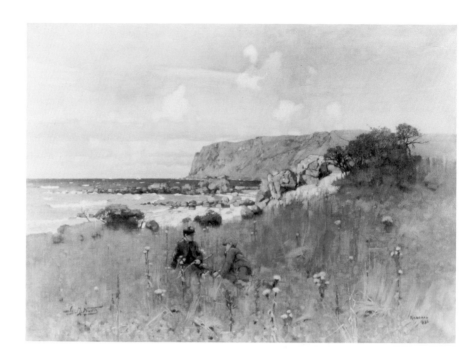

193
William Kennedy
The Fur Boa
c.1890–1
Canvas, 53.3 × 28.6
Glasgow Art Gallery

194
James Nairn
Kildonan, Arran
1886
Canvas, 86.4 × 116.8
Glasgow Art Gallery

inspired by a move to Berkshire with his wife in the 1890s. Many of these rural paintings do not have the bite of his 1880s naturalist pictures, either in their concern for the rural labourer or the pictorial qualities of the subject. Their handling is looser and the compositions less organised than the pictures of the 1880s but, unlike many of his Glasgow friends, Kennedy remained faithful to the images of his youth and retained á quality of selection and execution in his work which many of the Boys cast aside for the rewards of success as portraitists or producers of crowd-pleasing pot-boilers in a caricature of their earlier style. Kennedy's admiration for Whistler is evident in one of his few portraits, *The Fur Boa* (pl.193), which was probably painted in the early 1890s (it was perhaps the *Smiling Girl* exhibited at the Glasgow Institute in 1892). The Japanese print in the background pays a quiet homage to the 'Master' just as it did in the studios of Walton and Lavery. Like Crawhall, Melville, Dow and Lavery Kennedy succumbed to the attractions and climate of Tangier, where he spent his later years, dying there in 1918.

Henry noted that Walton was at Stirling with Kennedy; he was also at Broadway in the Cotswolds in September and October.[23] Whether he had by that time found himself a studio at Cambuskenneth is not known but he was certainly there the next year. Walton continued to paint in much the same manner as his last years at Cockburnspath, with a growing emphasis on portraits and water-colours. Not all of these were well received: the reviewer of *Quiz* dismissed his *At Helensburgh* (see p.141; shown at the RSW in 1886) as 'a mere impertinence'.[24] Walton may have had an influence on Henry's choice of subject and handling in some of the watercolours he showed in Glasgow and Kirkcudbright at this time, as Walton was by now the acknowledged Glasgow master of the medium after Crawhall and Melville. Crawhall was spending less time in Glasgow than before,

remaining in Newcastle between his trips to Tangier and then eventually settling in Yorkshire. Guthrie was probably a frequent visitor to Northumberland, and presumably Walton too as his brother had married Judith Crawhall. In September 1887 *Quiz* records Guthrie being at Felton in Northumberland with Crawhall[25]; later that year it mentions that he was hard at work on *The Stonebreaker* and his 'Northumberland pastoral'.[26] The latter picture seems likely to be the painting now known as *Pastoral* (pl.195), which differs considerably in handling from the work of 1885, the year to which it is usually ascribed. There is no other painting recorded by Caw which could correspond to a 'pastoral' subject painted in 1887–8. The signature and handling both differ from other pictures of 1885; the viewpoint, the choice of subject and the interest in landscape rather than figures all indicate a phase of Guthrie's painting which post-dates his years at Cockburnspath. As has been noted,[27] Guthrie's subject was space rather than substance and he modified his brushstroke to accommodate it. Similar brush-work appears in *The Stonebreaker*, which *Quiz* confirms was being worked on at

195
James Guthrie
Pastoral
1887–8
Canvas, 64.8 × 95.3
National Galleries of
Scotland, Edinburgh

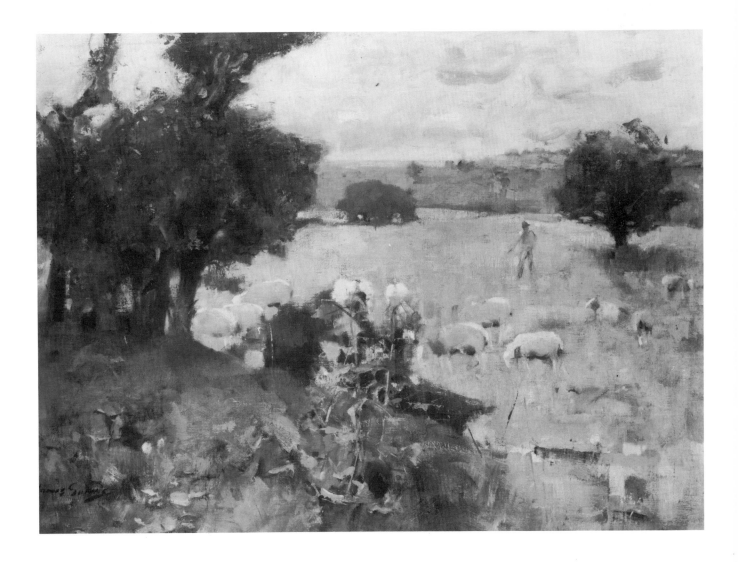

196
James Nairn
Oh! La! Very: a caricature
of John Lavery
1889

197
James Nairn
King Henry of Luna: a
caricature of George Henry
1889

the same time. *Pastoral* may be Guthrie's reaction to the more fluid handling of Henry's and Hornel's Kirkcudbright pictures. The wide vista, rather than the enclosed aspects of his Cockburnspath pictures, gave him the opportunity to apply a more consciously designed schema to the composition in line with the new ideas emanating in 1887 from the Kirkcudbright painters – whom *Quiz* had newly dubbed 'The School of Progress and Poverty'.[28]

Nairn, Roche and Lavery did not join the others at Kirkcudbright or at Stirling. Lavery was busy with his Paisley connections and in 1887 received a commission which took him away to Larne for a few months. The growing emphasis on the decorative aspects of composition appeared in a delightful picture by Roche in 1887, *Good King Wenceslas* (pl.181). Roche is not recorded as a visitor to Kirkcudbright but in several letters to Hornel in 1886 and 1887 which Henry wrote at the Glasgow Art Club he mentions that he was with Roche who sent his warm regards. *Good King Wenceslas* actually takes a step forward that Henry and Hornel had not yet managed. Design, or decorative motifs, play a substantial part in the composition with the canvas divided vertically into two halves, each with its own centre of interest. Roche has used various naturalist devices, such as the foreground grasses which rise up the frontal plane to help define the recession in the perspective and the young saplings which continue the upward movement across the horizontal bands of the distant river and fields. What is unusual is that this naturalist handling has been applied to an allegorical subject in a way which makes the painter's choice of the subject valid within the terms of reference that the Boys had set themselves. Rather like Lepage's painting of Joan of Arc, Roche has introduced a sense of reality, or actuality, to what was essentially a Christian legend. Only the dress of the two figures and the gold nimbus around the head of the king act as reminders that this is not a scene from contemporary life. This unreality is reinforced by the deliberate arabesques of the landscape and it is not too distant a step from this rather lyrical naturalism to the Celtic subjects which Henry and Hornel were to work on together at the end of the decade. Unfortunately, this is almost the only painting by Roche to have survived from the period 1885–90. The titles of those works shown at the Institute in this period, however, show that Roche had moved away from, in title at least, the more typical naturalist works of the early 1880s towards a more traditional subject, with which *Good King Wenceslas* is perhaps in keeping: 1886, *Reverie*; 1887, *Sweet-Do-Nothing, When One is Young, Rhapsody*; 1888, *In the Early Summer, Eventide*.

By contrast, James Nairn seems to have become more committed to the naturalist ethic. He spent the summer of 1886 on Arran where he produced a series of oils which show the influence of George Henry in their colour and handling. *Kildonan* and *Auchenhew* (pl.194 & 201) are the only evidence of Nairn's rustic naturalism and they display an individual approach, especially in their brushwork and palette. *Auchenhew*, in particular, shows that although Nairn was aware of and had assimilated the usual naturalist compositional devices, he could also choose to depict mood and atmosphere as well as recording daily life on the island. The twilight hues of red, blue and purple evoke a sense of time and place that is rarely an overt subject with the Boys but it was to become

more noticeable in their later paintings, particularly Guthrie's pastels and the Kirkcudbright work of Hornel and Henry. Nairn was to be recognised as a senior member of the group in the two or three years before he left Glasgow for New Zealand in 1889. It was his intention to return, as the visit was purely therapeutic in order to help him convalesce from an illness, probably tuberculosis, which the Scottish climate had aggravated; New Zealand captivated him, however, and he did not return. He was to become involved with the Boys' grandiose plans for mural decorations in various buildings in the city but he achieved another form of distinction with his series of caricatures of the Boys which were published in *Quiz* under the pen-name of 'Kopecks'. These not only give us a view of the various painters which differs from that of the camera, but they also convey some of the standing of each of the painters with their fellow members of the group. Henry makes several references to 'the great John Lavery' in his letters to Hornel and his opinion is confirmed by Nairn's drawing of Lavery[29] (pl.196) in overcoat and top hat, cane tucked under his arm, with its caption *Oh! La! Very.* Henry's fascination with nocturnes and moonlit scenes provoked *King Henry of Luna* (pl.197)[30] and Walton's seriousness is caught in *Tedious Wall-Tones* (pl.198)[31]; while Roche simply takes on the title of his best-known picture, *King Wenceslas* (pl.199).[32]

Another of the Boys had already left the city because of his poor health. Macgregor had gone as early as 1885, first to Bournemouth and then to Speyside before eventually settling at Bridge of Allan near Stirling and then leaving for South Africa where he remained until about 1890. Macgregor was asthmatic and there is no doubt that the smoky atmosphere of Glasgow would not have suited him but by 1885 he seems to have had serious doubts about the direction that the Boys were taking and on whom he was having less and less influence. In a letter to Paterson written in July 1887 he summarises his new position with regard to naturalism and the Boys' painting:

I don't think imitating nature is art, and pictures are better painted in the house from studies . . . I am perfectly sick of the Frenchy School and must put something into my work, some individuality in short.[33]

In many ways he was predicting the move that Henry and Hornel would take away from naturalism, although it is doubtful whether he would have approved of their eventual achievements:

Hornel and Henry's star picture has turned out a very fine thing indeed, I never thought it would have been so successful.[34]

These letters between Macgregor and Paterson are the way they kept each other informed about the latest developments in Scotland. Neither of them was particularly close to any of the other painters in the group and they could share confidences with each other secure in the knowledge that they were often of like minds about their fellow painters. Indeed, this correspondence is often our only guide to some of the less public affairs of the Boys. The most important of these was the establishment of a new journal devoted to the arts in Scotland which was to appear in 1888 and the setting up of a 'secret society' of which Macgregor, in his absence, was elected a member in 1887:

198
James Nairn
Tedious Wall-Tones: a caricature of E. A. Walton
1889

199
James Nairn
King Wenceslas:
a caricature of
Alexander Roche
1889

You mentioned in your note something about a 'secret society' of which I had been elected a member. To what use is this society to be put?[35]

What Paterson probably did not tell him in his reply was that the Boys were hoping that Macgregor's comfortable private income would provide the capital they required for their new journal (*The Scottish Art Review*), which was very much Paterson's own idea but which found little favour with Macgregor. Later in 1887 the 'society' voted itself a President and acquired new members from outside the original coterie of painters:

As you know, I was very much against Stevenson being elected. The Great Ones, you see, had to provide for their satellite. Let us forget all our differences and if the society is to survive let us keep down petty rows. Kennedy will make a very good President, will be perfectly straight and above board, and will take no end of trouble with the affair.[36]

The 'Great Ones' were probably Lavery and Guthrie who encouraged Macaulay Stevenson as a painter although they probably found him more useful in other directions. He and Paterson had already crossed swords. In some ways this is not surprising, for what talents Macaulay Stevenson lacked as an artist he made up for in self-advertisement. His brash manner, which appealed to Henry and Hornel, would not have impressed the more serious Paterson. Kennedy, the openly approved choice for President, soon lost Macgregor's support:

I am quite done with Kennedy as I found him intolerable, and it is a great relief to think I won't be plagued with his visits any more.[37]

The concept of a society may have lingered on until 1891 or 1892. In a letter of that period from Henry to Hornel there is an account of one of the meetings in Glasgow to discuss new business:

There was no 'bis' as usual done at the meeting. Kennedy and I came in from [Stirling] to attend it. Macgillivray proposed something like 'Society of Artists, Glasgow' and Paterson 'Glasgow Artists Guild', Roche 'The Art Workers' Guild' or some such Cockney fake with which he seems struck at present. We might as well have Tah, Rah, Rah, Boom-de-Aye Independents etc, etc. Kennedy and myself were the only ones present for 'Glasgow School' . . . Jamie RSA [Guthrie] confessed that he had a sneaking fondness for the old name of GS, [and] the matter was postponed. The rules were gone over and seem all right. Teddy [Walton] had some schemes about adding art workers to the qualification, as a way I suppose of bringing in the family as members, but it did not seem to catch on.[38]

With this greater sense of unity, through their own closer ties or through the general recognition by public and critics of their common aims, the Boys capitalised on their successes at the Institute and began to look further afield. London and the many exhibition opportunities it offered them was a strong call but they also realised that they could further consolidate their position in Scottish art circles. At the end of 1887 they were poised to attack both the bastions of the south and the higher echelons of the Scottish establishment. In England they joined the new exhibiting society that was formed by those dissatisfied with the Royal Academy – the New English Art Club; and in Glasgow they were to be well represented on the prestigious committees which were set up to arrange the forthcoming International Exhibition of 1888.

CHAPTER 9

A Kelvingrove Air

In the last two years of the 1880s the Boys were to consolidate their reputation and position within Glasgow and also began to make a wider mark outside the confines of the west of Scotland. London offered another lure through the establishment of a new exhibiting society, the New English Art Club, which was set up by a group of younger artists as an alternative to the Royal Academy and galleries such as the Grosvenor. Almost from the beginning it welcomed the Glasgow painters and they acquired a toe-hold in the metropolis. Edinburgh admitted to the existence of a new force in the west when the Royal Scottish Academy conferred an Associateship on Guthrie in 1888. The citadel had been breached and in the following year Walton joined him. Slowly the other Boys added ARSA to their names, with a rich crop coming around 1892–6 which included Lavery, Henry, Roche, Paterson, and J. Pittendrigh Macgillivray (pl.200). In 1890 the Boys created a *succès de scandale* with an exhibition at the Grosvenor Gallery; this was to be the first time that the critics paid attention to their London exhibits and it clearly identified them for a metropolitan audience which found their work, on the whole, too extreme for its taste. It was also the moment when, as a result of the critics' attempts to identify and categorise them, they were firmly dubbed the 'Glasgow School'. In Glasgow, however, 1888 was to be their *annus mirabilis* when the attention of the world was trained on Glasgow's International Exhibition and when they ventured beyond their easels to engineer the publication of a new journal devoted to matters cultural in Scotland: *The Scottish Art Review*.

Surprisingly, Glasgow had allowed Edinburgh to steal a march on it when, in 1886, the capital had staged in the Meadows the International Exhibition of Industry, Science and Art (following on from the International Fishery Exhibition of 1882 and the International Forestry Exhibition of 1884). The generally held opinion, in Glasgow at least, was that it was not the most successful of such events, particularly in its treatment of the fine arts. Some of the Boys sent work to the Open Section but, with the exception of Lavery, they attracted little attention. Despite the criticisms of the Glasgow artistic community, the Edinburgh International Exhibition contained a wide selection of recent European painting with special emphasis on the Hague School and on the work of a relatively unknown French painter, Monticelli (1824–86). His landscapes with figures, often allegorical in content or following in the *fête-champêtre* tradition of Watteau made an impression on Henry and Hornel in particular among the Boys. It seems very likely that Hornel made a careful study

200
*J. Pittendrigh Macgillivray
1856–1938*

of these paintings as his own work, produced after 1887, appears to owe so much to the techniques, if not the subject-matter, of Monticelli.

Glasgow set about preparing its own exhibition in 1886. A site was selected in the West End park, now called Kelvingrove, and James Sellars was appointed as architect. He chose to design his central buildings in a vaguely eastern style, more Arabic than Oriental. These were constructed of timber along the southern edge of the park with smaller pavilions, bandstands and tea-houses scattered over the hillside. All profits from the Exhibition were to be used towards the building of a new museum for the city's permanent collection and so the fine arts had a particular stake in the whole affair. The central galleries of the Exhibition, ten in all, were devoted to the visual arts, with separate sections for architecture, photography, sculpture and both Loan and Sale collections of paintings, black and white and watercolours. It was to be the most elaborate display of contemporary British and continental (particularly French) painting that had ever been assembled in Scotland. Many of the loans were obtained from local collectors, and the selection seems to have been intended to stress the close links between the Boys and those French masters such as Millet and Bastien-Lepage who received much attention from reviewers of the Exhibition.

One of the complaints about the Art Section of the Edinburgh International Exhibition was that very few artists were involved in its organisation or the selection of the British works in the Loan or Sale collections. In Glasgow in 1888 this omission was not repeated and Guthrie and Macgillivray served as representatives of the younger men alongside Fra Newbery, Director of the Glasgow School of Art, and local collectors such as T. G. Arthur and John Cargill. The Exhibition did not go totally without criticism, however. Even the anonymous critic of *The Scottish Art Review*, despite his overall praise for the Exhibition compared to the recent Manchester and Edinburgh events, found the selection of artists in the Sale collection somewhat disappointing:

Popular pictures have long been deemed necessary by the promoters of Art Exhibitions to draw the unreflecting crowds who like a show of things they can easily comprehend, and the habit has been too much to appraise the 'success' of exhibitions by the figures registered at the turnstiles . . . Thus public exhibitions, avowedly organised to foster the public taste for art, are made to exert powerful influence for the lowering of the very thing they exist primarily to conserve and elevate. Exhibition managers may not be able to count on educating the public but they can at least ensure, and the public have a right to demand, that all spurious work, which can only mislead, be excluded. The Fine Art Council of the present exhibition . . . might well have made an admirable new departure, by exhibiting only Art of a high class. It is to be regretted that they failed to avail themselves of this opportunity.[1]

The anonymous writer (who was probably Macaulay Stevenson, the most publicly rebellious of the group and one who was closely involved with *The Scottish Art Review*) makes no reference to the exhibits of the Boys but he has little praise for the efforts of other exhibitors:

It is a pity that considerable artistic ability should so often be misdirected by men from whom we have had not only fair promise, but even good performance. In this connection it cannot but make the judicious grieve to find, in the Exhibition, work from Sir Frederick Leighton, Luke Fildes, and Hubert Herkomer which has in it no more of the

vital spirit of Art than has the learned inability of E. J. Poynter and Sir J. D. Linton, the cheap sentiment of Faed and Phil Morris, and the sentimentality of Marcus Stone, the hideously unreal realism of Brett, and the meretricious prettiness of McWhirter and [David] Murray. The productions of the fashionable painter are at any time out of place among the works of the serious artist. But their presence becomes specially obnoxious, when round and round the Exhibition they have been accorded positions of the best, while works of art are relegated to obscure and inconvenient places.[2]

The reviewer does not go on to mention the work of the Boys, which may imply approval of their pictures (they were discussed by Paterson in a later issue), but after such a scathing condemnation it is surprising to find a parting concession in the final paragraph of his notice:

The distinguishing feature of the Glasgow Exhibition is, that, being truly International in spirit, it is rich in sufficiently representative examples of what the modern world has been doing in art to allow ample scope for comprehensive and intelligent study of the subject. This is what differentiates it from other recent Exhibitions and gives it a special and peculiar value; and lovers of art would do well to avail themselves fully of the opportunities it affords.[3]

The Boys were well represented, both by new work and by loans of the best of their earlier pictures, such as Guthrie's *To Pastures New* (see p.74). Surprisingly, Henry and Hornel showed only relatively minor works while Macgregor, who was away in South Africa at the time, arranged for the loan of *A Cottage Garden, Crail* (see p.78). Dow sent *The Hudson River* (see p.86) which was also lent as were the more important exhibits from Paterson and Walton – *Winter in Glencairn* by Paterson and Walton's portrait of the daughter of T. G. Bishop and a landscape, both lent by Mr Bishop, an important Helensburgh collector who had bought Walton's *A Daydream* and Guthrie's *In the Orchard*. It was left to Lavery, Roche and Corsan Morton to represent the Boys with new work – respectively, *Dawn, 14 May 1568*; *Shepherdess*; and *The Stillness of an Autumn Eve*.

Lavery's picture had been begun and, I believe, substantially finished in 1883 but in 1887 he had been engaged on another painting with Mary Stewart as its subject[4] – *Night after the Battle of Langside*. At that time he was probably aware that there was to be a display of various relics of the Queen at the International Exhibition and he may have intended to show his new picture there in the Sale collection. For some reason he submitted only *Dawn, 14 May 1568* (see p.89) which was probably worked on again at this time.[5] The reviewer for *The Scottish Art Review* (who seems to have been James Paterson[6]) found it stimulating:

[Lavery's] picture of Queen Mary in the wood, entitled *Dawn, 14 May 1568* . . . arrests the spectator in spite of himself. The traditions which have stifled the presentment of historical painting are here entirely abandoned; the subject is treated with a keen perception of the real conditions of the episode. Here we have none of the laboured learning that pleases the antiquarian; details are not insisted upon; but in that dreary dawn we feel this is how the poor Queen looked and felt. The beauty and thorough keeping of the whole is no surprise to those who know Mr Lavery's *Tennis* on which it is a distinct advance.[7]

Lavery asked £150 for his painting and Morton and Roche 45 guineas and £50 respectively. These were substantial sums and indicated not just the importance

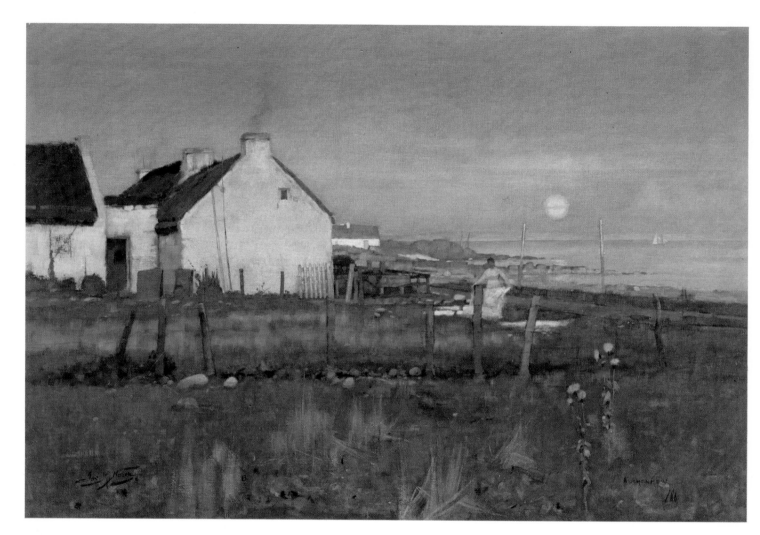

201
James Nairn
Auchenhew, Arran
1886
Canvas, 61 × 91.5
Andrew McIntosh Patrick

202
George Henry
Autumn
1888
Canvas, 45.7 × 38.1
Glasgow Art Gallery

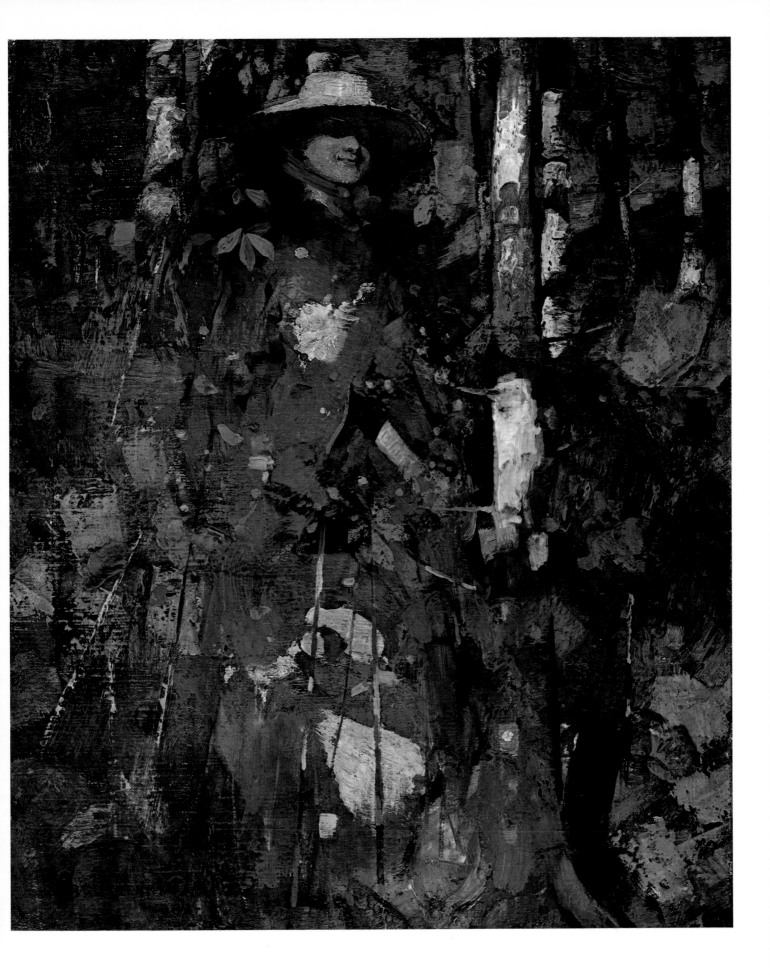

203
Alexander Roche
Shepherdess (line
illustration from The
Scottish Art Review)
1888
Canvas
Untraced

of the occasion but the importance of these pictures to each artist. Those by Roche and Morton are lost but a line drawing of Roche's picture (pl.203) and a contemporary description give some indication of it:

After the reserved grey tones of Mr Lavery's *Queen Mary*, this curiously composed picture, with its rich mingling of browns, purples, yellows, and greens, impresses us as a little forced in colour. The tenderly felt and beautifully drawn little girl kneeling in the foreground is treated in a naturalistic manner, while the sumptuous background of hillside, trees and sky, is distinctly romantic in conception and execution; hence a certain confusion. The individuality and strong feeling of the picture are unquestionable. There is nothing in the least like it in the galleries, it is the work of a man who has something of his own to say, who means to say it in his own way.[8]

This description shows that Roche had firmly moved away from naturalism just as Paterson considered Lavery to have moved away from the naturalism of *The Tennis Party*. Surprisingly, Paterson seems to have considered Lavery's picture 'a distinct advance' and it must have looked as if the Boys, in the most recent of their works to be included in this major Exhibition, were making quite determined steps to move away from the style they had adopted in the early and mid-1880s. Their achievement could still be assessed from the loans to the Exhibition but, in the case of Guthrie and Walton at least, the new direction that their work had begun to take was masked from public view. It may be that they felt their latest work was represented by the large decorative panels which adorned the Exhibition buildings; if that is so it merely serves to confirm that they were preparing to shake off what might be described as youthful excesses in exchange for the public – if not yet artistic – respectability of the established artist.

For the critic of the *Art Journal*, however, the Boys' exhibits were sufficient evidence of their growing stature:

There is in Scotland, and notably in Glasgow, a band of young painters who have broken from the traditions of the past and boldly struck into the road that is marked with the footprints of Bastien-Lepage. Among these men are some of the ablest in Scotland. Their future lies all before them: several of them will, without doubt, do great things, and they will be all the more certain to succeed if they bear in mind the lessons that all the past of Art can teach. Wisdom did not begin with Lepage; no, nor even with Velázquez. Freedom from conventionalism is in an artist an excellent thing; but protests against conventionalism are apt in their turn to become conventional. For their earnestness, for their lack of respect for what is merely respectable and popular in Art, these painters deserve the highest praise, and we feel sure that as the years roll on that bring the philosophic mind and lead to changed outlooks, the result will be good for Scotland. Perhaps the ablest of the 'new school', as it is sometimes very absurdly called, who have already attracted attention, are James Guthrie, John Lavery, E. A. Walton, James Paterson, George Henry and Alexander Roche.[9]

Guthrie, Walton, Lavery and Henry each contributed a large painted panel for the dome of the main Exhibition building. These were circular and were installed above each of the four supporting piers; they represented Art, Industry, Science and Agriculture. Public reaction was mixed, the most consistent criticism being that these representational paintings looked ill at ease installed in a building which was Islamic in style. They were, however, placed quite high and so were, on the whole, excused from too close a scrutiny. Unfortunately, none of them has

survived and only Guthrie's painting is known in any detail from a later photograph taken in his Woodside Terrace studio in Glasgow in the 1890s (pl.204). There were, in fact, several other wall paintings in the Exhibition buildings for which the Boys were responsible. Roche and Millie Dow painted 'decorative frescoes'[10] for the Sculpture Hall and Hornel, Nairn and MacGregor Wilson (a member of the Art Club) painted other murals on the gable ends of the Sculpture, Architectural and Photographic Galleries.[11] These all seem to have been destroyed with the buildings at the close of the Exhibition and no illustrations of them have survived.

It is interesting to see Hornel and Henry among the artists chosen to produce these murals. We can speculate that it was this excursion into large-scale decorative work that directed their joint efforts over the next three or four years. Their panels at the Exhibition, however, along with those of the rest of the group, did not attract a great deal of attention, not even from *The Scottish Art Review* which devoted a whole illustrated article to the murals commissioned by Patrick Geddes from a group of Edinburgh artists.[12] The Boys themselves were keen to continue to find similar commissions and in February 1889, shortly after the article about the Edinburgh murals had appeared, they orchestrated a deputation from the Art Club which approached the Corporation of Glasgow with regard to the decoration of the new City Chambers which was then rising in George Square.[13] *The Scottish Art Review* also took up the challenge to the Corporation, adding its voice to that of the Art Club and the Ruskin Society:

The renaissance of public mural decoration is now making notable progress. In Glasgow the Town Council have now received a deputation from the Ruskin Society urging on them the desirability of completing the new Municipal Buildings by a series of paintings worthy of the City . . . As the recent Glasgow Exhibition showed, we have among us artists able and willing to do such work, and whose powers, technical and imaginative, would develop as they proceeded; for, of course, no one would begin with the most important hall, but would work from minor panels onwards towards a climax. It is unfortunate that our annual exhibition contains no example of designs for mural decoration; but the more far-seeing painters are doubtless already gathering their sketches, materials, and planning many a symbolic and historic scheme.[14]

This note shows how the Boys could occasionally use *The Scottish Art Review* as their own mouthpiece. The article itself seems to be trying to disarm criticism of the idea which had already been voiced and at the same time points out that the councillors need look no further than their own city for suitable practitioners of the art of mural painting. The Editor, probably Macaulay Stevenson, also makes a jibe at the Institute for giving no opportunity for such artists to exhibit their decorative wall paintings. Later that year, in one of the Institute's autumn exhibitions, the Boys were given an opportunity to show a group of such pictures they had just completed.[15] Some of these had been commissioned by the Kyrle Society of Glasgow for installation in the Prisoners' Aid Society premises in Glasgow; some were also intended for Broomloan Hall in Govan but none of them has survived. No details of subject-matter or size are recorded and all we know is that of the various designs by Henry, Roche, Walton, Kennedy, Morton and Nairn, only that by Nairn was considered to be successful.[16]

The Kyrle Society appears to have been established in the mid-1880s, with its

204
*James Guthrie in his Studio, Woodside Terrace, Glasgow, with his International Exhibition panel, Music, in the background
c.1891*

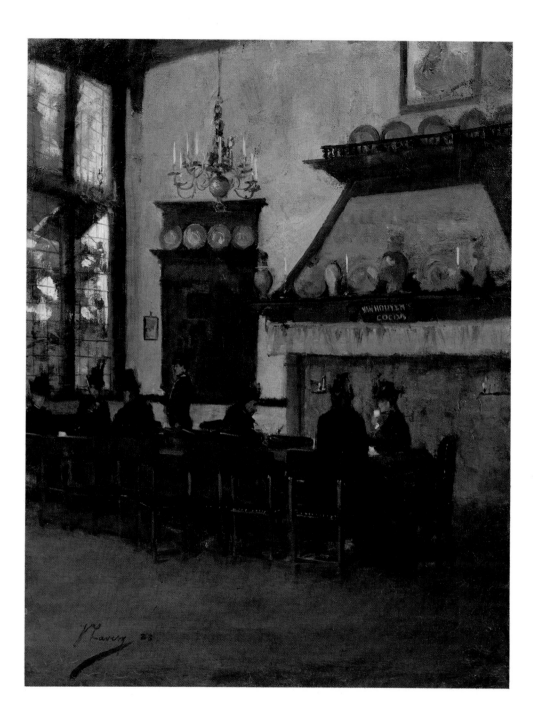

205
John Lavery
The Dutch Coffee House,
Glasgow International
Exhibition
1888
Canvas, 46 × 35.5
Private Collection

object 'to bring the influences of natural and artistic beauty home to the people'. The Society's Annual Reports show that it had encouraged the painting of murals in other Prison Missions, mainly by students at the School of Art and other local painters under the guidance of Samuel Reid. Other activities included the planting of flowers and shrubs, choral singing and the preparation of artistic decorations for churches and public buildings. The commission which was given to the Boys seems to have come from a special committee on mural decoration that was set up under the Chairmanship of Fra Newbery, the Director of the

Glasgow School of Art. The murals were painted on panels and similar sequences, possibly also painted by the Boys, were installed at the University Mission Hall at Garscube Cross and Merkland Street Mission Hall in Partick, Glasgow.

The outcome of the Art Club's campaign was that the City Fathers eventually offered a commission for the decoration of the grand public spaces in the City Chambers, but it was not until 1899. By this time most of the Boys had left Glasgow and the youthful inspiration they had displayed in the 1880s had already begun to wane in many of them, if it could not actually be said to be extinct. The commission was originally offered to Roche who insisted that others should share it with him and eventually Walton, Lavery and Henry joined him.

206
John Lavery
The Cigar Seller at the Glasgow International Exhibition
1888
Canvas, 30.5 × 38.2
Private Collection

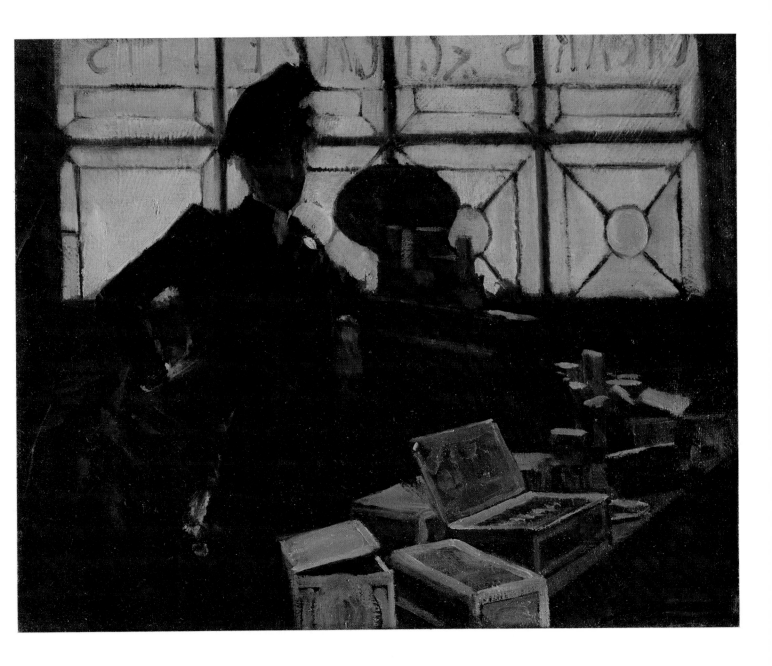

The theme was to be a historical account of the city: Roche chose the subject of St Mungo, patron Saint of the city, finding the ring of Queen Langoreth in the mouth of the salmon; Henry depicted the granting of the royal charter in the twelfth century; and Walton depicted the citizens of Glasgow at play on a fifteenth-century Fair Holiday on Glasgow Green. Lavery chose to ignore the historical thread of the panels and produced an account of Glasgow's major industry upon which much of its nineteenth-century prosperity was based – shipbuilding. He broke not only the historical sequence but in his dramatic composition he disturbed both the architectural framework of the Banqueting Chamber and the more tranquil arrangements of his colleagues' panels. The work was not completed until 1901 and we can only speculate on what might have been had the joint campaigns of the Art Club and *The Scottish Art Review* born fruit ten years earlier.

Lavery's success in the 1890s as a society portraitist can in some measure be attributed to events in Glasgow in 1888. He had spent the summer in the grounds of the International Exhibition making a number of sketches and more finished paintings of the bands, stalls, crowds and pavilions to be found in the park. These were exhibited in October at Craibe Angus' Gallery in Queen Street, Glasgow, where they achieved a great popular success (pl.207). More importantly for his later career, Lavery was chosen (or volunteered, as the exact circumstances of the awarding of the commission are unclear) to paint a large picture commemorating the visit of Queen Victoria to the Exhibition in August 1888. Lavery was to produce a canvas of heroic proportions (256.5 cm × 406.4 cm)

207
John Lavery
Invitation Card for Lavery's
exhibition of Glasgow
International Exhibition
Pictures
1888
Hornel Trust, Broughton
House, Kirkcudbright

recording the portraits of 253 individuals present at the Queen's visit (see p.225). His skills in achieving a pleasing composition along with reasonable likenesses, combined with the picture's popular success, established him as the leading portraitist of the Glasgow School and opened the way for him to settle in London.

In October 1888 *The Scottish Art Review* heaped praise on his Exhibition sketches:

The pictures are about fifty in number, and consist of finished work studies and lighter sketches of various parts of the Exhibition and Grounds. Many of the pictures are exceedingly beautiful, portraying aspects of light and colour on the buildings which only the artistic insight and delicate perception of such an artist as Mr Lavery could have been able to discern. The masterly drawing and skilful treatment of the crowds of people at the various sights throughout the Exhibition exemplify the artist's unusual power of rendering life and animation. To very many visitors and regular habitués these pictures will come like a revelation of numberless points of artistic interest and beautiful harmonious colour and form which exist in scenes with which they have become familiar. For ourselves, we may say that since seeing these studies a new interest has been added to our visits to the Exhibition, as we are now continually seeing beauties in the effects of sunlight and evening shadows which, combining with the bright costumes of the ladies, form a series of exquisite living pictures. The true aim of every artist is to make others see the subtle charm of nature as he sees it, to feel the beauty of colour, line and form as he feels it. Mr Lavery has succeeded in these pictures in demonstrating to all who see them the wondrous power of art to enrich our interest in what goes on around, by opening our eyes and minds to innumerable beauties and charms whose existence we scarcely suspect.[17]

Substitute the name of Whistler for Lavery in this review and the same judgement holds equally true; also, the inspiration for these fifty paintings becomes immediately apparent. Lavery had met Whistler in 1887 and had begun to send work to the Royal Society of British Artists which was then very much under Whistler's control. When Whistler's short reign as President was ended in 1888, Lavery was one of the artists who left the Society along with the 'Master'. Not always the easiest of men to get on with, Whistler was to remain a friend of Lavery throughout the 1890s and encouraged him in setting up in London. In Lavery's Exhibition paintings can be seen much of Whistler's teaching and example. The latter's Cremorne Gardens nocturnes and other paintings of the Vauxhall pleasure gardens offered antecedents for these tonal sketches of the Glasgow Exhibition. Lavery is a little more wide-ranging in his subject-matter but the validation of such a mundane theme as this huge commercial exhibition ground is based upon Whistler's continuing justification of the artist's right to choose his own subjects and to find beauty where an untrained eye might ignore it. In some ways, this series of pictures is the most open acceptance of the gospels of Whistler's *Ten o'Clock Lecture* so far encountered in Glasgow School painting. Despite their open commitment to modern urban life as a fit subject for an artist, Lavery's handling of these canvases also emphasises the Boys' gradual move away from the realism, or naturalism, of Bastien-Lepage towards the more decorative treatment of modern life that becomes so clear in their work at the end of the decade. There are considerable differences between these pictures and the contemporary work of Hornel and Henry, but the commitment to decorative and aesthetic effect within a composition is very similar.

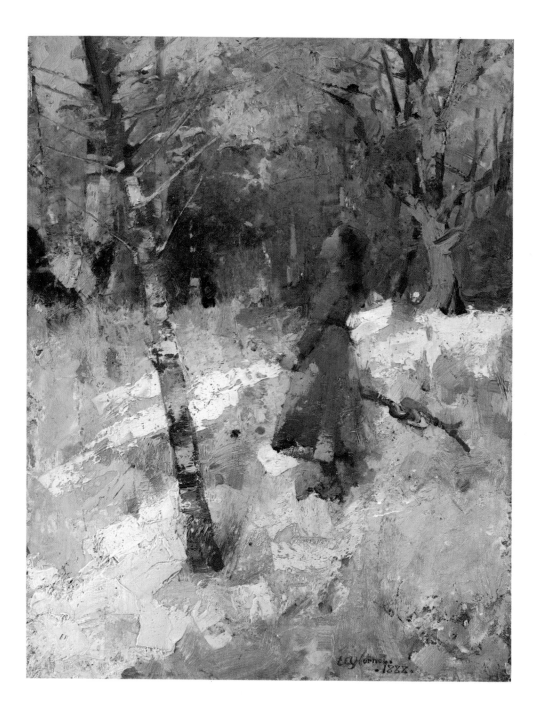

208
E. A. Hornel
Autumn
1888
Canvas, 44.5 × 33
Private Collection

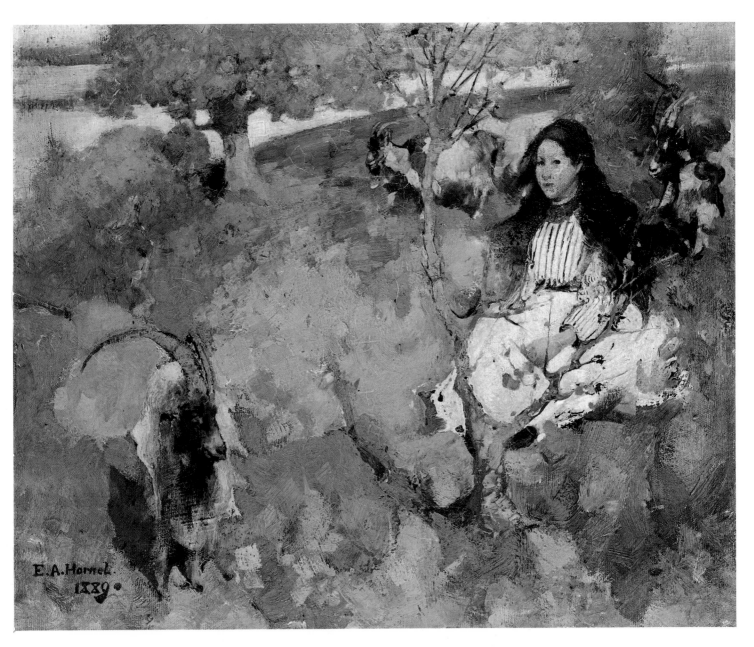

209
E. A. Hornel
The Goatherd
1889
Canvas, 38 × 43.2
Private Collection

211
John Lavery
The Musical Ride of the
15th Hussars during the
Military Tournament,
Glasgow International
Exhibition
1888
Canvas, 30.4 × 38
Dundee Museum and Art
Gallery

212
John Lavery
On the Verandah, the
Indian Pavilion at the
Glasgow International
Exhibition
1888
Canvas, 35.5 × 45.7
Private Collection

213
John Lavery
The Blue Hungarians at the
Glasgow International
Exhibition
1888
Canvas, 30.4 × 35.5
Andrew McIntosh Patrick

Lavery's sketches divide into various groups – views of individual buildings, specific events within the Exhibition, a group of single-figure compositions depicting people at work in the Exhibition, and a series of interiors, mainly of the numerous tea rooms scattered around the park. In handling they range from the strangely formal such as *Woman Painting a Pot* (pl.210) to the elegant figure of *The Cigar Seller* (pl.206), a painting of the Muratti cigar stand known as 'Au Bon Fumeur'. This is one of the most strongly coloured of the series, contrasting the shadowy interior of the booth with the brilliantly lit stained glass and the highlights on the edges of the boxes scattered along the counter. It is a daring composition, confidently handled. Outside his eye passed from the parading troops, as in *The Musical Ride of the 15th Hussars during the Military Tournament* (pl.211), to a more dynamic arrangement in *On the Verandah* (pl.212), a view of the Indian Pavilion from an adjacent terrace. *The Blue Hungarians* (pl.213) and *The Glasgow International Exhibition* (pl.216) show Lavery almost approaching the 'set piece' composition, but these two pictures retain a spontaneity and vivid impression of the bustle and activity of the Exhibition crowds despite being among the most finished of all the paintings. The latter is a nocturne and Lavery paid a more open homage to Whistler in painting at least two nocturnes of

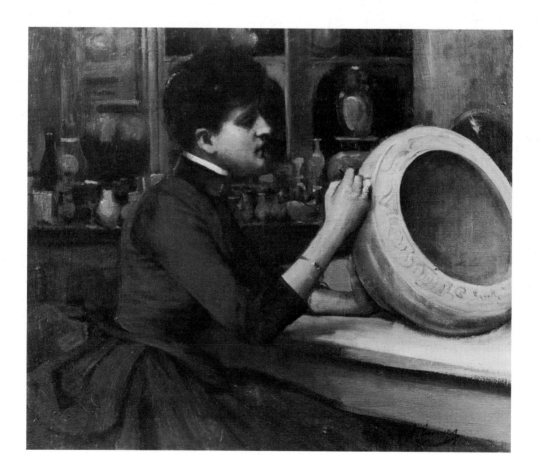

210
John Lavery
Woman Painting a Pot at
the Glasgow International
Exhibition
1888
Canvas, 38.1 × 45.7
Glasgow Art Gallery

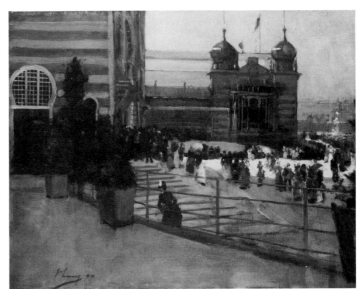

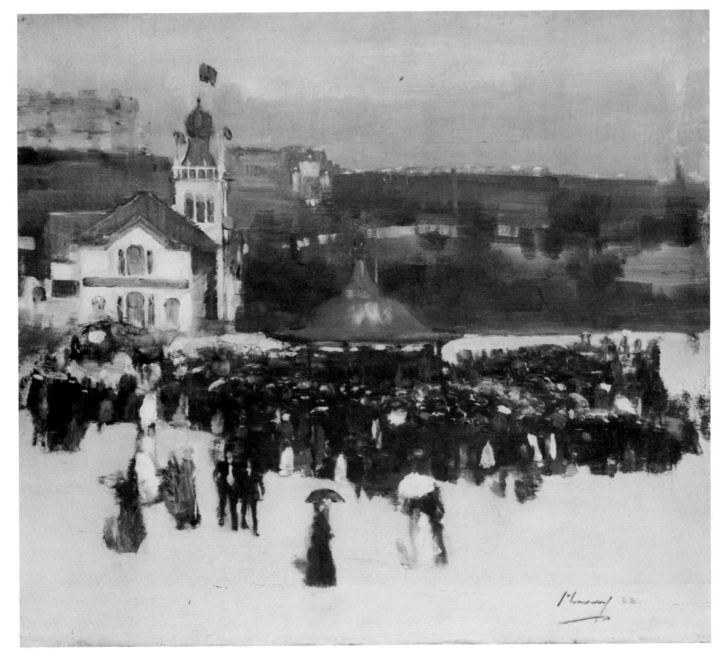

fireworks displays at the Exhibition (Private Collections). These were accompanied by a more oblique reference to Whistler's Venice paintings in Lavery's sketch of a Glasgow gondolier on the specially engineered Exhibition canal (Coll: Cecil Higgins Art Gallery, Bedford). One of the most elegant of the interiors is *The Dutch Coffee House* (pl.205), with its more considered handling.

Lavery had an undoubted popular success with these sketches which firmly placed him in the public limelight. In his autobiography he says that his exhibition was held in the spring and that following its reception he was asked to paint the large canvas commemorating the Queen's visit to the Exhibition (pl.212). In fact, his own exhibition was not held until October 1888 and Victoria's visit took place on 22 August. It may well be that Lavery had caught the attention of those who awarded the commission while he was sketching in the

214
E. A. Hornel
The Brook
1891
Canvas, 40.6 × 51
Hunterian Art Gallery,
Glasgow

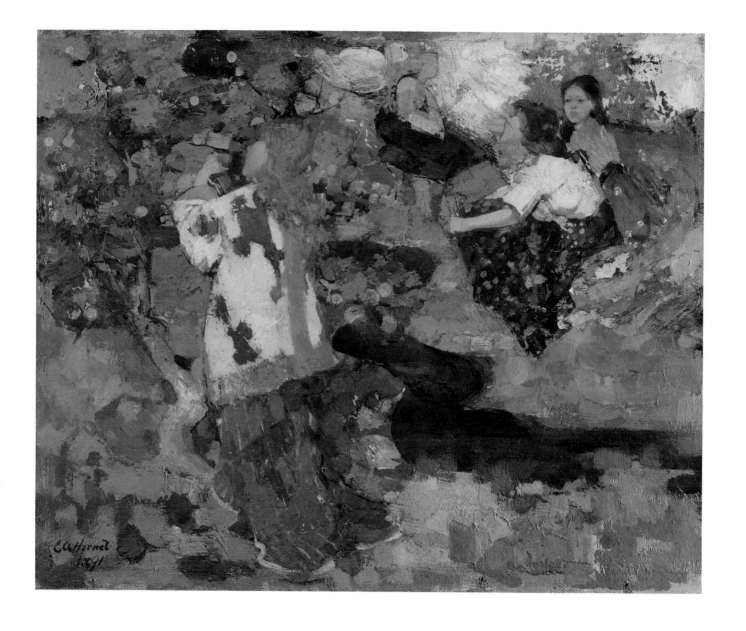

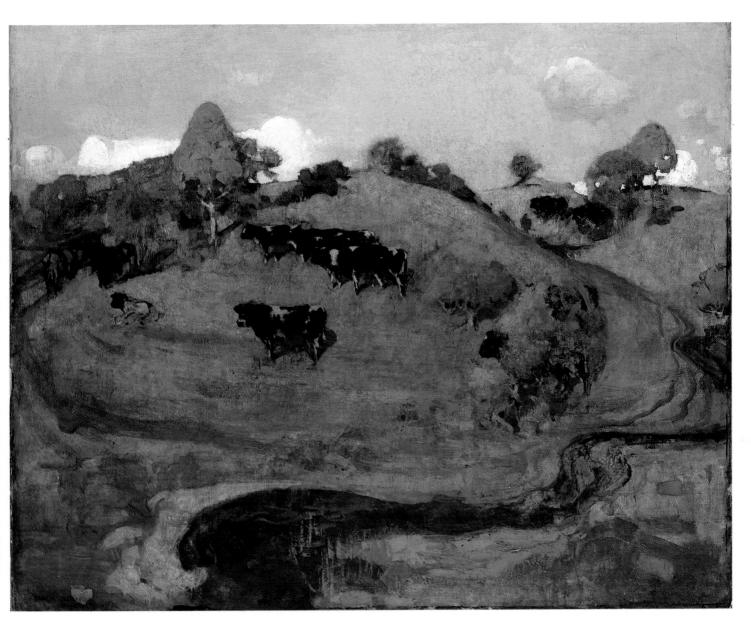

215
George Henry
A Galloway Landscape
1889
Canvas, 121.9 × 152.4
Glasgow Art Gallery

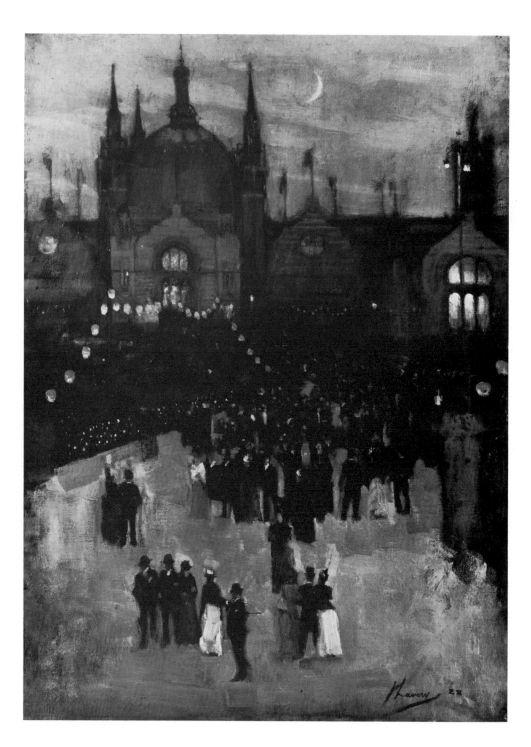

216
John Lavery
The Glasgow International
Exhibition
1888
Canvas, 61 × 45.7
Glasgow Art Gallery

Exhibition grounds. If that were true, it was a bold decision to award such a commission on the strength of the appearance of that group of paintings. As a portrait painter Lavery was not as well known as Guthrie, or even Walton, who had shown several commissioned works at the Institute. It is possible that the commission was first offered to one or other of these painters and that they turned it down; the fee of £600 was not exactly generous for such a considerable

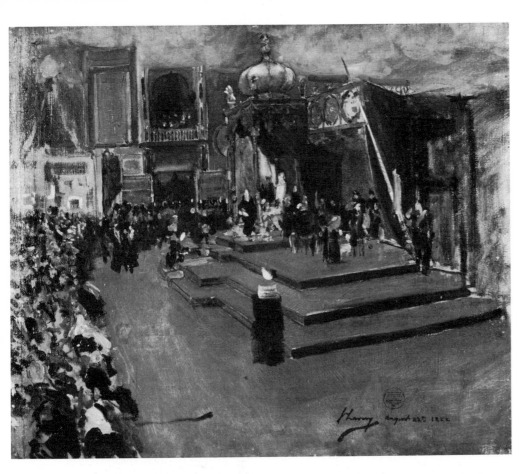

217
John Lavery
Study for State Visit of
Her Majesty, Queen
Victoria, to the Glasgow
International Exhibition'
1888
Canvas, 63.6×76.3
Aberdeen Art Gallery

218
John Lavery
State Visit of Her Majesty,
Queen Victoria, to the
Glasgow International
Exhibition, 1888
1890
Canvas, 256.5×406.4
Glasgow Art Gallery

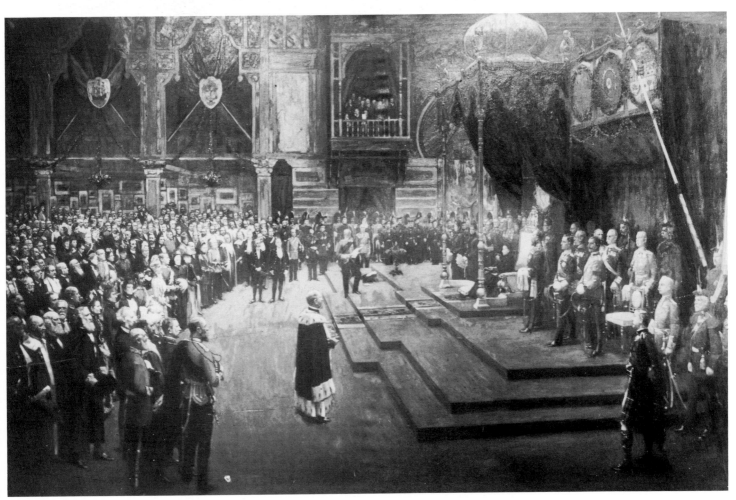

project, as the artist was to be expected to include in his painting a likeness of all the dignitaries who had been present in the hall at the Queen's visit. Guthrie would probably have rejected the commission anyway, not simply because of the low fee but because his method and pace of working were totally unsuited to such a huge canvas. He had had a number of apparently insuperable problems with the compositional arrangement of much smaller groups of figures and he had by now realised that the future for him lay in single-figure compositions – simple portraits, not elaborate groups. In many ways Lavery was the ideal choice and it is possible that those responsible for the commission realised immediately that he was the right man for the job. He worked quickly, was confident and exuberant in his approach to such difficult tasks; above all he was enthusiastic and ambitious enough to realise that should he succeed his future as a portraitist was almost assured.

Among his subjects, after the Queen herself, were many of the nobility of Scotland and England and many influential local collectors and businessmen. After having the good fortune to be granted a sitting from Queen Victoria, Lavery was given an entrée to the homes and social circles of all the other 'sitters' which was doubtless of the greatest use to him in later years. He made a rough sketch of the scene on the day of the visit, concealed from view behind a curtain on a balcony (pl.217). He remained faithful to this original concept, taking almost two years to complete all the portrait studies which formed the basis for the final version. As with the Exhibition sketches, Lavery's fluid handling gives even these brief notes a degree of finish which belies the speed at which they were made. Even as he was working Lavery must have had a clear concept of the particular position of each figure and its relationship with its neighbour and the Hall. All the information he needed was quickly put down on the canvas, giving many of these studies a quality which is almost entirely lacking in the rather mechanical painting of the final work.

Exhausted by it, Lavery left Glasgow for Morocco where he met Crawhall and R. B. Cunninghame Graham. Behind him he left some rather mixed reviews of his picture, which was roundly condemned by some critics and coolly praised by others. The critic of *The Times* identified Lavery's true position, however, in a perceptive review of the problems that such official commissions create:

It is scarcely possible that such pictures have an artistic interest equal to their historical or topical interest; and Mr Lavery had not done more than paint creditably a scene that he would never have chosen to paint for himself.[18]

Certainly, the picture brought Lavery public recognition and esteem in Glasgow, even though he almost undid all his good work by a misguided attempt to capitalise on his, or his picture's, new-found fame. He was offered £1000 – £400 more than he had received for the painting itself – if he would lend it to a Glasgow store which would display the painting at sixpence per visitor; £1000 is the figure that Lavery mentions in his autobiography but an article in *The Bailie* put the sum at £6000![19] Lavery had agreed with the Corporation of Glasgow that he should retain the picture for a year after its completion in order to send it to

various exhibitions. The Councillors felt that a Sauchiehall Street haberdashery was not what they had had in mind when they agreed to the request. Nor was it a fitting place for the Queen to be gawped at by the paying public. The painting was withdrawn after a month but the businessman obviously felt that he had had his money's worth and Lavery received his £1000 in full.

If the International Exhibition was an event in which the Boys merely participated, then *The Scottish Art Review* was something which was born of them and which they entirely controlled, at least at the beginning of its life in 1888. James Paterson seems to have been its chief inspirer; he genuinely seems to have wanted to create a journal which would link the discrete factions of artists, musicians, writers, and critics who acknowledged each other's presence in Scotland but who had no medium where they could acknowledge the validity of the other man's form of expression. Paterson's fault in his conduct of the early months of the campaign to establish the journal was, perhaps, to express himself too forcefully in its favour, to appear to be too keen. In many ways *The Scottish Art Review* was not a success but it seems to have been doomed before its first issue appeared on account of Paterson's excessive enthusiasm and the rather jaundiced attitude that some of the Boys took to it and to his protestation of its likely merits. Macaulay Stevenson saw only personal advancement for Paterson in his fervent support of the project, particularly his pushing for the inclusion of articles by various members of the Senate at Glasgow University.[20] Paterson was not very popular among the Boys, perhaps because of his awareness of the need to achieve financial security for his growing family, and this basic distrust of his motives may have coloured the general reaction of the group towards his scheme. Apart from any other considerations, the Boys were to be expected fo fund the operation themselves with an opening donation of £5 – a sum which many of them could hardly afford and which even the most comfortably off member gave with ill grace.

Surprisingly, this was Macgregor, whom, as his oldest friend, Paterson may have been counting on to act as a more substantial backer. They had been friends for nearly twenty years and Paterson was shaken by the distinct lack of enthusiasm for the project expressed by Macgregor to him in a letter dated March 1887:

I was somewhat surprised that the secret society of artists should have decided on starting a Review. In what I am going to say, you will no doubt think that I am a regular wet blanket. I am rather doubtful about the Review. Are there not too many reviews already? and it is not at all likely that this new one will beat the *Saturday [Review]* or the *Spectator*. It will in all probability be a mediocre affair. If we have all such a hatred of commonplace art, why should we send out into the world 'Gluepot' literature? R. A. M. Stevenson writes very well on art, but I know the kind of stuff Underwood and Veitch would write [Underwood was American Consul in Glasgow and Veitch was Professor of Logic at Glasgow University]. Really, the more I think of it this reading of Reviews and magazines is very bad for people . . . Seeing I don't go in for this scheme, and am not hopeful of its success (the British public having no sympathy with art or ever will have) I do not feel inclined to invest more than a five pound in it.[21]

Paterson's private comment on this letter reveals his disappointment:

Whatever relations Macgregor had with the Glasgow School it is evident that he was not the father of *The Scottish Art Review*. His more than cool reception of its birth was rather a damper to his fellow members, as hopes had been entertained that substantial financial backing might proceed from the only moneyed supporter.[22]

Despite this apparent set-back, Paterson set about raising the required funds to begin publication and the first issue appeared in June 1888. It carried a brief, unsigned editorial, setting out the aims of the new magazine:

The *Scottish Art Review* has for its object the dissemination of Art knowledge. Interest in the Arts is manifestly increasing throughout this country, and for intelligent guidance of this interest there is a generally felt desire. While primarily intended to meet this want, the aim of the Magazine will be to treat the subject considered in a spirit calculated to make it of value as a contribution to Art thought, independent of mere locality . . . In the pages of this Review the Painter will write about PAINTING, the Sculptor about SCULPTURE, the Architect about ARCHITECTURE, the Musician about MUSIC, and the Man of Letters about LITERATURE; but not to the exclusion of those who, though not professionally engaged in the Arts, may yet have general culture or special knowledge qualifying them to deal with subjects coming within the scope of the Journal.[23]

According to Macaulay Stevenson this editorial was prepared by a committee organised by Guthrie in response to Stevenson's fears that *The Scottish Art Review*'s editor was not capable of preparing such a statement. Although he was never anywhere publicly acknowledged, the first editor of *The Scottish Art Review* was called Gillon and he had been suggested to the Boys (according to Stevenson's letters to Honeyman) by an architect in Glasgow, John Archibald Campbell (although Paterson remembers him being another friend of Campbell's called Young). Stevenson recalled that he was not well suited to his task and various supporters of the magazine suggested that Stevenson himself should be asked to oversee its production:

Guthrie suggested that in making the start, Gillon should show his try-off introduction to Macaulay [Stevenson]. All agreed to this. Gillon came – he saw, but he didn't conquer for he showed me as the take-off the damnedest farrago of blatherskite I ever saw. He didn't know a damned thing about the job – and his chief point (to cloak ignorance) was 'We shall be wide.' 'My God!' I said to Gillon. 'That is exactly what we won't be.' I called in Guthrie – result, a committee excogitated a quite impersonal, unreadable, and un-understandable note for our send-off (Guthrie had a genius for that sort of thing – that is what humbugged his painting all his life – it must be impersonal, and it was).[20]

Paterson's account of the genesis of the magazine and its first issue is worth recounting as perhaps a less biased statement of affairs (Coll: Paterson Family):

The actual organisation of the body took shape in 1886 and 1887; in the latter year, after much debate, and acute dissent from some of the members, it was resolved to produce a magazine of sorts to promulgate healthy opinion regarding the art of the day . . . with a capital of £60 a start was to be made, the public would do the rest! A small committee was entrusted with the venture and innumerable meetings were held mostly in Paterson's studio. Search for an editor proved a difficult problem, but at last a Mr A. A. Young, architect with a flair for literature, was appointed at a nominal salary and preparations were made for the issue of a first number in June 1888 . . . At last the MSS were in the possession of the editor but on the day of going to press, editor and MSS could nowhere be found. He was not at his lodgings, the office knew him not, search was made and towards evening he was found hopelessly intoxicated in a public house at Hamilton, the precious

copy in his pocket. Dismissal followed and after a few days' delay the printing press was at work and hope revived.

The truth may lie somewhere between these two versions of events.

The first issue contained articles by Principal Caird, of Glasgow University, on 'Progressiveness in Art' (on the point about excluding laymen Paterson wrote 'beggars could not be choosers'); unsigned reviews of the painting and sculpture sections of the Glasgow International Exhibition (the sculpture notes actually being contributed by Macgillivray under the pseudonym 'Doryphorus'); on Allan Ramsay, the poet, by Professor Nichol; and various other reviews of music in Scotland, exhibitions in London and so on. It did not meet with favour from Macgregor:

I have not seen the July issue but that for June was a very poor affair, very uninteresting. A stale article of Caird's, a few notes of Hamilton Bruce which anybody might scribble on their catalogue, and though the notes on the Painting and Sculpture at the International are not bad, still they are not enough to raise the Review to anything like a high level. The Music department seems very poor and the literature the same.[24]

Not only was Macgregor annoyed at the content, he had also been asked to contribute another £5 to ensure its continuity. He was not pleased and Paterson had to placate him as best he could. Few of the Boys would have found it particularly easy to contribute further sums to the cause: Hornel, in particular, was very short of funds and Henry sent him the necessary £5 note for him to send in turn to Paterson so that his financial state should not become the latest talking point of the Art Club.

Stevenson tells us that the magazine was not well received outside the Boys, either, and took most of their capital to produce the first issue:

The first number, anyhow, came out somehow – and bang gaed saxpence – it took about half our capital, as I had warned them when Paterson brought on his wild-cat scheme.

Then helped into a sort of notoriety by a good many sneers from the press we were quiet (and somewhat subdued) for a fortnight or so.

On the 17th of the month [June], Macgillivray came up to my studio to ask me how No. 2 was getting on (Macgillivray and I grew up and fought like brothers). I asked him how the devil he thought I should know. 'Oh!' he said. 'You took to do with No. 1.' Oh damn you, Macgillivray, trying to fasten this one on me! I definitely told him, in Whistler's words, that 'I was curiously interested in some paintings' and showed him out.

He went to Guthrie, Poor Guthrie! He had a hell of a life always trying to straighten things out!

By the 20th of the month there being no sign of movement towards No. 2, up came a deputation of Guthrie, Macdevilry (Macgillivray, as we always called him and he took it like a lamb), Henry, and some more to beg me to do what I could about it.

I took it on . . .[26]

In the editorial for the second issue in July 1888, there appears some of Stevenson's ebullience, gained perhaps from his stint in the *Quiz* gossip columns:

The Scottish Art Review starts unhampered by traditions, but not without a definite policy . . . The Dilettante and the Dryasdust, and all whose hearts have been eaten out by the pride of caste, or the dry-rot of a self-sufficing culture, will have no place here. We are not for them, nor they for us. What we want is living truth for living people.[25]

Gradually, Stevenson changed the mediocrity of the first issue into something more substantial although never totally innovative. Artists were called upon to contribute pieces for subsequent issues, among them Roche, Lavery, Paterson, Stevenson himself, Macgillivray and others from Glasgow; from further afield came George Clausen with an article on Bastien-Lepage. R. A. M. Stevenson, Patrick Geddes and Gleeson White also contributed and there were articles on painters as far apart in style and period as Mabuse and Corot, Stott of Oldham and Romney. Stevenson introduced more illustrations, both engravings and drawings of paintings (the latter often prepared by Roche who discovered a new talent for illustration which was used to good purpose by W. E. Henley in a guide to the paintings in the Glasgow International Exhibition). Burne-Jones, Whistler, Corot, O'Meara, Bastien-Lepage and Puvis de Chavannes were among those to be illustrated in its pages but *The Scottish Art Review* did not have a long time to live. In April 1889 James Mavor took over as editor. He eventually moved on to the University of Toronto as Professor of Political Economy; he was also uncle of O. H. Mavor, better known as James Bridie, the playwright. Mavor made the magazine rather more professional in its appearance but its content was neither specifically Scottish nor identifiably linked with the young men whose money had founded it. It lost credence within the city and by the end of 1889 its future looked uncertain:

The *Review* has lately been Scottish only in name, and it has not 'supplied any felt want'. Is it impertinent to ask whether those who first started it are now much concerned in its ultimate fate. The Philistines are chuckling, that's all! Most men think they can run a magazine and drive tandem – until they try![26]

This piece may well have been written by Stevenson, whose animosity towards Mavor and his disapproval of the machinations to wrest control of the magazine from the Boys appears in a letter to Hornel in which he seeks his support for *Quiz*:

5 June 1889

Brlood sir! We must have some blood! I send you the latest. Two dozen copies of *Quiz* will be sent tomorrow morning to the best newsagent in Kirkcudbright – on sale – they'll arrive early in the afternoon. I fancy you will easily see that there should be demand for them, old boy.

We happen to know (strictly confidential) that the *S. A. R.* have sunk £2000 already, and that some boss art men here have put up another £2000 to give it a fair chance. It's damnable that Mavor should, by his utter incompetence, or self-willed folly, be allowed to throw all this in the gutter to get out his monthly potboiler to the hurt of Art. So he must either be constrained to walk in the straight and narrow path of progress and poverty or else walk the plank. Of course I'd never have written such a scorching article had I not known about the financial position. Keep all this strictly confidential. There's to be a brotherhood meeting soon to pass a resolution about the *Review* and make strong representations to Campbell about a return to honest common sense in the journal's policy. You will be notified about the meeting in due course, so, as you won't be coming up, please leave a good straightforward letter ready expressing your views. Post it up to Guthrie or any of the Boys – or better still it might be a good scheme to write complimenting Guthrie about the mention, and let into the *Review* in your letter to him, urging him to move to get things bettered. The Boys here are unanimous . . . and Campbell is also dissatisfied with Mavor. Of course we have no wish to shift Mavor if he will only just do the fair thing, he mustn't be allowed to go on in this insane style.

Excuse more at present, old chap, in awful hurry and write in great haste. Be sure and get the Art folks down your way to go in for the *Quiz* regularly. We are going to waken it up a bit. And send me up any notes you like about the oncoming Dalbeattie show or anything to keep up local interest. I am going to have a *Pall Mall* style interview with Teddy and Guthrie about the pastels in *Quiz* next week or week again. Some of us are strong for getting Ford down – Teddy and Guthrie saw him lately. If not, we hear the *Review* will go over to Henley and Hamilton Bruce, which means handing them a club to break all our backs with. Bruce is believed to be Cottier's partner, and it is his game to inflate prices of Barbizon men and Marises and run down all the Scottish art. The *Scots Observer* articles on our Boys I have reason to know were not sincere, but were written to get us to use influence to get Henley on the *Review* as Editor.

Teddy who is sitting by me sends love. I will write you soon telling you about the Boys' visit to Paris etc. Guthrie came back with that stale maidenhead of his still intact. Shocking!

Love, old Hornel, and all greetings to Gibson and the circle. From yours ever in fraternity,

Macaulay[27]

The events that Stevenson recounts led up to Mavor's resignation and the eventual handing over of the journal, and its debts, to an English publisher. His own talent as a gossip column writer is clearly evident in this chatty letter, one of the most revealing of the letters kept by Hornel. John Campbell, described by Paterson as 'a young architect associated with our group . . . and interested in the venture' seems to have put up the necessary capital to keep it in business following the depletion of the Boys' funds after the first issue. Eventually he could support neither the continuing loss nor the policies of its editor and he sold it to Walter Scott, a publisher in Newcastle.

In some ways, however, *The Scottish Art Review*'s gradual earlier drift away from Glasgow and Scotland in its subject-matter reflected the changing targets of the Boys themselves. The reviews of exhibitions in London and the New English Art Club, the Royal Society of British Artists and the Grosvenor Gallery are full of references to the pictures exhibited there by Lavery, Walton, Guthrie, Paterson, Melville, Henry and several others. As Macgregor had first suggested, however, such material was insufficient to draw readers away from the more general weekly and monthly journals such as the *Spectator* and the *Saturday Review* and in December 1889 the last issue appeared. In January it came out simply as *The Art Review* aimed at a wider audience with articles on Robert Browning and English country houses. Surprisingly it was often kinder to the Boys' exhibits than it had been in the days of Mavor and in its last issue in June 1890 it contained articles on the work of Marie Bashkirtseff, a pupil of Bastien-Lepage, and on Odilon Redon.

The Boys had presumably hoped that *The Scottish Art Review* would consolidate their position in Glasgow and in Scotland but as it gradually failed to make any impact on its intended audience its sponsors found that their futures lay elsewhere than in the city which had brought them together. By the time the journal had passed out of their control they had realised that for most of them the way to advancement, financially and publicly, lay outside Scotland. Sadly, it was not a way which also demanded of them the same commitment to their art that their years in Glasgow had in the 1880s.

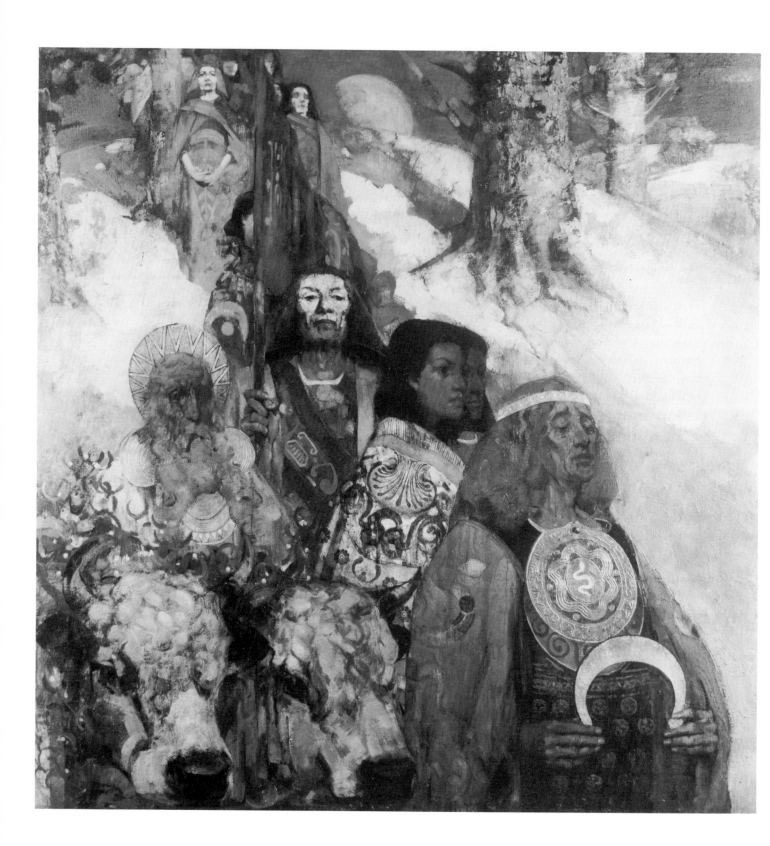

CHAPTER 10

Galloway Idyll

As the end of the decade approached Guthrie, Walton and Lavery found some public acknowledgement as leaders of the Glasgow School. Public commissions were gradually directed towards them (following Lavery's commission for the Glasgow International Exhibition picture and Guthrie's portrait of Gourlay, Walton was asked to paint the portrait of Glasgow's Lord Provost, Sir James King, in 1889) and their involvement in ventures such as *The Scottish Art Review* and the Glasgow International Exhibition helped to change their public image. From being the rebellious young artists of ten years earlier they were now perceived as more serious members of the Glasgow artistic establishment. Along with their new status, to some extent, came a slowing down of the pace of experiment in their work. While all three were to continue to produce novel ideas between 1888 and 1895, the impetus of change that they had generated was to be continued not by them but by the younger members of the group. As happens so often, the establishment, by absorbing the rebels into their ranks, quelled the spirited radicalism of those who had set out in the early 1880s to change the narrow views of the men who held the power in Scottish artistic life. Slowly the older members of the 'secret society' (as Macgregor dubbed it) were admitted to the Royal Scottish Academy, to the Council of the Glasgow Institute of the Fine Arts, to the Committee of the Glasgow Art Club; and, while it cannot be denied that these bodies were themselves changed by their admission of these young men, the outlook and attitudes of the Boys gradually changed too. Contributing to this change were the responsibilities of family and public life, a growing concern to project the right kind of image that would further their careers and, above all, the realisation that their futures, if they were to live up to their growing ambitions, lay almost certainly beyond Glasgow and probably even beyond Scotland. Guthrie, Walton, Lavery and Macgillivray saw their future as portraitists and they began, at about the time of the Glasgow International Exhibition, to cultivate the social and political contacts that they realised they would need to succeed in their chosen career.

George Henry was eventually to follow them along the same path to prosperity and a London studio as a painter of society portraits but at the end of the 1880s his friendship with Hornel generated a new phase of painting that continued to attract critical acclaim, as well as condemnation. Hornel is not the easiest of characters to understand. As a young man he was described by A. S. Hartrick, a friend and fellow painter, as 'a fine-looking man of strong character and stronger language'.[1] In later years Hornel, too, became a financially successful and sought-after painter but he rejected the honours bestowed on him by the Royal

219
*George Henry and
E. A. Hornel
The Druids
1890
Canvas, 152.4 × 152.4
Glasgow Art Gallery*

Scottish Academy and continued to live in Kirkcudbright for the rest of his life. His success allowed him to assume the role of 'gentleman-artist', travelling around the world and enjoying his position as father-figure in the colony of artists who established themselves at Kirkcudbright after the turn of the century. These two young men found in each other's company some of the same spirit which had drawn together Guthrie, Crawhall and Walton ten years earlier. Their friendship, if anything, went further than that productive liaison at Crowland and Cockburnspath to produce a group of paintings which confirmed Glasgow as one of the most important artistic centres in Britain.

Their work, and that of the other young men who gradually came to the fore, differed considerably from that of their more established colleagues – Guthrie, Lavery and Walton. In particular it was not concerned with the rustic naturalism which had been inspired by Bastien-Lepage and which had so far been the identifying mark of a Glasgow School painting. Strong colour, a concern for decorative effect, for pattern and line within a composition, and the introduction of an overt symbolism in the choice of subject-matter, all marked a new phase in the development of painting in Glasgow. Hornel's and Henry's involvement with the schemes for mural paintings at the International Exhibition and other sites in Glasgow in 1888 may have helped to crystallise their new ideas. Although there were to be no subsequent commissions for large-scale murals both men were eventually to collaborate on two large paintings which owe much to the concept of wall paintings – decorative and bold in composition and with an underlying narrative which confirmed the growing element of symbolism in their work. These changes were reflected in the paintings of Stuart Park and David Gauld, and, to a lesser degree, in those of Millie Dow and William Kennedy. It also affected the work of a new member of the group, John Reid Murray, a young man from Helensburgh who attached himself to the Boys in the 1890s.

Henry began to spend more time in Kirkcudbright with Hornel after 1887 and many of his pictures of this period were painted with Hornel at his side. They shared their ideas as readily as their equipment; easels, palettes, sketches – all seemed to be common property and passed freely between the two artists. Henry helped Hornel find a studio in Glasgow and Hornel found lodgings in Kirkcudbright for his friend and introduced him to the more forward-looking members of the artistic community. Their letters are full of such details (or rather, Henry's letters are, as the answers from Hornel have not been preserved):

Could you do me a sketch of a bit of winding burn, also some shrubs and twisted trees or blossom? Do them in pencil, don't trouble however if you are busy at anything.
[early 1889]

I had a pretty tough time of it at Stirling. The Kurnel [Kennedy] was pretty stinking in his remarks about Art generally. He seems to have his knife in you about something or other. He talked a lot of D——d rot and seems to have nothing in his head but 'material'. He says that creative work is easy. The difficult thing to do is to paint Material. B—ly fool he is! I told him in the heat of debate that his work for the last four years had been B—ly rot.
[spring 1889]

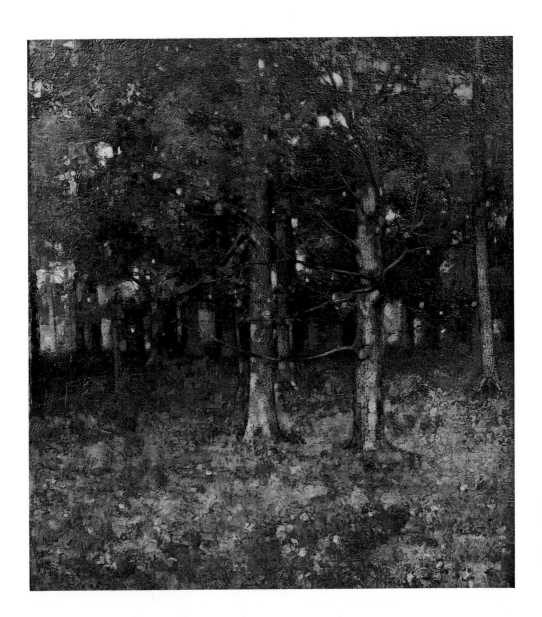

220
George Henry
Landscape
c.1886
Canvas, 61 × 51
Angus Maclean

Another call is on for the *Review*. Stevenson, to keep things dark and help you in the hour of trouble, as he says you did to him, sends you £1 which you will please forward without delay to the Treasurer. Don't for God's sake spend it! Would you kindly forward to Davidson's, 123 Sauchiehall Street, my easel and umbrella, also the sketching stool and easel combined. I want to do some work around Glasgow, and raise the wind so as to get away. I can do that much though I cannot pay for models. The state of things is getting every year worse. Please excuse more at present, I hope your work progresses.
[spring 1889]

I didn't write a reply to your last note as I couldn't oblige you with the £sd. I am still working at my panels, but hope to be through in a week or ten days. I have had a pretty exciting and harassing summer, in many ways. I cannot hope to be in Kirkcudbright this season as I must remain near Glasgow to be convenient for running into every fortnight as I am under medical treatment for stricture which is what I have been suffering from all along and I mistook it for the other thing and aggravated it immensely by the syringe treatment of Condy's Fluid, had I continued which I would have soon finished myself.

Teddy's [Walton's] panel is almost the pure canvas. With a Japanese figure with semi-Greek costume, some flowers in the foreground and leaves spotted around the head. Canvas background left pure, no work in it at all. I don't think it looks well. Roche's scheme I do not know as I haven't seen it, Teddy's scheme is really the white canvas with a few scrawls and blobs of paint on it. Tell us what you are doing.
[autumn 1889]

These letters chronicle the progress of their friendship and give us an almost unique insight into the Boys' activities in Glasgow. They chart the various alliances between different factions and are often waspish in their criticism of both people and pictures. There is, unfortunately, very little in them which accounts for the particular line of development which Henry and Hornel took after 1888.

Monticelli's influence on Hornel, derived from the Edinburgh International Exhibition of 1886, is readily apparent but the causes of Henry's change of direction are less obvious. Apart from changes in handling, the most common factor in the work of these years is the creation of a confined space within which the figures and animals in these paintings exist. Using a woodland setting both artists dispensed with a horizon and narrowed their field of view, almost as if they were wearing blinkers. The majority of these paintings take a vertical format which serves to emphasise this restricted view by the creation of a dominant vertical axis through standing figures or tree trunks. Within this space perspective is flattened, at first by the introduction of a slope or hillock against

221
George Henry
Sundown
1887
Canvas, 30.5 × 36.8
Hunterian Art Gallery,
Glasgow

222
George Henry
Gloamin'
1889
Panel, 24.4×30.8
Glasgow Art Gallery

which the figures are ranged progressively up the canvas, and later by the
merging of brushstrokes which cease to define the boundaries between landscape
and figure. In this way recession is reduced, in some pictures almost to the point
where there is no spatial depth at all, and is replaced by a concentration on
surface pattern created by the marks of the brush in the thickly applied paint. In
one of the earliest of these paintings by Henry, *Landscape* (pl.220), lies a clue to
one of the sources of this new approach (the date on this picture can be read as
either 1886 or 1888 but on grounds of style the earlier date is suggested). This
view of the heart of a forest owes much to Millie Dow's *The Edge of the Wood* (see
p.194), which is probably one of the paintings which Henry praised to Hornel in a
letter of 1885 (see p.194). The same restricted viewpoint, lack of a horizon and
claustrophobic atmosphere pervades both paintings. Henry's picture is unusual
in his *oeuvre* in that there is no figure present or other sign of human or animal life.
As in Dow's painting, there is some recession into the wood and a clear indication
of foreground, middle and far distance, held together by the usual naturalist
device of a tree which emphasises the vertical arrangement of the composition.
The delicacy of Dow's handling is not copied by Henry, however, and he uses a
more fragmented brushstroke which still gives a surface unity to the picture
while at the same time introducing a stronger element of surface texture and
pattern.

Several of the paintings which Henry exhibited at the Glasgow Institute

223
E. A. Hornel
Kirkcudbright Stick-
Gatherers
1888
Canvas, 61×45.5
The Fine Art Society

224
E. A. Hornel
The Brownie of Blednoch
1889
Canvas, 61×45.4
Glasgow Art Gallery

between 1887 and 1890 have disappeared and his progress towards his masterpiece, *A Galloway Landscape* (see p.223), has to be judged as much by Hornel's paintings of the period as by his own surviving pictures. *Sundown* (pl.221; formerly known as *River Landscape by Moonlight*) concentrates on creating an atmosphere, and with the problems of perspective masked by the dusk Henry has experimented with a new format for the painting. The orange sun clashes with the otherwise strongly linear composition to create a tension amid a decorative effect of straight lines and bold brushwork. *Gloamin'* (pl.222) is another work which concentrates on the atmospheric qualities of dramatic lighting, this time the glow comes from the embers of a fire, but these two works seem unusual in their nocturnal settings. *Autumn* (pl.202) shows Henry at his closest to Hornel, with the figure of a girl merging into the undergrowth, disguised by the similar colours of her dress and the vegetation and the identical broad brushstroke which makes no differentiation between figure and grasses, foreground and background. The title, with its hint of Gluepot subject painting, indicates a new interest in symbolism: the painting can be read as a charming portrait of a girl dressed in autumnal colours standing in a sunny glade; or her ethereal appearance, the way she merges with and emerges from her surroundings, can be seen as a symbol of the spirit of autumn. From either viewpoint she is isolated within a forest, detached from any other landmarks

which might help to orientate her position, looking as if she might at any moment disappear among the trees like a wood spirit.

In its handling this painting is as decorative as any mural painting, seeking, albeit on a small scale, to create a decorative texture and surface pattern through the application of the paint and its manipulation by the brush. The handling is as important as the subject itself and is the clearest indication yet of the break between Henry and Hornel and the rest of the Boys. The same emphasis on pattern, on broad brushwork and a narrow range of tones and colours is also to be found in Hornel's painting. The enclosed framework of a woodland setting dominates Hornel's paintings of the late 1880s but in most of his pictures there is usually to be found one or two girls at work in the forest – woodcutters and stick-gatherers, shepherdesses and goatherds. They are the only indication of movement in the earlier pictures, as in *Kirkcudbright Stick-Gatherers* (pl.223) where the poses of the two girls create a strong diagonal to break the stillness of the forest. They merge with their background as if they were camouflaged, echoing the figure in Henry's *Autumn*. Hornel also painted a picture with this title, confirming a gradual move away from realist or naturalist subjects of rural labour towards a more symbolic or allegorical subject such as the seasons or Celtic myth. Hornel's *Autumn* (pl.208), also painted in 1888, uses the same format as Henry's picture – a solitary girl in a woodland glade. The lighting, however, is much less natural than Henry's dappled light and the girl stands under a leaden sky, the colour of the autumn leaves reflected from the trees on to her face, and silhouetted in her green dress against the thick impasto of white paint in the foreground.

Kirkcudbright itself, or rather the Galloway countryside, played a large part in the gradual change of style and content in the two men's work. The gentle landscape of the Galloway hills and the mild climate which encouraged a more luxuriant growth of flowering shrubs and trees is reflected in their pictures in the same way as the legends of the countryside provided a host of subjects for their paintings. Galloway is like Cornwall in some ways, another artists' haunt, and the Celtic myths of earlier times played a large part in the daily lives of the Galloway people. Without becoming antiquarians, Henry and Hornel absorbed the old stories about the wood spirits and the rural genies and gradually built their paintings around these obscure creatures. Hornel, in later life, became fascinated by the history of his county and put together a fine library of books on Galloway. Certainly, it was he more than Henry who became totally infatuated by these old folk tales, particularly those relating to the goat. As a symbol of fertility the goat appears in a number of his paintings of the late 1880s, usually accompanied by his keeper, always a young girl, although in one picture, *The Brownie of Blednoch* (pl.224), the goat is personified as an evil spirit surrounded by sheep, witches and skulls. This picture is a rare, if not unique, essay into pure symbolism, for it is not a subject picture in the manner of the Gluepots. Hornel does not seem to have exhibited it but Henry must have known it, for there is in it a particular feature which was to become a key element of his *A Galloway Landscape* that same year. The twisting burn which runs hurriedly down Hornel's painting like a ribbon laid across its surface became a pointer, a guide

almost, to the contours of the Galloway hillside in Henry's painting. Here it serves to emphasise the unreality of the scene, broadly painted with sweeping brushstrokes like an art nouveau whiplash from French decorative work of the 1890s. In *The Goatherd* (pl.209) Hornel adopts a quieter, more considered composition, where the goats grow out of their surroundings and the young girl is framed by a spikily drawn tree in blossom, Japanese in feeling but with a handling which is pure Glasgow School. The thickly applied paint in a harmony of red, orange and green is broken by the slabs of white of the girl's dress against which the pink blossom is carefully highlighted. In many ways, this picture and others of the same period, such as *A Galloway Idyll* of 1890[2] are closer to the Post-Impressionism of Gauguin and the Pont Aven School than they are to Bastien-Lepage's naturalism. Pont Aven was not unknown to British painters but there is no evidence to show that Henry and Hornel knew of the work of Gauguin and his friends. Galloway and Brittany have much in common, however, from their local superstitions and legends to their landscape and climate and it does not seem too extreme to suggest that the *genius loci* of the two localities played a similar part in the development of both schools.

Hornel's apparent fixation on goats became something of a joke with the Boys. Their resident poet, the sculptor Pittendrigh Macgillivray, who was well known for his poetic jibes at the Royal Scottish Academy,[3] composed a bawdy rhyme about Hornel's quest for a perfect specimen to record on canvas:

HORNEL EXULTANT TO HIS GOAT ON THE GALLOWAY HILLS

B'Gode, I'll pent ye in style, ye B! As ye never were pented afore
Wi' colour and touch bloody nice, ye B! An' as fat as an Antwerp whore.
Ye're richt, said the Goat.

B'Heavens I'll lay it on thick, ye B! In a way that'll look mighty fine –
Monticelli's the fake for me, ye B! Sae to hell wi' y're glue pattin' swine.
Ye're right, said the Goat.

My Gode, what's that on yer hide, ye B! Thae markins in broon and white,
They're Hellish like Celtic designs, ye B! In the study o' which I delight.
Ye're richt, said the Goat.

Here richt on the Galloway Hills, ye B! Wi thae markins whatever they be,
Ye're a magnificent thing o' the kind, ye B! An sae is baith Henry and me.
Ye're right, said the Goat.

B'th Lord Harrie and Holy Mary, ye B! And deepest fecundity lipperin owre,
B'th phallus that hings at yer wame, ye B! the stinkin buggers'll glow'r.
Ye're richt, said the Goat.

When they see the fine stuff slab'ed on wi' the knife, ye B!
And feel it eat in like Hell,
And here in th'tune o'oor ringing Ko, ye B! An' noter th' gluepathic knell,
Am I richt, ye B!
Ye're richt, said the Goat.[4]

According to Hartrick[5] this poem was sung or quoted widely and its language was lurid and forcible, presumably a sample of the strong language one might have heard from Hornel's own lips. The references to Celtic designs point to a source for the decorative patterns that Hornel was trying to emulate in these compositions. Hornel spent a lot of his spare time seeking out the cup-and-ring markings in the Galloway hills – a hobby which became an obsession.[6] Line and pattern, inspired by these ancient carvings, has taken the place of naturalist detail in these works which, along with Melville's *Audrey and her Goats*, were responsible for the 'persian carpet' jibes of the London critics in 1890 when Henry and Hornel showed in London with the Boys at the Grosvenor Gallery. Celtic myth, Celtic decoration, both combined to turn the direction of their work towards an overt symbolism. Melville's feeling for suspense, the dramatic lighting of many of his Arab paintings, the mystery of life within the tents, palaces and mosques of the Middle East are replaced in these paintings by the more accessible life of the Galloway hills but the inspiration is undoubtedly that of Melville himself. More than any of the other Boys, Henry and Hornel picked up the challenge offered by the Edinburgh man; it was they who responded most clearly to his strong colours and decorative use of line in composition. Crawhall and Walton may have been Melville's disciples in the use of water-colour but the ideas implicit in much of his work were taken up only by Hornel and Henry.

In one picture Henry was to transcend all that he had produced before. It was not to be a painting which was universally acclaimed by the critics; nor did the public find it easy to understand or accept. It took Henry's painting away from Glasgow and placed it nearer the mainstream of European art of the period. It was not to be the first of a series of such pictures, rather an experimental work that Henry put on one side to refer to in later paintings instead of fully developing its potential. *A Galloway Landscape* (pl.215) was first shown in public at the Glasgow Institute in 1890. It was hung on the line by a Hanging Committee sympathetic to the Boys, including, as it did that year, James Paterson as one of the hangers. Their work was gathered together in Room IV, which was quickly dubbed 'the impressionist room', or, less kindly, 'the chamber of horrors'.

This painting is the closest any Scottish painter came in the nineteenth century to the Post-Impressionist work of Gauguin and his friends, Serusier and Bernard. Could Henry have seen their pictures or was his painting produced in isolation, a natural result of the changes which had appeared in his and Hornel's work over the last two or three years? In the late spring of 1889 Guthrie, Walton and Melville went to Paris. On his return Melville started work again on *Audrey*, presumably spurred on by what he had seen in France. It is not known whether Henry went with them, or, if he did not, whether he met Melville on his return in 1889. Melville would have been the most responsive to Post-Impressionist work in Paris and his return to *Audrey* – a painting begun five years earlier at Cockburnspath and which he now began to rework in bright colours and expressive brushwork – suggests some sort of acquaintance with the new trends in painting which were being discussed in the Paris cafés. Walton and Guthrie

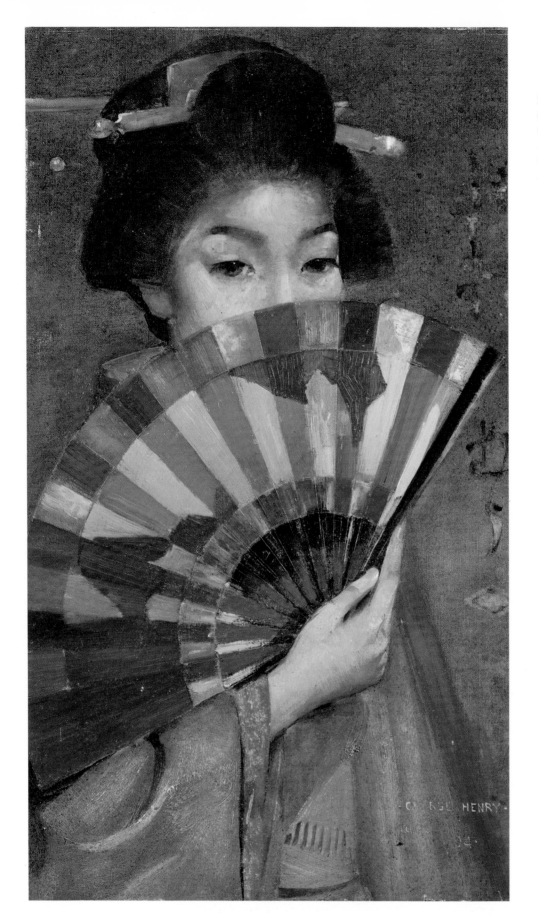

225
George Henry
Geisha Girl
1894
Canvas, 54.5 × 31.8
Private Collection

226
E. A. Hornel
Summer
1891
Canvas, 127 × 101.5
Walker Art Gallery,
Liverpool

would certainly have spoken to Henry about their visit but their own interests in French painting do not seem likely to have extended towards Gauguin or van Gogh. The latter had a more tangible connection with Glasgow through the dealer Alexander Reid, whose portrait had been painted by van Gogh, and with whom he had once shared a room when he was apprenticed in the same firm of art dealers where van Gogh's brother, Theo, worked. Reid, however, seems to have had no serious contact with the Boys in the 1880s although he was to act as agent for Henry and Hornel in 1891 over the sale of their joint picture, *The Star in the East*. On balance, the evidence – or the lack of any to suggest otherwise – points to Henry arriving at the style of *A Galloway Landscape* under his own power.

The picture is the antithesis of the naturalistic landscape painting which had been the Boys' credo five years earlier. Even the idiosyncratic aerial perspective which they used in their pictures has been rejected as has the square-brushed handling and the careful rendering of tonal values. Perspective and the comparative sizes of near and distant objects is here ignored and Henry has emphasised the two dimensions of his canvas by flattening the vista, exaggerating the slope of the hill and then ranging his trees and cattle against it in profile. Colour takes on a symbolic quality – blue for the burn, green for the field, red for the trees – with the black and white cattle being isolated against its intensity. Above all, the line of the burn, which snakes its way down from between two hills and then disappears off the bottom of the canvas, confirms the flat, linear nature of the painting with its ribbon-like presence linking the upper and lower – or distant and nearer – halves of the composition.

Hartrick says that he knew the spot where it was painted and that the burn was of Henry's invention.[7] If this is true (for Hartrick is not always the most reliable of witnesses[8]) then it is further evidence of Henry's deliberate rebuttal of naturalist principles. The burn acts not only as a compositional device, and a very important one at that, it also serves as a powerful symbol within the picture. Sky, earth, water, flora and fauna are all represented in a painting which is surely trying to make a statement about the landscape it depicts and the people who inhabit that landscape. Like Hornel's goats these cows, the burn and the slopes of the fields are symbols of life in Galloway and it matters not whether it is an exact representation of a specific field if it conveys that sense of place which was just as much part of the Cockburnspath and Grez paintings of the Boys. As has been noted, *A Galloway Landscape* has exactly that sense of place which more 'realist' painters failed to capture in their views of the Kirkcudbrightshire landscape, or elsewhere.[9] Despite Hartrick's denials of its accuracy as a painting of a specific location, it is evocative of almost all Galloway's hillside pastures and truly indicative of the beauty and atmosphere of this gentle countryside.

Composition, content, colour and handling, with its heavy use of the palette knife, were not likely to endear this painting to the exhibition-going public who made their annual visit to the Glasgow Institute. The critics were not prepared to look beyond their initial distress, either, and it received little constructive comment:

Doubtless there are as usual many pictures whose absence would have enhanced the walls, but that can be said of any collection. Take for instance the *Galloway Landscape* of George Henry. It may be clever but it is not art. It is utterly destitute alike of perspective, atmosphere, and poetry, three very serious defects, as we take it, in a landscape picture. Mr Henry scorns the idea of attending to the 'values', and the result is that the distant white clouds, and the hillside come slap upon the eye of the beholder with a bewildering effect. Such pictures, we fear, must damage art, and should have been rejected, much less hung upon the line.[10]

Mr G. Henry is the most pronounced of the 'impressionists' who exhibit. His *Galloway Landscape* has been a great puzzle to many; others have treated it as a huge joke played upon a too credulous Hanging Committee. Impressionism has its place in art, but such vagaries of the brush as this landscape (which suggests a nightmare), even allowing that it has a certain tonal quality, will not tend to raise the School in popular estimation.[11]

Strength of colour, a delight in the graceful use of the material with which he works, is an undoubted characteristic of the Impressionist, but this is coincident with a reverence for and a seeking after the real beauty that he finds in his subject. But, perhaps, the clearest conception of this recent departure in art is to be got by an examination of some of the works shown in Gallery IV. *A Galloway Landscape*, by George Henry, is a strong example – strong in more than one sense. Of the rich harmony of strong colour and effective distribution of form in this remarkable picture there be no question. But are the liberties taken with our sense of the realistic atoned for by these undoubtedly high merits? The picture certainly in the most unquestionable fashion challenges judgement on the merits of the School.[12]

When the painting was shown in London at the Grafton Gallery in 1893 the public reaction was little different:

George Henry's *Galloway Landscape* seems as new to the Londoners as it was to the Glasgow public a few years ago. 'What is it?' you may hear people say. 'Isn't this river pellucid?' (Sarcastically doubtless.) 'Don't you feel as if you could take off your clothes and jump in?' '*Ireland* must be a funny place!' It will be observed that some Londoners, even those on the opening day of a show, are not so well up in geography, as they might be.[13]

Hornel's pictures at the Institute in 1890 received similar, but not quite so vehement, criticism. It had little immediate effect on the two men, who probably felt justified by the placing of their pictures on the line at the exhibition. They had, in any case, already begun a new work which was to take a stage further some of the ideas they had shown at the Institute. This was a joint project, a picture which attempts to capture some of the mystery of the strange race of men whom they believed to have made the cup-and-ring markings in Galloway. *The Druids* (pl.219) was finished by the end of March 1890 and made ready for the new exhibition at the Grosvenor Gallery in London. It shows a procession down a hill, winding between the trees like the burn in *A Galloway Landscape*. The decorative elements of that painting, however, are here taken even further, with the figures of the priests superimposed against the hill and their patterned robes and regalia forming a two-dimensional framework which emphasises the exaggerated perspective of the procession. Amidst all the rich vestments Henry and Hornel added areas of incised gesso, overlaid with gold like a *trecento* altarpiece. These define the insignia of the priests and their instruments of office

and even appear in a nimbus around the head of one of the druids.

Hartrick tells a strange story which is probably the source of the imagery of *The Druids*. Hornel had come to know an old man in Galloway who had considerable knowledge of the whereabouts of the Celtic carvings which intrigued the painter. Hornel, Hartrick and another friend set out one day with a bottle of whisky on an expedition to see this man, Sinclair. He took them out to look at the markings and after several examples had been uncovered they returned to Sinclair's cottage where the whisky had been left behind:

Going into his bedroom, [Sinclair] took from a shelf a small china bowl in which was a small bluish stone like a bean. Holding this in his hand, in a few minutes he seemed to go off in a sort of trance, and then began to describe, like a wireless announcer of today, a vision of priests with sacred instruments and cattle which somehow were connected with the cup-and-ring markings. I cannot remember the details of it all; all I say is that the vision appeared to be genuine and that he was not drunk. After a time he became normal again, but would not talk any more on the subject.[14]

Not surprisingly, *The Druids* excited a great deal of attention at the Grosvenor; the critic of the *Saturday Review* considered it the most important Glasgow painting in the exhibition:

227
E. A. Hornel
A Japanese Silk Shop
1896
Canvas, 46.5 × 75
Private Collection

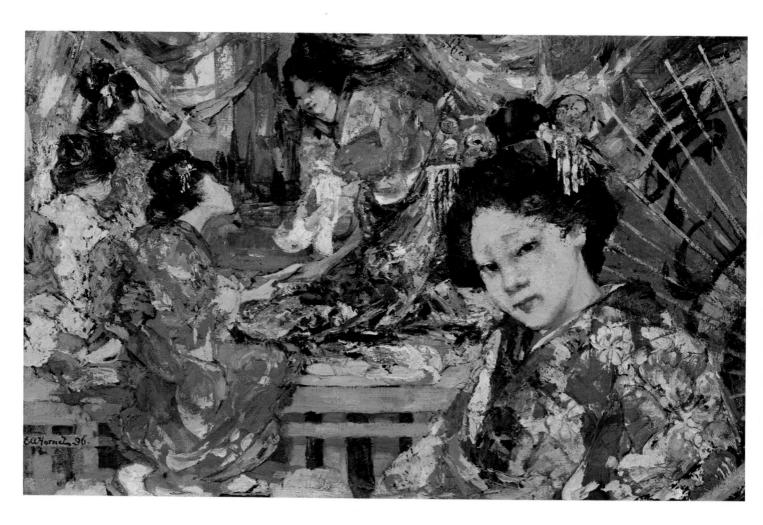

228
David Gauld
Portrait
c.1893–4
Canvas, 51 × 40.5
Sir Norman Macfarlane

We suppose the masterpiece of the Glasgow School at the Grosvenor Gallery would be considered *The Druids* due to the combined efforts of Mr G. Henry and Mr Hornel. This is a large square picture . . . very startling and at first sight very ridiculous. But the eye becomes accustomed to its strange forms and hues, and by degrees grows to like them. A procession of Druids, in vermilion, emerald and gold, carrying the golden circular sickle and the mistletoe with them, descend in a sort of Tartar majesty – grim, tawdry and savage – through a grove of oaks. Only the heads and trunks of the fierce priests are seen, glowing with crude colour. This strange work is painted broadly, in the spirit of decoration; it is really, perhaps, a fragment of a frieze. It is extraordinary but it would be useless to deny that it is effective.[14]

229
George Henry and
E. A. Hornel
The Star in the East
1891
Canvas, 198.4 × 182.99
Glasgow Art Gallery

230
George Henry
Through the Woods
1891
Canvas, 56 × 63.5
Angus Maclean

Walter Armstrong in the *Magazine of Art* had similar guarded praise for it:

Turning now to the young Caledonians . . . by far the most daring performance they have sent in is *Bringing Home the Mistletoe [The Druids]* . . . It is seldom safe to speak warmly of a skied picture. 'Hangmen', as a rule, are not absolute fools, and when they hoist a canvas up to the ceiling they are apt to have a reason for it. But in spite of this, I am not afraid to say that [this picture] is a very promising production, and that its authors, or at least that member of the partnership who is responsible for the figures, should be looked after carefully in future. It is frankly decorative. The crimson and green and gold which are lavished upon it form its aesthetic *raison d'être*.[16]

The Hanging Committee may have thought that the picture was intended to be 'skied' as a decorative piece but Henry was not pleased at their action. He evidently did not consider it to be in the tradition of the mural paintings on which he was often engaged at this date and regretted that their work had been singled out for discrimination. Despite its poor reception by both press and public, it is a picture which dispenses entirely with naturalist principles and considerations and firmly marks the entry to a new decade in which the painting of all the Boys underwent a number of changes but none so dramatic as those which appeared in the work of Henry and Hornel.

In 1891 *The Star in the East* (pl.229) followed as another joint work but it has little of the impact of the earlier *Druids*. Whether this was due to a less compelling subject (neither of the two men ever expressed as great an interest in the Christian religion as they had in the mysteries of Celtic worship) or more simply due to the illness which dogged Henry in 1890 and for the next two years, it is impossible to say. The picture did not sell, despite the attempts of Alexander

Reid who became a firm friend in the early 1890s, and Henry dubbed it the 'white elephant' in his letters. Certainly, this was a period when Hornel developed his own ideas while Henry lay ill and, as the likely originator of the decorative structure of *The Druids*, Henry's debility must have affected this second painting. His illness may account for his failure to take up the challenge of *A Galloway Landscape*, as his major pictures of the period 1890–3 do not follow its lead. In a small sketch of Barr in Ayrshire (pl.231), however, there is an indication of the form that his work may have taken, with its fluid handling and bright colours, if his illness had not had such a debilitating effect. His debts rose alarmingly while he lay ill in Dunlop and what strength he had was diverted into the production of 'boilers', as he called them, to pay off his creditors. In his more important pictures there is much of the influence of Hornel, paintings of young girls in the woods such as *Blowing Dandelions* (Private Collection) and *Through the Woods* (pl.230). The decorative arrangement of figures and trees moved more surely towards pure surface pattern in these pictures but many of his works of the period are little more than pot-boilers (which is how he described them to Hornel in his letters[17]). There is also a suggestion that Henry was beginning to find the constant company of another artist too wearing. Hornel quarrelled with the Kirkcudbright painter, W. S. MacGeorge, and Henry wrote to sympathise with him but added the following note:

After all it is impossible for two fellows to work together, at least for any lengthened period; this was growing in on me last year and all this spring . . . the novelty wears off and one finds a thousand and one little things, that to produce anything or get a favourable environment for, it is absolutely necessary to be alone where you work[18]

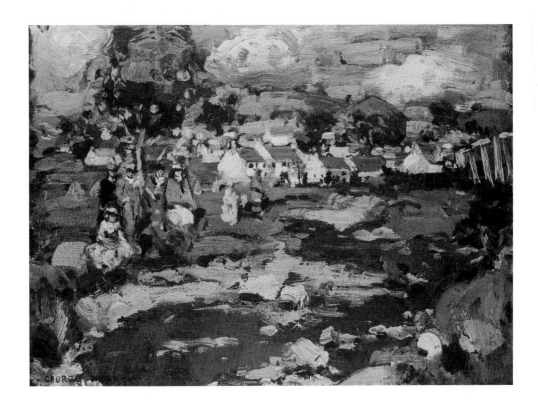

231
George Henry
Barr, Ayrshire
1891
Panel, 22.5 × 30.5
National Galleries of
Scotland, Edinburgh

His removal to Dunlop was justified in the letters by the illness of his grand-
mother whom he could not leave alone, his need to have his model close by or
living with him (which he found it difficult to do in Kirkcudbright), and by the
succession of illnesses which dogged him for several months until they erupted
into inflammation of the prostate in 1892 which severely weakened him.

Hornel, however, perhaps inspired by the attention which *The Druids* received
in London, went on to take the artistic lead in their new work. *The Brook* (pl.214)
echoes the paintings of goats and shepherdesses in the late 1880s but the stream
itself, painted in a strong blue applied with a knife across the centre of the
canvas, pays homage to *A Galloway Landscape*. There also appears a more overt
reference to Japan in the way the dress of the girl on the left is made to look like a
kimono, boldly patterned rather like the markings of the goats of the earlier
pictures. There is also a strong sense of movement created by all the diagonals
which sweep the viewer's eye across the canvas to the left, and Hornel was to seek
more and more to create a maypole-like rhythm in two or three paintings which
followed this. *The Brook* was universally disparaged by the critics but it sold at
the Institute in 1891 to a young man who was a very close friend of Charles
Rennie Mackintosh. Herbert MacNair paid for the picture with a prize from the
Art Union lottery and it is interesting to speculate what effect this picture and
others by Hornel and Henry had on the so-called 'Spook School' style of
watercolour and decorative work which these two young architects were to
produce over the next five years.

Henry spent a great deal of time in 1892 in persuading a Liverpool Alderman,
Philip Rathbone, that a display of the Boys' work in the Liverpool Autumn
Exhibition would be to their mutual advantage. Rathbone acceded to Henry's
persuasions and in 1892 the Autumn Exhibition had a room mainly devoted to the
Glasgow Boys. Unfortunately, the Hangers chose to split the Scottish contingent
and Melville and Crawhall were exhibited in another room which effectively
diluted the impact of the group. As Chairman of the Art Gallery Committee
Rathbone recommended to the Liverpool Corporation that they purchase one of
Hornel's exhibits there – *Summer* (pl.226). It was to be the first official purchase
in Britain of a painting by one of the Boys, excluding the official portraits
commissioned from Guthrie, Lavery and Walton, but its acquisition by the
Walker Art Gallery was no easy accomplishment. The picture was viciously
attacked both in the press and the Council Chamber and the decision to purchase
it was carried through only by the weight of Rathbone's experience both as a
politician and connoisseur. Hornel was deeply offended and disturbed by the
battle, which was carried on in the correspondence columns of the Liverpool
newspapers with defenders from within the city itself and from Glasgow. The
attackers were almost all Liverpudlians and their scurrilous accusations about
the artist's sanity and Rathbone's judgement depressed Hornel deeply. Henry
and Stevenson got the scent of battle and supported their friend wholeheartedly
and were perhaps even more elated than he at the victorious outcome. Paterson
played a curious part by sending an anonymous letter to the Liverpool
newspaper which seemed, to the Boys at least, as much to support the opposition
as it did Hornel. It did not endear him to Henry, who was the more hot-blooded

of the two men in such matters. He quickly guessed that the writer was Paterson and threatened to ask for his withdrawal from their new 'secret society' which had recently drawn up rules to accommodate such divisions of opinion. Whatever happened or was said privately, the 'society' should maintain a coherent and unanimous position on such matters, said the rules, and transgressors faced expulsion into the world of the Gluepots, where they presumably belonged. In fact, like many more recent examples of collective Cabinet responsibility, there was an almost immediate leak of papers and the resident Gluepots who commanded the fireside chairs at the Glasgow Art Club had much fun at the Boys' expense.

That Hornel had learned much from his association with Henry, particularly from working at his side on *The Druids*, can be clearly seen in *Summer*. This is not to belittle Hornel's achievement as *Summer* is one of the key works of the Glasgow School and, perhaps, Hornel's most important surviving painting. The high horizon with the tree trunks springing out of the middle of the canvas stems from *The Druids*, as does the way the cattle and shrubs merge into each other in the upper half of the canvas, which is perhaps indicative of Hornel's contribution to the earlier joint work. Against this tapestry of tone and brushwork the figure of the girl chasing a dancing butterfly seems all the more vivid. This is not just because of the vigorous movement of her pose; the careful drawing of her dress and head contrast their handling against the more homogeneous brushwork of the landscape, echoing the more finely drawn heads in *The Druids*. There is a greater feeling for the power of line in the way the girl is contained in a series of concentric ovals – the curve of her body, the flare of her skirt hem and her sleeves – which all emphasise the way that the composition has been designed; this feeling for strong design is again an indication of Henry's influence, but it is used here in a way that he never attempted.

Despite the sense of movement that Hornel has given the picture, it is a scene which is frozen in a particular gestural manner that is clearly dependent on the tradition of the Japanese printmakers such as Hiroshige and Hokusai. The exaggerated curve of the running girl's body is also a Japanese convention which was found in the work of several printmakers. There is a more open acknowledgement of Japan in the cotton shirt which the girl is wearing with its Japanese patterns stencilled or embroidered on to it. Hornel could have seen Japanese prints in Glasgow in Alex Reid's gallery, La Société des Beaux-Arts, in 1889 and Reid himself had quite a collection of them. It was not unknown in British painting for an artist to incorporate Japanese motifs into his paintings or even to adopt a more general Japanese manner in composition and handling. Roche, for example, had incorporated Japanese heraldic seals in the frame of his painting *Good King Wenceslas*. *Summer* goes further than any Glasgow painting had done so far, however, towards the kind of acknowledgement of Japanese art that is most clearly seen in French Post-Impressionist painting. Reid would presumably have told Henry and Hornel, with whom he seems to have had the closest business relationship of any of the Boys at this date, about the work he had seen in Paris in the 1880s, which would almost certainly have included Gauguin and the Pont Aven painters as well as van Gogh. All of these artists were

234
Stuart Park
Yellow Roses
1889
Canvas, 40.6 × 66
Sir Norman Macfarlane

aware of the impact of Japanese art and had themselves been profoundly influenced by it in a manner very similar to that displayed by Hornel in *Summer*. If the two young Scots had not visited Paris before, there is a possibility that they went there in 1891. An undated letter from Henry to Hornel (which almost certainly followed a letter of 12 May 1891 in which a trip to London is discussed) mentions a proposed visit to London with Keppie and Macgillivray and the possibility of carrying on to Paris; on the back of the letter Hornel has added details of train and ferry times for the journey to France but there is no corroboration that the visit ever took place.[19]

Hornel had shown *Summer* earlier in 1892 at the spring exhibition of the Glasgow Institute, without exciting much comment, but perhaps the Glasgow critics and gallery-goers were becoming used to the waywardness of this young artist. Another picture from the same period, *The Dance of Spring* (pl.236), shows Hornel in a similar mood. Here the turning movement of *Summer* is channelled into a twisting procession of young girls who laugh and dance as if they were part of some May Day celebrations. All they lack is a flagpole as the centre of their whirling dance but as a composition the painting is not as successful or innovative as that of *Summer*. Instead of forming a contrast with the landscape the girls merge and flow in and out of it, recalling the paintings of the late 1880s, such as *Kirkcudbright Stick-Gatherers* (see p.238). The colour and handling has also changed in a subtle way, with the softer forms being stressed through the

closer harmony of the colours and less emphasis on the linear elements of the composition. It was, however, paintings like this and *Summer* which must have led to the invitation which Hornel received to exhibit in Brussels in 1893.

This came from Les XX and Hornel sent a painting entitled *A Goatherd*. Les XX were a group of twenty artists who broke away from the established exhibiting societies in Brussels in 1884. They were led by Octave Maus and included James Ensor and van Rysselberghe among their number. Les XX were, therefore, one of the earliest 'secession' groups which flourished across Europe after 1880, fed by a growing disenchantment with the Academies and Salons of 'official' art which dominated Paris, London, Munich and Brussels just as they did Edinburgh and Glasgow. Other artists invited to show with Les XX were Toulouse-Lautrec, Georges Seurat and Vincent van Gogh, so Hornel was in distinguished company. A critic applauded his use of colour and noted the influence of Japan in the picture (which is, unfortunately, not more specifically identified or reproduced in the catalogue) and went on to mention the use of colour 'in the strong decorative areas in a way which has a relation to Japanese art and is strongly akin to Gauguin'.[20]

Japan had obviously become of serious interest to Henry and Hornel and in 1893 they took the bold step to investigate it and its art by embarking on a visit to the Far East which was to take them away from Glasgow for over eighteen months. The influence of Japan had reached Scotland by a variety of routes,

235
Stuart Park
Roses
c.1891
Canvas, 40.6 × 66
Ross Harper

236
E. A. Hornel
The Dance of Spring
1892
Canvas, 142.4 × 95.2
Glasgow Art Gallery

most of which were repeated in centres of avant-garde artistic activity throughout Europe.[21] Whistler was to be an important catalyst between the Boys and Japan, and his open championing of the work of Hokusai in his *Ten o'Clock Lecture*, which was published in 1888, would certainly have been known to them. Japanese artefacts could be readily found in Glasgow, both in the city museum (where a collection of Japanese material had been deposited by the Japanese Government in 1878) and in the city's galleries and antique shops. Reid displayed Japanese prints in 1889; one of the Boys, Grosvenor Thomas, dealt in Japanese curios and presented a number of Japanese prints to the Art Club in 1894. *The Scottish Art Review* carried articles on Japanese decorative arts and praised the new magazine *Artistic Japan* which was published by Bing, the Parisian dealer in paintings and antiquities, who did much to foster the new interest in things Japanese. Neither Henry nor Hornel may have heard him, but

in 1882 Christopher Dresser (who was born in Glasgow) gave a lecture in the city about his pioneering visit to Japan as a British Government observer.

Dresser was followed to the East by a number of artists, including Whistler's pupil Mortimer Menpes who visited Japan in 1887. *The Scottish Art Review* (in its later incarnation as *The Art Review*) published three illustrations of paintings of Japan by Alfred East made on his visit there in 1889. There were plenty of precedents, therefore, to justify their decision to sail for the Orient in February 1893. Henry had just recovered from his long illness of 1892 and Hornel was celebrating the purchase of *Summer* by Liverpool Corporation. *Quiz* gave them a literary send-off[22]:

The Inseparables of Art. Also the Irreconcilables. The twins of Table Mountain a Fool to them. As for the Gemini – bah! And they too are Stars. Erratic Stars. Of uncertain orbit. The newspapers reviled them. Art Club laughed at them. PRSA sneered at 'em. Instead of which they don't give a hang. And are unashamed. Pursuing their piratical Impressionist career. With the Scots accent. And thick boots. George is an Ayrshire man. Trained in Glasgow School of Art. But gradually recovering. Painted *Galloway Landscape* once. *Très magnifique!* But terribly tough on the masses. Does female studies. Superb. See *Mademoiselle* at Walker's show. Made ARSA last year. Otherwise very decent fellow. Confederate Ned born in Australia. At very early age. Place called Bacchus, Victoria. Suggestive but sober fact. No harm resulted. Came to Kirkcudbright when one year old. Took a steamer. Also parents. Here ever since. Except when studying in Antwerp. Principally Art. Scholar. Emersonian. Excellent *raconteur*. Pictures big. And brilliant. But beyond comprehension of the gay throng. No 'form'. No moral. No story. No nothing. But simply Art. And Colour. Inseparables sail for Japan. Today. Paints with them. Also pipes. Away a twelvemonth. Lucky Boys. *Bon voyage!*

The Bailie was somewhat less flippant[23]:

The most notable event in local art affairs last week was the leaving of Edward Hornel and George Henry . . . for London, *en route* for Japan. Through methods of their own, Messrs Henry and Hornel have mastered a *technique* not dissimilar in character from that favoured in the land of the cherry-blossom – let us call it Hokusai modified by Monticelli, and that they should resolve on a sojourn by the side of Lake Biwa or on the slopes of Fujiyama, seems, therefore, quite in the nature of things. At the same time, it may not be out of place to note that Mr Henry's *Mademoiselle* in the Exhibition of the Institute, with its flowing brushwork, and his sharply defined girls' heads in the Royal Scottish Academy, seems to indicate something of a new departure in his manner. During David Murray's recent visit, by the way, to the Institute, he was specially struck by the beautiful colour in Mr Hornel's *Children at Play*. This colour beauty, we may expect, will be accentuated by Mr Hornel's stay in Japan.

They were financed initially by Alexander Reid, as neither of the two men had any money, and in later months William Burrell and other patrons sent them funds which helped facilitate their return journey in 1894. Reid offered Hornel an exhibition of his Japanese work in 1895, which had probably been part of their financial arrangement but Henry did not show his Japanese work in this way. Many of his oil paintings stuck to each other on the journey home and he seems to have tossed them to one side rather than try to save them for an exhibition. This disaster may account for his reticence to lecture publicly about his experiences; the disappointment over the damaged canvases may have been so great that he

wished to put firmly behind him what he at first considered to have been a waste of two years of his life.

It was generally frowned upon for westerners to live among the Japanese but Henry and Hornel rightly felt that they would never come to know the country as they wished if they simply assumed the role of tourists. For some months they were employed by a Japanese house agent, which gave them fairly unrestricted access to the Japanese way of life which they had come to study. Most of their

237
E. A. Hornel
The Fish Pool
1894
Canvas, 45.1 × 35.62
Glasgow Art Gallery

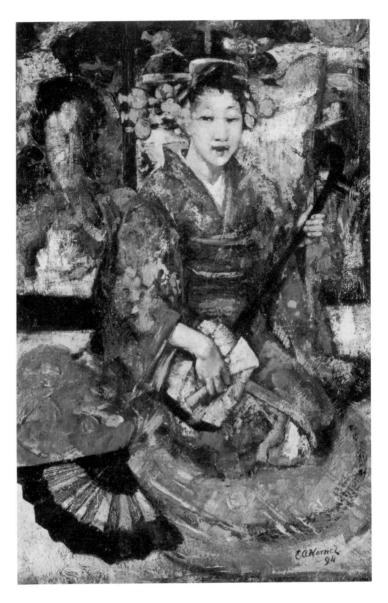

time seems to have been spent in Tokyo, Nagasaki and Yokohama. They met a number of Japanese artists and not a few ladies, Hornel in particular becoming closely attached to a young Japanese girl. The former they were not too impressed with, especially those who had adopted western methods of handling and composition. They did not spend all their time together as some letters from Henry to Hornel show (Coll: Hornel Trustees) and it may be that this was in accord with Henry's earlier expressed belief that he could not continue to live in another artist's company all the time. This separation may account for the quite distinct differences in style that began to appear in their work – Henry's emphasising more and more the qualities of line and design and Hornel's showing a greater interest in surface texture and colour. As many of Henry's oils may have been destroyed due to their sticking together during the voyage home, these

238
E. A. Hornel
Dancing Geisha
1894
Canvas, 141.5 × 61
Private Collection

239
E. A. Hornel
Music in Japan
1894
Canvas, 61 × 40.5
Private Collection

240
E. A. Hornel
Japanese Figures in a
Garden
1896
Canvas, 37 × 43.8
Andrew McIntosh Patrick

differences are accentuated because the best of Henry's surviving Japanese pictures are watercolours which, in any case, demanded different methods.

Their subject-matter is predominantly figurative and concentrates almost exclusively on Japanese women and girls, there being few, if any, men in their paintings and only a few boys. The girls are often posed to imitate the Japanese prints which had first drawn the two men to Japan and in all the paintings there is a conscious awareness of pattern in the design of the composition. The pictures can all be considered decorative in intention, which presumably reflects the overall impact of Japanese life and culture on Henry and Hornel. Within this convention, however, the Boys covered a wide spectrum of subjects, from musicians with their instruments, geishas at play or walking in the parks, street traders and other aspects of urban life, carnivals and processions. Hornel returned to the 'persian carpet' technique which the London critics had castigated but which he found perfectly suited to the patterned fabrics and brightly coloured gardens which so fascinated him. In several of these paintings it is possible to detect the probable influence of Henry in compositions which are more carefully organised such as *The Fish Pool* (pl.237) and *Dancing Geisha* (pl.238). In paintings such as *Music in Japan* (pl.239) and *Japanese Figures in a Garden* (pl.240), Hornel displays more of the self-assurance which characterised his recent Galloway paintings. Colour and form are evenly balanced and the

subjects of the paintings remain easily identifiable from their enveloping background. Reds and yellows, green, blue and black predominate making these some of the most richly coloured works of his career.

The damage to his Japanese canvases which Henry reported to Hornel may account for the high proportion of watercolours by Henry which survive from this period. Henry, much more than Hornel, had always worked in watercolour and was a regular exhibitor at the Royal Scottish Society of Painters in Watercolour. In many ways the medium was ideally suited to his visit to Japan as it was an art form with which the Japanese were themselves familiar and also a medium which could easily emulate the tones and colours of Japanese prints. Perhaps in no other pictures dating from their visit is the quality of Japanese life so well rendered as in *An At Home in Japan* (pl.241) and *Koto Player, Tokyo* (pl.242). The simplicity of Japanese interiors, with their reliance on the power of line as decoration, contrasting with the pattern of Japanese costume make these images among the most memorable of the 150 or so the two friends produced in Japan. Of the oil paintings which did survive in good condition there is a similar emphasis on line and decorative detail, with the paint thinly applied. A strong sense of design in composition distinguishes these paintings from those of Hornel. *Geisha Girl* (pl.225) is one of the most successful of the surviving oil paintings. Along with *Japanese Lady with a Fan* (pl.243), it represents the translation of the typical Glasgow School single-figure composition into an Oriental icon, strong in design and colour and capable of extremes of expression through a deliberately limited vocabulary, imitating the conventions of Japanese image-making. If

241
George Henry
An At Home in Japan
1894
Watercolour, 30.5 × 56
Glasgow Art Gallery

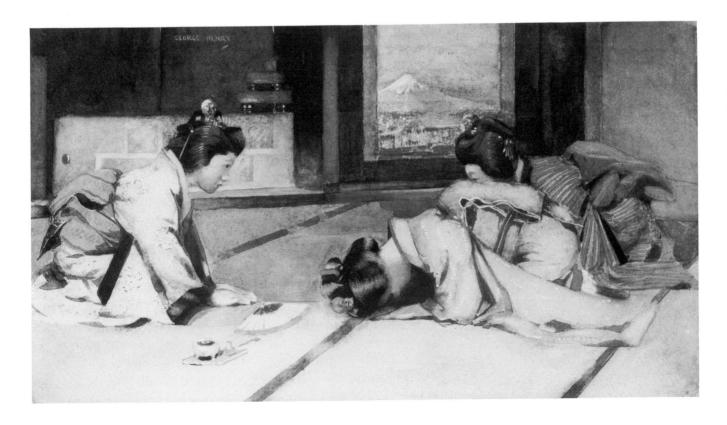

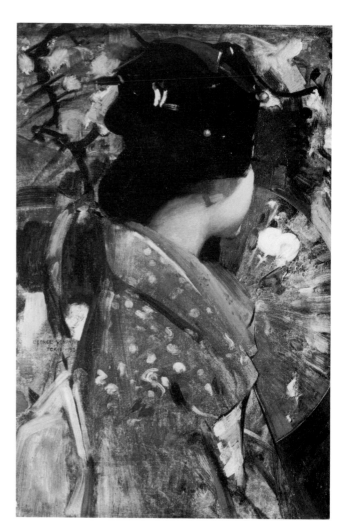

242
George Henry
Koto Player, Tokyo
1894
Watercolour, 71 × 48.3
Glasgow Art Gallery

243
George Henry
Japanese Lady with a Fan
1894
Canvas, 61 × 40.5
Glasgow Art Gallery

there were other pictures like this which Henry was unable to salvage from the tacky mess of paint and canvas, then our loss is great indeed.

On their arrival back in Scotland, Henry returned to Glasgow and Hornel to his family in Kirkcudbright. Henry was assailed on all sides for accounts of their experiences and became both weary and hoarse from the repeated telling of the tale. Unable, or unwilling, to show much of his Japanese work Henry passed to Hornel the honour of displaying the products of their visit. Reid gave Hornel a show in his Glasgow gallery in 1895 which was both critically and financially successful. Henry, annoyed more by the condition of his work than its quality, turned away from the new directions he had begun to follow in Japan and tried to pick up the threads of his painting of 1892. This resulted in a group of paintings – of which *Lilac* (pl.244) is one of the most interesting – which move further away from the naturalism of the 1880s, towards a form of more popular painting (if not quite Gluepot) which helped to restore Henry's professional and popular standing, as well as assisting him to pay off his not insubstantial debts. Many of these paintings, like *Lilac*, clearly display Henry's debt to Japan but it was to be

a short-lived phase. The lure of portraiture, both as a route to financial security as well as public acceptance, beckoned Henry as it had Guthrie, Walton, Lavery and Macgillivray. He followed the almost inevitable trail to London, swelling the ranks of expatriate Scots who adorned the walls of the Royal Academy and inhabited the smoke-filled rooms of the Chelsea Arts Club. Henry seems never to have forgotten Japan, however, and in later years he frequently returned to the theme, painting views of Japanese gardens, groups of geishas and other decorative subjects which may well have been inspired by the photographs which he and Hornel took during their visit.

For some reason, which the letters between Henry and Hornel do not adequately identify, the two men made an agreement not to formally comment on their experiences in Japan. Their relationship became strained, therefore (but not irrecoverably), when Hornel accepted an invitation from the Curator of the Glasgow Art Gallery, Mr Paton, to deliver a lecture on his visit and his Japanese work. Although he eventually prepared the lecture, using what were reported as very good slides, he arranged to contract some debilitating 'illness' at the last moment and his friend John Keppie delivered the lecture for him. Like Henry, Hornel frequently returned to Japanese themes in his later paintings. As early as 1896 he painted *A Japanese Silk Shop* (pl.227), one of the most elaborate of his Japanese paintings which may well have been begun in the east. The symbolism and originality of the earlier Kirkcudbright pictures, however, was never recaptured as Hornel succumbed to the traps which success placed before him. He had returned to the imagery of young girls set in the Galloway countryside, but instead of being engaged in some specific and natural task, such as tending goats and sheep, they seem to be in perpetual pursuit of butterflies or elusive anemones and woodland flowers. Hornel evolved a formula for such paintings; *Fairy Stories* (pl.245) shows its success in depicting these groups of young girls at

244
George Henry
Lilac
1895
Canvas, 56 × 91.5
Mr and Mrs Tim Rice

245
E. A. Hornel
Fairy Stories
1900
Canvas, 38 × 29
Ross Harper

play in the forest, and although there are many like it there are far more which fail dismally. The formula helped Hornel to assuage the demands of collectors and museums for the latest examples of his work but, separated from the invigorating spur of a painter like Henry, he failed to develop beyond the limitations of these pretty but essentially empty paintings. Photography became his prop, his replacement for the intellectual stimulation of other artists as he took refuge in a Kirkcudbright which no longer attracted the progressive painters from the cities. Indeed, Hornel himself was seen by other Galloway artists as someone to emulate and instead of stimulating him to new work they merely confirmed him in the style into which he had fallen.

Japan was a high spot in the careers of Henry and Hornel, a culmination of five years of stimulating advances on the naturalist ethos that the Boys had developed in the mid-1880s. These two young men, working in some isolation from the rest of their peers, took Scottish painting and placed it in the forefront of European developments. Only in France was there any body of work produced which explored as consistently new ideas and new techniques in the same way as Henry and Hornel did at this date. Sickert and the 'London Impressionists' were still responding to the work of Degas and were apparently unaware of the work of Gauguin and his friends, just as they were certainly ignorant of the Japanese paintings of the Glasgow men. Les XX in Brussels had dissolved by the time they went to Japan, and the German and Austrian Secessions looked to Glasgow, and not Paris, for a lead – a lead which they saw had clearly passed from Guthrie and Lavery to the two 'wild men' of Galloway.

CHAPTER 11

Sunlight and Shadows

The decorative elements which had come to the fore in the work of Henry and Hornel by the end of 1888 were also to appear in the work of some of the other Boys, particularly the younger men. Two of them, David Gauld and Stuart Park, produced equally original work in this new manner without directly copying the Galloway paintings of their friends. Gauld, who was working as an illustrator for the *Glasgow Weekly Citizen*, was very much involved with the design and manufacture of stained glass panels in Glasgow. He translated some of the new imagery he had devised for his panels into designs for canvas and, perhaps more importantly, he also transferred the colours and glass-painting techniques to his new easel paintings. Designs for stained glass traditionally had a strong narrative content and, in religious work, an overt symbolism. Gauld mixed both religious and secular symbolism in a group of paintings which, for their date, were even more radical than the experiments of Henry and Hornel. *Music* (pl.232) and *St Agnes* (pl.233) are unequalled in the story of the Glasgow Boys for their reliance on the symbolic effect of colour and line. They had little, if any, effect upon the other Boys, however (although the two Galloway painters may have known them), and it may be that Gauld never publicly exhibited the paintings in Scotland but kept them in his studio. It seems likely, however, that his closest friend among the Boys, Macaulay Stevenson, knew these pictures; at least, Stevenson owned a leaded glass panel with a design almost identical to *Music* which he eventually incorporated in his house, Robinsfield, at Bardowie Loch near Glasgow.

The strength and clarity of colour in these two paintings, and the emphasis on the linear elements of the composition both emulate the qualities of stained glass. Perspective is flattened even more than one would normally expect in a painting by the Glasgow Boys and the colour – of fields, sky, river, costumes and shadows – is applied in flat panels, each separated from the next by a distinct line like the lead kames of a window or as in a Japanese print by Hokusai or Hiroshige. The paint is applied quite thickly and is visibly worked – stippled almost – on the canvas, this taking the place of more usual brushwork to give the surface some texture. There is little movement in the compositions, however, both paintings having a stillness of some religious icon. In fact, given the strange surface texture they have, they resemble tapestries as much as they do stained windows. The imagery of each comes from a distinctly different source from most Glasgow paintings. It is the romantic world of medieval legend as re-interpreted by the Pre-Raphaelites, particularly Burne-Jones, Morris and Rossetti. Perhaps the Morris & Co. tapestries designed by Burne-Jones were the inspiration for these

246
David Gauld
Homeward
c.1891–3
Canvas, 35.5 × 45.5
Angus Maclean

pictures, for in technique and content they have much in common. Burne-Jones would have been well known to Gauld as his pictures were often to be seen at the Glasgow Institute in the 1880s. The Boys were not usually susceptible to Burne-Jones' imagery or methods, however, but a group of young artists who were admirers of his imagery may well have been introduced to it through these paintings by Gauld. A member of this group was one of David Gauld's young friends – Charles Rennie Mackintosh – whom he might have met at the Glasgow School of Art which they both attended in the evenings or, later, through his contacts with Guthrie and Wells, the Glasgow stained-glass makers. The first imaginative works which Mackintosh produced, a series of watercolours beginning in 1892, draw quite clearly on Gauld's interpretation of Pre-Raphaelite imagery. Mackintosh and Gauld became close friends and Mackintosh designed a suite of bedroom furniture for him when Gauld married in 1893 (Coll: Hunterian Art Gallery, Glasgow).

Another possible source for Gauld's new imagery was a colleague on the staff of the *Glasgow Weekly Citizen*, Leslie Willson. Gauld's illustrations for a book of poetry by James Hedderwick, *Lays of Middle Age and other poems*, 1889,[1] include not only Rossetti-like figures but others which seem to owe much to the illustrative style of Willson. Several of Gauld's illustrations echo the dresses or the figures of the girls in *St Agnes* and *Music*, motifs also to be found in Willson's work of the period.

Although a number of Gauld's early panels of glass have survived[2] there are no

other known paintings which approach the achievements of *Music* and *St Agnes*. One or two paintings which are datable to the early 1890s have a similar handling and surface texture, but their subjects are quite different and mark a return to more usual Glasgow School imagery, as in *Homeward* (pl.246). There remains a strong concern for the decorative aspects of composition but the symbolism of colour and content are no longer to the fore. In 1896 Gauld visited Grez, where Lavery, Kennedy and Roche had worked a dozen years earlier. His subject-matter, like theirs, became the village and the surrounding countryside but there entered into his work a softness of vision and tone which characterised his work for the rest of his life. The Grez paintings were not unattractive (pl.247), but they were not created in the spirit of experiment and exploration. The cool tones and muted colours are very different from the work of 1889 but they had their admirers and several Grez paintings were shown at exhibitions on the continent, including the Vienna Secession in the late 1890s. These Grez paintings were preceded by a group of paintings of young women, which may have been of his wife and were possibly inspired by his marriage in 1893. The girl is usually surrounded by the foliage of a tree which hangs mysteriously as a backdrop, effectively negating the need for perspective and allowing the painter to pay full attention to his subject (pl.248). A sense of mystery, of lingering sadness, is in the atmosphere; perhaps more than *Music* and *St Agnes*, these are Gauld's true personal reaction to the melancholia of the Pre-Raphaelite brotherhood. Other paintings are more decorative, as in *Portrait* (pl.228), and have a delicacy of touch and a sensitivity which was to disappear from later paintings.

Gauld's most important work (or at least the largest and most complex) was not a painting but a series of stained-glass windows for St Andrew's Scottish

247
David Gauld
Grez from the River
c.1896–7
Canvas, 61 × 66
Andrew McIntosh Patrick

248
David Gauld
Head of a Girl
c.1893–4
Canvas, 51 × 38
Andrew McIntosh Patrick

Church in Buenos Aires. These were made in Glasgow by Guthrie and Wells but they took up almost the whole of the first decade of the new century and when Gauld returned to serious painting it was as a producer of popular images of cattle and calves which came to adorn many middle-class Glasgow drawing rooms, along with the later paintings of Hornel and two younger Glasgow men, William Wells and W. A. Gibson.

The romance of Stuart Park's work of the later 1880s was contained not in idyllic or fairy-tale landscapes but in a series of delicately painted canvases of roses. For a couple of years, beginning in 1889, Park seemed inspired to produce work which lifted his reputation far higher than his later flower paintings could ever justify. In a group of works which are as enigmatic as their painter himself, Park transformed still-life painting in Scotland. Almost all of these pictures are of roses, simply arranged in glass vases whose transparency becomes a crucial part of the design (pl.234 & 249). These pictures are very consciously designed. They emphasise the two dimensions of the canvas by strewing the flowers along the frontal plane, contrasting them against a background which offers just the perfect tonal foil to the richness of colour of the petals. The reflections in the vases and the water in them complete the composition, the whole being ranged against an amorphous background which is never properly defined. This background – whether pale in the earlier paintings of 1889 and 1890 (p.254), or dark as in the pictures of 1891–2 (p.255) – became more and more tangible in the later paintings of flowers where Park's facility allowed him to produce an ever-increasing range of work, much of it of little interest although there is still the occasional glimpse of his early brilliance. Pink, yellow and red roses gave way to a more vigorous painting in a series of heads of girls each surrounded by flowers such as *Expectancy* and *A Gypsy Maid* (Coll: Dundee Museum and Art Gallery). After the mid-1890s, however, Park embarked on the series of flower paintings

249
Stuart Park
Roses
1889
Canvas, 40.6 × 66
Glasgow Art Gallery

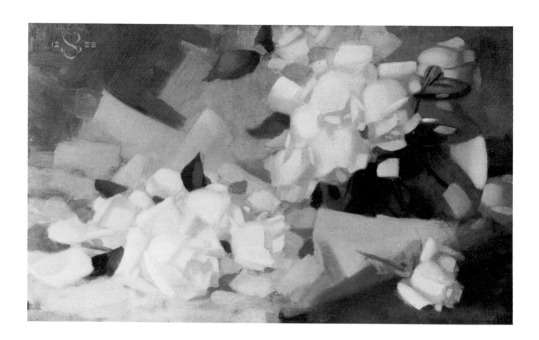

for which he has become best known. These repetitive bouquets of roses, violas, pansies or lilies gradually became so stereotyped as to make one wonder whether their painter could be the same man as painted the roses of 1889–92.

Gauld and Park were to remain in Glasgow, or at least the west of Scotland, long after the majority of the Boys had left the city. In 1889, however, most of them were still resident there with the exception of two painters for whom Glasgow had never been home – Crawhall and Melville. Joseph Crawhall had spent only brief periods in Glasgow after he, Guthrie and Walton had discovered Cockburnspath. When Walton left for Glasgow for the winters Crawhall returned to his family in Newcastle instead of remaining with his friends in Scotland. His work was, therefore, influenced less by the Glasgow painters than it had been in previous years and, as he gained confidence and explored further afield without the guidance of Walton and Guthrie, it changed slowly in both style and content. Crawhall became committed to animal life as his subject-matter. He was a keen rider, a huntsman and jockey, and horses and other animals, particularly birds, fascinated him. Crawhall reputedly found difficulty in his relationships with other than his very closest friends and family; perhaps he discovered a natural rapport with animals which would have been unaware of his silences and introspective nature. They became the main subject of his increasingly sophisticated watercolours as the decade wore on.

He followed Melville's example of seeking the sun and bright light of the Mediterranean, visiting Morocco and Spain. In Spain the bullfights captivated

250
Joseph Crawhall
The Bull Fight
c.1890–3
Watercolour and gouache,
37.5 × 35
Burrell Collection, Glasgow

251
Joseph Crawhall
Pigeons on the Roof
Gouache on linen, 38 × 32.5
Burrell Collection, Glasgow

252
Arthur Melville
The Little Bullfight:
'Bravo Toro'
c.1888–9
Watercolour, 56 × 77.5
Victoria and Albert
Museum, London

him and he broke away from his usually static compositions to record his impressions of the duel between the horses and the bulls (pl.250). At home, he had turned away from the realism of *Landscape with Cattle* (see p.125) and *The Forge* (see p.138), with their ruralist associations, towards more straightforward pictures. These watercolours of birds – ducks, doves, pigeons and hens – horses and dogs are immaculate in their rendering of the texture of feathers and fur, but they go further than mere natural history illustrations. In a way, Crawhall simply diverted his attention from studying man in his natural habitat (the countryside) towards studying other species in their own surroundings. These are not zoological studies, however, in the same way that Mackintosh's watercolours of flowers are not botanical illustrations (although both could be used for scientific purposes). They are the celebration of another kind of life by someone who perhaps felt more at ease with his new subject-matter than he would ever have done with sitters of his own species. These watercolours differed in other ways from those of the Boys. Crawhall discovered, towards the end of the 1880s, that by painting his watercolours on holland linen he could imitate many of the qualities of oil paint. These later works have an intensity and solidity of colour that he found difficult to attain on paper. They required a more careful preparation and totally different technique; they were the result of several days, if not weeks, of work and preparatory studies and they have lost something of the spontaneity of the Boys' work. Crawhall worked from memory, as well, which allowed him to be more selective in his recording and also to be more incisive in his depiction of his subject. A degree of synthesis results, combined with a ready acceptance of the decorative qualities of line and colour within a composition.

Nowhere is this seen better than in *The Aviary* (pl.255), where Crawhall's colour harmonies and strong brushwork record a visit to the aviary at Clifton Zoo, Bristol, in 1888. These birds have none of the anthropomorphic silliness of Stacy Marks' popular creations for the Royal Academy crowds; they are birds in captivity on public show, but they, and not the two young ladies who can be seen in the background, are the only subject of this painting. *Pigeons on the Roof* (pl.251) and *The Flower Shop* (pl.256) show how sophisticated his technique and his particular vision was to become. These paintings almost go beyond realism towards an un-natural synthesis of nature. The subjects become larger than life through the detail and immediacy of their handling in a medium over which Crawhall achieved complete mastery.

Arthur Melville never aimed for such detail and although he used similar methods – working from memory or a series of rapidly made sketches in the comfort of a studio – his paintings achieve a breadth and vigour that is equally rarely associated with the medium. Following Crawhall's example he visited Spain and Tangier where he was similarly captivated by the drama of the bullring, as in *The Little Bullfight: 'Bravo Toro'* (pl.252). These paintings and others like them would have been known to the Boys from their appearances at the Glasgow Institute and Royal Scottish Academy exhibitions but Melville himself left Scotland and settled in London at the beginning of 1889. He was to visit Scotland often, however, and continued to produce such fine landscapes as *Autumn – Loch Lomond* (pl.260). Most of his later work, however, was of

253
Arthur Melville
A Mediterranean Port
1892
Watercolour, 51.3 × 78.7
Glasgow Art Gallery

Mediterranean inspiration and during the 1890s he produced some of his most memorable paintings: *A Mediterranean Port* (pl.253) and *A Captured Spy* (pl.261) show him at the height of his powers.

Melville's association with the Boys was undoubtedly the reason that painters such as Walton, Lavery and Crawhall responded to the medium of watercolour. They began to produce finished watercolours for the Glasgow Institute and the Academies in Edinburgh and London, following Melville's example and in 1889 they seem to have persuaded the Institute to arrange a special exhibition, the 'Black and White', which was to be devoted entirely to works on paper. In particular, the exhibition was to encourage the greater use of pastel, a medium which seemed to find itself newly in fashion at the end of the 1880s following pastel exhibitions at the Grosvenor Gallery in London in 1888 and 1889. In 1888 Guthrie had sent two pastels to the Art Club show and *The Bailie* reviewer noted them as the start of something new.[3] It was virtually Guthrie's first essay into the medium; he had not even seriously espoused watercolour as had his friends while at Cockburnspath but he was to demonstrate a new virtuosity in a series of pastel drawings which were shown in both London and Glasgow in 1890 and 1891.

The earliest of these pastels were produced at Cambuskenneth and Stirling, where both Walton and Kennedy had studios and where the Boys often congregated in the summers of 1887–90. Not surprisingly, Guthrie took his subject-matter from the villages and fields around him. Even at this date he had not yet acquired Walton's or Lavery's taste for urban subjects and the first series of pastels, dating from 1888–9, are almost all rustic in subject. Some of these are tentative in handling and insubstantial in subject, which is hardly surprising when one realises that the artist was experimenting with, for him, a totally new medium. Yet one of this first group must be counted among the most accomplished of his pastels and placed alongside the best of the work of the other artists for whom working on paper had become second nature – Melville, Crawhall, Walton and Lavery. *The Ropewalk* (pl.265) was drawn in 1888 and shown by Guthrie at the Institute's autumn exhibition of Black and White in 1889 and at the New English Art Club in London. It was favourably noticed by the critics and acclaimed by the Boys and Guthrie was later to send it to the first of the Munich Glaspalast exhibitions to which the Boys were invited during the 1890s. In some ways this pastel represents a return to the ideals of the Cockburnspath period, with its emphasis on a single figure which takes up a large proportion of the drawing. At Kirkcudbright Guthrie had had difficulty in repeating the successes of Cockburnspath and had laid aside his big composition, *The Stonebreaker*. It is possible that, by working on a reduced scale in a medium which perhaps did not demand the same respect for convention as oil, Guthrie felt liberated from the problems which had beset his subject paintings after he had left Cockburnspath. In *The Ropewalk* he had sufficient confidence to break away from the repetitive formulas often found in his early work. Compared with the static compositions of *A Hind's Daughter* (see p.91) and *In the Orchard* (see p.131) there is a clear sense of movement in this pastel and a strong *chiaroscuro* which is new to Guthrie's work. Crawhall's *The Forge* (see p.138) was almost certainly a direct inspiration for this composition, both pictures looking from a

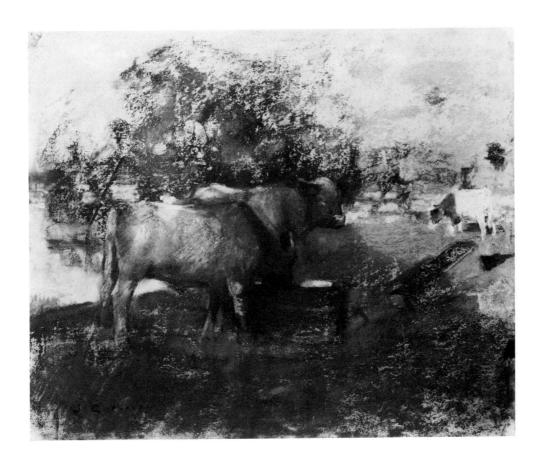

254
James Guthrie
Pastureland
1890
Pastel, 24.7 × 30.5
Glasgow Art Gallery

dark room out through a door or window to bright sunlight. Guthrie even drew his own version of the same subject (Coll: Glasgow Art Gallery) which was perhaps a personal acknowledgement of Crawhall's influence. The compliment was in some way reciprocated by Crawhall who, presumably at Guthrie's instigation, turned to pastel himself in one or two drawings made around 1889. *Oxen Ploughing, Tangier* (pl.262) is the most elaborate of these and shows Crawhall adapting his style to the looser handling demanded by the medium. Walton, too, was not unaffected by Guthrie's experiments and exhibited a pastel, *Jean*, at the Glasgow Institute in 1890.

In the summer of the following year, 1890, Guthrie returned to the medium but this time Helensburgh on the Firth of Clyde dominated his subject-matter. In this he was following Walton's lead as his friend had been inspired by the life of the town since 1883. Guthrie recorded the middle-class daily round of tea parties and tennis matches but he also chose to look beyond this immediate circle of friends and acquaintances to the more workaday aspect of the town. The farms at the top of the hill overlooking the town provided him with more rural subject-matter (pl.254) but he also found an unusual industrial theme in the town. At this time, 1890, the new West Highland Railway was being constructed and the line passed through the upper part of Helensburgh, swathing through the elegant streets with their large villas and extensive gardens. The navvies who were drafted in to pick out the deep cutting which hides the incline of the line soon

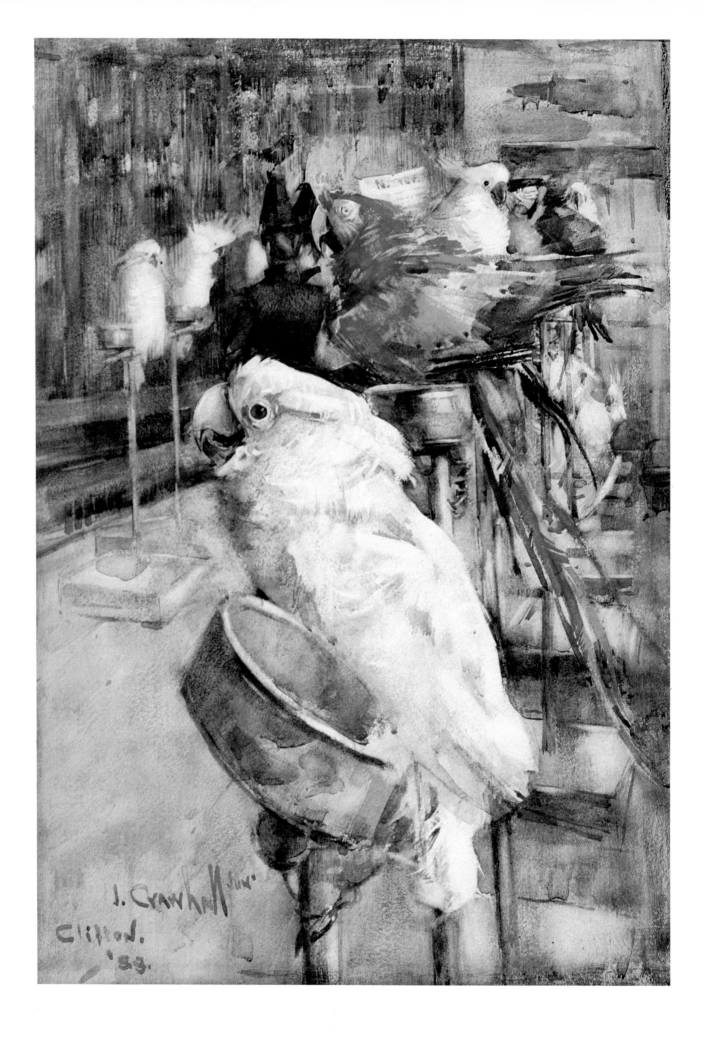

J. Crawhall jun.
Clifton.
'83.

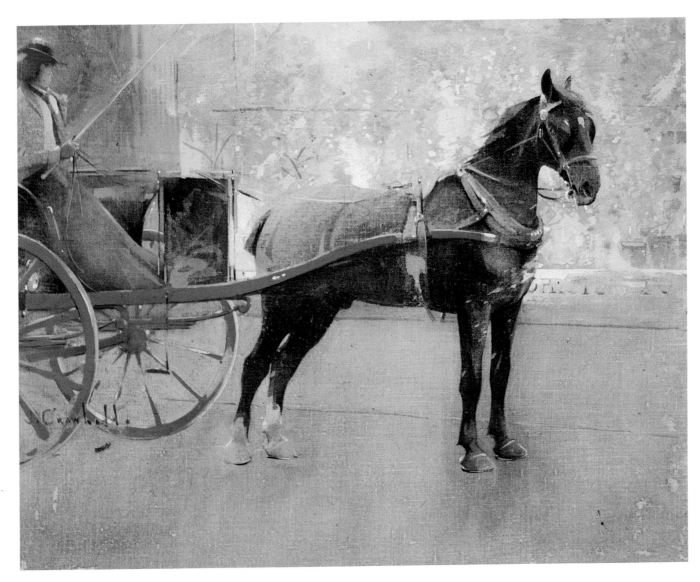

256
Joseph Crawhall
The Flower Shop
Gouache on linen, 27.5 × 34.3
Burrell Collection, Glasgow

255
Joseph Crawhall
The Aviary, Clifton
1888
Watercolour and gouache,
51 × 35.5
Burrell Collection, Glasgow

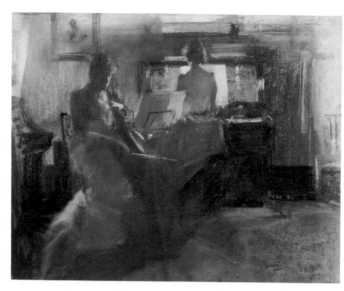

257
James Guthrie
Firelight Reflections
1890
Pastel, 61 × 52
Renfrew District Museum
and Art Gallery, Paisley

258
James Guthrie
Candlelight
1890
Pastel, 42.5 × 51.5
Private Collection

became Guthrie's subjects, just as much as the young ladies of Helensburgh. Helensburgh's more traditional industry was based on the river and a further group of drawings concentrates on the piers of the waterside where the Clyde ferries were moored.

The most elaborate of Guthrie's Helensburgh studies, however, reflect Walton's earlier interest in the daily life of the ladies whose husbands, fathers and brothers made the daily journey on the new railway to Glasgow or across the Clyde on the ferries to Greenock and Port Glasgow. Several of them take up the fascination with the effects of light seen in *The Ropewalk* and attempt to capture the effect of firelight or candlelight in drawing rooms populated by young ladies playing music or reading, as in *Firelight Reflections* and *Candlelight* (pl.257 & 258). These indoor pursuits are contrasted against the sunlit skies of *Tennis* (pl.266) in a study which rivals Lavery's earlier achievements with the same subject. Another such drawing, *The Tennis Racket* (pl.259) is an informal portrait illustrating Guthrie's growing ability as a painter of more formal likenesses. There are many other studies of the Helensburgh girls whom he met at Whitelaw Hamilton's or Mrs Whyte's house, where he had painted several of his early pictures such as *To Pastures New*.

Guthrie exhibited some of these pastels in the Glasgow Institute exhibitions in the autumn of 1889 and in the annual spring show in 1890. The following year he was invited to show the complete series at Dowdeswell's in London; shown without titles they aroused critical approval but no sales. In 1891 he arranged a similar exhibition in Glasgow at Lawrie's Gallery where every one, by contrast, was sold! Despite this critical and financial success Guthrie did not continue to make pastel drawings; even his attempts at watercolour (*The Orchard* and *Harvest*, both untraced) which he exhibited at the Institute in 1891 do not seem to have been repeated. All of which begs the question as to why Guthrie became involved with this new medium and why he should forsake it so quickly after having mastered it? Certainly, public reaction to his portraits at the end of the

1880s was not always laudatory, despite the success of his equestrian portrait of George Smith (Private Collection) both at home and abroad. The portrait of Mr Gourlay, Manager of the Bank of Scotland in Glasgow, and another of Mrs Fergus were not well received and other commissions do not seem to have been forthcoming. Perhaps Guthrie turned to pastel because he did not have any portrait commissions but did not want, or could not bear, to get involved with another large composition on canvas which he would have to drop should a

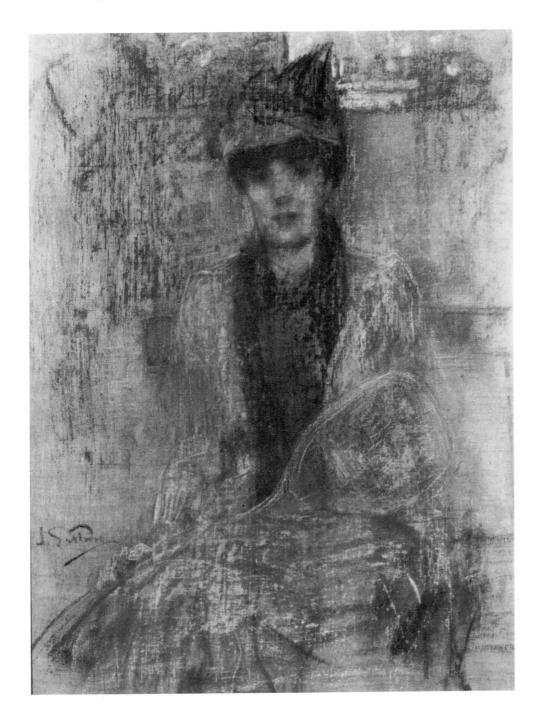

259
James Guthrie
The Tennis Racket
1890
Pastel, 58.5 × 43
Private Collection

request for a portrait materialise. The successes of the Boys in London and
Munich in 1890 returned him to the public eye, however, and after 1891 his order
book for portraits was never empty. The pastels exhibition in Glasgow would also
have confirmed his public position as one of the leading members of the Boys and
could only have helped his temporarily stagnant career as a portraitist. The
critics were aware of his dilemma and expected these pastels to herald a return
to more 'suitable' painting in the manner of the work of the 1880s. In reviewing
the pastels at Lawrie's one wrote: 'It seems a pity James Guthrie does not
concentrate his great powers on an important picture.'[4]

The pastels mark almost the last phase of Guthrie's career as an inquisitive
painter who wished to push his painting further in the search for new ideas and
new methods of expression. He had long been categorised by the Press as an
'impressionist' but these fifty pastels are the only works he had painted so far to
which that term would be applied today. There is a spontaneity about them, an
attempt to capture the fleeting effects of sunlight or the mystery of artificial
light, which is absent from his naturalist manner and which marks a final break

260
Arthur Melville
Autumn – Loch Lomond
1893
Watercolour, 59 × 85
Glasgow Art Gallery

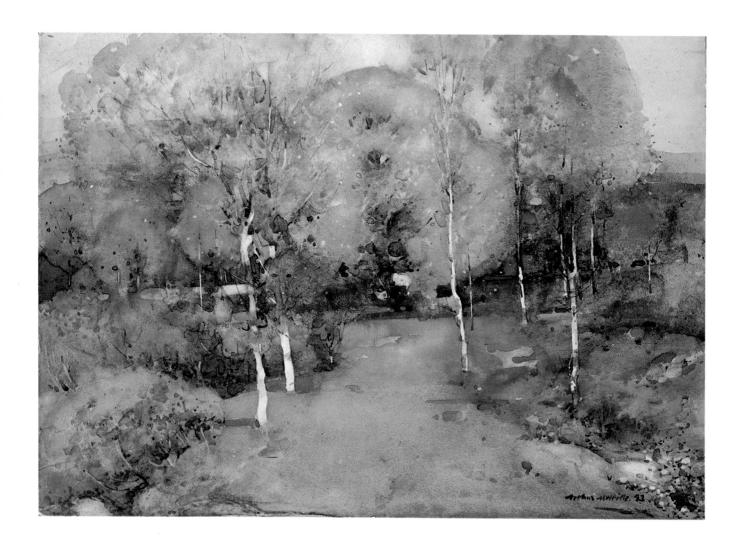

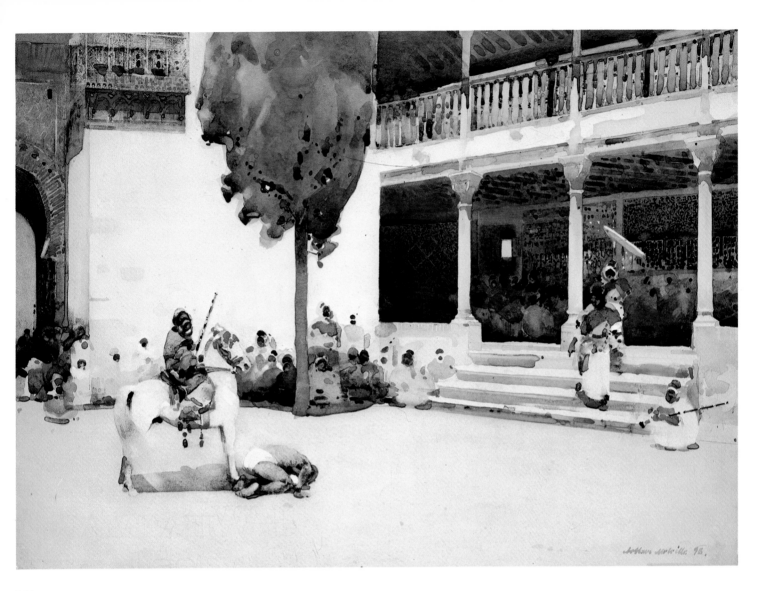

261
Arthur Melville
A Captured Spy
1895
Watercolour, 52×72
Glasgow Art Gallery

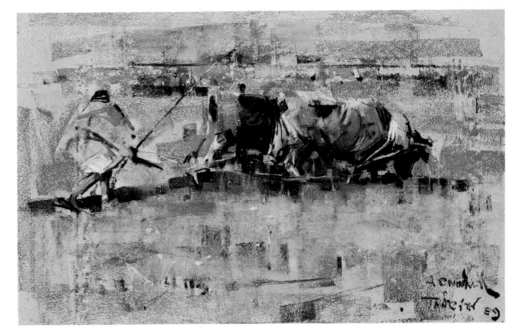

262
Joseph Crawhall
Oxen Ploughing, Tangier
1889
Pastel, 28.3×45.1
National Galleries of
Scotland, Edinburgh

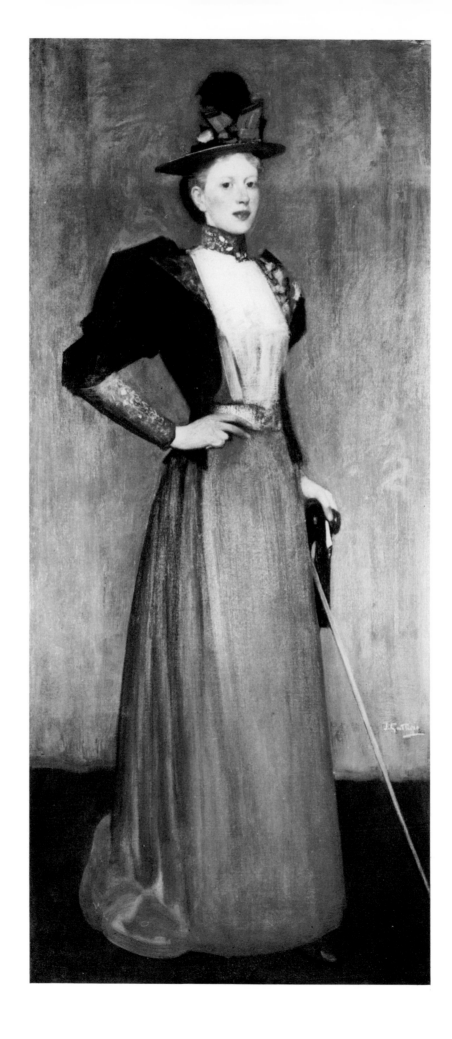

263
James Guthrie
Maggie Hamilton
1892–3
Canvas, 195.6 × 87.6
Glasgow Art Gallery

from the style of Bastien-Lepage. There is actually little in his oils of 1890 and later which reflects his skills in pastel apart from a short-lived fluidity of handling or brighter colour which appeared in two or three works produced early in the decade. *Miss Wilson* (pl.264) shows a considerable loosening of handling when compared with, for instance, the portrait of his uncle, Dr Gardiner (see p.144), and which almost certainly derives from his pastel drawings. A portrait of Maggie Hamilton (pl.263), the sister of his friend Whitelaw Hamilton, displays a similar lightening of palette but it was in a less formal group portrait that the full effect of his working in pastel is best seen – *Midsummer* (pl.269).

The three young ladies sitting around a tea table in a garden are a continuation of the society theme of the Helensburgh pastels of 1890. This is also a Helensburgh subject and the three girls are, left to right, Maggie and Mary Hamilton and Hannah Walton, sisters of Whitelaw Hamilton and E. A. Walton. Guthrie may have been spurred on to produce this picture by the criticism voiced at his show of pastels, that his talent should be directed towards something more substantial than coloured drawings. *Midsummer* is certainly a return to the subject painting

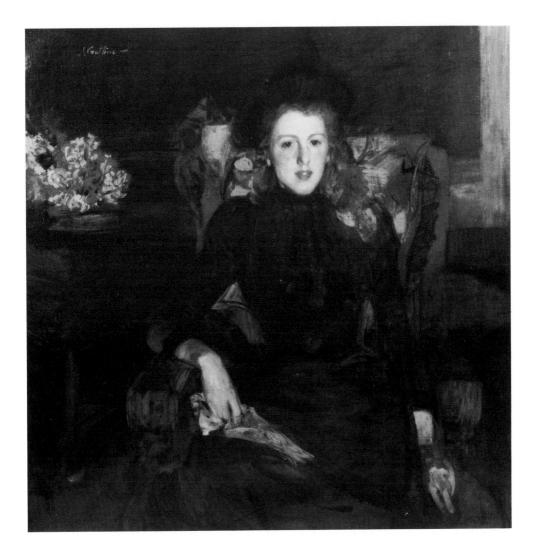

264
James Guthrie
Miss Wilson
1890
Canvas, 105.5 × 108
Private Collection

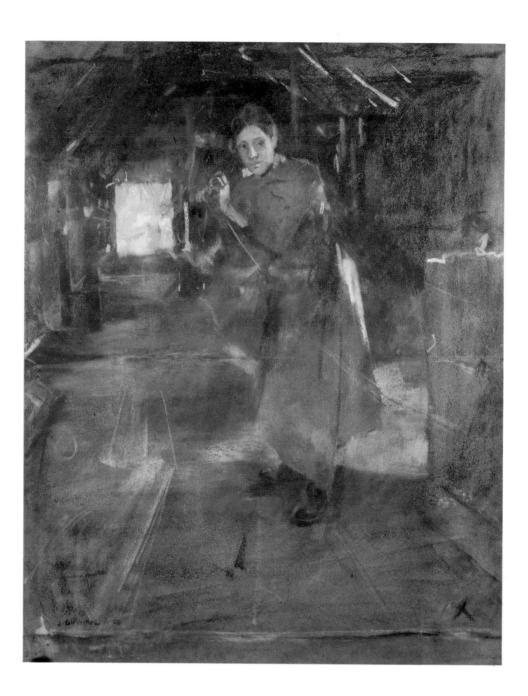

265
James Guthrie
The Ropewalk
1888
Pastel, 63 × 49.5
Private Collection

of the 1880s; Guthrie has, however, turned his back on rustic life in favour of more genteel happenings. Like Lavery before him, he turned to the realism of life in middle-class families for his material. Walton, who can be credited with introducing such subjects to the Boys, seems never to have produced a similar work in oil, restricting his urban pictures to watercolour. Compared with Guthrie's Cockburnspath and Kirkcudbright oils *Midsummer* seems a deliberate move towards impressionism. It is bright in tone and colour and its painter was clearly aware of the effect of light and shade on colour. Shadows are painted in greens and pale purples and the whole range of colour used is far removed from

that of *Schoolmates* or *In the Orchard*. Full sunlight appears for almost the first time since Guthrie painted *To Pastures New* in 1882–3. The problems of composition in such large canvases which had dogged him for several years seems to have been overcome and the overall result is an elegant painting which should have been the start of a new phase in its painter's career.

In later years Guthrie regretted his decision to give this painting to the Royal

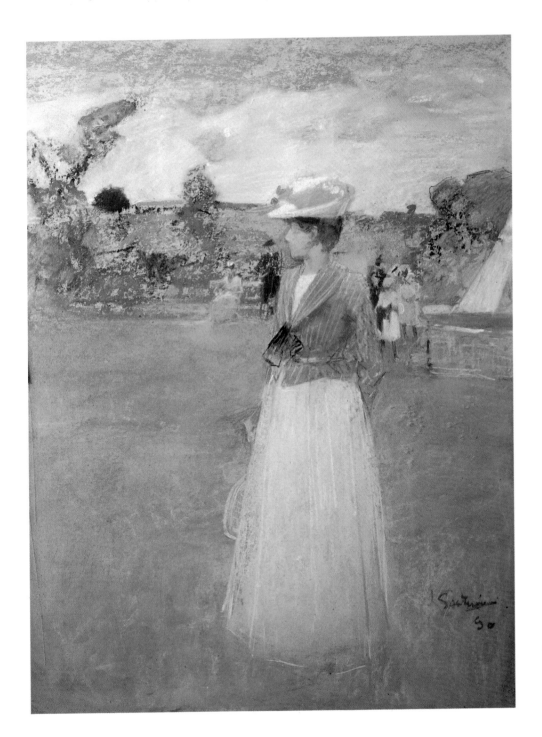

266
James Guthrie
Tennis
1890
Pastel, 49.5 × 42
Private Collection

Scottish Academy as his Diploma work on the grounds that it was experimental and unresolved. Sadly, Guthrie did not persevere with this 'experiment' and, as the commissions for portraits began to come in, he turned his mind away from such excursions to concentrate almost entirely on the completion of the latest commission. With the exception of a couple of landscapes painted in the mid-1890s Guthrie was not to paint another picture which was not a portrait until 1927. This rejection of painting for pleasure – painting that pleased him rather than his clients – is something which sets Guthrie aside from all the other Boys. Lavery, Walton, Henry and Roche, who all turned to portraiture in later life, continued to paint the kind of pictures which they had produced as young men – albeit in somewhat different styles from that of their youth. Admittedly, Guthrie took a great deal on his shoulders when, in 1902, he became President of the Royal Scottish Academy, but others followed similarly busy lives (Lavery in particular) without neglecting their painting. Guthrie undoubtedly took his official duties seriously, and he was never to be at ease with any picture which involved more than one figure.

Walton and Lavery had not encountered the enforced halt to the mainstream of their development which had fallen on Guthrie around 1889. Lavery was kept busy with the official commission to record Queen Victoria's visit to the Glasgow International Exhibition in 1888 which was to establish him immediately as the most fashionable portrait painter in Glasgow. After it was completed he left for a much-needed rest in Tangier where he was able to return to less elaborate subjects and was impressed by Melville's and Crawhall's Mediterranean pictures. Walton continued to send a mixture of portraits and subject pictures to the Glasgow Institute and the Royal Scottish Academy. The most important of these, *Peasant Girl and Boy*, remains untraced but reviews of the Glasgow Institute in 1891 show that it was considered to be his finest work to date. At the same time certain aspects of it were commented upon which suggest that Walton was also gradually rejecting the Bastien-Lepage manner of his earlier works in favour of a more traditional method of working:

In the midst of some greenery in a cottage garden, the girl, bareheaded and with her light coloured dress protected by a rough sackcloth apron, stands speaking to the boy who has been unearthing some turnips and turns to listen to her. There is a striking directness and force in the simply natural rendering of the figures and the telling scheme of colour; the lower tones of the girl's apron and the boy's dress play an important part.[5]

[Walton's] *Peasant Girl and Boy* is strong in colour not less than in draughtsmanship, although again one deplores the absence of sunlight. The figures are set in a vegetable garden of luxuriant greenery, that of the boy, in stooping posture, being drawn with consummate skill, while the girl stands in *pose* of statuesque grace. She is an ideal peasant, perhaps, who owes a good deal to the artist.[6]

E. A. Walton's *Peasant Girl and Boy* is probably presented by the artist as primarily a figure subject, and not, except in a secondary sense, as a landscape. The title justifies such an inference, if the picture itself leaves one in doubt on the point, for the kitchen garden in which the girl and boy find themselves is very much in evidence in its lusty and somewhat confused life. There is, indeed, too much garden and it is all foreground. As to the figures, that of the boy is most happily characteristic. The little fellow, in shirt and highly braced trousers, kneels among the kitchen stuff, and turns round as if replying to something

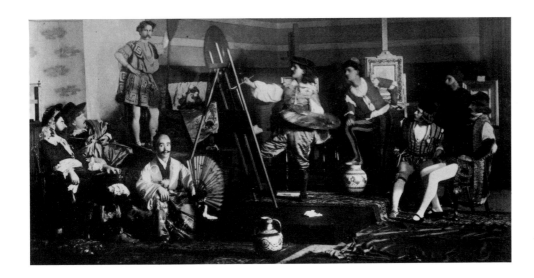

267
The Grand Costume Ball,
1889. Lavery at the easel ;
Guthrie stands at left ;
Walton is holding a fan

which has been said by his companion, his ruddy, healthy face, with thatching of brown hair, blue eyes and full roseate lips, is instinct with purpose, and in point of draughtsmanship is nearly as possible perfect. The girl, again, has all the grace of early womanhood, and more than the dignity perhaps of a peasant. Reddish-brown hair crowns a sweet oval face, healthily tinted with sun and wind. She wears a white bodice and over her dress an apron of sacking. The arms, bare to the elbows, are finely modelled, as are also the well-formed hands. The eyes are downcast, and the lines of the mouth sensitive and proud. Mr Walton's peasant girl is idealised. Remove the garden apron, bring out your satin and pearls, and her natural place is a drawing room in Belgravia. All the same the picture is noteworthy.[7]

The inference to be drawn from all these, and other, reviews, is that Walton was moving further away from rustic naturalism towards a more traditional kind of genre painting based on models posed in the studio. With the loss of the picture it is difficult to be more precise but a smaller painting, exhibited at the Royal Scottish Academy in 1892, would seem to confirm this view.

The girl in *Bluette* (pl.268) is probably the same as the one in *Peasant Girl and Boy*. The oval face, hair, fine features and elegant hands all correspond to the description of the girl in the earlier painting. If that is so then she was almost certainly a model and not a real peasant girl, which marks a fundamental break with the work of Guthrie at Cockburnspath and Bastien-Lepage. *A Daydream* (see p.151) may have been painted in the studio, but it was surely based on *plein-air* sketches. Its landscape background was carefully observed, unlike that in *Bluette* which is sketchily brushed in and made clearly subservient to the main focus of the composition, the girl herself. The sunlight which the critics 'missed' in *Peasant Girl and Boy* fills the background of this picture but, as in Guthrie's *Midsummer*, the main subject is shown in shade and contrasted against the brighter landscape behind her. The interaction between the children in *Peasant Girl and Boy* is now open and a crucial part of the subject. This first appeared in *Grandfather's Garden* of 1884 (see p.133), where it broke the convention which Guthrie and Walton had established at Crowland and Cockburnspath of not introducing dialogue between the figures in their compositions. It brings

Walton's work nearer to the genre painting of the Art Club Gluepots and into line
with the 'soft' realism which was gradually pervading the work of the older
members of the School – Roche, Kennedy, Lavery, Paterson and Guthrie. In
fact, these painters were recognised by the critics at the 1890 and 1891 Institute
exhibitions as developing into mature and assured artists, having dropped some
of the wayward excesses of their youth and the mantle of rebellion was awarded
to Henry and Hornel. This was due not to a change in critical standards or the
acceptance of the validity of the Boys' earlier painting, but was brought about
by a gradual movement by the older Boys away from their earlier enthusiasms
towards more conventional themes and methods.

 All of this was symptomatic of the Boys' gradual absorption by the
establishment in both Glasgow and Edinburgh. By 1889 both Guthrie and
Walton had been made Associates of the Royal Scottish Academy and in that
same year they took a major part, along with Lavery, in the Art Club's
organisation of a Grand Costume Ball in aid of the Scottish Artists' Benevolent
Society. The Boys joined with the more staid members of the Art Club to create
an occasion which became one of the social highlights of the year in Glasgow.
Over 900 guests filled the St Andrew's Halls, in costumes as predictable as Mary,
Queen of Scots, and as unexpected as 'A Fuchsia'. The artists went as Old

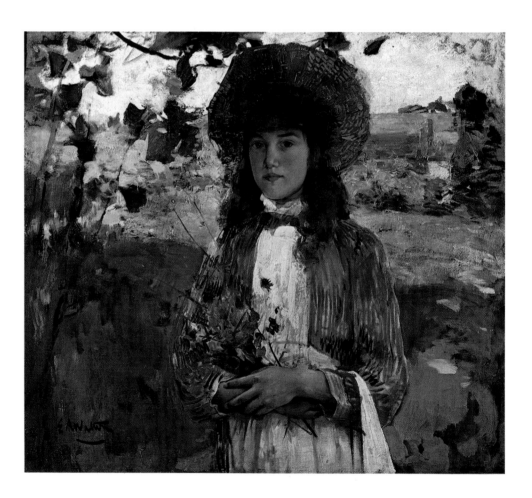

268
E. A. Walton
Bluette
c.1891
Canvas, 75×78
National Galleries of
Scotland, Edinburgh

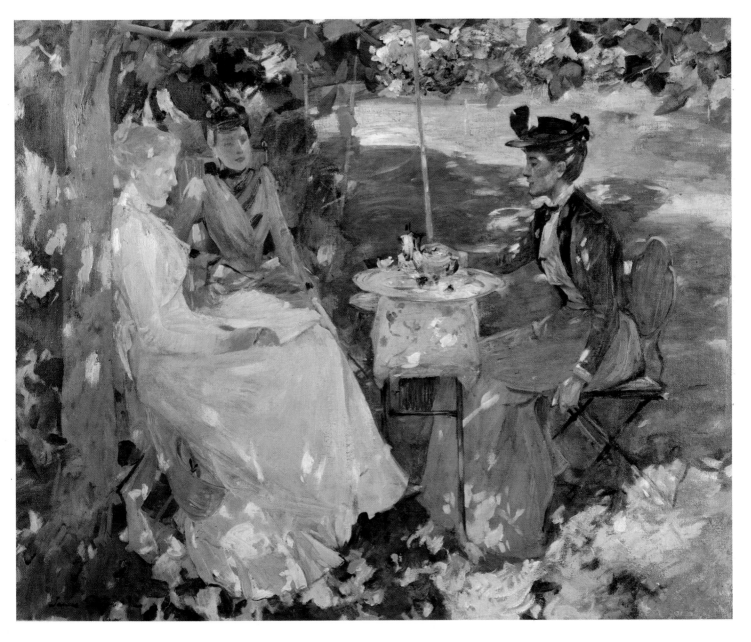

269
James Guthrie
Midsummer
1892
Canvas, 99 × 124.5
Royal Scottish Academy,
Edinburgh

Masters and there were some interesting choices made. Lavery, who always had 'a guid conceit o' himself', appeared as Rembrandt; Guthrie as Apelles (not an original choice as there were at least two other Apelles on view); Paterson as Botticelli; Grosvenor Thomas as Bellini; Whitelaw Hamilton as Michelangelo; and Walton, the only artist to have chosen one of his idols, as Hokusai (pl.267). A studio was set up in a corner of the hall where the painters made quick sketches of many of the guests as a record of the occasion. Guthrie painted Sir Frederick and Lady Gardiner, his cousins, as William Pitt and a Swedish peasant (pl.270). Lavery painted a programme of the evening's dances (Coll: Glasgow Art Club) and recorded one of the main events of the evening – Hokusai's engagement to

270
James Guthrie
At the Buffet
1889
Canvas, 46 × 37
Private Collection

271
John Lavery
Hokusai and the Butterfly
1889
Canvas, 61 × 46
National Galleries of
Scotland, Edinburgh

the Golden Butterfly, bringing Japan and Whistler together in the form of Walton and Helen Law, who were married the following year (pl.271). This makeshift studio must have proved very useful to those artists who saw a future in portraiture, as many of the most influential sitters in Glasgow were at the ball and many took the opportunity to sit to the artists in attendance. The easel was not monopolised by the portraitists, however, as even George Pirie, whose skills at 'face-painting' had so far been confined to furred or feathered sitters, took the opportunity to capture a few of the elegant costumes (Coll: The Fine Art Society). Even Henry and Hornel, who are not listed among the guests,[8] were present to paint 'Carmen' and the 'Glee Maiden'.

The Ball no doubt strengthened the Boys' position in the city, following as it did their success at the Glasgow International Exhibition and their initiative in establishing *The Scottish Art Review*. In 1890 they were to increase their standing through an exhibition at the Grosvenor Gallery, quickly followed by an invitation to show as a group in Munich. These exhibitions did not meet without some criticism from the national Press but in Glasgow they did much to help establish the Boys as serious painters of whom considerable notice was taken outside Scotland. Had it not been for this publicity it is doubtful that they would have succeeded in the coup that they achieved in 1891.

For many years the Boys' chief inspiration, if not in the exact manner of their

painting then certainly in the formulation of their attitudes towards art and its meaning, had been James McNeill Whistler. As a homage to the 'Master' they included a full-page reproduction of his portrait of Thomas Carlyle (pl.272) in *The Scottish Art Review* in August 1889. The painting had been included in the Sale collection at the Glasgow International Exhibition in 1888 where it was priced at £1000. It had earlier been on show at the Royal Scottish Academy in 1884 in an exhibition of Scottish historical portraits and was priced in the catalogue at 500 guineas. A group of Edinburgh citizens had tried to raise funds by public subscription to purchase the painting and this sum had almost been reached when Whistler discovered that among the subscribers were a number of

272
James McNeill Whistler
Arrangement in Grey
and Black No. 2:
Thomas Carlyle
1872–3
Canvas, 171.1 × 143.5
Glasgow Art Gallery

people who did not accept his own views on art, no matter how much they admired the *Carlyle*. In one of those acts of perversity of which only he seemed capable he cabled the organisers: 'The price of the *Carlyle* has advanced to one thousand guineas. Dinna ye hear the bagpipes?'

In 1889 Whistler's portrait of his mother was shown at the Institute, thus keeping him firmly in the public eye in Glasgow. The Boys set their sights on acquiring one of these portraits and realised that a portrait of Thomas Carlyle, who was very much seen as a Scottish hero, was likely to be rather more acceptable to a Glasgow purchaser. With Walton at their head, assisted by Guthrie, the members of the Glasgow Art Club prepared a petition to the Convener of the Art Gallery Committee in an attempt to persuade Glasgow Corporation to buy the portrait of Carlyle:

We, the undersigned, being deeply interested in the scheme of the purchase of pictures on behalf of the Corporation of this City, beg to place before your committee for consideration the following suggestion, viz., the desirability of purchasing for the town the celebrated portrait of Thomas Carlyle by James McNeill Whistler, regarded by Carlyle as the most successful portrait of himself. Not only is the subject of this picture one that appeals strongly to all Scotchmen, but the masterly execution, the dignity, and the simplicity rank it among the noblest works of art of our time.[9]

The signatories amounted to eighty-nine names, including sixty-four artists, among whom were Millais and Orchardson.

Walton acted as the intermediary with Whistler; a wise choice as Walton was reckoned in later years to have been the only artist with whom Whistler had not irrevocably fallen out. He was unable to do anything about the price, however; in fact, Whistler subtly increased it from the £1000 asked for at the International Exhibition in 1888 to 1000 guineas. On 3 February 1891 he replied to Walton's approach:

You wish to know what I am asking for the *Carlyle*. The picture, as I told you when I received your first communication, I had begun to think would find its home in America – but this flattering effort on the part of the Painters of Glasgow to obtain for their own town my portrait of their great countryman, is with me all influential – and I shall be pleased to forego the increase of price which I should now have put on it. A thousand guineas you know I asked for the painting when in your Exhibition – let it remain at that sum.[10]

After listening to a deputation from the Art Club which included Walton and Guthrie, the Art Gallery Committee gave full powers to its Convener, Councillor Robert Crawford, to purchase the picture within the sum of 1000 guineas as mentioned by the artist. That was on 27 February and on the next day Crawford and a fellow Councillor set out for London and a series of meetings with the artist. There have been several accounts of the ineptitude of the two men in their dealings with Whistler but most of these were written to put Whistler and his wit in the best possible light against the 'unsophisticated' and 'mean' Scots. Crawford recorded his version of events in the *Glasgow Evening News*, 23 February 1905.[11] Apparently the Corporation had as much as £4000 in their purchase fund for the Gallery and were quite prepared to acquire the picture at the price quoted. It was not at all uncommon, however, for reductions to be made

by the vendors on such occasions and Crawford was instructed to investigate whether a deal might be made for 800 guineas. Whistler was probably forewarned by the Glasgow painters that the Corporation had agreed to buy the painting and at the price asked and so when Crawford and his colleague came to call he was prepared. Crawford's assistant was a self-confessed Philistine and it was his task to try to achieve some movement on the price. Over tea, laced with rum and lemon, Whistler refused to haggle about the price and, to Crawford's amusement, the Philistine ventured

out of the financial into the artistic arena, but was sorry for it a moment later . . . 'Mr Whistler, do you call this life-size?'

'No, I don't,' snapped Whistler, with a gesture which plainly said 'if I could throw you out of the window then I would.' 'There is no such thing as "life-size". If I put you up against that canvas and measured you, you would be a monster.'

The Philistine was considerably crushed . . . but made one more rash conversational venture: 'The tones of this portrait are rather dull, are they not. Not very brilliant, are they?'

'Not brilliant! No, why should they be? – Are you brilliant? No. Am I brilliant? Not at all. We are not "highly coloured" are we? – We are very, very ordinary looking people. The picture says that and no more.'

There seemed nothing more to say after that, and so the Philistine and I departed, after promising to send a cheque for the picture, highly charmed with the gay persiflage of the greatest of modern Impressionists.

Some years later Whistler wrote to Crawford in terms that showed he held no malice in his memory of the occasion. He would probably have been disappointed had the two Councillors not tried to get the better of the deal. The *Carlyle* came to Glasgow (pl.273), evidence of its own worth but also indicating how Glasgow's attitude to its Boys had markedly changed.

273
*Jimmie Whistler on the Job:
the Last Touch to the Carlyle
1891*

CHAPTER 12

Border Crossings

In the early and mid-1880s the Boys consistently sent works to the Royal Academy in London, even if they were to ignore their own Academy where they knew that they would almost automatically be rejected. Walton and Guthrie, in particular, had some success in London and others, such as Lavery, continued to send their major pictures there. Their English counterparts, however, regarded the Academy in much the same way as the Glasgow painters considered its sister in Edinburgh. Its restrictive manner, allowing only approved work to be shown on its walls and rejecting anything which it considered to be questioning its position, caused dismay and anger among those painters who, like the Boys, were striving for the advance of art in Britain. In response to the Academy's unrepentant attitude, at the beginning of 1886 a group of young English artists established a new exhibiting body in London – the New English Art Club. Like the Grosvenor Gallery, operated by Sir Coutts Lindsay, a wealthy banker, it was to offer an alternative venue for the display of work that the Academy refused to admit. Unlike the Grosvenor, it was to be run by artists for the benefit of artists, without the guiding hand of a proprietor or entrepreneur to censor the exhibits. One or two painters, led by H. H. la Thangue, wanted to go even further and operate the Club as an enormous Open Salon, where all practising artists might have the right to exhibit. La Thangue and his friend Clausen, who supported his plan, would have been well known to the Boys as their work was also directly inspired by Bastien-Lepage. The Boys were prevailed upon to join the Club and in 1887 sent a group of works which formed the first coherent display of the Glasgow School in London. It was probably Clausen who was instrumental in encouraging the Glasgow men to send to the Club, as la Thangue resigned when his proposals for its re-organisation were rejected. The work of Guthrie and Walton up to 1886 was quite close to that of Clausen and the latter was invited to contribute an article on Bastien-Lepage to *The Scottish Art Review*. In 1887 Clausen would have found the Boys to be willing allies against the different factions within the Club which always threatened its stability and which in 1892 provoked the mass resignation of the Scottish members, halving the Club's membership and seriously weakening its artistic credibility.

Christie (who was at this time resident in London and only ever on the fringes of the Glasgow School), Dow, Whitelaw Hamilton, Henry, Lavery, Alexander Mann, Paterson, Harry Spence and Walton were represented in the 1887 exhibition. All of them sent serious and substantial works and they repeated the exercise until 1890. After that they were less well represented in 1891 and 1892,

probably because their available work was committed to exhibitions elsewhere. Guthrie, Nairn, Roche, Morton and Robert McGown Coventry joined them in 1889; Guthrie sent his portrait of Dr Gardiner and *The Ropewalk*, Henry showed *Moonrise: November*, Paterson sent *Winter on the Cairn* and Lavery was represented by a portrait and one of his Glasgow International Exhibition pictures. The biggest display came in 1890 when Guthrie sent three works (two of them pastels), Lavery, Walton and Paterson each showed three pictures, Crawhall sent *The Aviary*, Kennedy made his début with *Stirling Station*, Roche showed *Good King Wenceslas* and *Miss Lou* (whose sister married the dealer, Alexander Reid); other Scottish exhibitors included Helen Law, who was shortly to marry Walton, and James Caw, later to become Director of the National Gallery of Scotland and biographer of William McTaggart and Guthrie. Despite the importance of the works shown in the 1890 exhibition of the New English Art Club, the critics seem to have paid little attention to the Scots. This seems all the more surprising when one considers the reaction to another exhibition of the Boys' work in London that year at the Grosvenor Gallery. It may be that the Grosvenor was a little more professionally organised and succeeded in attracting the all-important critics to its show but it probably had more to do with the presence of Melville, Hornel and Henry at the Grosvenor, each represented by major and audacious works.

The Grosvenor Gallery had become synonymous with the work of the more avant-garde painters in London, particularly those who did not wish to be associated with the Royal Academy, or whose work was not acceptable to the Academicians. Whistler and Burne-Jones were its two luminaries and the Boys were no strangers to its walls. Christie, whose association with the Boys is based more on his upbringing in Scotland than his artistic aspirations, had shown there regularly from 1881. In 1886 William Kennedy showed *A Siesta*; in 1889 he returned with Lavery, Melville, Paterson and Roche but it was in 1890, in the last exhibition that the Grosvenor put on, that the Boys had their biggest, and most noticed, display in London. Christie, Dow, Guthrie, Henry, Hornel, Kennedy, Lavery, Melville, Morton, Paterson, Pirie, Roche, and Walton all sent work, as did the arch-Gluepot James A. Aitken from Glasgow and several other Scottish artists including David Murray, Thomas Austen Brown and Sir William Fettes Douglas, President of the Royal Scottish Academy and main stumbling-block to the admission of the Boys to its Edinburgh walls. Melville and Clausen were on the Hanging Committee and it also seems likely that these two were responsible for persuading the Gallery to include such a large group of Glasgow painters in the exhibition.

The critic of *The Saturday Review* gave them most attention and it is he that the Boys had to thank for introducing the tag 'Glasgow School' to a London audience. He made some attempt to analyse the beginnings of the School, but substantially underestimated its age in a patronising remark about the – as he thought – 'first' appearance of the continental artists at the Glasgow International Exhibition in 1888:

The Grosvenor Gallery has asserted its right to exist by producing a decidedly original and, in some respects, a very interesting exhibition this year. It is given up to Scotch art;

but not merely to that rather greasy Academic Scotch art showing the lines of the brush in the long smears of paint with which we are only too well acquainted. On the contrary, what is most noticeable at the Grosvenor Gallery this year is the work of a group of young Glasgow painters whose names are mainly unknown in the South, and who, if we are not mistaken, have never exhibited their pictures in London before. These Glasgow painters give freshness and importance to the show, and add that element of novelty which we have seen to be wanting at the Royal Academy and the New Gallery.

. . . These painters are so like one another, and so unlike any other existing British artists, that their works are not to be overlooked, although they are scattered all over the galleries. The existence of this school of artists – and this is a very curious fact – dates from the Glasgow Fine Arts Exhibition [1888]. On that occasion the youth of Glasgow saw the famous French and Dutch *romantiques* for the first time, and they were smitten with the longing to do likewise . . . Like all direct imitations, the art of these Glasgow students has something violent and extreme in it. They do not always understand why their models obtained a certain effect, and they blunder like a man who repeats a story of which he has misunderstood the point. Yet we are bound to say that this seldom happens and that their work presents very few of the disadvantages which we should expect from the violent manner of its production. The colour of these Glasgow pictures is, in particular, extraordinary; it is never really bad; it is often superb.[1]

Other critics, in *The Times* and Walter Armstrong in *The Magazine of Art*, wrote in similar praising terms, welcoming the Scots to London and showing their ignorance of their earlier appearances in the New English Art Club. Some journals were less polite, however: 'purposeless eccentricities and impertinences' claimed *The Portfolio*; '[we are] compelled to wonder how they could have obtained admission into a gallery with such honourable traditions as the Grosvenor . . . The worst of them are outrages on the cardinal laws of art and are not redeemed by any intrinsic merit' spluttered *The Athenaeum*. *The Spectator* adopted a much more positive view:

What are the characteristics of this school? for the element of 'school' is clear from a glance at the walls. There is a stamp of common inspiration about the work of Messrs Guthrie, Roche, Lavery, Melville and Hornel. We might attempt to label it under those French names that suggest themselves as obvious prototypes. But there is stuff and original power in the work to make it more than derivative. Its general character is that while handling the resources of modern technique, it uses them to a distinctly decorative purpose. The real is there but the artists are not satisfied with the subjection of the subject to the nature of paint, where the modern artist often sets up his rest; they compel the thing as well to a tapestry.[2]

The critics were not able to make up their minds about some of the works, however. Not all of them were new. Guthrie showed *Pastoral* and *In the Orchard* and Lavery sent *Dawn after the Battle of Langside: 14 May 1568* all of which were well known in Scotland but had not been seen in the south. The paintings which received most attention, however, usually in the form of abuse, were those by Melville, Henry and Hornel. Melville's *Audrey and her Goats* had been started at Cockburnspath but the artist had returned to it in 1889. It had been sent to the Royal Academy but was rejected and so was included in the Grosvenor show as a last-minute addition. Henry and Hornel sent their joint work *The Druids* and Hornel also showed *Among the Wild Hyacinths* (untraced). After expressing some enthusiasm for *The Druids* the critic of *The Saturday Review* turned his attention to Hornel and Melville:

In Mr Hornel's *Among the Wild Hyacinths* all is sacrificed to colour; a green girl and a blue girl stand in a green glade, with a purple carpet of bluebells at their feet and a vista of rosy cloud behind them. This is extravagant, but essentially right and artistic. Less can be said in favour of *Audrey and her Goats* by Mr Melville. This picture is needlessly huge, for the subject is very slight. Audrey's red head is relieved against a background of red foliage of the beech, regardless of the fact that she and her goats stand in a meadow of the freshest emerald grass of early May. That the goats have only one leg each is really unimportant, but that in the leafy world spring should thus lose itself in coppery autumn is a blunder. Another eccentric, and perhaps it will be whispered impudent, production of Mr Melville's is a watercolour drawing, *The Javanese Dancers*, a brilliant 'impression' of whirling angular figures in loose crimson garments. We are not sure about Mr Melville. He is, as the old women say of precocious children, 'too clever to live', and we are afraid he knows it.[3]

Similar views were expressed by Armstrong in *The Magazine of Art* (see also pp.246–8):

Mr Arthur Melville's *Audrey and her Goats*, on the other hand, is neither decorative nor expressively true. Its general arrangement and constitution suggest that it was meant to be an ordinary *paysage étoffe*, but all that is contradicted by the colour. Strong reds, crude greens, a blue like the bunting of the blue ensign, are combined in arbitrary quantities and declare that, for their part, they are helping in a decoration. Clever as it is, this *Audrey* is out of place in a picture gallery. It should be hung in a room submissively arranged to suit it. Mr Melville's second number, a study from the Javanese dancers at the Paris exhibition, is singularly truthful in the impression it makes.[4]

The general impression was that the Scots had carried themselves well and this, confirmed by the events of the next two or three months, was to do more for their standing in Glasgow than any of the achievements of 1888. Press comment on the 1890 Institute had not been all congratulatory, especially towards Hornel and Henry, but the Boys' reception in London did much to outweigh that and their invitation to exhibit as a group in Munich in the late summer of 1890 swung the balance of public opinion in their favour. This was reflected in the growing number of portrait commissions offered them after 1890; in the subtle change in the attitude of such magazines as *Quiz* and *The Bailie*, which became less sarcastic and shallow in their comments and began to pay more attention to the Boys' achievements rather than ridiculing their latest works. Their gradual absorption into the Royal Scottish Academy would doubtless have influenced public opinion in their base in the west of Scotland, but the invitations to join the Academy were themselves hastened by the Boys' continuing success in London and abroad. After they left the New English Art Club in 1892 they found other venues to show their work. Indeed, they were much in demand in London and just as they appeared at the last exhibition at the Grosvenor in 1890 they received invitations to show in the inaugural exhibition at one of its more influential successors, the Grafton Gallery, in 1893. In the latter years of the decade they also took their place on the council of a new artistic body, the International Society, which had as its President the Boys' idol, Whistler. Lavery, Guthrie, Walton and Crawhall served alongside him in its early years; but it was in a different international context that they ratified their standing as artists and gained the approval which was to cement their position in artistic life in Glasgow and Scotland.

The first important phase of this international success – in Europe – stemmed from the Grosvenor Gallery exhibition in 1890. It was visited by Adolphus Paulus, who was responsible for the foreign section of the Munich Art Society exhibition. He was immediately impressed by the Scottish exhibits at the Grosvenor Gallery and visited Glasgow to make arrangements to show as many as possible of the Grosvenor paintings, or new ones, in the forthcoming exhibition in the Glaspalast in Munich. Seventeen of the Boys showed in Munich that year, and several of their most important works were among the sixty paintings and drawings exhibited.[5] Both the *plein-air* phase of their work, as typified by Lavery's *A Tennis Party*, *The Bridge at Grez* and Guthrie's *Field Work in the Lothians*, and the more highly coloured and symbolist work of Henry, Hornel, Melville and Gauld were included in the exhibition. The German painters would have known the sources of the *plein-air* paintings, as the Barbizon and Hague Schools and Bastien-Lepage were well known across Europe by 1890. The Glasgow men's adoption of a more colourful palette, even in the earlier work of Guthrie, made a considerable impression on them, however, and the impact of *The Druids*, *Audrey and her Goats* and Guthrie's pastels was unprecedented.

It was the depth of colour, not just its brightness, which so impressed the more progressive Munich painters. They knew Bastien-Lepage's work well, as he was idolised by young painters all over Europe, but for many his 'bright painting' – high tone and suppression of strong hue – rang a false note. The Boys' paintings showed them how this could be overcome, how the painting of detail in a naturalistic manner need not be done at the expense of colour. The Germans also recognised that the colours which the Boys used were deep and full in tone, applied in a harmony which emphasised their origins in nature. German painting was said to change overnight after their appearance in Munich and the Boys were to play a considerable part in the decision of the leading younger painters in Munich to secede from the Art Society in 1893 and form their own exhibiting society, the Munich Secession. Paulus became its Secretary and the Boys transferred their allegiance from the old Society to the Secession. Glasgow paintings continued to be seen in Munich throughout the 1890s and the Boys were also to be invited to Berlin and, from 1897, to the Vienna Secession, which undoubtedly became the most avant garde of these new societies which sprang up outside France in the 1890s.

Paulus made repeated visits to Glasgow and more and more painters were invited to Munich. The Gluepots were not excluded; it seems that, until the formation of the Secession, anything Glaswegian, or Scottish, in origin was held to have an automatic mark of approval. By 1894, however, the sheep and the goats had separated and the Boys were almost all included in the Secession exhibition while the more prosaic Scots painters showed at the Glaspalast. While Guthrie, Lavery and Walton were acclaimed by the younger painters, David Murray reigned supreme among the more conventional members of the Art Society. History seemed all set to repeat itself, with the Boys seemingly toppled off the pinnacle of public acceptance for which they had always striven. In Germany, however, it was generally recognised that the Secessions represented the more serious aspects of modern painting and reflected its advances across Europe. This

is confirmed in a wide-ranging history of the modern movement in painting which, alone among such contemporary accounts, gave due credit to the Boys' achievements:

The powerful effect which was made when the Scotch gallery was opened in the summer of 1890 at the annual exhibition in Munich is remembered still. All the world then was under the spell of Manet, and recognised the highest aim of art in faithful and objective reproduction of an impression of Nature. But here there burst out a style of painting which took its origin altogether from decorative harmony, and the rhythm of forms and masses of colour. Some there were who rendered audacious and sonorous fantasies of colour, whilst others interpreted the poetic dreams of a wild world of legend that they had conjured up. But it was all the expression of a powerfully excited mood of feeling through the medium of hues, a mood such as the lyric poet reveals by the rhythmical dance of words, or the musician by tones. None of them followed Bastien-Lepage in the sharpness of his 'bright painting'. The chords of colour which they struck were full, swelling, deep and rotund, like the sound of an organ surging through a church at the close of a service. They cared most to seek Nature in the hours when distinct forms vanish out of sight, and the landscape becomes a vision of colour, above all in the hours when the clouds, crimson with the sunken sun, cast a purple veil over everything, softening all contrasts and awakening reveries.[6]

The practical results of this enthusiastic reception – apart from a strengthening of their position at home in Scotland – was the award of medals and other honours and the official purchase of several of the Boys' paintings. Lavery's *A Tennis Party* was acquired by the Pinakothek in Munich in 1890 and the museums in Leipzig, Weimar and Stuttgart were to acquire paintings by Paterson and Macaulay Stevenson from subsequent German exhibitions. Dresden, Berlin, Vienna, Barcelona, Budapest, Venice, Bruges and Brussels were all to become hosts to Scottish painting over the next ten years, led by a strong group of paintings from the Boys. In 1897 Diaghilev organised an exhibition in St Petersburg of drawings and watercolours from the Boys which proved immensely popular. In Belgium, the museum at Ghent bought Guthrie's *Schoolmates* and other Glasgow paintings found their way into the permanent collections in Barcelona and Venice.

While France followed Glasgow's example by acquiring Whistler's portrait of his mother for the Luxembourg Museum in Paris, none of the Boys' paintings followed it into other French public collections. The Boys were by no means ignored in Paris, however, as several of them won medals or *Mentions Honorables* at the Salons. Guthrie and Lavery were made members of the Société Nationale des Beaux-Arts; Lavery won a gold medal for *A Tennis Party* in 1888; Guthrie followed in 1889 with a *Mention Honorable* for *In the Orchard* and his portrait of Dr Gardiner received a third-class Medal in 1891; Paterson and Roche in 1890 and 1892, respectively; and Walton finally in 1892. The success, or at least the recognition, that had avoided them in Scotland now came in what many of them considered the natural home of modern painting – Paris. It brought with it grudging praise at home but gradually, coupled with the award of Associateships from the Royal Scottish Academy, the Boys achieved acceptance and commendation in their home city. In some ways, however, it was to be a hollow victory for their success abroad and in London conditioned them to expect more

than Glasgow could offer and their growing ambition caused many of them to leave the city for good. Before this final decision was to be made, however, there was one more distant country to be won.

At an exhibition of the Boys' work in Barcelona in 1894 a visiting curator from the United States decided that he had to include some Glasgow paintings in the next St Louis Exposition, of which he was Director of the Art Department. Unfortunately for Mr Kurtz it was too late to arrange for the pictures to be included in the 1894 Exposition but in the following year he returned to Europe and visited Glasgow to select paintings for the new show. He chose 125 paintings which were also exhibited in Chicago at the Art Institute, at the Cincinnati Art Museum and in a gallery in New York. The response was as it had been in Germany, with many of the works being sold and the exhibition a popular and critical success. Throughout the 1890s the Boys returned to exhibit in the United States, beginning at the Pittsburgh International Exhibition in 1896. They received several awards and over thirty pictures were acquired for museum collections, including Lavery's *A Passing Salute – the Bridge at Grez*. (Unfortunately, this and other similar works acquired at this time were sold or 'de-accessioned' when such paintings fell out of fashion, some as recently as the 1950s.) Lavery became a Jury member for the 1898 exhibition, the year that Roche won a $1000 prize and Walton an Honourable Mention.

With such experience under their belts the Boys could no longer be ignored by either the public or the artistic establishment of Scotland. In Glasgow they were welcomed to the fold but for many of the painters it was to be a gesture which arrived too late. The events which had driven painters such as Wilkie, Pettie and Orchardson out of Scotland to London seemed to be about to repeat themselves. Being slow to award recognition to talented local painters the Scots had only themselves to blame when these same young artists moved south to an environment where their talents were recognised and appreciated. Then they were hailed by the Scottish public as 'exiles' who had made good in a hostile environment, demonstrating the tenacity and innate qualities of all Scottish painters, poets, writers, musicians or whatever. It was a story to be repeated time and time again in many walks of life, to be seen at its worst in the treatment meted out to Charles Rennie Mackintosh who never saw the acclaim he deserved in his native country despite great international success throughout Europe. The Boys were luckier than most in that it was principally ambition that led most of them to leave Glasgow as the recognition that they achieved abroad from 1890 was reflected in a change of public attitude towards them in Glasgow. Following their European successes, the public and collectors in Glasgow and the rest of Scotland found it difficult to maintain an attitude of hostility, or at best indifference, to the Boys. Led by the critics they were fêted and awarded some of the commissions they sought but the welcome came too late or was not strong enough to hold the Boys' attention. Fifteen years earlier they had set out to make Scottish collectors and exhibition-goers see that there was an honest alternative to the Gluepot pictures which formed the majority of Scottish painting. They had hoped to create an atmosphere of tolerance and a commercial market for their work and had they succeeded in 1885 they might not have been quite so

easily tempted to leave Scotland for pastures new. In 1895, however, success came too late and it came in the wrong place first. By exhibiting in England and abroad, and successfully selling their pictures abroad too, the Boys came to realise that Glasgow and Scotland could never sustain a similar level of financial or critical success. To satisfy their new ambition most of them were forced to follow the well-worn path of previous Scots artists and take the road to London.

EPILOGUE

The Glasgow Boys were not revolutionaries. They were not politically motivated and their brand of realism cannot be linked directly to that of Courbet in France, whose work set out to challenge not only artistic conventions but social attitudes as well. The Boys did not wish to supplant the more academic styles of older artists with their own particular form of painting, nor did they even see their work as an overtly radical alternative to the pictures of their more established contemporaries. What they wanted was acceptance of their right to paint as they wished and to take their due place in the Academies and Institutes on the merits of their work. In accepting the style of Bastien-Lepage the more adventurous among them were emulating many of their French and English contemporaries who also saw in the young master's painting a novel, yet in many ways traditional, path which could lead to public respectability and which was at the same time tinged with modernity of outlook and technique.

Bastien-Lepage's naturalism – a particular blend of objectivity and acceptable sentiment – appealed to many young painters who had received a French *atelier* training as it retained the traditional accent on tonal values and technical proficiency and combined it with a new approach to composition and subject-matter. Despite the loud condemnation of Bastien-Lepage's work both in France and Britain by the ultra-conservative Academicians (who felt threatened by the swiftly achieved public success of this young man), his painting was by no means as divorced from theirs as was the work of the Impressionists led by Monet, Renoir and Pissarro. Bastien-Lepage's public acclaim at such a young age also appealed to the younger painters at the beginning of the 1880s for it made him a much more tangible idol than those other heroes of the Barbizon School who were also very important to the young Scots painters, more so than to their English contemporaries, but who were now venerable figures and possibly out of touch with the aims of the younger generation. Bastien-Lepage's painting challenged current academic thinking both in Scotland and England but it was not such an affront to it that it might forever bar his followers from public acceptance. Indeed, the public took an earlier attraction to the new style than did the critics or the artistic establishment and it was this public acceptance of the new painting which was to prompt academic recognition of its younger practitioners.

In England the Boys' only real kindred spirits were George Clausen, Stanhope Forbes and H. H. la Thangue. Other painters adopted the naturalist manner, particularly those members of the so-called Newlyn School, but rarely took on board the more detached and objective manner which the Boys and Clausen espoused so wholeheartedly in the mid-1880s. Both English and Scots naturalists had to fight against the derision of their respective Royal Academies. In England they achieved this by spurning the Academy and establishing new exhibiting societies or showing at less restrictive venues – respectively, the New English Art

Club and the Grosvenor Gallery. The New English and other societies such as the International were concerned that artists should have the right to have their work publicly exhibited. In many ways a number of members of the New English did not object so much to the style of painting which appeared on the Academy's walls as to the censorious policy which the Academy operated. This prevented paintings which did not conform to its own restricted views on modern painting from being hung on its walls. That painters such as Clausen, Guthrie and Lavery did not object to Academies *per se* is perhaps shown in their ready acceptance of those bodies' invitations to join the ranks (although in Scotland this followed a definite change of official policy). The appeal of the New English, the Grosvenor and the Grafton Galleries is that they were prepared to recognise such differences of artistic opinion as might exist without making too harsh a value judgement upon the merits of any particular style.

So in many ways the Scottish situation mirrored that in England. In one crucial difference, however, the way was prepared for a more concerted attack upon the bastions of artistic privilege which was missing in England. The particular arrogance of the Royal Scottish Academy in excluding from its membership any painters who were not resident in the capital, or at least along the east coast, was a spur to the young Glaswegian painters which was absent from the confrontation south of the border. The Boys were ambitious. To achieve their ambitions they realised that formal recognition by the Royal Scottish Academy was necessary, but that recognition was not forthcoming. It was withheld not simply because of a disapproval of the Boys' work but also because that work emanated from beyond the confines of the capital city, inside which there was apparently some magical property which immediately conferred artistic and social respectability. Like many Glasgow painters before them, the Boys had no wish to settle in Edinburgh and objected to the automatic dismissal of their talents which an accident of birth and residence placed upon them.

It was not just to Glasgow which such exclusions applied but it hit hardest against the Glaswegians for there were many more of them, Edinburgh being only a quarter of the size of the city in the west, yet it was able to exert such an unfair discrimination. Other ambitious painters by-passed Edinburgh and moved straight to London but at the end of the nineteenth century the Boys crystallised a strength of feeling against the Academy, coupled with a resistance to being forced to leave their native soil, and their common cause drew them closer together. This was reflected not only in their painting, although a single homogeneous style was never attempted and never achieved, but also in their efforts to establish something more than a loose association of painters in the 'second' city – not that great city of the Empire but that 'second-class' centre of artistic achievement. Their 'secret society' was doubtless something of a rejection among themselves of both Glasgow's Institute and Edinburgh's Academy. *The Scottish Art Review* was no doubt intended to exhibit their intellectual aspirations, not a quality for which the members of the Academy were well regarded. The Boys' sending of work to London and Paris, and its ready acceptance there, was seen by them as a public rejection of the official Scottish attitudes to their work.

In many ways, however, all of these achievements can be seen as the Boys putting on a brave face at the shabby treatment of them and their work by their fellow Scots. There was nothing they wanted more than the acceptance of the principle of their right to work as they pleased and to have equal opportunity to display that work in the recognised shop-windows of the Scottish art world. Closely following this ambition was another – that their work should be successful and create for them the kind of wealth, or at least a degree of comfort, that was available to other professions. Artistic respectability and financial success in Scotland, they felt, need not be synonymous with the second-rate, unimaginative and hackneyed work to be seen year after year in the Institute and the Royal Scottish Academy.

After 1888, when Guthrie was admitted to the Academy as an Associate, the Boys were able to watch the barriers that they had hammered against for so long slowly crumble from the forceful validity of their cause. Sadly, as those barriers were gradually withdrawn the Boys slowly changed. They became inextricably bound by the penalties of their own success. The public acclaim in London, the Continent and the United States which had hastened their admission to the Academy without a change of residence also brought home to them the fact that Scotland, let alone Glasgow, could not hope to support such a prolific and active group of young painters. The financial success which followed critical acclaim outside their birthplace could be sustained only by their leaving Scotland and moving to London. Walton left in 1893, followed by Guthrie, Lavery and Henry. Without the lead offered by these four the impetus of the group quickly decayed and, painting more as individuals than as a group, the work of most of the Boys became less clearly distinguishable from that of the Gluepots whom, as young men two decades earlier, they had so wholeheartedly despised.

For Walton and Lavery the change in their work was gradual. Both of them became close associates of Whistler – Walton lived alongside him in Cheyne Walk for a while – and Guthrie joined their ranks when he followed them to London. All of them took more and more to the practice of portrait painting, although both Lavery and Walton continued to paint figure and landscape pictures which were not commissions and which were produced as much for their own enjoyment as for speculative purposes. Henry joined them in London towards the end of the decade, again to take up the mantle of portraitist. In Scotland, Paterson reversed the southerly drift by leaving Moniaive for Edinburgh. Ever a realist, in matters of life as well as art, Paterson's growing family and the failing health of his wife called for a greater security of income than life outside the main artistic centre of Scotland could guarantee him. Eventually Walton and Guthrie were to join him in Edinburgh but his great friend from the 1880s, W. Y. Macgregor, was to remain in Bridge of Allan where he had settled on his return from South Africa at the beginning of the 1890s. Hornel was to make Kirkcudbright his particular artistic fastness, emerging to visit the Far East – Japan and Burma – rather than the metropolises of Edinburgh, Glasgow or London. He turned down an Associateship from the Royal Scottish Academy in 1901 on the, not unjustifiable, grounds that when he needed the Academy it did not need him – their roles were now reversed and he saw no need to accept unwelcome honours.

Nairn was not to return from New Zealand and Crawhall was an infrequent visitor to Scotland after 1890. Tangier and Yorkshire held more attraction for him and he assumed a role more suited to the local gentry in Yorkshire than that of bohemian artist. His work hardly faltered, however, and he continued to produce exquisite watercolour paintings of birds and animals, probably because of, rather than despite, his apparent seclusion. Kennedy moved south to Berkshire and later to Tangier, accepting Lavery's offer of his house there during a particularly debilitating illness. Like Lavery, Crawhall and Melville before him he became captivated by North Africa and settled there with his wife until his death in 1918. Melville died too young – like Alexander Mann – of typhoid, while still in the full spate of creativity. He and Crawhall never compromised their youthful promise or ambitions, achieving critical and financial success but not allowing it to deflect their objectives.

The qualities of leadership which Guthrie had exhibited in the 1880s in Glasgow, settling quarrels and arbitrating between disputatious colleagues, was to be put to surprising use in the new century. His stay in London was shortlived and his return to Scotland was marked by a more rapid acceptance of academic values in the ever-increasing numbers of portraits that he was called upon to produce. More by accident than design, he was to become President of the Royal Scottish Academy in 1902, following the unexpected retiral of Sir George Reid. Coming only ten years after his election to full membership of the Academy, his elevation to the Presidency marked not only the success of the Boys in achieving their aim of respectability and public acceptance; it also confirmed that their days of experimentation and ready acceptance of new ideas were well and truly a thing of the past. Guthrie was to have little sympathy for some of the new ideas emanating from France, particularly the work of Matisse and the Fauves, and although the Academy was well and fairly run during his Presidency it was not marked for its notable change of attitude towards the young and questioning generation of painters who came to take the Boys' place. That this new generation of painters were not faced with an obstructive profession and an unsympathetic public is one of the Boys' greatest achievements; after the pleasure of their paintings themselves it was, perhaps, their most important legacy to the visual arts in Scotland.

They had shown that the young need not accept the status quo as it was presented to them. The Boys had fought for private and official approval of their work and, above all, for the right to produce the kinds of pictures which pleased them and the right to have them publicly assessed on their merits, rather than on the personal merits or otherwise of their creators. They had made the profession of artist respectable in Scotland, in more ways than one. They had shown that a young man need not give up his principles in order to achieve a living as a painter in Scotland; and they had forced the Scottish artistic establishment, and the picture-buying public, to recognise that talent could arise from unexpected places. Admittedly, should an artist want, or expect, too much from Scotland, either in financial or social terms, then he would still have to turn to London. The old Scots adage 'I ken't his faither' would continue to dog coming generations of painters, architects, composers or whatever in Scotland and the only way to

escape its tyranny was to leave. Would Lavery ever have been considered a possible Viceroy of Ireland had he stayed in Scotland? I somehow doubt it. Would he have been a better painter had he not been attracted by the prizes which London had to offer? In his case, I doubt that too. But the example which Lavery, Guthrie, Paterson, Walton, Melville, Henry and Hornel gave to the next generation of Scots painters was that one could succeed without necessarily deserting one's homeland or selling out to the Gluepots. For the Boys had achieved their greatest artistic successes by 1895 without doing either of these things. Had they not achieved these aims then the course of Scottish painting might have gone a different way.

In the late 1890s a group of four young men were so impressed with the Boys' achievements that they too took up the profession of painting, often against their families' wishes. For J. D. Fergusson, S. J. Peploe, Leslie Hunter and F. C. B. Cadell, the Boys presented a tangible and accessible image of artistic integrity and public success. All of them studied in France, which the Boys had made an almost normal occurrence for young Scots painters. All of them looked at what was happening in the Paris *ateliers* and made up their own mind as to what they should take and what they should leave behind of the maelstrom of artistic styles and theories with which Paris was inundated in the years before the outbreak of war in 1914. That these four young men, later to be called the Scottish Colourists, should choose the path of light and colour is due almost entirely to the impact of the paintings of Henry, Hornel, Melville and Guthrie of the 1880s. The Boys' handling of paint and colour established a tradition in Scotland, particularly in Glasgow and the west, which survives still and which continues to distinguish the work of the Glasgow-trained painter from that of his colleagues from the east. The Boys liberated Scottish painting a century ago and their influence lingers still.

It was to Glasgow that the Boys owed their greatest debt; and it was Glasgow which received the ultimate benefit of their pioneering stance. The vitality of the great Victorian city, its self-assured ebullience in matters of business and industry had enormous effect upon these young painters. They drew from the city the energy and resolve to continue until their battle for recognition was won. In return, they gave to the city an international reputation for the excellence of its artistic endeavours and should Fra Newbery's belief ever come to pass – that Glasgow would one day stand alongside Venice and Bruges in a cultural history of the world – there is no doubt that the Boys' role in its achievement would be placed in the first rank.

NOTES

1 THE SECOND CITY

1. David Martin, *The Glasgow School of Painting*, London, 1897; with an Introduction by Francis H. Newbery.

2. The artists listed by Martin, *op. cit.*, are:

Sir David Young Cameron RSA RA RSW RWS LLD 1865–1945
James Elder Christie 1847–1914
Joseph Crawhall Jr RSW 1861–1913
Thomas Millie Dow RSW 1848–1919
David Gauld RSA 1865–1936
Sir James Guthrie PRSA HRA RSW LLD 1859–1930
James Whitelaw Hamilton RSA RSW 1860–1932
George Henry RSA RA RSW 1858–1943
Edward Atkinson Hornel 1864–1933
William Kennedy 1859–1918
Sir John Lavery RSA RA RHA LLD 1856–1941
William York Macgregor RSA RSW 1855–1923
Harrington Mann 1864–1937
Thomas Corsan Morton 1859–1928
Stuart Park 1862–1933
James Paterson RSA PRSW RWS 1854–1932
Sir George Pirie PRSA HRSW 1864–1946
Alexander Roche RSA 1861–1921
Robert Macaulay Stevenson RSW 1854–1952
Grosvenor Thomas RSW 1856–1923
Edward Arthur Walton RSA PRSW HRWS 1860–1922

Martin omits Arthur Melville ARSA RSW RWS 1855–1904 (presumably because of his Edinburgh links) and James Pittendrigh Macgillivray RSA LLD 1856–1938 (a sculptor closely associated with the activities of the group in Glasgow in the 1880s). Not all of those named above played a major role in the development of the group's style: Christie was resident in London for most of the 1880s and was associated with the Boys when they showed in London because of his Scottish origins; Grosvenor Thomas, Whitelaw Hamilton and Harrington Mann, although more closely in touch with events in Glasgow, were never among the vanguard; Cameron and Pirie were younger than the other artists and came to join them only in the 1890s, as the group was dispersing.

Other painters more properly associated with the group are:

Thomas Austen Brown ARSA 1859–1924
Alexander Mann 1853–1908
John Reid Murray 1861–1906
James McLachlan Nairn 1859–1904
Harry Spence 1860–1928

3. *The Bailie*, 17 November 1880. An extract from the weekly column detailing the latest gossip from the studios of Glasgow's artistic community which appeared above the signature 'Megilp'. The identity of the writer(s) is not known but there was probably more than one columnist involved as the tone of the articles swings unpredictably for and against the younger painters who were just being noticed in Glasgow. The use of the term 'school' refers not to the subjects of this study but to the generality of painters working in the city.

4. Elizabeth Bird, 'International Glasgow', *Connoisseur*, August 1973, pp.248–57; see pp.250–2.

5. *Ibid*.

6. Letter from R. Macaulay Stevenson to Dr T. J. Honeyman, 9 January 1941, quoted in J. Reid, T. J. Honeyman *et al.*, *The Glasgow Art Club 1867–1967*, Glasgow, 1967.

2 NEW FRIENDSHIPS

1. J. M. Reid et al, *The Glasgow Art Club 1867–1967*, Glasgow, 1967, p.12.

2. James L. Caw, *Scottish Painting Past and Present 1620–1908*, London, 1908, p.380.

3. G. Baldwin Brown, *The Glasgow School of Painters*, Glasgow, 1908.

4. James Paterson, *William York Macgregor and the Glasgow School*, a manuscript history of Macgregor's involvement with the Boys, including transcripts of several letters from Macgregor to Paterson. Coll: the Paterson family.

5. James L. Caw, *Sir James Guthrie: a biography*, London, 1932, pp.4–5.

6. *Ibid*. p.8.

7. Adrian Bury, *Joseph Crawhall: the Man and the Artist*, London, 1958, p.41 *et seq.*; Crawhall's early schooling consisted of: Dame Emslie's School, Newcastle, 1869–73; Dr Wood's Preparatory School, Harrogate, 1873–7; King's College School, London, 1877–9.

8. Caw, *Guthrie*, p.8.

9. John Lavery, *The Life of a Painter*, London, 1940, p.57; Lavery recalls how he met Bastien-Lepage for the first and only time and his advice was: 'Always carry a sketch-book. Select a person – watch him –

then put down as much as you can remember. Never look twice. At first you will remember very little, but continue and you will soon get complete action.' This was not particularly original advice and had been very much a tenet of the Impressionists and Lecocq de Boisbaudran who had run a school for young painters in Paris as an alternative to the Ecole des Beaux-Arts.

10. Caw, *Guthrie*, p.8; Bury, *op. cit.*, p.45.

11. Bury, *op. cit.*, p.45.

12. Scottish Arts Council, *The Glasgow Boys*, vol I, 1968, p.30; Cordelia Oliver quotes Glasgow School of Art records which show that Henry attended classes during the summer term in 1882, giving his occupation as 'clerk'; the following summer he again attended similar classes but called himself 'art student'.

13. A number of letters from Henry to Hornel, covering the period c.1885–97 are in the collection of the Hornel Trustees, Broughton House, Kirkcudbright.

14. Robert Louis Stevenson, R. A. M. Stevenson, William Stott of Oldham, Frank O'Meara and Frederick Delius, in addition to the Scottish painters, all stayed in the village in the 1870s and 1880s. See R. L. Stevenson, 'Fontainebleau: Village Communities of Painters – IV', *Magazine of Art*, vol II, 1884, p.345; and K. McConkey, 'From Grez to Glasgow: French Naturalist Influence in Scottish Painting', *Scottish Art Review*, vol XV no 4, 1982, pp.16–34.

15. Arthur Melville had also visited Grez as early as 1878. He returned there in 1879, spending most of the year in the village, and probably also in 1880. See Agnes Mackay, *Arthur Melville: Scottish Impressionist*, Leigh-on-Sea, 1951, pp.22–5.

16. A colourful account of his early life is given by Lavery in his autobiography, *The Life of a Painter*, *op. cit.*

17. Lavery, *op. cit.*, p.42.

18. Letters from Henry to Hornel show that Henry at least, and probably Hornel, made extensive use of photographs in the 1880s and 1890s (coll: Hornel Trustees). Substantial numbers of photographs used by Hornel in his later paintings (post-1900) survive at Broughton House (Hornel Trustees).

19. *The Bailie*, 23 and 30 November 1881, 'Lavery intends to go to Paris'; 11 January 1882, 'Lavery and Roche are in Paris'; *Quiz*, 25 November 1881, 'Lavery is off to Paris'.

20. *The Bailie*, 30 March 1881; Millie Dow was a later pupil of Gérôme.

21. Scottish Arts Council, *The Glasgow Boys*, 1968, vol I, pp.42–3.

22. In 1882 Kennedy showed *In the Forest of Fontainebleau* at Paisley Art Institute, followed by *La Rue de Barbizon – Clair de Lune* in 1883.

23. Walter Shaw Sparrow, *John Lavery and his Work*, London, 1911, p.40.

24. Much of the information about Dow's early life was provided by Norman Garstin in an article, 'The Work of T. Millie Dow', *Studio*, vol X, 1897, pp.144–52.

25. *Ibid*. See also Ross Anderson, *Abbott Handerson Thayer*, 1982, a catalogue of an exhibition for the Everson Museum, Syracuse, New York, pp.129, 130, 132. Thayer also visited Dow in St Ives in 1893 and 1898. I am grateful to Mrs Una Rota for drawing this catalogue to my attention.

26. Caw, *Scottish Painting*, p.408.

27. The most extensive information concerning Mann's career can be found in the catalogue of the exhibition of his work held by The Fine Art Society in 1983; introduction by Christopher Newall.

28. *The Bailie*, 1 June 1881.

29. *Ibid.*, 14 October 1882.

30. Letter from James Guthrie to *Glasgow Herald*, 19 March 1886. Other letters in support of Mann followed on subsequent days. Caw, p.384, mistakenly dates the showing of the painting in Paris as 1884 but it was, in fact, exhibited in 1885 (no 1655).

31. 'Nairn is off to New Zealand – but plans to return', *The Bailie*, 11 September 1889.

32. The Pallett Club, formed by 'prominent' members of the Black and White Club and the St Mungo Society, held a 'conversazione' at 101 St Vincent Street, Glasgow, and its exhibition in 1882 included five works by Henry and Nairn, *The Bailie*, 20 December 1882.

33. No 60, *Old Barracks, Eyemouth*; 65 *Clearing Stakenets, Eyemouth*; 92 *Old Joiner's Shop, Bearsden* (catalogue of the 1883 Glasgow Art Club Exhibition, coll: Mitchell Library, Glasgow).

34. Roche, Hornel, Nairn and MacGregor Wilson made wall-paintings for the gable ends of the Sculpture, Photographic and Architectural Galleries of the 1888 Glasgow International Exhibition, *Quiz*, 20 April 1888. I have not been able to trace any illustrations of these paintings.

35. *Ibid.*, 5 July 1889.

36. *Ibid.*, 27 September 1889.

37. The most extensive source of information on Melville is Agnes Mackay's monograph *Arthur Melville: Scottish Impressionist*, Leigh-on-Sea, 1951. See also the exhibition catalogue *Arthur Melville*,

Dundee Art Gallery and The Fine Art Society, 1978; introduction by Gerald Deslandes.

38. Stevenson on Grez: 'My Dear Mother, – I have been three days at a place called Grez, a pretty and very melancholy village on the plains. A low bridge, with many arches choked with sedge; green fields of white and yellow water-lilies; poplars and willows innumerable; and about it all such an atmosphere of sadness and slackness, one could do nothing but get into the boat and out of it again, and yawn for bedtime.... I was very glad to be back again in this dear place [Barbizon] and smell the wet forest in the morning.' Quoted by Graham Balfour, *Life of Robert Louis Stevenson*, London, 1901, vol I, p.132.

3 GLUEPOTS AND TEASELS

1. Quoted by A. S. Hartrick in *A Painter's Pilgrimage Through Fifty Years*, Cambridge, 1939, p.54.

2. An excellent account of the development of nineteenth-century landscape painting in Scotland is given by James Holloway and Lindsay Errington in *The Discovery of Scotland*, National Gallery of Scotland, Edinburgh, 1978.

3. 'How I Became An ARSA: A Chapter of Auto-biography', *The Scottish Art Review*, November 1889, pp.163–6.

4. *The Glasgow Art Club Book 1885*, Glasgow, 1885, pl.35, *The Broken Doll*.

5. Scottish Arts Council, *The Glasgow Boys*, vol II, pp.11–12.

6. *Ibid.*, quoted by W. Buchanan, p.11.

7. Jean-François Millet (1814–75); Pierre Edouard Frère (1819–86); Leon L'Hermitte (1844–1925); Julien Dupré (1851–1910); Jules Breton (1827–1906); Josef Israels (1824–1911); Jacob Maris (1837–99); Matthew Maris (1839–1917); William Maris (1844–1910).

8. Walter Sickert spoke for many critics and painters alike when he wrote: '[Bastien] was a painter of exhibition pictures, of what are called in Paris *machins*. He was an inveterate *Salonnier*, with the ideals and the limitations of the typical uncultured Paris art-student, the *fort* of his *atelier*', in his article 'Modern Realism in Painting' in André Theuriet, *Jules Bastien-Lepage and his Art: a memoir*, London, 1892.

9. Quoted in André Theuriet, *Jules Bastien-Lepage and his Art: a memoir*, London, 1892, pp.73–4.

10. George Clausen, 'Bastien-Lepage and Modern Realism', *The Scottish Art Review*, October 1888, pp.114–15.

11. Walter Shaw Sparrow, in his *John Lavery and his Work*, p.41, records how Stott of Oldham, Lavery, Dow *et al.* met in Paris where 'ardour and tobacco were burned freely before the shrines of Puvis de Chavannes and Jules Bastien-Lepage. Between these extremes the talk went to and fro on some evenings, but, as a rule, the favourite topics were Bastien-Lepage and *plein air*.'

12. In 1887 Stott exhibited *Venus Born of the Sea*, where the model was Whistler's mistress Maud Franklin. Whistler disapproved and his friendship with Stott was terminated.

13. James Paterson, MS notes, Coll: Paterson family.

4 EN PLEIN AIR

1. *A Strayed Covenanter*, 1881 (236); *The Commentary*, 1881 (358); *An Attentive Hearer*, 1883 (416). The sending-in day for Glasgow Institute exhibitions in the 1880s was in early January and it can be assumed that all Institute exhibits were painted in the year previous, at least, to that of exhibition. Paintings first shown at the Royal Academy and the Royal Scottish Academy, where the sending-in days were in early spring, could have been painted, or at least finished, in the year of exhibition.

2. *The Bailie*, 18 May 1881.

3. *Ibid.*, 6 June 1881.

4. *Ibid.*, 1 June 1881.

5. *Ibid.*, 14 October 1882. Both painters returned to Glasgow early in November (*ibid.*, 8 November 1882).

6. *Ibid.*, 30 August 1882.

7. *Ibid.*, 14 October 1882.

8. Caw, *Guthrie*, includes a list of all work by Guthrie known to Caw (with the exception of pencil drawings and similar material). This list was based upon notes made by the artist shortly before he died, supplemented by evidence from exhibition catalogues etc. Although it is not complete it remains the best published source for information on his work and makes Guthrie the best-documented of all the Glasgow Boys.

9. Caw, *op. cit.*, pp.8, 211, records that it was shown in Newcastle in 1881 where it was purchased – perhaps by a friend of the elder Crawhall. Guthrie repurchased it many years later and it was in his collection at his death. Unfortunately, the majority of the forty or so pictures recorded by Caw as bequeathed by Guthrie to his son, T. W. B. Guthrie, are now lost, this painting among them.

10. *The Bailie*, 27 April 1881: 'Jas Guthrie of London and Duncan McLaurin [a leading Gluepot] are . . . at present located in Helensburgh, the latter of whom, however, has not yet left his studio for out-of-doors painting.'

11. This is presumably the type of painting to which *Quiz* was referring in its comment: 'E. A. Walton has made considerable progress. His work is honest in aim, and he is not without the landscape sentiment. He seems fond of snow and yellowish-green herbage; he might do worse than put a little more "greenery" in his "yallery".'

12. Guthrie showed four works at the Institute in 1882, the first time he had shown at the annual Spring Exhibition: *The Cottar's Garden*, *Gypsy Fires are Burning for Daylight's Past and Gone*, *Paid Off* and *Sheep Smearing*.

13. Repr. in Kenneth McConkey, 'From Grez to Glasgow: French Naturalist Influence in Scottish Painting', *Scottish Art Review*, vol XV, no 4, Nov. 1982, pp.16–24, 29–34, fig 11.

14. *Ibid.*

15. I am grateful to Ailsa Tanner for drawing Murray's picture to my attention. See also McConkey, pp.16–21.

16. Trained at the Royal Scottish Academy School; worked as an illustrator before turning to a professional career as a painter. ARSA 1882; RSA 1889.

17. Caw, *op. cit.*, pp.14–16.

18. Whyte was a Glasgow dentist who, in 1880, had bought from the Autumn Exhibition of the Glasgow Institute a large painting by Guthrie, *The Highland Shepherd*. For more information about Whyte, Helensburgh and the Glasgow Boys' connections with the town, see *Helensburgh and the Glasgow School*, 1972, a catalogue of an exhibition written and arranged by Ailsa Tanner.

19. Caw, *op.cit.* p.16.

20. *Ibid.*

21. William Hardie, *Scottish Painting 1837–1939*, London, 1976, p.76.

22. McConkey, *op. cit.*, pp.19–20, n17.

23. Probably shown at the Institute in 1883 as *A Heart for a Rose*, no 516.

5 TO PASTURES NEW

1. Caw, *Guthrie*, p.213.

2. *Ibid.*, p.16.

3. For a discussion of the appearance of Bastien-Lepage's work in London in the 1880s see Kenneth McConkey, 'The Bouguereau of the Naturalists – Bastien-Lepage and British Art', *Art History*, vol 1, no 3, 1978, pp.371–82, and 'From Grez to Glasgow: French Naturalist Influence on Scottish Painting', *Scottish Art Review*, vol XV, no 4, Nov. 1982, pp.16–24, 29–34.

4. See McConkey, 'The Bouguereau . . .', p.374, pl.49.

5. McConkey, 'From Grez to Glasgow . . .', p.20.

6. Caw, *Guthrie*, p.213.

7. Ailsa Tanner, *Helensburgh and the Glasgow School*, *op. cit.*, p.15, no 2.

8. *The Bailie*, 18 April 1883.

9. Listed in *Quiz*, 24 November 1882.

10. *Ibid.*, 11 August 1882.

11. *Ibid.*, 24 December 1882; *A Lincolnshire Harvester*, *North Bank, Crowland* and *The Idle Corner, Crowland*.

12. *The Bailie*, 27 December 1882.

13. *Ibid.*, 8 November 1882, reported that Macgillivray, Nairn, Henry, Paterson and Christie had applied for membership. On 15 November it reported the failure of Nairn and Henry to be elected.

14. William Buchanan in *The Glasgow Boys*, *op. cit.*, cites three paintings at the Institute as having a specific influence on the Boys in 1883. The third painting mentioned, however, was Melville's *Evie*, which was not exhibited in Glasgow until the Institute Exhibition of 1885 (no 201).

15. *The Bailie*, 14 March 1883.

16. Caw, *op. cit.*, p.213.

17. David Murray had already used the device of half a duck in a painting shown at the Glasgow Institute in 1879 (*Tarbert*, Coll: Hunterian Art Gallery, Glasgow). In 1878 he had also exhibited a goose-feeding picture, also including children in the composition. I am grateful to Ailsa Tanner for drawing these pictures to my attention.

18. *The Bailie*, 16 May 1883.

19. *Ibid.*, 14 April 1883.

20. *Quiz*, 1 June 1883.

21. *The Bailie*, 25 April 1883.

22. *Ibid.*, 30 May 1883.

23. Paterson family archives.

24. *The Bailie*, 2 April 1884.

25. Quoted in E. A. Taylor's obituary of Macgregor, *Studio*, vol LXXXIX, 1925, p.90; and by D. and F. Irwin, *Scottish Painters at Home and Abroad, 1700–1900*, London, 1975, p.373.

6 GREZ & COCKBURNSPATH

1. K. McConkey, *Sir John Lavery R.A. 1856–1941*, a catalogue of an exhibition organised by The Fine Art Society and The Ulster Museum, Belfast, 1984, p.11, n.14.

2. *Ibid.*, p.11, n.15; see also J. Lavery, *The Life of a Painter*, London, 1940.

3. *Ibid.*, p.16.

4. Repr. in McConkey, *Lavery*, p.11, fig 3.

5. McConkey, 'From Grez to Glasgow . . .', p.23.

6. *The Bailie*, 20 February 1884, reports that Lavery had just returned to Paris but there is no earlier record of when he arrived in Glasgow for the winter; if the previous year is any guide he could have been in Glasgow from as early as August 1883.

7. November 1888, pp.156–7.

8. *Quiz*, 7 October 1887, reports that Lavery had just returned from Larne with a family portrait group which he had just started in the open air and was now to finish in the studio.

9. See Ailsa Tanner, *Helensburgh . . .*, p.19.

10. McConkey, *Lavery*, pp.17–19.

11. Lavery, *Life . . .*, p.58.

12. McConkey, *Lavery*, p.17, no. 8, states that the painting is inscribed '1883–7'; although Lavery worked on the painting until at least 1887 the date on the painting is undoubtedly *1883* which suggests that, in some form at least, it was substantially finished that year.

13. McConkey, *Lavery*, p.19, suggests that the artist can be identified as William Mouat Loudan (1868–1925) who was working in Grez in 1884.

14. 18 February 1885.

15. McConkey, *Lavery*, p.26, n.2.

16. *Ibid.*, p.23.

17. Sketch-book, Coll: Glasgow Art Gallery; some pages bear date *June 1881*.

18. *Art Journal*, 1881 p.124.

19. See McConkey, *Sir George Clausen R.A., 1852–1944*, catalogue of an exhibition organised by Bradford Art Galleries and Museums and Tyne and Wear County Council Museums, 1980.

20. The reverse of the canvas bears the stamp of an American artists' materials supplier. It seems unlikely that Dow would return from the United States with blank canvases, which suggests that *Spring* was begun before he left the United States in 1884.

21. *Glasgow Herald*, 18 February 1885.

22. *The Bailie*, 7 January 1885.

23. Caw, *Guthrie*, pp.21–2.

24. *The Bailie*, 5 & 26 July 1883.

25. *Ibid.*, 30 May 1883.

26. *Ibid.*, 10 October 1883.

27. *Ibid.*, 25 May 1884.

28. *Quiz*, 3 March 1882.

29. Caw, *Guthrie*, pp.22–3.

30. *Ibid.*, p.214.

31. Repr., Mackay, *Melville*, pl.7.

32. *Ibid.*, pp.67–8.

33. *Scotsman*, 10 February 1885.

34. *The Bailie*, 14 January 1885.

35. *Ibid.*, 12 March 1884.

36. Caw, *Guthrie*, pp.30–1.

37. *Ibid.*, p.213.

38. *Ibid.*, p.213.

39. *Ibid.*, p.214.

40. *Ibid.*, pp.28–9.

41. *Quiz*, 26 October 1883.

42. *Art Journal*, 1884, p.243.

43. *The Bailie*, 21 November 1884.

44. *Quiz*, 29 October 1886.

45. *Ibid.*, 9 January 1884.

46. *Ibid.*, 8 January 1886.

47. *The Bailie*, 17 March 1886.

48. *Scotsman*, 6 February 1886.

49. *The Bailie*, 9 September 1885, reported that Walton had returned to Helensburgh where he was working on a picture of two children.

50. *Ibid.*, 21 May 1884.

51. *Ibid.*, 13 August 1884.

52. *Scotsman*, 10 February 1885.

53. *Glasgow Herald*, 18 February 1885.

54. Untraced; in the possession of Mrs Sam Warnock in 1935.

55. Letter to Hornel from Henry, dated 'Cockburnspath, 11 February 1886' (Coll: Hornel Trustees).

7 MONIAIVE AND GLASGOW

1. Paterson's relations with Moniaive are charted in the catalogue of an exhibition, *James Paterson, Moniaive*, Lillie Art Gallery, Milngavie, 1983; introduction by Ailsa Tanner.

2. *Scottish Leader*, 3 February 1888.

3. Quoted by Ailsa Tanner, *op. cit.* The notes were probably prepared by Paterson for a lecture given at the Art Galleries, Glasgow, in February 1892.

4. Caw, *Scottish Painting 1620–1908*, p.447.

5. See Ailsa Tanner, catalogue entry on David Gauld in *The Glasgow Boys*, Scottish Arts Council, 1968, vol I, pp.18–19.

8 TOWN AND COUNTRY

1. *The Bailie*, 27 May 1885.

2. I am grateful to Ailsa Tanner for drawing this picture to my attention.

3. David Scruton, *John Lavery: the early career 1880–1895*, catalogue of an exhibition organised by the Crawford Centre for the Arts, St Andrews, 1983, p.9.

4. Lavery, *Life*, p.42.

5. *Ibid.*, p.61.

6. *Ibid.*, p.57.

7. See McConkey, *Lavery*, cat. no 16A, repr. p.29.

8. *Ibid.*, p.29.

9. *Athenaeum*, 26 June 1886, p.852.

10. *Glasgow Evening News*, 28 January 1887.

11. *North British Daily Mail*, 28 January 1887.

12. *Glasgow Herald*, 16 February 1887.

13. *The Bailie*, 13 January 1886.

14. *Ibid.*, 28 December 1887.

15. *Quiz*, 16 February 1893.

16. Coll: Hornel Trustees.

17. Undated letter, *c.* March 1886. Coll: Hornel Trustees.

18. *Quiz*, 23 September 1887.

19. Undated letter, *c.* October 1892. Coll: Hornel Trustees.

20. *Quiz*, 9 September 1887.

21. Undated letter, probably summer 1887. Coll: Hornel Trustees.

22. *Quiz*, 2 March 1888.

23. *Quiz*, 7 October 1887.

24. *Ibid.*, 29 October 1886.

25. *Ibid.*, 23 September 1887.

26. *Ibid.*, 2 December 1887.

27. See *The Discovery of Scotland*, p.147.

28. *Quiz*, 23 September 1887; Macaulay Stevenson was one of the contributors to the magazine at this time and it was perhaps he who was responsible for this new title.

29. *Ibid.*, 3 May 1889.

30. *Ibid.*, 19 April 1889.

31. *Ibid.*, 31 May 1889.

32. *Ibid.*, 12 July 1889.

33. Letter from Macgregor to Paterson, dated 11 July 1887; Coll: Paterson Family.

34. Letter from Macgregor to Paterson, dated 16 August 1890. This is the date given by Paterson in his transcription of Macgregor's letter but if Macgregor's reference to the 'star' picture refers to *The Star in the East* then the letter must date from the summer of 1891 at the earliest. Coll: Paterson Family.

35. Letter from Macgregor to Paterson, undated, *c.* February 1887; Coll: Paterson Family.

36. Letter from Macgregor to Paterson, dated 10 December 1887; Coll: Paterson Family.

37. Letter from Macgregor to Paterson, undated, but probably written *c.*1892; Coll: Paterson Family.

38. Letter from Henry to Hornel, undated but probably 1891 or 1892. The reference to Walton's family as art workers refers to his brother George and sisters Helen, Hannah and Constance. Coll: Hornel Trustees.

9 A KELVINGROVE AIR

1. 'Art at the Glasgow International Exhibition', *The Scottish Art Review*, June 1888, pp.5–6.

2. *Ibid.*

3. *Ibid.*

4. *The Bailie*, 30 March 1887.

5. For a discussion of Lavery's preparations for the International Exhibition and a reproduction of the second painting (*Night after the Battle of Langside*) see K. McConkey, *Sir John Lavery R.A.*, pp.17–18.

6. In a copy of *The Scottish Art Review* which had belonged to the Scottish Arts Club, Edinburgh, James Paterson added his signature at the bottom of this article along with the inscription 'I had forgotten

this. Edinburgh 1915'. I am grateful to Mrs Una Rota for drawing this to my attention.

7. 'Art in the West of Scotland', *The Scottish Art Review*, November 1888, p.149.

8. *Ibid.*

9. *Art Journal*, 1888, p.276.

10. *Quiz*, 16 March 1888.

11. *Ibid.*, 20 April 1888.

12. 'Some Recent Efforts in Mural Decoration' by G. Baldwin Brown, *The Scottish Art Review*, January 1889, pp.225–8.

13. *Quiz*, 15 February 1889.

14. *The Scottish Art Review*, April 1889, p.304.

15. *Quiz*, 27 September 1889.

16. *Ibid.*, 5 July 1889.

17. *The Scottish Art Review*, October 1888, p.132.

18. *The Times*, 9 June 1891.

19. *The Bailie*, 31 December 1890.

20. Macaulay Stevenson's account of the history of *The Scottish Art Review* was given to T. J. Honeyman in letters to the latter written in 1941. These are now missing but a large quotation from them appeared in 'A Hundred Years of Art in Glasgow' by Honeyman in J. M. Reid *et al.*, *Glasgow Art Club, 1867–1967*, Glasgow, 1967, pp.43–6. All the quotations attributed to Stevenson which follow are from this same source.

21. Coll: Paterson family.

22. *Ibid.*

23. *The Scottish Art Review*, June 1888, p.1.

24. Macgregor to Paterson, July 1888. Coll: Paterson family.

25. *The Scottish Art Review*, July 1888, p.25.

26. *The Bailie*, 2 October 1889.

27. Coll: Hornel Trustees.

10 GALLOWAY IDYLL

1. A. S. Hartrick, *A Painter's Pilgrimage through Fifty Years*, Cambridge, 1939, p.58.

2. Private Collection; repr. W. Buchanan, *The Glasgow Boys*, Vol II, 1968, p.83.

3. Macgillivray's diatribe against the RSA, 'Anent the Scots Academy', was written in 1897 but not published until 1922 when it appeared in *Bog-Myrtle and Peat Reek*, privately printed and published in 1922.

4. Written and privately published in 1888 by Doryphorus (Pittendrigh Macgillivray). No printed version has been traced but the above is a transcript of a manuscript version discovered by L. L. Ardern and published by him in the *Dumfries and Galloway Standard and Advertiser*, 21 September 1984.

5. Hartrick, *op. cit.*, p.59.

6. *Ibid.*

7. *Ibid.*, p.61.

8. Hartrick also recounts the untrue story that Henry and Hornel did not speak to each other while they were in Japan together for eighteen months in 1893–4.

9. L. Errington and J. Holloway, *The Discovery of Scotland*, p.149.

10. *Helensburgh and Gareloch Times*, 12 February 1890.

11. *Scotsman*, 7 February 1890.

12. *North British Daily Mail*, 15 March 1890.

13. *The Bailie*, 22 February 1893.

14. Hartrick, *op. cit.*, p.61.

15. *Saturday Review*, 10 May 1890, p.565.

16. *Magazine of Art*, 1890, p.326.

17. In a number of letters to Hornel written in the summer of 1892 (Coll: Hornel Trustees) Henry mentions various schemes for wall paintings or decorative canvases for installation in new houses. These usually seem to have had allegorical or symbolical subjects, such as the muses or the seasons; three such paintings, dated 1887/8 are in the collection of Paisley Art Gallery. One of the schemes was for a client of the architect John Keppie, who in 1889 joined the practice in which the young Charles Rennie Mackintosh was employed as draughtsman. The panels which Keppie asked Henry for were intended for the house of Thomas Mason in Dumbreck, Glasgow. It is not known whether Henry ever carried out the commission but the final details for the new work at the house were devised by Mackintosh (see Roger Billcliffe, *Charles Rennie Mackintosh: the Complete Furniture, Furniture Drawings and Interior Designs*, 1979, pp.29–30). Keppie became a close friend of Mackintosh during the early 1890s and was also on good terms with Hornel for whom he designed the extension to his Kirkcudbright house about 1910.

18. Letter from Dunlop, Ayrshire, dated 7 December 1891 (Coll: Hornel Trustees).

19. Coll: Hornel Trustees.

20. Quoted by W. Buchanan in *Mr Henry and Mr Hornel visit Japan*, Scottish Arts Council, 1978, p.9.

21. For a fuller discussion of the effects of Japanese art on painting in Glasgow and the routes by which it became known in the city see W. Buchanan, *Mr Henry and Mr Hornel visit Japan*, Scottish Arts Council, 1978.

22. *Quiz*, 16 February 1893.

23. *The Bailie*, 22 February 1893.

11 SUNLIGHT AND SHADOWS

1. I am grateful to Ailsa Tanner for drawing my attention to the illustrations of Hedderwick's poetry. For a further discussion of Gauld's debt to Willson see her catalogue entry on Gauld, *The Glasgow Boys*, vol I, Scottish Arts Council, 1968.

2. For a discussion of David Gauld's work as a designer of stained glass and illustrations of other pieces, see Michael Donnelly, *Glasgow Stained Glass*, a catalogue of an exhibition held at the People's Palace, Glasgow, 1981.

3. *The Bailie*, 17 October 1888.

4. *The Bailie*, 18 March 1891.

5. *Daily Mail*, 13 December 1890.

6. *Glasgow Herald*, 13 December 1890.

7. *Ibid.*, 7 February 1891.

8. A complete list of Guests, with their costumes, was published by the Art Club as a souvenir in 1890. It also contains a number of reproductions of paintings made at the Ball by the Boys and other artists.

9. Quoted by T. J. Honeyman in *Whistler: Arrangements in Grey and Black*, Glasgow Art Gallery, 1951.

10. *Ibid.*

11. *Ibid.*

12 BORDER CROSSINGS

1. *The Saturday Review*, 10 May 1890, p.565.

2. *The Spectator*, 10 May 1890.

3. *The Saturday Review*, 10 May 1890, p.565.

4. *The Magazine of Art*, 1890, p.326.

5. Included among the works exhibited were:
Oils:
Gauld: 404, *St Agnes*, 405, *Idylle*; Guthrie: 450, *Portrait of George Smith*, 451, *Portrait of Revd Andrew Gardiner DD*, 452, *Portrait of Robert Gourlay*, 453, *The Cornfield [Fieldwork in the Lothians]*, 453a, *Portrait*; Hamilton: 471a, *Sunset over the Cliffs*, 471b,

The Shepherdess; Henry and Hornel: 517b, *The Druids*; Hornel: 570, *At the Oven*, 571, *Goats*, 571a, *Among the Wild Hyacinths*; Kennedy: 644, *Spring Idyll*, 645, *Teatime on the Couch*, 646, *Stirling Station*; 647, *Cooking*, 648, *Girl in Red*; Lavery: 737, *A Tennis Party*, 738, *Study*, 39, *Young Girl in Black*, 740, *Summertime*, 740a, *Dawn after the Battle of Langside*, 740b, *A Passing Salute – the Bridge at Grez*; Melville: 842a, *Audrey and her Goats*; Paterson: 945, *Evening*, 945a, *Evening on the Cairn*, 945b, *Landscape*, 945c, *The End of the Storm*; Roche: 1048, *At the Summit*, 1049, *Good King Wenceslas*, 1050, *Miss Lou*, 1050, *The Shepherdess*, 1050b, *Am Hofe der Kartenkonige*; Spence: 1196, *Nature's Garden, East Coast*; Stevenson: 792b, *Idyll*; Thomas: 448, *Dawn*.

Watercolours, pastels and drawings:
Crawhall: 1455, *Dick* (w/c), 1456, *Cow with a load, Tangier* (w/c), 1457, *Camels, Tangier* (w/c), 1458, *Bull Fight in Spain* (w/c), 1459, *The Forge* (w/c), 1460, *The Duckpond* (w/c), 1461, *The Aviary, Clifton* (w/c); Dow: 1464, *On the Hudson River* (w/c), 1465, *Chrysanthemums*, 1466, *Moonlight on the Sea* (pastel); Guthrie: 1476, *Study* (pastel), 1477, *Autumn* (pastel), 1478, *September* (pastel), 1479, *Stirling: Town and Castle* (pastel), 1480, *In the Cable Car* (pastel); Kennedy: 1487, *The Arrival of the Shah in Scotland*, 1488, *The Departure of the Shah* (both pastels); Macgregor: 1499, *In the Garden* (w/c), 1500, *Study of a Head* (charcoal); Melville: 1503, *Javanese Dancer*; Paterson: 1516, *Azaleas* (w/c), 1517, *Flowers* (?pencil); Stevenson: 1498a, *The Setting Moon* (w/c).

6. Richard Muther, *A History of Modern Painting*, English translation, 1896.

BIBLIOGRAPHY

Major printed sources are listed below, including individual articles in journals and exhibition catalogues. The Bibliography in David and Francina Irwin's *Scottish Painters: At Home and Abroad* is the most complete in its listing of further books, articles and catalogues devoted to Scottish painting prior to 1900. The two parts of the Scottish Arts Council catalogue, *The Glasgow Boys*, contain further references to articles and reviews of the Boys' work. *The Scottish Art Review*, *Quiz* and *The Bailie* all contain references *passim* to the Boys and the general state of the fine arts in Glasgow and Scotland during the period.

GENERAL WORKS

Bird, Elizabeth, 'International Glasgow', *The Connoisseur*, vol 183, August 1973, pp.248–57.

Brown, Gerard Baldwin, *The Glasgow School of Painters*, Glasgow, 1908.

Caw, Sir James Lewis, *Scottish Painting: Past and Present 1620–1908*, Edinburgh, 1908.

Caw, Sir James Lewis, 'A Phase of Scottish Art', *Art Journal*, 1894, pp.75–80.

Edinburgh International Exhibition, 1886, *Memorial Catalogue of the French and Dutch Loan Collection*, Edinburgh, 1886.

Farr, Dennis, *English Art 1870–1940*, Oxford, 1978.

The Fine Art Society, *The Glasgow School of Painting*. Exhibition catalogue and introduction by William R. Hardie. London, 1970.

The Fine Art Society, *Glasgow 1900*. Exhibition catalogue and introduction by Roger Billcliffe; introductory essay by Elizabeth Bird. Glasgow, 1979.

Geddes, Sir Patrick, *Every Man his Own Art Critic: Glasgow International Exhibition*, Glasgow, 1888.

Glasgow Art Club, *Glasgow Art Club Book, 1885*, Glasgow, 1885.

Glasgow Art Club, *Souvenir of the Grand Costume Ball* [Glasgow, 1889].

Glasgow Art Club, *Glasgow Art Club, 1867–1967*, Glasgow, 1967. Including J. M. Reid, 'Glasgow Art Club, the First Hundred Years' and T. J. Honeyman, 'A Hundred Years of Art in Glasgow'.

Glasgow Art Gallery and Museum, *Summary Catalogue of British Oil Paintings*. Catalogue by George Docherty and Anne Donald, Glasgow, 1971.

Glasgow Art Gallery and Museum, *Scottish Painting*. Exhibition catalogue by George Buchanan and Alasdair Auld, Glasgow, 1961.

Glasgow International Exhibition, 1888, *A Century of Artists. A Memorial of the Glasgow International Exhibition of 1888*, Glasgow, 1888. Text by W. E. Henley; illustrated with line drawings by Alexander Roche.

Gould, Brian, *Two Van Gogh Contacts: E. J. Van Wisselingh, Art Dealer, Daniel Cottier, Glass Painter and Decorator*, London, 1969.

Hardie, William R., *Scottish Painting, 1837–1939*, London, 1976.

Hartrick, Archibald Standish, *A Painter's Pilgrimage through Fifty Years*, Cambridge, 1939.

Helensburgh and District Art Club, *Helensburgh and the Glasgow School*, Helensburgh, 1972. Exhibition catalogue by Ailsa Tanner.

Honeyman, T. J., 'The Glasgow School of Painting', *Proceedings of the Royal Philosophical Society of Glasgow*, LXV, 1941, pp.45–52.

Honeyman, T. J., *Patronage and Prejudice*, W. A. Cargill Memorial Lecture in Fine Art, Glasgow, 1968.

Irwin, David and Francina, *Scottish Painters: At Home and Abroad 1700–1900*, London, 1975.

Kossatz, Horst-Herbert, 'The Vienna Secession and its Early Relations with Britain', *Studio International*, vol 181, London, 1971.

Laughton, Bruce, 'The British and American Contribution to Les XX, 1884–93', *Apollo* LXXXVI, November 1967, pp.372–9.

McConkey, Kenneth, 'From Grez to Glasgow: French Naturalist Influence in Scottish Painting', *Scottish Art Review*, vol XV, no 4, Nov. 1982, pp.16–34.

Martin, David, *The Glasgow School of Painting*, London, 1897. Introduction by Francis Newbery.

Morley, Henry, 'The Craigmill Art School and a Cambuskenneth Group of Painters', *Stirling Natural History and Archaeological Society*, 1933–4.

Moore, George, *Modern Painting*, London, 1893.

Munro, Neil, *The Brave Days*, Edinburgh, 1931. Chapter VII, 'Art and Artists'.

Muther, Richard, *History of Modern Painting*, English translation, 4 vols, London, 1895–6 (German edition, 1893–4).

National Gallery of Scotland, *Catalogue of Scottish Drawings*. Keith Andrews and J. R. Brotchie, Edinburgh, 1960.

National Gallery of Scotland, *The Discovery of Scotland*. Exhibition catalogue by James Holloway and Lindsay Errington, Edinburgh, 1978.

Newcastle upon Tyne Polytechnic Art Gallery, *Peasantries*. Exhibition catalogue by Kenneth McConkey, David Gray, Jack Dawson and Ysanne Holt, Newcastle upon Tyne, 1981.

[Paterson, James], 'Art in the West of Scotland', *The Scottish Art Review*, vol I, 1888, pp.146–9.

Rinder, Frank, and McKay, William Darling, *The Royal Scottish Academy, 1826–1916*, Edinburgh, 1917.

Royal Academy of Arts, *Post-Impressionism*. Exhibition catalogue, London, 1979.

Scottish Arts Council, *The Glasgow Boys*. Exhibition catalogue by William Buchanan and others; two parts, Edinburgh, 1968 and 1971.

Scottish Arts Council, *A Man of Influence: Alex Reid*. Exhibition catalogue by Ronald Pickvance, Glasgow, 1967.

INDIVIDUAL ARTISTS

CRAWHALL, Joseph

Rinder, Frank, 'Joseph Crawhall', *The Art Journal*, 1911, pp.71–6.

W. B. Paterson Gallery, *Catalogue of a Loan Collection of Watercolour Drawings by Joseph Crawhall*, London, 1912.

M[ackie], T. C[ampbell], 'The Crawhalls in Mr William Burrell's Collection', *Studio*, vol LXXXIII, 1922, pp.177–86.

Bury, Adrian, *Joseph Crawhall: The Man and the Artist*, London, 1958.

DOW, Thomas Millie

Garstin, Norman, 'The Work of T. Millie Dow, *Studio*, vol X, 1897, pp.145–52.

GAULD, David

Bate, Percy, 'The Work of David Gauld', *Scottish Art and Letters*, Sept.–Nov. 1903, pp.372–83.

GUTHRIE, Sir James

Rinder, Frank, 'Sir James Guthrie PRSA', *Art Journal*, 1911, pp.139–44, 270–5.

Walker, A. Stodart, 'Portraits by Sir James Guthrie PRSA', *Studio*, vol LIV, 1912, pp.18–26.

Caw, Sir James Lewis, *Sir James Guthrie PRSA LLD: a Biography*, London, 1932.

The Fine Art Society, *Guthrie and the Scottish Realists*, Glasgow, 1982. Exhibition catalogue by Roger Billcliffe.

HAMILTON, James Whitelaw

Walker, A. Stodart, 'The Paintings of James Whitelaw Hamilton', *Studio*, vol LX, 1914, pp.9–19.

HENRY, George

M[artin], D[avid], 'Studio Talk', *Studio*, vol IX, 1897, pp.140–4.

Bate, Percy, 'The Work of George Henry', *Studio*, vol XXXI, 1904, pp.3–12.

Buchanan, George, 'A Galloway Landscape', *Scottish Art Review*, vol VII, no 4, 1960, pp.13–17.

Scottish Arts Council, *Mr Henry and Mr Hornel visit Japan*, 1979. Exhibition catalogue by William Buchanan with assistance from Ailsa Tanner and L. L. Ardern.

HORNEL, Edward Atkinson

Hornel, E. A., *Japan. A Lecture delivered in the Corporation Art Gallery, Glasgow, 9 February 1895*, Castle Douglas, [1895].

Dibdin, E. Rimbault, 'Mr E. A. Hornel's Paintings of Children and Flowers', *Studio*, vol XLI, 1907, pp.3–9.

Hardie, William R., 'E. A. Hornel Reconsidered', *Scottish Art Review*, vol XI, no 3, 1968, pp.19–21, 27; *ibid.*, no 4, 1968, pp.22–6.

Scottish Arts Council, *Mr Henry and Mr Hornel visit Japan*, 1979. Exhibition catalogue by William Buchanan with assistance from Ailsa Tanner and L. L. Ardern.

The Fine Art Society, *Edward Atkinson Hornel, 1864–1933*, Glasgow, 1982. Exhibition catalogue by Roger Billcliffe.

LAVERY, Sir John

Shaw-Sparrow, Walter, *John Lavery and his Work*, London, [1911].

Lavery, John, *The Life of a Painter*, London, 1940.

The Fine Art Society and the Ulster Museum, Belfast, *Sir John Lavery RA, 1856–1941*, 1984. Exhibition catalogue by Kenneth McConkey, which contains a complete bibliography of Lavery.

MACGREGOR, William York

Taylor, E. A., 'W. Y. Macgregor [an obituary]', *Studio*, vol LXXXIX, pp.89–92.

MANN, Alexander

The Fine Art Society, *Alexander Mann*, 1983. Exhibition catalogue; introduction by Christopher Newall.

MELVILLE, Arthur

Mackay, Agnes Ethel, *Arthur Melville, Scottish Impressionist, 1855–1904*, Leigh-on-Sea, 1951.

Dundee Art Gallery, *Arthur Melville*, 1977. Exhibition catalogue by Gerald Deslandes.

PATERSON, James

Paterson, James, 'An Art Student in Paris', *Scottish Art Review*, vol I, 1888, pp.118–20.

Caw, Sir James Lewis, 'James Paterson PRSW RSW RWS', *The Old Watercolour Society's Club*, vol X, 1933 (with a list of watercolours exhibited).

Belgrave Gallery, London, *The Paterson Family*, 1977. Exhibition catalogue by Anne Paterson Wallace.

Lillie Art Gallery, *James Paterson, Moniaive, and following Family Traditions*, Milngavie, 1983. Exhibition catalogue by Ailsa Tanner and Anne Paterson Wallace.

ROCHE, Alexander Ignatius

'Of Love in Art', *Scottish Art Review*, vol I, 1888, pp.29–30.

'Of Finish in Art, *Transactions of the National Association for the Advancement of Art and its Application to Industry*, 1889, pp.332–44.

Macfall, Haldane, 'The Art of Alexander Roche', *Studio*, vol XXXVII, 1906, pp.203–13.

STEVENSON, Robert Macaulay

Bate, Percy H., 'The Work of R. Macaulay Stevenson', *Studio*, vol XXII, 1901, pp.232–42.

THOMAS, Grosvenor

West, W. K., 'The Landscape Paintings of Mr Grosvenor Thomas', *Studio*, vol XLI, 1907, pp.257–62.

WALTON, Edward Arthur

Caw, Sir James Lewis, 'A Scottish Painter', *Studio*, vol XXVI, 1902, pp.161–70.

Walker, A. Stodart, 'The Recent Paintings of E. A. Walton', *Studio*, vol LVIII, 1913, pp.261–70.

Glasgow Art Gallery, *E. A. Walton: Memorial Exhibition*, 1923.

Taylor, E. A., 'E. A. Walton PRSW RSA. Memorial Exhibition at Glasgow', *Studio*, vol LXXXVII, 1924, pp.10–15.

Bourne Fine Art, Edinburgh, *E. A. Walton 1860–1922*. Exhibition catalogue by Helen Weller, 1981.

INDEX